THOMAS GAINSBOROUGH

His Life and Art

THOMAS GAINSBOROUGH

His Life and Art

Jack Lindsay

Universe Books
New York

Published in the United States of America in 1981
by Universe Books
381 Park Avenue South, New York, N.Y. 10016

© 1980 by Jack Lindsay

Library of Congress Catalog Card Number 80-54397
ISBN 0-87663-352-1

Printed in Great Britain

For Orin Anderson

Two worlds we always somehow straddle,
one here and one that's somewhere else,
or both together sadly squabbling.
The whole thing is a deadly riddle
that we can't answer. In despair
we strive to inhabit both at once,
and lose them both: which isn't fair.

For life's a balance oddly unstable
and tips us headlong as we trust it,
or an unbalance subtly poised
upon a guileful point of rest.

Tom drew the objectionable gentry,
but much preferred to play his fiddle
at midnight, with his wife abed,
or watch on horseback down below
the children in the other world
romping before the cottage-door,
paradise's forbidden entry,
freedom no longer to be dared.

I've sold my heritage for pottage,
he muttered, on the stage of fools,
no consolation now but drink,
I can't pass through that door, I'm scared,
I'm changed and given a different face;
the scenes are shifting as I look.

Yet he was in there all the while
hugging the girl, without a clock
to toll him back to loss once more.
He muttered: Yes, the game is strange,
I'd like another set of rules,
but keep the old ones, as I range,
from the mad cowardice of habit.

Jack Lindsay

Contents

List of Plates

Preface

*S*ince 1951 I have been living in North Essex only a few miles
from Sudbury, and have steadily felt more and more
Gainsborough's presence in the area. So my interest in his life and
work has been linked with this growing familiarity with his home-
area as well as the impact of his work in galleries or repro-
ductions. The more I have come to know him the more I have felt
him to be the most creative and adventurous artist in England
between Hogarth and Turner: so that it seemed natural to write a
study of his life and work which would also be a link between the
Lives I have written of those two artists. Though in many respects
the direct opposite of Hogarth, he is yet closely related to him in
complex ways I have tried to analyse. And though his direct
influence on other artists, even on Constable, is not of any
obvious importance, yet the impact of his work as a whole had a
profoundly liberating effect, which lies behind both Constable
and Turner. His letters give us many illuminating glimpses into his
mind and enable us to estimate with some certainty the deep-
rooted dissidence that underlay his achievement: a dissidence that
always remained personal in his formulations of it, yet had many
far-reaching aesthetic and social correlations.

As I have argued elsewhere, a biography enables one to bring
together the personal, aesthetic, and social aspects in the
development of an artist or writer as no directly critical study can
do. With Gainsborough the linking and fusion of the various
aspects enables one to get a profoundly new perspective on his
art, which I have tried to bring out in this book. The work which

made possible this fuller approach to his art was Mary Woodall's edition of the *Letters*.

A biographer must pay tribute to the pioneering work of Whitley in collecting much material about Gainsborough's life, his sitters, the reception of his work. But his main debt, apart from the edition of the *Letters*, will be to the devoted labours of Ellis Waterhouse and John Hayes, with further useful work by Woodall, Oliver Millar, and others, and a stimulating study in interpretation by Paulson. It is to Dr Hayes, however, that I acknowledge my main debt, both for his books – the excellent general study of 1975, the thorough edition of the Drawings, and *Gainsborough as Printmaker* – and for his large number of articles in art-periodicals. Through his indications I have located four largely new letters, two of them of much biographical importance.

These letters are those of (1) 7 May 1756 to Mr Harris, and those to Mary Gibbon, (2) 12 September 1777, (3) 22 September 1777, (4) undated, on Mary Fischer. For aid in obtaining the texts and for permission to use I must thank Miss Marjorie Maynard, Local History Librarian, Suffolk Record Office, Miss Mary Ann Thompson of the Paul Mellon Collection, and Miss Joan M. Friedman and Mrs Joyce Guiliani, of the Yale Center for British Art. Part of (2) appears in Woodall, *Letters*, as no. 39, in which also is given one sentence of (3). Hayes cites a phrase of (3) and mentions it as evidence that Gainsborough kept his landscape prices from his wife. Otherwise these letters are here dealt with for the first time.

Jack Lindsay

Introduction

Nothing could be further from the truth than the idea of Gainsborough as a contentedly successful portrait-painter. 'Now damn Gentlemen,' he wrote to his friend Jackson, 'there is not such a set of Enemies to a real artist in the world as they are, if not kept at a proper distance.' He continually complained of the drudgery of Face-painting, as he called it, and wanted to turn to landscapes, for which there was no market. From one angle his life was a ceaseless struggle to get away from the genre which provided his livelihood and in which he achieved remarkable skill, and to immerse himself in another genre for which a public was only slowly emerging. This conflict in fact gave strength and variety to his methods of portraiture, at the same time deepening and adding variety to the landscapes in which he felt himself truly at home. He thus stands out as the one English artist of the eighteenth century, apart from Hogarth, with a highly original and adventurous sensibility all his own. (Turner, though born in 1775, matured in the next century.) In many ways he was the exact opposite of Hogarth, and yet he and Hogarth were the two artists who reveal powerfully the innermost struggles in the art of their century, struggles which broke through the prevailing conventions and canons, and which released great new potentialities. They were the two artists with comprehensive new visions of life, of man and society, of man and nature. Visions that required new techniques, new ways of handling paint and of interrelating objects.

Gainsborough, after his youthful studies of nature in the Suffolk countryside, quickly absorbed the main elements that he

needed from two opposing schools of the time: the Dutch landscapists with their faithful versions of the scenes at which they were looking, and the French exponents of graceful, decorative rococo. What he found in the Dutch closely akin to his own outlook was the deep and intimate feeling for the actual forms of the countryside, for the relation of peasants and animals to the setting of their labours and leisure. In the paintings of artists like Watteau he responded to the lyric elements, the ordering of nature and people in terms of rococo curves. He brought the two opposed positions together by seeing, as Hogarth had seen, the significant curve, the Line of Beauty, as much more than a decorative device for producing a charming effect. He saw in it an organic element, something inherent in vital structure and in the movement of forms at their point of highest concentration and release. Thus he was able to merge Dutch realism with the curvilinear space of rococo. Not that the process of merging them was an easy one, which could find fulfilment in any simple or schematic way. The struggle to enter into nature, accept it for what it is, and yet to transform it with a deeper vision of how its structures operated, went on all his life and was still with him at the end. The story of his life is the story of that struggle.

In thus merging realism and rococo he became the first great exponent of romanticism in landscape, the first master who moved decisively away from formally imposed structures (however much he learned from Ruisdael, Claude, Rubens and others), and who sought to define what he saw in a lyrical flash, in the immediacy of a momentary yet unifying response.

Landscape in his sense of the term had no market-value except in limited ways, for instance as part of the decorations of a fireplace. But he refused to give up, making countless drawings for his own satisfaction, and in his later years he managed to find ways of developing landscape that commanded respect and attention, mainly by using it in what were called Fancy-Pictures. (Vertue in 1738 used the term Fancy to mean some pleasant conceit introduced into Conversation Pieces, informal portrait groups. It became linked with pastorals of an arcadian type and sentimental genre pictures. Indeed, it was used to define a genre picture which was somehow refined and lifted on to a higher level than the ordinary direct type. In a sense the Fancy-Picture took over the allegorical approach of the previous century and achieved something of poetic suggestiveness.)

By his introduction of children into the rustic scene

Gainsborough was able to gain acceptance of his landscapes and to move to the setting that most deeply moved him: that of a humble cottage on a slope of trees, with a peasant mother at the open door and perhaps with a woodman coming home at evening with his burden on his back. Though he was in some ways modifying his vision to suit contemporary taste, he was more than happy to bring peasants into his paintings and to relate them to the forms of nature.

But all this while his main work was in portraiture, by means of which alone he was able to make a living. We noted how he chafed at being bound down to Face-painting, and yet he could not but find satisfaction in his increasing mastery of the medium, especially in his capacity to produce striking likenesses. (We shall see the various devices he worked out to ensure the close resemblance between the portrait and the sitter just as he or she was at the moment of painting.) He could not help putting more and more of himself into the portraits, smuggling into them the sensibility which he wanted to give wholly to landscape. He put his sitters into rural situations and steadily developed ways of linking them, merging them, with nature. But whereas the peasants climbing into a waggon, or the lovers lying by the roadside, or the mother standing at the door into another world, were all figures with whom he could simply and fully sympathize he had to maintain his interest in the rich or noble people he depicted by concentrating on the problems of paint they set him with the fine texture of their clothes, the ringlets of their hair, and so on: not so that he might glorify the sitters, but so that he might learn more about ways of seeing and representing the subtle textures and movement of forms in the world of nature. Most of all, he responded to women sitters with charm and character, and ended with almost merging them entirely with the natural world by the complex ways he used his paint, harmonized his colours, and interrelated the movement of forms and textures (hair and foliage, and so on). He became by far the most original and uninhibited handler of paint in his century, carrying much further the free treatment developed by artists like Watteau and La Tour.

Thus he managed, at his best, to define the sitter by the light of the same lyric flash as he used in grasping the totality of forms and colours in a moment of nature. He often expressed his direct and active relation to the thing seen by his use of broken passages and squiggles of paint, which so bewildered a more conventional painter like Reynolds. When Reynolds said that he 'did not look

at nature with a poet's eye', but 'saw her with the eye of a painter', what he really meant was that he did not import external meanings or purposes (concepts of History Painting) into his vision, but sought above all for the most vivid way of realizing the object in terms of paint. For this reason he was truly poetic, in a sense that Reynolds did not understand. Like Hogarth he bypassed or transmuted History Painting (which took as its subjects gods, heroes, mythological beings, kings, the great of the world), and in fact achieved the deep and comprehensive significance which History Painting was supposed to encompass and reveal, but which it had long ceased to grasp.

Seen in this way, the story of Gainsborough's career becomes an exciting one, a continual advance into new spaces of sensibility, with a romantic sense of lost nature at its core. In one sense, whatever he painted, he was seeking to return to his early Suffolk days, rediscovering with fresh vividness and fullness the world of his childhood, which was also that of the peasants. He was thus a consistent rebel, but he never formulated his revolt in any direct political or social terms, apart from expressing his contempt for the Gentry.

He managed to maintain this revolt, despite his inability or refusal to formulate in any clear theoretical terms his aesthetic and social positions, because his passionate obsession with music was able to release and direct his sensibility. He played practically every instrument of the period, mainly by ear, and among his best friends he had many of the leading musicians of the time. In an artist like Watteau we can see a certain link between the rococo curvilinear world and the rhythms and patterns of music; but Gainsborough carried this attitude further than anyone else. Music provided him with the model of a universe of forms and emotions obeying their own rhythmic laws and systems, and so gave him both the courage and the enriched sensibility that enabled him to build his own system of free brushwork and rhythmically interrelated forms and colours. Clearly, in music he felt that he was inhabiting the liberated and harmonious world of his dreams.

A lesser aspect of dissidence appears in his predilection for wine and wenches. He certainly owed a great deal to his wife in providing a stable background for his life and work, but all the while the feckless element in him, which repudiated the establishment values of his world, drove him to turn from the family sphere, where the constraints and constrictions were linked

with the need to make money by Face-painting, into the back-streets of loose living. Interestingly, the bawdy jokes in his letters are often connected with the theme of music. (He seems to have written a large number of bawdy letters to his old Ipswich friend, Kilderbee, which squeamish executors destroyed.) No doubt his looseness was mild in terms of much of the behaviour of the period, but it had an important emotional content for him. The new letter here printed about the deserted girl from Bath (p. 137) is a valuable revelation of his character in these relations.

1 Childhood (1727-1740)

*I*t is an odd fact that of the three greatest English landscape painters (Gainsborough, Turner and Constable) two were born and grew up in the Stour Valley, which runs between Essex and Suffolk, and which is rather flat, with slight hills on either side for much of its way. There are no striking features. Round Gainsborough's Sudbury the slopes come closer and there are water-meadows; further down, in Constable's country, we meet broader lands for crops. It is a region for close intimacies with nature, not for large scale vistas or imposing features. Gainsborough and Constable each loved the area in which he grew up. Constable continued to paint directly the scenes of river and field he knew so well; Gainsborough, working in a different way, remained faithful to the impressions he had gained in early years, concerned with his Suffolk woodland and the rough roads or tracks through it, which nearly always led down to water. The county is full of fertile river valleys; no spot in it is more than ten miles from a stream. At Sudbury starts a wide area of cold clay, reaching to Ipswich some twenty-five miles away, which bears good wheat crops in a dry season. But near Sudbury the soil is alluvial, with willow, alder, and elm thick in the woodlands and with much pasture ground feeding herds of cattle and sheep in Tom's days.

Fulcher, Gainsborough's Sudbury biographer, stresses that 'the woodman's axe had not then thinned the old ancestral trees', and that the winding Stour, so dear to Tom, followed 'Hogarth's line of beauty in all its graceful variety'. Trimmer (grandson of Gainsborough's friend, Kirby) later recorded:

As my mother came close from Sudbury, in my youth I knew Gainsborough's sketching grounds well. Thirty years ago, before the oaks were cut down, and the thatched cottages done away with, every step one took reminded one of Gainsborough, not the least the slim-formed, though rustic figures.

Constable described the Stour valley: 'its gentle declivities, its luxuriant meadow-flats sprinkled with flowers and herds, its well-cultivated uplands, its woods and rivers, with numerous scattered villages and churches, farms and picturesque cottages.' In the summer of 1799, sketching in Suffolk, he wrote, 'It is a most delightful country for a painter. I fancy I see Gainsborough in every hedge and hollow tree.' Gainsborough himself told his friend Philip Thicknesse that

during his *Boy-hood*, though he had no Idea of becoming a Painter then, yet there was not a Picturesque clump of Trees, nor even a single Tree of beauty, no, nor hedge-row, stone or post, at the corner of the Lanes, for some miles round the place of his nativity, that he had not so perfect in his *mind's eye*, that had he known he *could use* a pencil, he could not have perfectly delineated. [1]

We do not know the day of his birth, but he was baptized on 14 May 1727, at the Independent Meeting House in Sudbury. He said later, 'Old pimply-nosed Rembrandt and myself were both born in a mill.' He probably meant the Tudor house in Sepulchre Street, which his father John had bought in 1722 for £230 and given a Georgian front next year. Fulcher says it had been an inn, the Black Horse. John Gainsborough was a textile manufacturer, and into the house (originally two houses, it seems, united by the new façade) he brought his wife and four children, together with servants. No doubt he carried on weaving there, and needed space for looms, raw materials, and finished products. As he prospered, he seems to have bought the near house at the corner of Weavers Lane. [2]

John belonged to a family long settled in this area of Suffolk, probably coming originally from Lincolnshire. His grandfather Robert was of Ipswich, dying in 1644; his father Robert was apprenticed to John Tompson, saymaker (maker of serge) ·of Sudbury, in 1657, and became a freeman of the borough in 1671. A leading nonconformist, Robert held a number of borough and parish offices. In 1682 he described himself as a gentleman, and a 1709 deed states that he held eleven houses and twenty-two acres of land in North Street. He was twice married and had three sons

and two daughters. When he died at the age of seventy-four, he was buried on 8 March 1716-17 at St Gregory's Church. John, the youngest son, was baptized in 1683. His elder brother, Thomas, baptized in 1678, carried on as an influential nonconformist, was instrumental in building the Meeting House in Friars Street and was linked by marriage with other prominent nonconformist families, the Feens and the Pettos. His will of 1739 shows that he was worried about his brother John:

I am fearfull that should my brother John Gainsborough live many years he may come into such Circumstances as may stand in need of some assistance towards the procuring of the necessarys of Life. And if that should be the case with him, My Will is that my Executors do make provision out of the Overplus of my Estate that he may be paid five shillings a week during his Life.

In 1704 John had married at Great Cornard Mary Burroughs, sister of the Rev. Humphry Burroughs, who was curate at St Peter's Church and master of Sudbury Grammar School. He and Mary had eight children: John, Humphry, Mary (baptized 26 April 1713), Sarah (baptized 28 August 1715), Elizabeth (baptized 26 May 1723), Matthias (baptized 29 August 1725), Thomas and Robert. [3]

Why did John's brother have such fears of his solvency in 1739? Fulcher records the local tradition. John was 'a fine old man who wore his hair carefully parted, and was remarkable for the whiteness and regularity of his teeth.' When in full dress he wore a sword, 'and was an adroit fencer, possessing the fatal facility of using his weapon in either hand.' Cunningham romanticizes the local accounts in saying that John was remembered as 'a stately and personable man, with something mysterious in his history, for the pastoral and timid rustics of Sudbury suspected him of carrying a dagger under his clothes'. He was enterprising in business. Fulcher says that John introduced from Coventry the shroud trade, 'which he managed to keep in his own connexion for some time, by the mystery in which he enveloped it.' So, for a while he did well. He himself travelled into distant countries to get orders, and employed a young man named Burr as his agent. At times he journeyed in France and Holland. A story in Fulcher illustrating his quick wit, showed him ready, as so many of his world, to profit from smuggling. 'On one occasion, when in his untaxed cart which contained, besides samples of the dresses for the dead, a keg of

smuggled brandy for the comfort of the living, some vague information of his supposed delinquencies was given to a revenue officer.' On a moonlight night the officer held him and asked what he carried. 'I'll show you,' said John, who caught up a shroud and enveloped his tall figure in it, 'to the astonishment and speedy departure of his weak-nerved nocturnal visitor.'

A law of Charles II had enacted that English persons must be buried in shrouds of English make. Coventry for some time was the centre of shroud-making, but somehow John learned the methods used. However, in May 1722, in deeds of house-conveyance, he is styled Milliner; a 1725 mortgage calls him Clothier; and in 1725 in some more property-dealings he appears as Crapemaker. In his bankruptcy proceedings he is again described as Clothier. He failed, says Fulcher, through his kindness of heart. He would not press for payment when creditors were in difficulties. Also, he refused to take advantage of the custom called Toll, by which masters kept nearly a third of their spinners' weekly wages. Already in 1730-1 he seems in trouble. The trustees of the chapel, among whom was his brother Robert, gave orders for the altering of the pew that he 'now sitts in unless the Three Pounds be paid for it.' Also he must sign a guarantee in the minute-book

that when ever the Number of Hearers belonging to his family; that are accustomed to sitt in the said Pew: shall be Redused to the Number of Six Persons; that then the Trustees shall have Liberty & they are hereby Required – to Reduse the said Pew to its originall State.

He did not comply and was called before the Meeting. Orders were given, with no one dissenting, that the pew should be reduced and John be requested 'to remove him to his own Pew'. His bankruptcy proceedings came in 1733, when young Tom was about six years old. John's nephew (John, son of Thomas) bought the house in Sepulchre Street in 1736 for £500, and allowed the family to stay on. John was given the job of Postmaster by the Sudbury authorities; when he died in 1748 his wife carried it on.

Tom was then a member of a fairly large family, with many relations around him in the compact small community of Sudbury. Of his three elder brothers John, known as Jack, became a feckless inventor. Humphry, who entered the ministry, also made inventions, with more success. Matthias died when young. Running out of a room with a fork in his hand, he fell and

the prongs were driven into his forehead. Of the young brother, Robert, we know little, save that he eloped with the girl who became his first wife, was twice married, had three children, and went off to Lancashire. Fulcher could not find out what his work was. Of the girls, Mary became Mrs Gibbon and later let apartments in Bath; Sarah, as Mrs Dupont, stayed on in Sudbury; Elizabeth became Mrs Bird; Susannah, marrying a man named Gardiner, settled in Bath like Mary.

Sudbury appears as a town in Domesday Book. Its importance in medieval days is shown by its possession of three churches and a priory. In Tom's day most of the houses were still medieval, timbered, with high gables and projecting upper stories. The Moot Hall, only a few paces from Tom's house, was a large ramshackle building, in front of St Peter's Church, on Market Hill. With its busy market, Sudbury was the largest town on the Stour, and in 1705 an Act was passed to make the river more navigable up to it from Manningtree, with the Mayor and ten others to act as Proprietors of the Navigation, and with a hundred Commissioners to deal with disputes involving farmers, barge-owners, and so on. The need to keep an open towpath all the way down the river was one of the main problems. Ambrose Waller in *The Suffolk Stour* lists as cargoes of 1750: vinegar, tar, soap, glass-bottles, rosin, bundles of paper, iron, tallow, lead, grindstones, bags of nails, butter, fruit, sugar, grain. Sudbury, as far back as Elizabeth's reign, had had companies of actors coming to stage plays; in the eighteenth century a barn was used, a permanent theatre being built in 1814. Tom may then have seen plays before he left for London. [4]

There was a large orchard at the back of his house, with only a slight fence, and not far from the garden were the ivied ruins of the thirteenth-century Archbishop Simon of Sudbury's palace, then used as parish poorhouse. Rambling out this way, the boy passed the church and went down across the commonland, the Stour Croft, to the banks of the river which bounded the town on its western and southern sides. On the Croft a fair was held on 29 June. Tom loved to wander down the river, along its banks, and up the near slopes.

As we go on it will appear how strongly the scene of the Croft affected him. Looking up from the river, he saw the tower of St Gregory's Church looming above the treetops on the right: a system that was to recur in various ways in his drawings and paintings. The early impressions of the Croft, with the Stour

flowing at its foot, were to be made more complex as he absorbed fully the landscape-structure of the surrounding hill-slopes with their winding paths, tree-clumps, cottages; but they provided the basis on which was to be developed his most characteristic compositions as he sought to return to his childhood-memories. Those memories enshrined for him a satisfying world which denied, and was in turn denied by, the world of property-values dominant in the gentry whose portraits he painted. The latter revealed those values in their clothes, their postures, their expressions, their essential characters, their alienation from the world of the peasants. Portraiture or Face Painting was the art form dedicated to their property-sense, their egotism. The artist entered a different world when he depicted the peasants at work or resting, moving along the roads or embraced as lovers in the shadows, homing at last in the evening to the cottage-door which opened into a warmth of renewing union.

We do not know when he began to draw. His mother, Fulcher tells us, was a woman of well-cultivated mind who excelled in flower-painting, and she encouraged Tom when he showed an aptitude for drawing. (She carried on a small millinery business, no doubt after her husband got into difficulties. It is a pity that we know so little of her, since she probably influenced Tom a great deal in his childhood.) Thicknesse said 'the *first* attempt Gainsborough made with a pencil was a group of trees,' which he gave him. 'A wonderful performance not to be unworthy of a place in one of the Painter's best landscapes.' Tom may well have said it was the first work that pleased him, or something of the sort. Thicknesse adds: 'It was accompanied with a great many sketches of Trees, Rocks, Shepherds, Ploughmen, and pastoral scenes, drawn on slips of paper or old dirty letters, which he called his *riding School*.'

Tom went to the Grammar School where his uncle Burroughs was master. Writing in the 1850s, Fulcher says that there was still to be seen 'near his initials a deep cut figure in the mouldering wall, an evident caricature of the school master', and that he made rough drawings on the covers of his books, then on those of the other boys. Once, he says, when disappointed of a holiday, he forged his father's script on a piece of paper: 'Give Tom a holiday.' However, when he arrived home that evening, something had happened that gave away the trick. His horrified father said, 'Tom will one day be hanged.' But when Tom showed the drawings he had made during the day he changed his prophecy: 'Tom will be a genius.' The story is however

suspect. The first version comes from J.T. Smith, who declared that the family warming-pan was found full of such orders for holidays; he got the tale from the artist John Jackson who was only ten years old when Gainsborough died.

What, if any, artworks influenced him at this phase we do not know. Later his friend the Rev. Henry Bate said, 'The first manner he studied was Wynants, whose thistles and dockleaves he frequently introduced into his early pictures. The next was Ruysdael.' But it is not clear whether the Dutch influences began before he left Sudbury. Since his mother did flower-paintings, she may have collected engravings or known some local families with a few artworks. A number of Dutch paintings had made their way into East Anglia because of the trade connections. A letter Tom wrote near the end of his life to a Norwich master-weaver, who had collected works by Cuyp, Hobbema, Gaspar Poussin, and Richard Wilson, seems to link a love of Dutch landscape with quite early years of his childhood: ''Tis odd how all the Childish passions hang about me in sickness. I feel such a fondness for my first imitations of little Dutch Landskips that I can't keep from working an hour or two of a Day, though with a great mixture of bodily Pain – I am so childish that I could make a Kite, catch Gold Finches, or build little Ships.'

But it seems unlikely that he could have had more than a very slight knowledge of Dutch landscapes as a boy. What is certain is that he did take seriously to drawing, no doubt aided and encouraged by his mother, and that this led to his going to London to study. His niece Mrs Sophia Lane later stated:

An intimate friend of his mother's, being on a visit, was so struck by the merit of several heads he had taken, that he prevailed on his father to allow him to return with him to London, promising that he should remain with him and that he would procure him the best instruction he could obtain.

According to Fulcher, 'Consultations were held, opinions canvassed, and Mr Burroughs (seeing that Thomas had made such progress in his studies!) recommended his removal to London. Accordingly, in his fifteenth year, Gainsborough left Sudbury for the great metropolis.' It seems, however, certain that the boy was only thirteen. Bate in an obituary stated: 'After painting several landscapes from the age of ten to twelve, he quitted Sudbury in his 13th year.' It was, then, in 1740 that Tom left for London.

His uncle Thomas had left money for Humphry to be trained for the ministry, and he bade his executors

take care of Thomas Gainsborough another of the Sons of my brother John Gainsborough that he may be brought up to some Light Handy craft Trade likely to get comfortable Maintenance by and that they do give any Summe not exceeding Twenty pounds to bind him out to such Trade and I leave it to my Executors if he shall prove sober and likely to make good use of it to give him Ten pounds over and above the Ten pounds I have herein given him the better to enable him to get out into the world.

We can be sure however that the executors would not have considered that Tom was starting off on a trade likely to bring him comfortable maintenance; and although some arrangements must have been made about a place of residence in London, what they were we do not know. [5]

2 London (1740-1748)

*T*om seems at first to have lived in the house of a silversmith who, Bate says, was a good friend to him and a man of taste. Fulcher echoes this tradition. The man may have been one of the Duponts practising the craft in London in the first half of the century; for Sarah, one of Tom's sisters, married a Dupont of Sudbury. Mrs Lane, generally reliable as one who lived on intimate terms with Tom and his family, says the man was a close friend of the Gainsboroughs. Tom may even have begun working at his craft, as Hogarth did with Gamble. In any event he soon made his way into the London art world, which was small enough; and Bate stated that from the day of his arrival he did not cost his family a penny. Fulcher says the silversmith introduced him to Gravelot; Bate adds that Tom, soon after arrival, met the latter, from whom (adds the engraver Charles Grignion) he received some rudimentary instruction. There is no doubt, in fact, that the relationship with Gravelot had permanent effects on Tom's development.

Hubert Gravelot (1699-1773) was a draughtsman and engraver trained in French rococo, who had settled in London in 1732. Under him Tom would have learned a great deal about French artwork of the period; he would have seen engravings of Watteau's paintings and may even have seen some originals. There were two in the collection of Dr Mead whom Watteau had come to London to consult as a physician and whose pictures could be inspected by students. Gravelot had a school with facilities for drawing from models. Edward Dayes wrote in 1805 that 'Gainsborough studied under Gravelot with Grignion and

several others at his house in James Street where he had all the means of study the age could afford him.' Like Hogarth, Gravelot made caricatures and mocked at establishment values; he is said to have attacked Sir Robert Walpole and Lord Burlington for their support of Italian classicism. Tom may have owed to him something of his irreverence for the grand style. His obituary in the *Morning Chronicle* declared that soon after his arrival he 'became a pupil of Mr Gravelot, under whose instruction he drew most of the ornaments which decorate the illustrious heads, so admirably engraved by Houbraken' for the Birch's *Lives of Illustrious Persons in Great Britain*. None of the surviving decorations are by him, but a large number have been lost, so that he may have drawn some. In any event he studied the set. He had a copy of Birch among his small number of books sold in 1799, and we may note his ease in introducing rococo frames in the backgrounds of portraits. Gravelot was famed as a designer of ornamental portrait-frames, and in his studio Tom certainly absorbed a strong taste for rococo with its use of C-scrolls and counter-curves. Rococo reached its fullest form about 1730 in the asymmetrical arrangement of curves in panelling, silverwork, and so on. [1]

Fulcher says that Tom left Gravelot's studio for that of the scene-painter and illustrator Francis Hayman. He would certainly have known Hayman, who was linked with Gravelot in various enterprises of the early 1740s, for example, the illustrations to Richardson's *Pamela*, 1742. In 1744, and probably earlier, Gravelot was drawing teacher at St Martin's Lane Academy, where Hayman taught painting. The *Morning Chronicle* says that Gravelot introduced Tom there. Tom's name does not occur in the list of members compiled by W.H. Pyne with the aid of John Taylor, who had been Hayman's pupil and who 'knew them all'. But even if Tom was not a formal member, he must have been connected with the Academy. Hogarth was very interested in the boy, and Tom would have often seen him and heard him speak. He clearly enjoyed himself in this world of engravers, draughtsmen, illustrators, who were ready to question the values accepted as sacred by the connoisseurs and who responded in varying ways to Hogarth's call for the linking of art with the life around it.

The 1740s were an exciting time for a young artist. The old aristocratic tradition, developed from Van Dyck through Kneller and Lely, had weakened steadily, and baroque pomposities were

felt to be quite out of date. A new middle-class audience was emerging and even members of the nobility were affected to some extent, even if they still imported the accepted Old Masters for their mansions. Hogarth had forced many doors open and there was a strong feeling of extensive new possibilities opening up for the artist with an independent mind. Two new tendencies, which conflicted and yet were brought together in various ways, had invaded the sphere of art. On the one hand there was the decorative world of rococo curves; on the other, the realistic trends of Dutch art. The reign of William of Orange had seen an increase in the sales of Dutch and Flemish paintings. With the 1740s, when England was Holland's ally against Prussia, the taste for Ruisdael, Hobbema, Wijnants grew. Here was revealed a direct vision which ignored the classic patterns of Claude and sought to grasp the actual systems giving coherence and evocative charm to familiar scenes and objects. About 1745 came the moment of definite swing in favour of such works, although Cuyp had to wait till the late 1750s. Nobles were affected by the trend. As early as 1742 the Duke of Bedford bought a Ruisdael for seventeen guineas. In September 1745 Lady Harcourt wrote about a Ruisdael waterfall bought by her husband: 'The water prodigiously finely painted; the landscape, figures, etc., extremely well done; and what is very fortunate, with turning in a part that was damaged, it exactly fits the frame over the dining-parlour chimney.'

However, History Painting, depicting gods, kings, heroes, on a large scale, remained the important genre, though no English artists were effectively tackling it. Tom throughout his life ignored History and was hostile to it. His friend Jackson says that he 'either wanted conception or taste, to relish historical painting, which he always considered as out of his way, and thought he should make himself ridiculous by attempting it'. As we shall see, his antagonism went much deeper than this statement suggests.[2]

Hogarth was at the centre of the new developments. Partly inspired by the stage, he created a new genre which dealt with everyday life and which was a sort of defiant Modern History; with his conversation-pieces and his portraits with out-of-door settings he built on what artists like Mercier were attempting, and widened the scope of material with which art could concern itself. As well as starting the St Martin's Lane Academy, he was behind the scheme for using the Court Room of the Foundling Hospital

as a showplace for works by contemporary artists. With his *Captain Coram* he triumphantly created the solid middle-class portrait and devised informal and direct ways of expressing character. Allan Ramsay, settling in London in 1739, helped to carry on some aspects of the new kind of portraiture, while Roubiliac applied the Hogarthian attitudes to sculpture.

Another important project which Hogarth did much to bring about was the decoration of Vauxhall Gardens, which his friend Jonathan Tyers had taken over and which became the most lively and fashionable pleasure-resort of the times. Tyers was thus one of the earliest patrons of a genuinely English art. He commissioned from Hayman a series of large paintings of traditional games and pastimes for the supperboxes. At Vauxhall the tradesmen and professional men of the city jostled the gentry and the nobility: these were men who were rising in the world and wanted to better themselves in all ways, including knowledge of art. They were subscribers to the *Tatler* and the *Spectator*, and later to the *Gentleman's Magazine*; at the theatre they applauded works like Gay's *Beggar's Opera* or Lillo's *London Merchant*. They included men like Charles Jenners, who patronized Hogarth and Hayman, and who by 1761 owned more than a hundred Dutch works. [3]

What was Tom doing in the midst of these new social and artistic developments? First of all he must have been taken up with learning all he could in the studios of men like Gravelot and Hayman, and trying to find how he could apply his talents. He was learning all he could simultaneously from French rococo and Dutch realism, and he was picking up many tricks that stayed with him. Gravelot taught drawing from dressed-up dolls; they were described in the catalogue of his sale, and one survives in the British Museum with full wardrobe. Roubiliac also used dolls. Tom took over the method, as can be seen clearly in many of his early small full-length portraits.

Meanwhile, to gain a footing in the art world, he was ready to put his hand to almost anything. He repaired works for the art trade. A sales catalogue of 1766 records: 'A Dutch landscape, repaired by Mr Gainsborough', and 'Wynants, a landscape, the figures by Mr Gainsborough.' He was also working at his own landscapes. 'His first efforts,' said the *Morning Chronicle*, 'were small landscapes, which he frequently sold to the dealers at trifling prices.' He drew scenes for the print trade; four were en-

graved by John Boydell in 1747. J.T. Smith mentions a chat between the sculptor Joseph Nollekens and Panton Betew, silversmith and picture-dealer. 'Well, there is your great Mr Gainsborough. I have many and many a time had a drawing of his in my shop window before he went to Bath; ay, and he has often been glad to receive seven or eight shillings from me for what I have sold.' He was also modelling animals.

He made his first essays in the art of modelling figures of cows, horses and dogs, in which he attained very great excellence: there is a cast in the plaster shops from an old horse that he modelled, which has peculiar merit. (Morning Chronicle)

He no doubt worked in clay. A plaster cast of the old horse was taken during his lifetime, from which copies were made. Constable got one soon after 1800 and inscribed the base. John Morland had another, and a third was in the sale of the plaster-cast shop run by John Flaxman's father in 1803. The horse indeed was modelled with a fine sense of organic form.[4]

But Tom was learning more than how to draw and model in London; he was gaining a taste for drink and loose living that never left him. Fulcher insists that whatever was questionable in his behaviour was due mainly to his early removal from home influences and to the example set by Hayman; and it seems very likely that Tom admired both the latter's art and his careless way of life. Hayman had begun as a scene-painter at Drury Lane, then he turned to book illustrations and portraits. From about 1745 he popularized portraits of people set in a natural or artificial landscape. We saw how his Vauxhall works vividly depicted all sorts of games and amusements. Full of gusto, he drank a lot and frequented brothels, in one of which Hogarth drew his attention to a young whore squirting wine into another's face. One of his boozing companions was James Quin, the actor. Once when they were fallen in the gutter, Quin told him not to bother to struggle to his feet as the watch would soon be along to take them up.

Hayman was keen on boxing. Henry Angelo in his *Reminiscences* tells how the Marquis of Granby came into his studio and wanted a bout with gloves (then called mufflers, lately devised by the boxer Jack Broughton). Hayman pleaded gout. 'I have gout,' replied the Marquis, 'we're about the same age, and a fair match.' They fought so hard that the house shook and Mrs Hayman rushed in to find out what was wrong. Tom was no doubt fascinated by such a man; but in any event, in the London

of the 1740s, with his lively mind and avid appetite for life, he would have found his place in the taverns and brothels as well as the studios. A link with Hayman is suggested by what Nathaniel Dance later told the diarist Joseph Farington: he had gone to Italy in 1755, 'having before that period been about 8 years with Hayman, as a pupil, when he became acquainted with Gainsborough.'

Gravelot left for Paris in October 1745 and Tom seems to have set up on his own a little before that. There are few dateable early works, but we can see that his first drawings were tight, careful, neat in outline and modelling. The designs he did for Boydell were rather mechanically worked out, with figures stuck in, in an effort to make the scene interesting and with planes alternately dark and light to ensure an effect of recession. He had been influenced by the work of both Boydell and Hayman; but he soon managed to loosen out his style. It is of interest that Hayman used the motif of the tree-enclosed cottage that was to become so important for Tom, and indeed the Vauxhall paintings display many elements that Tom was to take over and develop in his own way. *Sliding on the Ice* has the motif of a heavy dead tree swinging over into the scene. Hayman, using strong diagonals, binds his figures both by a serpentine line and by a circular movement curving subtly in and out among them. We see this effect for instance in the opposed dancers in *The Milkmaid's Garland*, who are about to swing round and who communicate their movement to all the other elements of the picture. In *Bird-nesting* this kind of dynamic construction is given special force by the kicking wheel-like form of the boy falling from the tree; and the movement of light in the two open spaces, from that on the left to the deeper cavity on the right, is richly underlined by the rococo curves. Most of the Vauxhall paintings have been destroyed, but these three survivors make us realize the originality of Hayman's contribution and how strong an impact it had on Tom. The Milkmaids are painted in hard clear luminous tones; the Bird-nesters, though their design is Hayman's, may have been painted by someone else, as the foliage is defined in soft masses.

The Dutch influence on Tom's drawings came largely through David Teniers and Waterloo, although Nicolaes Berchem, Wijnants and Jacob van Ruisdael helped to vary the impact. Thus, from Ruisdael he learned a hard angular way of treating the boughs and trunks of trees.

No doubt he visited Sudbury now and then. In 1745 the fund

raised there to help the government against the Jacobites included in its list John Gainsborough, junior, who gave twenty-five guineas, and Elizabeth Gainsborough, who gave ten. Before that Jack had, like Tom, ventured away from Sudbury and had set up a watchmaking business at Beccles. A notice in the *Ipswich Journal* of 10 December 1743 stated that he 'has grossly abused the interests of his friends, and carried off Goods and Effects given him in Trust'. The inserter wanted

to apprise all persons to whom he may offer any watch to Sale or Pawn to stop the Watch, and give notice of the same to Mr Thomas Otting watchmaker, in Yarmouth, or to Mr Thomas Tangey of Beccles, and they shall be paid for their trouble. He is a spare, thin person about five foot nine inches high, with a large hook nose, blinkey'd and with a long visage:

But no further steps seem to have been taken against him, and he is found at Sudbury for the rest of his days. [5]

In 1746 Tom took an important step. On 15 July he married Margaret Burr at Dr Keith's chapel in Mayfair, which was used for runaway marriages. He gave his place of residence as in the parish of St Andrew's, Holborn. Margaret was the sister of the man who had been commercial traveller for Tom's father. Fulcher calls Tom 'her brother's young friend'; but it is hard to see how he could have been close to the brother since he was about six when his father's firm went bankrupt. How he met Margaret we do not know. We may dismiss Cunningham's tale of a young woman coming along as he sketched a woodland scene of sheep and doves. Fulcher says that she was a year younger than Tom and that the courtship began through his painting her. 'The sittings were numerous and protracted, but the likeness was at last finished, and pronounced by competent judges, perfect.' He adds that the memory of her extraordinary beauty still survived in Sudbury; he also says that when the young couple visited that town, an old family servant was sent to meet them. 'On his return, announcing their near approach, the old man gave it as his opinion that "Master Tommy's wife was handsomer than Madame Kedington" – then the belle of the Sudbury neighbourhood.' So she was not known in the town. We may surmise that Tom encountered her brother in London, was introduced to her, offered to paint her portrait, and wooed her. The Mayfair marriage suggests that the couple had not let their families know. No doubt the Burrs would have objected to Tom.[6]

Margaret had an annuity of £200 a year, which was very useful for a needy young painter. Thicknesse, who disliked her, called her 'a pretty Scots girl, of low birth, who by the luck of the day, had an annuity settled upon her for life of two hundred pounds.' She herself liked to make a mystery of her origins. Cunningham states that she

was said to be the natural daughter of one of our exiled princes; nor was she, when a wife and mother, desirous of having this circumstance forgotten. On one occasion of household festivity, when her husband was high in fame, she vindicated some little ostentation in her dress, by whispering to her niece – now Mrs Lane, 'I have some right to this, for you know, my love, I am a prince's daughter.'

Her daughters professed to know nothing about it. 'The money was regularly transmitted through a London bank, and placed to Mrs Gainsborough's private account.' Thomas Green of Ipswich noted in his *Diary of a Lover of Literature,* under 22 April 1818, 'Much chat with Mrs Dupuis [Ipswich gossip], respecting Gainsborough, who lived here on the site which Mr Tunney's house now occupies. Very lively gay and dissipated. His wife Margaret, natural daughter of the Duke of Bedford. Rapid in painting, his creations sudden.' But Mrs Dupuis did not have things quite right. On 18 February 1799 Tom's daughter told the artist Farington that her mother was the natural daughter of Henry Duke of Beaufort. Proof of this was found much later in the papers of James Unwin of Castle Yard, Holborn, who became Tom's attorney. The papers show that the annuity did in fact come from the Duke of Beaufort.

Margaret was indeed handsome. As for Tom, Trimmer remarks of a self-portrait of him 'reclining on a bank, looking at a sketch on a stretching-board on which he is engaged,' that he was 'very personable in his youth, and in this sketch he presents a remarkably fine figure. I have also a sketch of himself and his wife on a small piece of paper before they were married. She was very pretty.' Trimmer also had a crayon drawing of Tom's head 'apparently about twenty years of age. He has on a dingy yellow coat, black neck band and kerchief, and small collar his hair dark-brown, eyes brown, and under-lip full, as in a portrait I once saw of his daughter. The features are delicately chiselled and his complexion delicate; the forehead by no means highly developed.' In profile 'his Roman nose shows a face full of intelligence.' There was a tradition that he painted his wife's portrait on each

anniversary of their marriage.

He seems to have been living in Hatton Garden, and the young couple would have gone there. Well over twenty years later, in 1768, he wrote, 'Shall I never mend O dear O dear I don't think I'm a bit altered since I lived in Hatton Garden only that I'm Grey in the Poll – my Wife says I'm not so good as I was then tho I take more pains.'

Certainly he was showing remarkable talent in the late 1740s. Probably about the time of his marriage he painted a young couple, whom we may identify as himself and Margaret; they are seated among trees; the young man gesticulates as he talks and the girl gazes demurely out of the picture; in the background is a piece of a classical building. A drawing of about the same date shows the pair standing among the trees, close together, while she holds her hat on. Her costume – bergère hat, criss-cross lacing, single sleeve ruffles – belongs to the period 1745-50. At the back a cow stares at the lovers. The undulating foreground is oversimplified and there are only two planes, that of the lovers and that of the trees at the back. But there is charm in the handling and the total effect; the work is lyrical in a way that similar themes treated by Laroon, Hayman or Sandby are not.

We are on sure ground with *Bumper*, which is dated 1747 and inscribed on the back, 'A most Remarkable Sagacious Cur'. The dog, who belonged to Mrs Henry Hill, is alive in every muscle, tense, alert: an effect gained by the fine handling of the paint. But Tom cannot get the transition from dog to woodland, and the heavy tree on the right unbalances the composition. He has come up against the problem of the framing tree that he was to tackle throughout his life. In *Road through a Wood, with Boy resting and Dog* (signed and dated 1747), we see two clumps of trees, the large one on the left dominated by a dead leafless trunk. The road, with its movement stressed by the ruts, swerves up and out of sight; in the foreground it sinks down. Though he was soon to show more rhythmical control of the elements of such a composition, we have here a characteristic image that haunted him all his days. [7] *Wooded Landscape with Seated Figure* was done about the same time. Here the various tree-planes come together in a single silhouette and the light falls beyond them over fields on to a church tower. In *Sandy Pit by a Sandy Road* (1746-7) we see how he is merging Dutch and rococo elements, relating the cloud shapes to the forms below and bettering his definition of planes. He is managing to combine Ruisdael and

Watteau, gaining a freshness and fidelity that puts him already ahead of the other landscape painters of the time.

The *Town and Country Magazine* in September 1772 stated that he did not sell six pictures in a year at this time. But he was attracting attention, for in 1748 he was one of the artists who made gifts of work to the Foundling Hospital. His painting of the Charterhouse was part of a series that included two works by Harley, three by Wale, and two by Richard Wilson, all artists older than he was. Vertue wrote that of the various views of hospitals, his was 'tho't the best'. (As the gift was recorded in minutes for 11 May 1748, we may assume the work was done in 1747.) To have a picture shown in the Hospital was a good advertisement, but Tom seems to have gained no commissions. In his painting there was something of Van den Heyden or Van Goyen, and also a debt to Hogarth: the trick of taking a building on the angle and with strong perspective lines. But while setting out to put down plainly what he saw, he organized the composition with a richly simplified effect. There is strong shadow over the building on the right; the light falls on the path in an oblong that diminishes upwards and thus leads the eye on into the scene where the main element in the architectural structure, the gateway, is left in shadow. The trees on the left and the sunlit tower balance the in-movement and the heavy structure on the right, as do the clouds rearing and crossing above. We thus get a precise moment of a summer day in London, with strong structures and yet a movement in and round that gives a sense of transience, of wavering change.

The landscapes of this period, painted or drawn, suggest that he went back to Sudbury, if only for brief moments, in the years 1745-7. About 1748 he seems to have made a definite return to his home town.

3 Sudbury Again (1748-1752)

*T*hicknesse says that he had not formed 'any high idea of his own powers, but rather considered himself as one, among a crowd of young Artists, who might be able in a Country town (by turning his hand to every kind of painting) to pick up a decent livelihood.' Certainly he had ambitions far beyond what that suggests, but he may well have wondered how he was to fit into the art-scene in London and how he was to bring together the various art-impulses and responses he strongly felt. The failure of *Charterhouse* to gain commissions may have worried him; and the birth of his elder daughter, Mary, shortly before July 1748, may have brought home the need to find some way of earning a regular income. Margaret would have urged this point. His father was probably in bad health, as he died in October. Gainsborough felt the need to return to his home town with its beloved familiar surroundings and consider just where he stood. Fulcher says that after his marriage he lived a while in Friars Street, then after some six months went off to Ipswich. But it seems certain that he stayed much longer in Sudbury, building up there what position he could and establishing his contacts with Ipswich. Jack seems at the time to be living next door to the family house; but Humphry this year went off to serve as congregational minister at Henley.

Gainsborough's earliest supporter (we are told by William Windham, who became Pitt's secretary for war) was Mr Fonnereau whose family long owned a fine house in Christchurch Park, Ipswich. Windham disliked Gainsborough, calling him dissolute, capricious, and not very delicate in sentiments of honour. Gainsborough, he says, was given his first chance

through Fonnereau, who lent him £300, yet he later voted against his patron's interest in a parliamentary election. (One of the Fonnereaus was for a time MP for Sudbury.) 'His conscience, however, remonstrating against such conduct, he kept himself in a state of intoxication from the time he set out to vote till his return to town, that he might not relent of his ingratitude.' We have no means of checking this story. [1]

Several works give us a good idea of the stage he reaches in the period around 1748-9. Soon after his return he painted Hadleigh Church for the Rev. T. Tanner to use as overmantel in his vicarage. The church had been 'greatly improved and beautified' in 1747 and the rector wanted a record. So Gainsborough overcame his aversion to topographical works and turned out a picture on a rather mechanical system, with the battlemented roof of the church more or less parallel with the skyline and the bottom edge of the canvas. The painting is hard and heavy, and there is nothing of the rich and solid organization of *Charterhouse*. We see, however, how closely he followed Hogarth's work; for the group on a tombstone near the front are based on a group in the latter's *Industrious and Idle Apprentice* (published 1747).

A very different work is the painting called *Cornard Wood*. In 1788 Gainsborough wrote to Bate of it:

Mr Boydell bought the large landscape you speak of for seventy-five guineas last week at Greenwood's. It is in some respects a little in the schoolboy stile – but I do not reflect on this without a certain gratification; for as an early instance how strong my inclination stood for Landskip, this picture was actually painted at Sudbury in the year 1748; it was begun *before I left school*; – and was the means of my Father's sending me to London.

It may be worth remark that though there is very little idea of composition in the picture, the touch and closeness to nature in the study of the parts and *minutiae* are equal to any of my later productions. In this explanation I do not wish to seem vain and ridiculous, but do not look on the Landskip as one of my riper performances.

It is full forty years since it was first delivered by me to go in search of those who had *taste* to admire it! Within that time it has been in the hands of twenty picture dealers, and I once bought it myself during that interval for *Nineteen Guineas*. Is not that curious?

He presumably means that he had made a study of the same scene in 1739-40, and then re-used the study in 1748. The picture is remarkable for its fine definition of oak foliage, both in detail and in mass, produced by a subtle flickering touch. When

Gainsborough finds little 'idea of composition' in it, he must refer to the relative lack of rococo rhythms, though the foreground banks fall away and there is a road winding to the church in the distance. In the left-hand corner is the woodcutter who became an ever more important image for him over the years. A chalk drawing of the period shows how much he was learning from Ruisdael; it is a copy of some copy of the latter's *Forest* (Louvre). We find in it the zigzag technique learned from Dutch drawings and a thought-out correlation of space and the patterns of leaf-masses in their various planes. [2]

Probably in 1749 he painted Mr and Mrs Andrews, who had been married at All Saints, Sudbury, in November 1748, when he was twenty-two and she sixteen. They are set against a sturdy oak, he standing cross-legged (a pose common in the informal portraits of the time) with gun and dog, and she seated in blue satin on a seat of rococo curves. Behind is the farm; on the right is a glistening field of stooked hay (symbolizing fertility); at the back are the broadly brushed hills on the other side of the Stour in their mauve distance. The result is a remarkable open-air painting with fresh atmospheric quality and delicate colours. The textures of Frances Andrews's dress in particular are subtly yet broadly rendered. All is clearcut, brightly demarcated, though Gainsborough finds some difficulty in the transition from the couple to the field at the side and back. He seems to have meant to put a pheasant, shot by the husband, in the bride's lap, and he left an uncompleted space for it. But already he seems to have disliked returning to a work when he had once stopped working on it. (To reach the site, Auberies, he walked a couple of miles up the road leading from Sudbury to Bulmer in Essex.)

He had also tried his hand at a conversation-piece, a portrait-group, such as Hogarth, followed by Hayman and Arthur Devis, had done. In their works the settings tended to have little relation to the figures. Gainsborough was stressing the landscape. Already in his picture of the Gravenor Family of Ipswich he drew the cornfield right into the foreground, with corn-ears dangling in front of a girl's skirt; and brought the figures dramatically into contact with the background by lighting their heads against dark leafage or cloud. In the early 1750s, dealing with the two Lloyd children, he attempts a mixture of modish artificiality with fidelity to nature. The children are set by a stone balustrade leading to a pavilion, while on the left a small lake, with church beyond it, is linked to the glimmering sky above between the

trees. He painted also the elder Lloyds, but the standing man and seated women are dummies unrelated to the scene.

If we look further at some landscapes that can be dated 1747-9 we see how restlessly he was trying to extend his range, to develop his expressive mastery of paint. *River Scene with Figures and Dogs barking* has an oblong shape which suggests an overmantel and which enables him to compact the forms in a binding rhythm that uses the curves of path and river, and to link clouds and earth-mass. Here is the idea of composition which he felt lacking in *Cornard Wood.* There is a broad expanse of distance with the moist clouds veiling the line where fields and sky meet. There is an increase in what we may call his impressionism, which merged the parts in a moving atmospheric whole. The small pair of windblown lovers shows how he was now combining broad brushwork, sure structural definition, rhythmic interrelations, in a vital image of momentary life. The long swerve of the path and the simpler turns of the stream lead on to the far-off upright note of the church tower.

In *Sandy Lane through Woods with Cottage and Donkey* the rococo swirl increases, with twisting clouds, tree-trunks, boughs and variegated pattern of light and shade. The pool with lateral lines and vertical reflection gives a stabilizing and yet revolving centre below, while the chalky banks, with brushwork bringing out their weight and texture, hold together the two halves of the picture; the cottage centralizes the system above. *Wooded Slope with Cattle and Felled Timber* uses a Claudean pattern with the church tower between two clumps of trees, with the felled treetrunks lying sharply with their twisting branches across the foreground. The cows among the branches, in patches of light, are painted with warm reddish-brown tones that come up in foregrounds more and more through the 1750s. *Old Peasant with Ass and Dog outside Hut* has a church tower on the right and a path running across from the man to a gate. The hut with its dark door on the left prefigures the cottage-door that Gainsborough was to call on so frequently in his later work. We see also how he uses a church tower to provide a central point or to close the lines that are moving rhythmically in from the foreground. The woodland scene moves into the village, yet stands outside it, with its own resistant vigorous rhythmic energy. The hut, the tree behind it, the old man are ultimately all one; man emerges out of nature yet is part of it.

If we then set the landscapes of the period side by side with

Charterhouse and *Mr and Mrs Andrews* we cannot but be astonished at the originality and breadth of Gainsborough's achievement by his early twenties. What was he to do with it all? That was the question that hit him hard and drew him out of the London hurlyburly. He knew with considerable clarity what he wanted to do, but how was he to relate his work to the prevailing art world? Clearly the connoisseurs could not be interested in his aims, which ran counter to so many of their settled values. There was no final satisfaction in continuing to paint for himself alone, even if his wife Margaret had let him. How then was he to find a point of contact with things as they were, and yet at the same time remain true to his innermost convictions and keep on developing his vision of the earth?

Somehow, he felt, he would have to find a place in the world of portraiture, accepting certain aspects of contemporary procedure, while doing his best to adapt them to his own view of artistic truth. Then he could go on seeking for ways of defining men as part of the natural scene and of deepening his own grasp of that scene. Sudbury alone could clearly not provide him with a living, and he therefore strengthened his links with Ipswich.

One Ipswich man whom he already knew well was Joshua Kirby; for his portraits of Kirby and his wife can be dated about 1749. Fulcher tells a story of Kirby coming up to him as he sketched near Preston Tower on the Orwell, and starting a conversation. More likely they met through Gainsborough's search for contacts in Ipswich. Kirby, born at Wickham Market, Suffolk, was son of a schoolmaster-topographer; he settled in Ipswich about 1738 as coach-and-house painter, but he also made drawings of Suffolk castles, churches, monuments, which he published with an historical account of Ipswich in 1748. More, he studied linear perspective and lectured on it at the St Martin's Lane Academy, becoming friendly with Hogarth. (James Gandon says he was apprenticed to a widow with a house-and-signpost painting business in Ipswich; and that Hogarth, seeing a rose he did for a sign, encouraged him to turn to the fine arts.) In 1751, as agent for Hogarth, he advertised large prints of *Beer Street* and *Gin Lane* at 18*d* each, and the same year called for subscriptions to his edition of Brook Taylor's *Perspective Made Easy*, for which Hogarth designed the title page showing a medley of false perspectives. So there were many ways in which Gainsborough could have met him. He would have felt in him a countryman who was yet in the London swim.

Kirby was a man of piety, and highly moral in speech and behaviour. A layman, he was made a member of a clerical club at Ipswich and his daughter Sarah, as Mrs Trimmer, became an outstanding compiler of moral and educational literature for the young. However, somehow he and Gainsborough got on very well together. Sarah's son later told how the pair made many a long day's ramble together. 'Many a sketch was made of the quaint old house in the Butter Market, Ipswich; and many a winter evening did they spend in each other's company, discoursing on the art they loved, whilst the future Mrs Trimmer, perchance, sat drawing by their side.'[3]

Gainsborough painted Kirby and his wife together, seated rather primly in a woodland setting; and a half-length of Kirby's father in which the body is awkwardly set but the white hair defined in fluent glossy paint. When later he saw Kirby's portrait at Mrs Trimmer's place, he remarked, 'Ah, there is old Kirby in one of his brown studies'. A painting by Kirby hung near, 'almost the only one he ever did', and Gainsborough said, 'He would have made a good painter if he had gone on with it.' Henry Angelo, in his careless way, says that the pair were intimate friends from boyhood and studied 'amidst the sylvan scenery adjacent to Sudbury'.

Everyone acquainted with Gainsborough knew that he was a rattle. It was therefore highly amusing to witness the contrast of character in him and his friend, the mild and modest Kirby. Kirby worshipped the talent of Gainsborough; he considered him the greatest genius of his age, and looking on as he performed his moppings, in an ecstasy would exclaim, 'Marvellous, inscrutable, miraculous!' – in return for which honest expressions the other used to dub him *'old pudging Josh'*.

I remember Gainsborough once saying, in speaking of the landscape effects of his old crony Kirby, whom he really loved, and, capricious as he was, whom he never slighted, that if on their sketching excursions an unusually unpicturesque building or a fantastically formed tree occurred, Kirby immediately sat down to delineate it as an addenda to his portfolio. 'His lines are all straight,' said Gainsborough, 'and his ideas are all crooked, by Jove. How the old frump ever consented to Hogarth's travestie frontispiece to his "Treatise on Perspective," I never could devise; had I proposed such a thing, he would have pronounced me mad.'

About this time Gainsborough painted an effigy of Thomas Peartree. Fulcher's version is that one early morning as he was drawing a tree in the summerhouse at the end of the orchard, he saw a man peep over the fence at some ripe pears, then climb over

and scale the tree. He came out and the man ran off. Gainsborough had recognized the man and he drew his face. Sent for, the culprit denied the charge till the painting was produced. It was an effigy, cut out of board, of the man's head and shoulders, with folded arms; the hat threw deep shadows on the upper part of the face; the man's elbows rested on a wall. Since there are records of a Thomas Peartree who was made a freeman of Sudbury in 1703, the story may well have a factual basis with Sudbury as the location, not Ipswich as in the account by Thicknesse which we shall soon consider.[4]

Tom's brother, Jack, was carrying on with inventions, too fervent to complete things. Gainsborough used to say that he never knew him finish anything. 'Curse it,' Jack would say, 'some little thing was wrong; if I had but gone on with it, I am sure I should have succeeded, but a new scheme came across me.' Once he tried to fly with metal wings, constructing them light enough to be opened and shut with ease, yet strong enough to take the weight of his body. On the appointed morning:

He appeared on the top of a neighbouring summer-house, a crowd of spectators having assembled to witness his ascent. Waving his pinions awhile to gather air, he leaped from his summit, and, in an instant, dropped into a ditch close by, and was drawn out amidst shouts of laughter, half dead with fright and vexation. (Fulcher)

Once he painted a sign for the landlord of the Bull, who was 'ambitious of having a new sign "by Gainsborough," but restricted the price to twenty shillings.' Jack tried in vain to get the price raised to thirty shillings: which would ensure that the Bull was fastened with a golden chain. But the landlord would not give in. Jack painted the sign; but when rain came, the Bull was washed out. He had done it in distemper. 'It's your fault,' he said. 'I would have chained him down for ten shillings and you would not let me, the Bull therefore, finding himself at liberty, has run away.' Thicknesse tells us:

When a man at Colchester made the first smoke jack, this curious man walked over to see it, but the maker refused him, observing that he probably was an artist himself – it is true said Gainsborough I am – and then asked what weight the jack would roast – a whole sheep replied the Artist, then said Gainsborough I will go home and make one that will roast a whole ox, and he did so!

He had married Mary English of Braintree, who is said to have borne him seven daughters.[5]

Tom was hard up. There is evidence that in November 1751 his friend and banker James Unwin obtained for him a loan of £400 on the security of his wife's annuity. Margaret with her thrifty nature would have been upset by such dealings and strengthened in her determination to take charge of his finances. They already had one daughter, Mary, and in 1752 a second girl, Margaret, was born to them at Sudbury. We can calculate her age only from her tombstone, which states that she died on 1 December 1820 in her sixty-eighth year. It was probably in late 1752 that Gainsborough moved to Ipswich. Thicknesse says 'Soon after his removal to Ipswich I was appointed to Governor for Landguard Fort, not far distant.' That was in 1753.

4 Ipswich (1752-1759)

*G*ainsborough took a house in the St Mary Key (Quay) Parish facing the Shire Hall. In January this house was occupied by the Rev. Broom, but the *Ipswich Journal* announced that it would be vacant in June. In June, then, the Gainsboroughs seem to have moved in. There was a frontage of some thirty feet onto Foundation Street, and the house consisted of 'a Hall, and two Parlours, a Kitchen, Wash-house; with a Garden and Stable, good Cellars, and well supplied with Cock water; five Chambers and Garrets with other conveniencies'. (So it was described in the advertisement when the Gainsboroughs left it in 1760.) The Shire Hall was a building of red brick and white stone at the centre of an open space adjoining Foundation Street and known as Whitehall Yard. The Yard was bounded on the north by the ancient buildings of Christ's Hospital, and on the west by Foundation Street. The space corresponding to the Yard on the opposite side of the street was mainly taken up by a playing field of the Grammar School.[1]

Ipswich, a larger town than Sudbury, had a population somewhat under 11,000. Like Sudbury, it dealt mainly in wool and agricultural produce, but it was also a port with docks, warehouses and wharves along the river. It housed many prosperous families, and there were large estates in the surrounding country. The gentry wanted to live up to the accepted standards of fine taste in furniture, architecture, chinaware, and so on; they also wanted portraits. So there seemed a good chance here for a capable painter.

Fulcher says that soon after Gainsborough had settled in, a rich

squire who lived near the town heard that a new painter was available, and sent a servant asking him to call. Gainsborough hurried along, wondering whether the commission would be a family portrait or a view of the mansion. On his arrival the squire opened a window leading onto the lawn and went on with calculations as to the sizes of doors and windows. Gainsborough at last realized that he was taken for a house-painter and glazier. 'A look of scorn at the Squire concluded the scene and turning on his heel, Gainsborough left him to discover his error.'

Thicknesse, we saw, encountered him in 1753. The Cut-out of Thomas Peartree was the cause of their meeting.

While I was walking with the then printer and editor of the *Ipswich Journal*, in a very pretty town-garden of his, I perceived a melancholy-faced countryman, with his arms locked together, leaning over the garden wall. I pointed him out to the printer, who was a very ingenious man, and he, with great gravity of face, said the man had been there all day, that he pitied him, believing he was either mad or miserable. I then stepped forward with an intention to speak to the madman, and did not perceive, till I was close up, that it was a wooden man painted upon a shaped board. Mr Creighton – I think that was the printer's name – told me I had not been the only person this inimitable deception had imposed upon...
Upon finding the artist himself lived in that town, I immediately procured his address, visited Mr Gainsborough, and told him I had come to chide him for having imposed a shadow instead of a substance upon me.

Thicknesse took for granted that the episode of painting the fruit-thief had occurred in Ipswich, but it seems sure that Sudbury was the scene. Calling at Gainsborough's studio, he found him taken up with portraiture. The portraits ranged along the wall included one of Admiral Vernon, and were, he thought 'Perfectly like, but stiffly painted, and worse coloured.' However, 'when I turned my eyes to his little landscapes, and drawings, I was charmed; these were the works of fancy, and gave him infinite delight; MADAME NATURE, not MAN, was then his only study.'

Thicknesse, who was long to be connected with Gainsborough, was an odd character. Born in 1719, he was the seventh son of John Thicknesse of Farthinghoe, Northampton, of a Staffordshire family. Starting as an apothecary, in 1735 he went with General Oglethorpe to Georgia; two years later he was back in England in the employ of the colony's trustees. Plain speaking about the Oglethorpe administration lost him his job. Later he fought against rebel slaves in Jamaica, but quarrelled with his

brother officers and was back in England in 1740. In 1745 he was serving in the marines in the Mediterranean. In February 1753 he bought the governorship of Landguard Fort near Felixstowe. As usual, he was soon in hot water. Quarrelling with the colonel of the local militia, he derisively sent him a piece of artillery carved in wood. He was fined £300 and spent three months in jail. He was three times married. His second wife, married in 1749, brought the barony of Audley to her eldest son. Thicknesse resented this fact and in his *Memoirs and Anecdotes* he calls himself 'Late Lieutenant-Governor of Landguard Fort, and unfortunately father to George Touchet, Baron Audley.' His will directed that his right hand be cut off and sent to George 'to remind him of his duty to God after having so long abandoned the duty he owed to his father.' At issue with the Court of Chancery and the House of Lords over £12,000 he claimed from relatives of his first wife, he wrote violent letters signed Junius, in which he attacked those tribunals in opposition newspapers. Gillray gibbeted him as Lieutenant-General Gallstone.

Soon after meeting Gainsborough, he received the King at the garrison under his command, then invited the artist to dinner and got him 'to take down in his pocket-book the particulars of the Fort, the adjacent hills, and the distant view of Harwich, in order to form a landscape of the Yachts passing the garrison under the salute of the guns, of the size of a panel over my chimney-piece.' Gainsborough carried out the commission. Thicknesse brags that he was the first who saw, 'through bad colouring, what an accurate eye he possessed, and thus dragged him from the obscurity of a country town, at a time that all his neighbours were as ignorant of his great talents as he was himself.' Next winter Thicknesse went to London and got the engraver Major to make a plate of the painting, though the latter 'doubted whether it would by its sale (as it was only a perspective view of the Fort) answer the expense; to obviate which, I offered to take ten guineas worth of impressions myself; he then instantly agreed to it.' He adds, with extreme exaggeration, that the engraving 'made Mr Gainsborough's name known beyond the circle of his country residence.' The painting, the third and last topographical work by Gainsborough, later perished through being left against a wall made of salt-water mortar. It was a slight work, which the artist tried to enliven with rustic figures (drawn from Watteau) and with the boats in the estuary. He asked fifteen guineas for it. 'I assured him that in my opinion it would (if offered to be sold in London)

produce double that sum, and accordingly paid him, thanked him, and lent him an excellent fiddle.'2

Here is the first reference we have to Gainsborough's passion for music, which had no doubt been fed by the performances at places like Vauxhall Gardens in London. So deep-rooted a response may, however, have gone back to his earliest years. Only a few steps away from his Sudbury home was the house of textile-manufacturers, the Burkitts, one of whom in the previous century had been locally known as a composer and musician. Thicknesse says he found that Gainsborough 'had as much taste for music as he had for painting, though he had never then touched a musical instrument, for at that time he seemed to envy my poor talents as a fiddler, but before I got my fiddle home again, he had made such a proficiency in music, that I would as soon have painted against him, as to have attempted to fiddle against him.' As usual, Thicknesse magnifies his own role.

The earliest extant letter by Gainsborough deals with money-worries. The date seems 1753. He pleads with his landlady Mrs Wrasse:

I call'd yesterday upon a Friend in hopes of borrowing money to pay you, but was disappointed & as I shall finish the Admiral's picture in a week you shall have it when I go to Nacton, will call & pay you at your new abode. I'm sorry it happens so but you know I can't make money any more than yourself & when I receive it you shall surely have it before anybody.

He was doing a three-quarters length of Admiral Edward Vernon, who had bought Nacton in Suffolk and who became MP for Ipswich. The commission must have been an encouraging one and he looked to Hudson's series of admirals for his system: a conventional pose (right hand tucked in coat, left hand gripping sword) with cannon, rocks, ships. For the modelling of the head, however, he looked to Ramsay.

His main interest had been in smaller works, where the subject or subjects were put in a natural setting, like the Andrews and Lloyds. *Gentleman with Dog* shows a man planted solidly in a sylvan scene, but with little sensitivity. Lambe Barry, in a half-length, was shown as a hunter with whip and dog, and with something of the stress of the hunt. But Gainsborough's heart went more into a work such as that which depicts Thicknesse sprawled on a bank with a heavy pollarded tree behind on the left, and on the right a tree-clump and a girl with donkeys. The squire

John Plampin of Chadacre Hall, Shimpling, sits a little more upright on a bank, with a church in the distance towards the horizon above the point where the bank curves down. Here everything is rococo, with forms radiating in serpentine curves from the central point (the man's waist), with his legs and the outstretching bough also playing their part as diagonals. The leaves on the bough draw the clouds into the system, and the paint grows looser to match the looseness of the pose. Gainsborough also painted himself, wife and daughter (apparently before the second girl was born). He sits on a bank, looking straight out; his wife and the tree-setting seem to have been painted in later. An unfinished sketch of himself shows his long heavy eyebrows, his largish nose, his full underlip. The expression is somewhat strained, unsure, but he gains a jaunty effect by the tricorne hat. The soft creamy highlights and reddish shadows are typical of his work at this time. In a small full-length of the Rev. John Chafy he brings music directly in; the sitter plays a cello in a landscape.[3]

He was having varying success in his attempts to link a person with a landscape, but there is no doubt that he had set himself the problem of finding how to integrate the human and the natural elements. At the same time he was doing many less ambitious portraits, showing the upper part of the body with the face in profile or straight, and with no accessories. For instance he painted his brother Jack in profile with the features clearly drawn and the paint handled in the crisp way typical of the period. The white cravat under the face produces a simple pattern against the darker hair, hat, coat. His friend Samuel Kilderbee, a rising young lawyer, who became Town Clerk and who was doing his best to get him sitters, he painted him three-quarters: a solid rounded form, well-framed by the tree and the dark clouds, with his belt-curve balanced by the light space above, but without any real relationship to the background.

He was extending his clientèle, charging (says Thicknesse) five guineas a head, though he later raised a head to eight guineas and asked fifteen for a half-length. Fulcher says that he was 'afraid to put people off when they were in a mind to sit'. His attitude indeed seems generally to have been deferential, with touches of ironic self-depreciation, but he was capable of flaring up throughout his career. Trimmer tells a tale of his being commissioned by a gentleman near Ipswich to paint a group of gypsies.

When about two-thirds of it were finished – for Gainsborough in his early works, owing to his great execution, finished as he went on – he came to see it, and was not pleased with it; he said he did not like it. Then, said Gainsborough, 'You shall not have it;' and taking up his penknife he drew it directly across it. In this state Joshua Kirby begged it, and my father had it mended, and it was sold at his death. It was a terrible gash, and Gainsborough must have been in a flaming passion when he did it. After this, he painted for the same person the picture from which the engraving is taken.[4]

Less than eighty portraits of his Suffolk period are known, of which two-thirds can be identified. That makes ten a year, mostly half-lengths. No doubt there were others now lost; but even so he was not doing very well.

He was visiting London now and then. No doubt he wanted to keep in touch with what was going on in the art world, to meet old friends, and to escape awhile from his wife's supervision. At times he was concerned with the production of etchings. In 1753-4 he etched, and John Wood completed, a *Wooded Landscape with Church, Cow and Figure* for Kirby's perspective book. In it a nearly dead tree slants across the scene, with a church behind it. Though the gypsy group was not published till 1759, also engraved by Wood, the original etching was probably done by Gainsborough about this time. It shows the gypsies round a fire under a large tree with a dead bough jagged over them like an arm of lightning. The clouds piled on the right echo the mass of the tree.

He was always keen to follow up new techniques, new materials. About this time he etched the *Suffolk Plough* (now lost, though the painting survives), with a man ploughing at the side of a rising hillock on which stands a windmill, and with the sea in the distance. Edward Edwards tells us, 'he spoilt the plate by impatiently attempting to apply the aqua fortis, before his friend, Mr Grignion, could assist him, as was agreed.'

In London he picked up all the art-gossip and saw new works of art. He must have followed with close attention the uproar caused by Hogarth's *Analysis of Beauty*. Averse as he was in general from abstract theory or literary study, he most likely read the book, and would in any event have discussed it at length with Kirby. Many of Hogarth's ideas were close to his own views and would have made him much more conscious of those views and their implications: the inner movement and tension of forms, the

significance of the serpentine line of beauty. At the same time the attacks on Hogarth would have convinced him more than ever that he was right to avoid all theoretical discussion, which laid an artist open to misunderstanding and denigration. His letters show that he thought hard enough about art, but he wanted to keep clear of all arguments, in which he would only be worsted in the eyes of the art world and abused for his unconventional positions.

In February 1755 he had to borrow £200 from his attorney Unwin, which he repaid two years later out of his wife's annuity. Landscapes were very hard to sell, but this year, in May, he sold to the Duke of Bedford for twenty-one guineas *The Woodcutter courting a Milkmaid,* apparently as an overmantel for one of the ground-floor rooms at Woburn. There is a decorative effect in the pink of the sky and the heavy pollarded tree drawn out in twisted forms as a background for the lovers, with the broadly-painted cow on their left. The man's head is the point from which radial lines emerge – one of the most important running along the back of the cow. As a contrast the ragged ploughman on the left is hard at work behind another framing tree. In July the Duke bought, no doubt also for an overmantel, *Peasant with two Horses: Hay Cart behind*; the price was fifteen guineas. The large framing oaktree on the left arches over the horses and curves on to the cart and the tree-embosomed church (with the pond before to keep a circling balance).[5]

How he varied his motifs can be seen by comparing the last item with *Farm building with Figures, and Milkmaid milking Cows*. Here there are framing trees on either side and the church tower has receded to close the distance; the oval pond moves to the centre; the cloud-masses echo the trees and the farm buildings are balanced by a dead tree with twisting branches. In *Farmyard with Milkmaid* the church and farmhouse come up behind trees at the centre, with trees lunging over from either side (both nearly dead). In a related pencil drawing, varnished, the forms are larger and closer, with a heavy pollarded tree leaning over from behind the cows in the centre. In *Figures and Donkeys on a Road, distant Windmill* (probably an overdoor), the earth and trees are massed in fairly straight lines, with contrapuntal cloud-forms. The stript pollarded tree is strongly lighted, uniting earth and sky, with the windmill on the right echoing its effect. The warm-reddish foreground with its slowly rising line gains its spatial depth by tone and light, the gap between it and the darker masses behind.The road curves up from the gap and goes down again out

of sight, and there is a cottage to the rear of the tree.

We see how he is steadily widening the scope of his vision, gaining spatial mastery while varying his use of rococo rhythms, and working out certain motifs that have a deep emotional meaning for him.

In 1755 Kirby moved to London. Advertising the second edition of his *Perspective* he stated that 'The Author continues to carry on the Painting Business as usual, and all orders shall be obeyed with the greatest punctuality.' In August we catch a glimpse of Andrew Baldrey, who at his death in 1802 was described as diffident though owning much merit as a painter, and as having long had an acquaintance with Gainsborough. He was chief assistant in Kirby's house-and-coach painting firm, and this year he became a partner. 'J. Kirby humbly hopes that those gentlemen who have not been personally applied to on this occasion will be so good as to excuse it.' Kirby, however, kept up his connections with Ipswich till September 1759.[6]

On Friday 7 May 1756 we find Gainsborough again in debt, this time to Harris, churchwarden of St Mary Key.

Now as I am already Indebted to you for waiting so long, Why won't you stay till I can pay you. Or let me give you a picture: this I assure you I shall willingly do, for I'm neither so ungrateful or Ignorant as to think you are wrong in what you wrote me, so far from it; that what I'm obliged to do in the picture way to end this affair I had much rather do for you, than another who might lend the money; for besides the disagreeable Jobb of asking, take my word that no one does services of that nature without a picture, Excepting one man & he is far from home. These are truths but yet secrets, therefore [I] trust that you'll not let this letter be seen. What I propose to you is this, if you'l still stay till Midsum[mer] for the money (for which if you desire good security you shall have it) I will then paint you any thing you like, either Landskip, or if you will yourself upon a little Canvas, the size of Mr Barry's; which I'll shew you whenever you'l call. Give me your answer by John Davis which will oblige Sir your humble Servt Tho: Gainsborough.

The Lambe Barry picture to which he refers was 13 by 12 inches. The rambling repetitions of the letter show how agitated he was. Unable to leave off, he adds a postscript and tries to make a joke of the whole thing.

I have but 3 Debts standing against me, one of them is 6 pounds, to Olliver who instead of writing like a gentleman as you have done, got into a way of sending an old Crooked woman every Day or two; She I got rid of by threatening to Draw her picture. Now tho' I won't threaten you, yet

I hope to get rid of you by means of the pencil [hand drawn with pointing finger] if you have a girl that you'd rather have drawn than yourself tis Equal to me.[7]

The newspapers record regular musical evenings and concerts, and Gainsborough soon found out the local musicians. About 1755 he painted Joseph Gibbs, head and shoulders, with a quill-pen standing by a manuscript headed SONATA. In his *Eight Solos for a Violin with a Thorough Bass for the Harpsichord or Bass Viol* (1748) Gibbs gave his location as Dedham in Essex; but he soon moved to Ipswich, where he became organist of St Mary le Tower. About 1755 Gainsborough also painted a group of P. D. Muirman, C. Crockett, and W. Keeble in the open air, two of them with flutes. One flautist, seated against a tree, plays. There was further a painting of the Musical Club, slight and unfinished, but exceedingly spirited, said its owner, Strutt, and

the more interesting as it was composed from memory. Immediately in front of the spectator are the portraits of Gainsborough himself, and his friend Captain Clarke, who is leaning familiarly on the Painter's shoulder. The heads of both are turned towards Wood, a dancing master, who is playing on the violin, accompanied on the violincello by one Mills. The latter figure is merely outlined, Gainsborough declaring that he 'could not recollect the expression of his phiz'. Gibbs, on the opposite side of a table which is standing in the centre, is sound asleep. There is a sly piece of satire in this, he being the only real musician in the party, and his sleeping would seem to indicate that the performance is not of first-rate quality. It is a candlelight scene, and by the condition of the table, some degree of conviviality appears to have prevailed. Gainsborough has his glass in his hand, that of Gibbs stands before him, as also does Clarke's, and one is overturned: a couple of lights are placed on each side of the music stand, before which are two performers... [Gainsborough] is dressed in a dark claret-coloured coat; Clarke is in uniform; Wood, in blue; and Gibbs, in sober grey.

In 1797 Constable was asked by J. T. Smith for information about Gainsborough. He replied that he could not find out much, even after talking to people who had known him in Ipswich, save that he had 'belonged to something of a musical club in the town, and painted some of their portraits in a picture of a choir; it is said to be very curious.' Gainsborough was 'generally the butt of the company, and his wig was to them a fund of amusement, as it was often snatched from his head and thrown about the room.'

In 1768, writing to Garrick, Tom tells how he was steward for a benefit concert at Ipswich, went to the cabinet-maker who was

their vocalist, and asked if he could sing at sight.

'Yes, Sir,' said he, 'I can.' Upon which I ordered Mr Giardini of Ipswich to begin the Symphony... but behold, a dead silence followed the Symphony instead of the song; upon which I jumped up to the fellow: 'Damn you, why don't you sing? did not you tell me you could sing at first *sight*?' 'Yes, please your honour, I did say I could sing at sight, but not *first* sight.'

However, Charles Burney tells the same story of Handel at Chester in 1741.

Felice de Giardini had played in opera-orchestras in Rome and Naples, toured in Germany, and, some ten years back, appeared in London, the first violin virtuoso heard there. Leading the band at the King's Theatre in the Haymarket, he 'introduced new discipline and a new style of playing', says Burney, much superior to 'the languid manner of his predecessor.' Charles Avison noted 'his amazing Rapidity of Execution, and Exuberance of Fancy, joined with the most perfect Ease and Gracefulness in the Performance.' In the later 1750s he started concert-tours in the provinces. He and Gainsborough became close friends. (In 1759 there were twenty-six concerts followed by balls, in Ipswich.)[8]

In the mid-1750s Gainsborough was fairly busy. He painted Mr and Mrs Browne of Tunstall, with child and dog, before a tree on the right of a broad landscape, a pond on one side and farm-buildings on the other. The light on the figures also gleams in a whited wall, and a dead tree with gesturing boughs is in the middle above the farm. Clouds echo the forms on the right. John Sparrowe of Worlington Hall was also painted; Mrs John Rix of Gowold Hall, Thrandeston, North Suffolk; the Rev. Henry Hubbard; and the Rev. Robert Hingeston near Southwold. The latter's son told Fulcher that 'many houses in Suffolk as well as in the neighbouring county, were always open to him, and their owners thought it an honour to entertain him.' Fulcher was writing after Gainsborough had become a famous painter; but clearly the artist liked to wander about, glad of a spell away from Margaret's watchful eye, and made himself welcome with his high spirits.

I remember Gainsborough well, he was a great favourite of my father; indeed his affable and agreeable manners endeared him to all with whom his profession brought him in contact, either at the cottage or the castle; there was that peculiar bearing which could not fail to leave a pleasing

impression... I have seen the aged features of the peasantry lit up with a grateful recollection of his many acts of kindness and benevolence. My father's residence bears testimony alike to his skill as a painter, and his kindness as a man.

In a letter of 24 February 1757, probably to the lawyer William Mayhew (whom Tom painted that year), he says that he has nearly done the portrait and will send it to Colchester with a frame. He gives thanks for the offer to find him some sitters, with whom he will deal when he himself comes along: 'which I purpose doing as soon as some of those are finished which I have in hand.' He adds, 'I should be glad [if] you'd place your picture as far from the light as possible; observing to let the light fall from the left. Favor me with a faithful account of what is generally thought of it; and as to my bill, it will be time enough when I see you.' He had been using more and more the light flickering touch of the French pastellists, La Tour and Perronneau; and as time went on he grew ever more concerned about the way his pictures were hung.[9]

This year, on 22 July, he made a draft for payment to Kilderbee: '£50 ten days after date'. The draft is addressed to Bertie Burgh, Castle Yard, Holborn. On 28 January 1758 he made a draft for payment of £49 10s to Mrs Ann Christian a month later.

Then, on 13 March, more than a year after his first letter, he wrote again to Mayhew, regretting that he still had not managed to visit Colchester, 'as I promised my sister [Mrs Mary Dupont] I would the first opportunity.' He has been busy in the Face way. 'I'm afraid to put people off when they are in the mind to sit.' He sets out at length the right way of looking at his paintings.

You please me much by saying that no other fault is found in your picture than the roughness of the surface, for that part being of use in giving force to the effect at a proper distance, and what a judge of painting knows an original from a copy by; in short being the touch of the pencil, which is harder to preserve than smoothness. I am much better pleas'd that they should spy out thing of that kind, than to see an eye half an inch out of its place, or a nose out of drawing when viewed at a proper distance. I don't think it would be more ridiculous for a person to put his nose close to the canvas and say the colours smell offensive, than to say how rough the paint lies; for one is just as material as the other with regard to hurting the effect and drawing of a picture. Sir Godfrey Kneller used to tell them that pictures were not made to smell of: and what made his pictures more valuable than others with the connoisseurs was his

pencil or touch. I hope, Sir you'll pardon this dissertation upon pencil and touch, for if I gain no better point than to make you and Mr Clubb laugh when you next meet at the sign of the Tankard, I shall be very well contented. I'm sure I could not paint his picture for laughing he gave such a description of eating and drinking at that place. I little thought you were a Lawyer when I said, not one in ten was worth hanging. I told Clubb, of that, and he seemed [to] think I was lucky that I did not say one in a hundred. It's too late to ask your pardon now, but really Sir, I never saw one of your profession look so honest in my life, and that's the reason I concluded you were in the wool trade. Sir Jaspar Wood was so kind [as] to set me right, otherwise perhaps I should have made more blunders.[10]

We see how he mixes a little cajoling flattery humorously with his serious point. A letter such as this gives us the very accents of his talk.

We have now three drafts in 1758 for payments to be made. On 13 July the draft was for Nathaniel Burrough, £10 at a month's time. On the same day he promised to pay Michael Thirkle £10 in six weeks. On 1 August he gave a receipt for a half-length (lost) of Daniel Wayth, brother of Mrs Mary Kilderbee. He had painted her, perhaps the year before, with her head done in the hatching technique which he defended in the letter to Mayhew and which he was using to get away from the smooth finish of Hudson and other fashionable portraitists; it gave a new fullness to flesh, a vitality of surface. He caught Mary's warm challenging character in all its lively charm. (It seems that he reworked parts of the picture in the late 1770s, for instance the high-piled hair with falling tresses in the loose brushwork of that period. She would have been then twenty years older; but no doubt she did not want to lose the record of the delightful face of her youth.)

In the later 1750s he painted Mrs Acton, a member of the Lee-Acton family of Livermere. The half-length was more in conventional style, with the head against a plain dark background, but the features were roughly modelled. Besides Mayhew, he did George Montgomerie (MP for Ipswich in 1754), the Hon. Charles Hamilton (a straightforward head and torso), Robert Edgar and two Misses Edgar, Mrs Hill, wife of the rector of Buxhall, with her vivacious quizzical face painted in a direct way, and her husband, the Rev. Henry Hill. The Rev. Richard Canning, rector of Harkstead, he painted, head and shoulders, in an oval as he often did with middle-class professional men. He uses his hatching here to provide a contrast with the plain brown background and the wig with its neat distinct brush-strokes.[11]

Painting a girl in a pink riding habit, he put a castle at the back and trees on either side and made her stand in an easy pose. Quite a different effect was given in his *Lady Innes*, where he was up against an aristocrat. The head is modelled in tight hatching, but there is a general effect of Van Dyck: the rose in the hand, the concentration of texture in lace and satin folds, with wrist and hands rendered in loose flowing style. The head is set against a rounded mass of foliage with light farther off breaking through a stormy sky; but it seems to belong to a different world, one of polite inanities. With the Hon. Richard Savage Nassau Gainsborough again had an aristocratic customer, but he tackled him in a quite different way, sitting him in a chair in a room in a nonchalant pose, with the arms making an oval that supports the diagonal coming up from the lower right corner. Nassau leans back but is pulled forward by the oval to the lighted hands and book. The informal pose is offset by the rhythmical construction. (The work is one of the few for which a preliminary rough sketch, in black chalk, was made.) The movement of the figure back-and-up is further balanced by the landscape framed in the upper right hand corner, which looks forward to the sketchy style Gainsborough was to work out in the next decade. At last he had achieved a portrait in which the sense of character and movement pervades the whole work, though here and there touches of his earlier method show up.

With his two portraits of William Wollaston he makes yet further advances. Wollaston sits with his flute held across his body, which turns round on three different axes. Lines lead up pyramidally to the head, which is turned to the right, and there are also strong diagonals, the flute, the curtain, the lower lines of braid. There is an effect of spirals in movement, an effect given a dynamic note by the scatter of highlights. It is as if he had just finishing playing the flute and the music is still eddying round him, vitally a part of his body as of his mind. The *contraposto* pose suggests Roubiliac's statue of Handel in Vauxhall Gardens, but is far more complex. Here at last is something of the grand manner, which did not come off with Lady Innes – but the grand manner in Gainsborough's own way: rococo and realism merged, with the rococo not something applied from outside, but an inner force transforming the material. Here it is indeed that the musical element asserts itself as a formative force.

Gainsborough also painted a full-length of Wollaston leaning on a fence with legs crossed, a dog at his feet and his mansion far

at the rear. Foliage arches over the casually turned head. But there is nothing of the unity of movement in the flute-portrait. This work (85 by 58 inches) is the first large-scale full-length by Gainsborough, and the only one he painted at Ipswich.

In the late 1750s he also did three paintings of his young daughters, which are again quite different in style. In one, showing their heads and shoulders, Mary has her hand on Margaret's head; in another the girls are seated with Mary loosely holding Margaret in her arms (a cat suggested with a few sweeping lines); in the third the girls chase a butterfly. All are masterpieces of freshness, with the casual moment caught objectively and yet given a limpid lyrical quality, the emotion communicated by the rapid, rough, sensitive brushwork. Though there is slight indication of the natural setting in two of them, the main effect is of a caressing space of play and meditation, which is itself childhood.[12]

The drawings of the Ipswich period consist of careful studies direct from nature, which could be used in paintings; notes of scenes that could be developed further or provide motifs for use in fully worked-out compositions; or finished drawings that might be used for paintings or considered artworks in their own right. In one study of trunk and leaves strokes are dashed boldly across and downward, gaining depth and rhythmical force, with a general hatching effect. In *Wooded Landscape with Herdsman and Cow* there is a blunt pyramidal bank with trees climbing up on the left and a road on the right winding into the open, on to a church tower on the skyline – trees and bank giving an effect both of a fine rhythmical ascent and a circling movement.[13]

About this time, says Fulcher, Kirby 'placed his only son, William, a youth of great promise, with Gainsborough. In a letter written shortly after his son's arrival at Ipswich, urging him to the practice of religion, Mr Kirby observes: "My letter may serve as Sunday meditation, and let no one see it except Master W—, the companion of your studies." ' It seems that there was another youth in the house. Gainsborough must indeed have been hard-up if he took in pupils, for he strongly disliked teaching. About the same time Sarah Kirby wrote to her brother, 'Having so good an example to copy after, I imagine you improve very much in politeness.' It seems that Gainsborough was on his best behaviour with the Kirbys. As Fulcher dates Kirby's letter 12 August 1759 and says that it was sent soon after the boy's arrival, the

arrangement could not have lasted long. Perhaps young Kirby's presence was one of the factors that made Gainsborough want to leave Ipswich. Trimmer says: 'He was some time with Gainsborough but did not, I have been told, like him as instructor. He had often disputes with his brother artists.' (Edwards remarks: 'It is not known whether Mr Gainsborough had any pupils.')

In late 1758 and early 1759 Gainsborough travelled quite afar. We find him in the Midlands, painting the Earl of Jersey and Lord Villiers; and probably on this trip he visited Hartwell, in much the same area, and did half-lengths of Mr and Mrs Lee (for which there exist receipts dated 19 April). William Whitehead, poet and tutor to Lord Villiers, wrote on 6 December 1758 to Lord Nuneham from the Earl's seat near Bicester. (Lord Villiers, eldest son of the Earl, was then about twenty-three or twenty-four.) At Middleton Park, says Whitehead,

we have a painter here, who takes the most exact likenesses I ever saw. His painting is coarse and slight, but he has ease and spirit. Lord Villiers sat for him before he left Bath [? for Bath], and I hope we shall be able to bring his picture to town with us, as it is he himself, and is preferable in my opinion to the finest unlike picture in the universe, though it might serve for a sign; he sate only twice. The painter's name is Gainsborough.

We see how the expressive use of paint seemed mere coarseness, fit for signposts, to the person of conventional tastes. Whitehead's letter is ambiguous; apparently 'for' has dropped out before 'Bath'. Otherwise it would follow that Gainsborough had painted Lord Villiers in that town.[14]

A self-portrait of 1758-9 shows how Gainsborough had matured. His face has filled out and he has learned to take more care of his appearance, with his brown hair curling out broadly on each side.

In January 1759 he was again in debt to Mrs Christian; on the 5th he signed an order for her to be paid £30 in three weeks. By the autumn he had worked himself up to leaving Ipswich. On 20 October the *Ipswich Journal* stated:

To be sold, Opposite the Shire Hall, Ipswich. On Monday and Tuesday next, the 22nd and 23rd inst. All the HOUSEHOLD GOODS of MR THOMAS GAINSBOROUGH, with some PICTURES and original DRAWINGS in the Landskip way by his own hand, which as he is desirous of leaving them among his friends, will have the lowest price set upon them. The house to

be let immediately Enquire of Mrs Elizabeth Wrasse, in Ipswich.

According to Strutt (cited by Fulcher) 'his friends paid a last visit to his studio, and expressed a wish to have some memorial of his pencil. The good-natured artist complied. One took one sketch; another, another; and finally', that of the Musical Club 'came to my father's hands.'

Thicknesse claims that it was he who persuaded Gainsborough to move to Bath. Soon after the Fort was engraved, he was 'by me and several of his friends, urged to remove to Bath and try his talents at portrait painting, in that fluctuating city, at which time I had a house there, and resided during winters.' Thicknesse's accounts of Bath may have been one of the factors bringing Gainsborough to make up his mind; but he had clearly outgrown Ipswich; and Bath in many ways must have seemed the next step, rather than London.

We may pause here to glance in general at his development up to 1760. He had absorbed the main trends which were advancing art in the 1740s and had partly adapted them to his own needs, but was not yet fully aware what those needs were. He was fighting to sort out just what potentialities in the new lines of approach he could most fruitfully develop. In his early Suffolk days many portraits are head-and-shoulders with plain background, often using the feigned oval. At first glance they seem much in the traditional manner of Cornelius Johnson, which was being continued in East Anglia by men like David Heins and Bardwell (both settled in Norwich). But he was also struggling to find ways of extending the direct vision of Hogarth (as carried on by men like Hayman, Joseph Highmore, G. Bear), which was concerned with getting a likeness more than with using style and properties to give an effect of status. What is sought is the everyday habitual self, with no hint of the drapery-swirl still to be seen in some early Ramsays. There is no reason to think that in general the lesser country gentry and the town professional men would object to such an approach – though we have seen that he had to try to explain his method when the brushwork became too unorthodox. At first he was absorbed in taking over the fresh tonality and smooth flesh-texture of men like Van Loo, Mercier, Ramsay. Then, stirred by the French pastellists, he started to use a quick light flickering touch, which grew into his hatchings. The rough surface, as in the head of Lord Villiers, was felt to convey the

immediate effect of breathing reality. But he did not halt there; in time he felt the need for a broader, more unifying definition of light and shade (as was attempted by Reynolds). Not that there was any simple succession of styles, one ousting the other. Elements from a previous phase may reassert themselves to some extent without disturbing elements from a later one.

Thus, we see the earlier stiffness of pose and tightness in brushwork modified by the scattered lights over the halftones which build up the head of *Prudence Rix*. He grows more assured and even anticipates Renoir in using tones of green set in paler sections of the background near the head to complement and enrich the flesh-tones. In *John Sparrowe* he intensifies the kind of brushwork used to bring Prudence Rix's head alive, now not afraid of loose highlights. We continually see an advanced and experimental vitality of response modified and even thwarted by an uncertainty that falls back on more conventional solutions.[15]

He is still far from being sure of his final aims, though he keeps on working towards greater richness of texture and compositional organization, towards immediacy of impact, towards methods which will more fully integrate human beings and the world of nature. One climax comes in the complex unity of movement in Wollaston with his flute; another in the girls chasing the butterfly, where there is an overall feeling of spontaneous invention and direct impact.

In landscapes he was widening his scope and strengthening his imagery, achieving different balances between Dutch or French influences and the scene before him – or the scene as recalled and reconstructed. Struggling with the French pastoral idyll and the arcadian conventions of a Zuccarelli (fluently pretty with dainty impasto), he sought to transmute such material into representations of true rustic life. Again he had unequal successes, but was taking a decisive new turn.

The imagery which most haunted him came from his early Sudbury days. The scene in his mind was dominated by the banks of the Stour and the flowing water, the slopes through woodland up from the river and down to it, the winding rough tracks. Though at times he depicts a view that opens out unimpeded, his main bent is towards the slope traversed by a winding road that comes up from an undefined depth and goes over the top of the slope or is lost in further levels of ascent. His vision rejects the idea of space as a boxlike structure with mathematical perspective-lines; it is concerned with space made

up of rhythmical formations and the play of light and shade. Music plays an integral part in making the rococo systems concrete: not a set of curves imposed on the scene, but the scene itself realized in its unfolding and organizing rhythms. Again, success is intermittent; but the whole drive is in the direction of imaginative realization rather than arbitrary imposition of rococo preconceptions. Hogarth's *Analysis of Beauty* seems present as a continual source of inspiration, which helps the artist to resist set decorative patterns or naturalistic reflections. (It is amusing that he was the close friend of the most consistent advocate of mathematical systems of perspective, Kirby.) The accepted landscapists were John Wootton and George Lambert, who made pastiches of Claude and Gaspard Poussin with a decorative bias, though they were ready enough to incorporate Dutch elements as taste changed. Lambert indeed at times achieved effects more truly based in the English countryside, but there was nothing in him of the deep transformative energy that drove Gainsborough on in his fascinated grappling with the Suffolk scene. Until the end the latter needed to draw on what he had seen and learned in his study of nature, but he was not interested in merely transposing the scenes that enchanted him, in carrying the Dutch vision a little farther or in pleasantly domesticating elements from French rococo.

What we may call his archetypal image of nature, of the earth – the wooded slope rising from seen or unseen water and traversed by a winding path – we may trace back to the Stour Croft beside St Gregory's Church at Sudbury where he played as a child. A map of 1714 shows that trees grew along the bank at the lower side of the commonland, and the boy must have seen cattle, sheep, horses, donkeys grazing on the Croft as he looked up at the rising ground.

In dealing both with people and with nature he was taking up, absorbing, readapting elements from contemporary art but in the last resort what mattered was the deep emotion evoked in him by a scene, the strong sense he had of the individuality of a sitter, and the way in which his emotions and sensibility could be expressed in terms of paint. Paint was not a medium to be used to express something unconnected with it. Since it was the medium of expression, it had its own life, its own powers, and he always felt a tension between the object to be represented and the means of representation, a tension that had to be resolved by the projection of a rhythmical living whole which was simultaneously

the subject and the means by which the subject was realized and defined. He was seeking to fuse with a new fullness the rococo sensitivity and the Hogarthian grasp of the tension and movement of forms, in which resided both individual character and the dynamic relation of that character to the whole of which it was a part, an aspect. Herein lay his originality, his contribution to the development of art. He still had far to go before he had worked out all he wanted to say, but by 1760 he had laid the essential bases.

5 Bath (1760-1766)

*T*hicknesse tells of Gainsborough's first days in Bath as he sought to settle down. Clearly he made the move hastily without inquiries or contacts at the other end.

After Mr Gainsborough's arrival in Bath, I accompanied him in search of lodgings, where a good painting room as to light, a proper access, &c., could be had; and upon our return to my house, where his wife was impatiently waiting the event, he told her he had seen lodgings of fifty pounds a year in the churchyard, which he thought would answer his purpose. The poor woman, highly alarmed, fearing it must all come out of her annuity, exclaimed, 'Fifty pounds a year Mr Gainsborough! Why are you going to throw yourself into a gaol?' But upon my telling her if she did not approve of the lodgings at fifty pounds a year, he should take a house of a hundred and fifty, and that I would pay the rent if he could not, Margaret's alarms were moderated.

Thicknesse cannot lose any chance to jeer at Margaret, but she may well have had reason to fear that her careless husband would start living beyond his means at Bath, where they had not yet tested his chances of making a livelihood. Whether he took rooms in the fashionable Abbey Churchyard and then moved to Ainslee's Belvedere, we are not sure. But in late 1763 he took a detached house known as Lansdowne Lodge in Lansdowne Road.[1]

Bath, famous since Roman times for its mineral waters and set among gentle hills, was the principal lounging place for persons of wealth and leisure in the winter. Beau Nash was no more to be seen in the streets in his fine chariot, though his full-length statue

stood in the Assembly Room between mere busts of Pope and Newton. The creator of eighteenth-century Bath was Ralph Allen, who also ran the efficient postal service by substituting postboys on horses for foot-runners. Soon after 1727 he had grasped the possibilities of Bath freestone, and the new Bath was built with blocks from his quarries on Doome Down. He was aided by the architect John Wood, who built North and South Parade, then Queen Street, and next planned the Circus on the crown of the hill at the top of Gay Street. The Circus was an ellipse of thirty three-storeyed houses, with ground floors in Doric style, Ionian above that, and Corinthian on top: the whole surmounted by a balustrade. Wood's son completed the Circus and planned the two Crescents on the heights. Wood also built Prior Park where Allen, the original of Fielding's Squire Allworthy, lived in princely style. Gainsborough must have watched the building of Pulteney Bridge by the Brothers Adam at the bidding of the heiress Frances Pulteney. It was thrown over the Avon on three piers, leading in a series of mansions to Spring Gardens.

The amenities of Bath were increased by John Palmer, a brewer's son who became one of Gainsborough's friends. With the help of other citizens he replaced the old playhouse with a theatre in Orchard Street, for which he got a patent. He carried the whole company in a vehicle called the Sociable, which proved faster than the vehicles being used for journeys and which led to the stage-coach and the completion of Allen's postal system. By the 1760s Bath had been purged of many of its raffish excesses; there was more decorum at assemblies and concerts; and attempts were made to discourage too-wild gambling (from which Nash had drawn much of his income). Only the gouty and aged used the hot baths, but all visitors were likely to appear at the assemblies and sip the waters while flirting or gossiping. Theatre and music had reached a much higher level, and the season lasted some six months, October to April.

At first Gainsborough found no rush of sitters. Thicknesse offered himself, suggesting that 'his head should be held up as the decoy duck'. To his surprise and resentment he was given one sitting of fifteen minutes and no more. Soon there was no need of a decoy. Sitters kept turning up. The one serious rival was William Hoare, brother of Prince Hoare, who had long held the main patronage of the town. A Suffolk man, born at Eye in 1706, he had been affected by the Italianate taste; studied under Grisoni in London; then went to Rome where he was pupil of Francesco

Imperiale and associated with Pompeo Battoni, who was highly fashionable with travellers.[2]

Within a year Gainsborough was well known. On 23 October 1760 Mrs Delany wrote to a friend, Mrs Dewes:

This morning went with Lady Westmoreland to see Mr Gainsborough's pictures (the man that painted Mr Wise and Mr Lucy), and they may well be called what Mr Webb *unjustly* says of Rubens, 'they are splendid impositions'. There I saw Miss Ford's picture, a whole length with her guitar, a most extraordinary figure, handsome and bold; but I should be very sorry to have any one I loved set forth in such a manner.[3]

Ann Ford sits with her legs crossed in a careless way, her body leaning to the right while she turns her head to the left. Her left arm supports her head, while her right arm falls into her lap. The result is a rococo design as dominant as in Wollaston with his flute, but more clearly a Hogarthian beauty-curve or spiral. The serpentine twist of the body is accentuated by the dress cascading down and at the same time stabilized by the lines of the viol behind and the stand of the table. (The viol takes the place of what was a window and landscape view in the preparatory sketch.) The line-of-beauty swerves from jaw and right shoulder down the out-thrust leg; it is resisted by the diagonals as they run upwards. There is thus a conflict and unity of two movements. Further there is a creation of restless triangles as the diagonals move up against the main curve. There are two points of rest: the face which the neckband both cuts off and balances, and the viol at the side which has both a strong vertical line and swelling curves. In the centre the guitar with its rounding shape and its neck parallel with the right shoulder provides a secondary system. The intersecting triangles are not static elements of design; they create a supporting system, yet also flow back dynamically into the woman's shape.[4]

There is thus a powerful image of a woman who is also viol and guitar, and the instruments in turn become aspects of her vital totality. Clearly an inspiration here was Tom's love of the instruments, his feeling of the music they potentially enclosed, and so of their active relation to the woman. She is not playing them, but the picture as a whole becomes an expression of her being as a musician. The music is part of her personality, which in turn is defined by the whole complex of forms making up the picture. Thus a new sense of human character evolves from the relation of a person and his or her situation: which is also a new

concept of the aesthetic elements making up the picture. (There is a link with a Van Dyck such as his *Lady Digby*, but any borrowings are transformed.) We see something of Cézanne, something of Hogarth. The Hogarthian element robs the Cézanne element of any tendency to abstraction; the Cézanne element transforms the Hogarthian sense of the living situation, its social content and the personal refraction of that content, by a pervasive stress on the lived moment, on the identification of the human being with the instrument through which she realizes herself.

Thicknesse had arranged the sitting. Ann was the only daughter of T. Ford, Clerk of the Arraigns, and niece to a royal physician. She had been giving polite Sunday concerts at her home, in which Dr Arne, Tenducci and other professionals also performed. But she was determined to appear in public. Her father twice arrested her, but she escaped to the house of her close friend, Lady Elizabeth Thicknesse, and arranged a concert at the little theatre in the Haymarket for 18 March 1760. Her father had all the streets around blocked by Bow Street runners, who dispersed only when Lord Tankerville threatened to send in a detachment of the Guards. There was a huge crowd at her concert, at which she sang and accompanied herself on her viola da gamba and guitar. She was carrying on a sort of liaison with the aged Earl of Jersey. He too objected to her public performance and their relations ended in a violent quarrel. In 1761 she frankly told the whole story in *A Letter from Miss F--d, addressed to a Person of Distinction* as well as publishing *Instructions for playing on the Musical Glasses, etc.* In her Letter she related how her father urged her to accept the Earl's offer of £800 a year, 'and upon my expressing my astonishment, added, that I was not obliged to comply with the terms, though I accepted the settlement.' Her uncle also objected to her appearing in public. He 'does not think he dishonours his family, in paying a servile court to your L--d-p, who he knows used every art to seduce and debase his n--e.' In 1762 she married Thicknesse. She was certainly a suitable character to help Gainsborough into his full release as a painter. Her portrait was the first big work he did at Bath. Though based on rococo, the total effect went far beyond it.

If we look at the names of many of Gainsborough's sitters in the early 1760s we find that recommendations must have been circulating among interrelated families of Bristol and Somerset. He soon had made personal friends of several of these sitters: the

Prices of Foxley, Lord Bateman, Sir William St Quintin. He became known at the mansions of Badminton, Longleat, Bowood, Wilton. For a while his style was still unsure, carrying on from his late Ipswich work; then a group of half-lengths showed a change. The best works are those depicting oldish men of strong character. He uses his hatching system to bring the features to life, so that the figures seem to move out of the picture plane. And he gains confident control of full-lengths.[5]

In London public shows had begun at the Society of Artists in 1760, with Hayman as Vice President. (Five years later he was President.) Artists thus had a chance to get their works known by a wider public. In 1760 Tom seems to have been too busy settling in at Bath; but from 1761 onwards he sent along a number of full-lengths and some of his finest landscapes. (His 1761 picture was a portrait of Earl Nugent.) As he grew more popular, a wit remarked, 'Fortune seemed to take up her abode with him; his house became Gain's borough.' He soon raised his fees to twenty guineas for a head, forty for a half-length, eighty for a full-length. We meet tales of his reaction against pomposity and dictatorial airs. A man whom Thicknesse calls an alderman, Cunningham a lord, set himself in what he thought an advantageous position, with a new-powdered five-guinea wig, and finally asked Gainsborough not to overlook the dimple in his chin. 'Damn the dimple in your chin,' was the reply, 'I can neither paint that nor your chin neither.' There was a tradition that he was liable to guffaw in a sitter's face.

He had become friendly with Uvedale Tomkyns Price, whom he painted. The son, Sir Uvedale Price, then a boy of fourteen or fifteen, was to become famed for his *Essay on the Picturesque,* 1794; and his father may well have been in part the originator of his ideas. In the portrait Price holds a crayon and a drawing of trees. On the wall behind him another drawing is framed. (Gainsborough at times put a part of one of his landscapes on the walls of portraits; nowhere else does he use a drawing. He made drawings of trees in the park at Foxley, and later he and young Price roamed about together.) In the Foxley collection was a high proportion of Dutch landscapists: Cuyp, Berghem, Both, Du Jardin, Ruisdael. The way that the lighting emphasizes the head and hands in Price's portrait suggests that Gainsborough worked on it by candlelight.[6]

An early Bath landscape shows a mixture of his Ipswich style and the grand manner. The figures are rustic, a boy on a horse

and a woodman, and the road winds to a church in the distance; the movement is rococo but the main design looks to Claude. In this picture first appears the motif of the woodcutter coming home after a day's work, which was to become deeply charged with emotion for Tom.

In 1761 Kirby, in an audience with the King, presented him with the latest edition of his *Perspective*; and Humphry, Tom's brother, was awarded a £50 prize by the Society of Arts for a tide-mill he had devised. Like Jack, he was an inventor, but a more successful one. Among his products Thicknesse mentions a sundial that showed the hour of the day in any part of the world 'to a second', without the wheels and calculators usual in such instruments. Richard Lovell Edgeworth also saw the dial and said that it gave the time 'to one minute, without the assistance of wheel-work or microscopes'; he added that he had 'never known a man of more inventive mind'. Humphry further devised a fireproof safe. He gave one of the boxes to a friend, whose house was burned down soon after; the box and its contents were uninjured. He seems to have superintended the making of new roads near Henley. A man of high rank in the neighbourhood, says Fulcher, 'offered him preferment if he would enter the Established Church'. Humphry replied, 'I dwell among mine own people.'

In 1761 in Sudbury Jack made a triangular wooden sign for himself, carving his name on it, and he painted the royal arms over the old Town Hall. He was now living in Friar Street.

On 13 April 1762 Gainsborough wrote to Richard Stevens, whom he had painted, with a bill of ten guineas, plus two guineas for the portrait's frame and seven shillings for the case. On the 22nd he wrote to Captain Townshend in Old Burlington Street, London. 'I am sorry that from the nature of my damn'd Business, the Time of my Coming to Town remains yet uncertain'. When he does come, he'll go to the house of the Captain's sister and make any alterations she thinks needed in her brother's portrait. We see that he kept making visits to London.

This year he opened an account at Hoare's bank in Temple Bar, London, which he kept going till 1785. Henry Hoare had a gallery of pictures at Stourhead, Wiltshire; his collection was the first one of any importance to take in one of Gainsborough's landscapes. This year the latter exhibited at the Society of Artists in London. He sent his silvery-toned portrait of Poyntz. Here his much-

favoured motif of the almost dead tree is used: the trunk swings over like a great shell with the man's head strongly-lighted against the hollow part as he leans on it. The loosely-held gun with its clear line stabilizes the swung-over mass of man and tree; but no more than in the picture of Wollaston at his gate does Poyntz holds his own in the setting.

In 1763 Gainsborough painted the actor Quin, whom he had doubtless known slightly in his early London days. Quin, born in Dublin in 1693, had retired in 1751 and gone to Bath as 'a fine slope to the grave'. At first he refused to sit. Gainsborough joked, 'If you will let me take your likeness, I shall live for ever,' and Quin gave in. Gainsborough, who liked his jovial bawdry, spent much time with him, and Quin in his will left to 'Mr Thomas Gainsborough, limner, now living in Bath, £50.' In the portrait he sits with a book of plays in his hand. The design is closely adapted from Hogarth's *Lord Lovat* of 1746, but the weight is shifted to one side and the head turned, to hide the debt.[7] Angelo describes the relations of Gainsborough and Quin.

When just relieved from a fit of the gout, he [Quin] would crawl to the painting-room of Gainsborough, and, tapping at the door, would inquire, 'Is Old Grumpus at home?' 'Come in,' was the reply, when the painter, placing a chair for his gouty friend and a stool to rest his foot upon, would put on a grave doctorial look, and, resting his chin upon his maulstick, inquire in the Bath medical phrase, *secundum artem*, 'Well, how is the toe?'
If a portrait happened to be upon the easel, as Quin said, he, Gainsborough, was in the humour for a congenial growl at the dispensation of all sublunary things. If, on the contrary, he was engaged on a landscape composition, then he was all gaiety, his imagination in the skies. Dependent, then, upon either of these circumstances, did these two strange men and boon companions shape and model the tenor of their discourse.
Gainsborough, for all his apparent playfulness of style, often told Quin, who again assured my father of the fact, that nothing could equal the devilism of portrait-painting. Indeed, he told me at his house in Pall Mall, that he was sure the perplexities of rendering something like a human resemblance from human blocks was a trial of patience that would have tempted holy St Anthony to cut his own throat with his palette knife.

Here we find expressed the strong antagonism that Gainsborough felt for the gentry who commanded his services, and for a genre that existed to perpetuate their features, their sense of status. Quin, Angelo adds, used to remark, 'Sometimes, Tom Gainsborough, a picture in your rigmarole style appears to my

optics the veriest daub; then the devil's in you, I think you a Van Dyke.'

On 20 June Garrick wrote to Quin about the painter Hudson, who had promised to paint him (Garrick), then kept evading him. 'It was hinted to me that the much, and deservedly, admired picture of you by Gainsborough has piqued him not a little, and *hinc illae lacrimae*. If it is so I sincerely pity him, for there is merit enough in that performance to warm the most stoical painter, and what must it do when it works among the combustibles of our friend Hudson?' We see that Gainsborough had at last made his impact on the London art world. This year he showed in London another full-length, of Thomas Medlycott leaning nonchalantly on a stile; and Reynolds tried to put him in his place with an idealized portrait of the sportsman Philip Gell relaxed in midst of nature.[8]

On 21 July he wrote to Lord Royston, whose portrait he was working on. He hoped to hand it to the sitter's father, Lord Hardwicke; but if it wasn't done in time, he'd send it to London, whence he hoped it would be forwarded unopened into the country: 'as I shall paper it up to secure the dust from lodging in the surface of the Picture.' Lord Royston could pay the rest of the fee when he came to Bath, or put it at once into Hoare's bank. Then some gossip is added. Quin has gone for a few weeks to Chatsworth. Dr Abel Moysey has the ague and says he'd be ready to lose his money if he lost the ague too. 'But whether the loss of the Money might not bring on a shaking fit that form'd itself into an Ague I must leave.'

Gainsborough did go to London. On 24 July he wrote to tell his attorney Unwin that he had just returned from an unexpected call thither. He had seen Unwin's brother for five minutes and had meant to spend a grave evening with him:

But such is the nature of that D—— place, or such that of his T.G. that I declare I never made a journey to London that I ever did what I intended. 'Tis a shocking place for *that* and I wonder among the number of things I leave undone which should be done, that I don't do many more which ought not to be done.

He promises to work hard at the portrait of a Mrs Saumarez (which he had started as far back as 1760). He is also overdue with a portrait of Mrs Unwin. As usual he tries to joke himself out of his discomfort. 'I pray Sir, could you not *divert yourself* with the original for one week longer!' And addes of his children, 'Molly is

better I think than ever she was, & the Captain [Margaret] *the same.*'

On 25 October he wrote again. He had been very ill, abed for five weeks. Now he was just able to hold a pen, but unsure what to write.

I have kept my Bed 5 weeks to morrow excepting two hours sitting up for the last 3 Days of a most terrible Fever. It has been all upon my spirits from the *first*, that is from a single trip I made in London, as you guess'd; and occasioned by the uncertainty which followed the foolish Act. I was safe in the Opinion of two of the best men in their way, but possess'd in my Mind that I was ruin'd. O my dear Friend nobody can think what I have suffered for a moments gratification.

He had been drunk and gone whoring in London; but why he assumes that Unwin knows all about it and so is made his confidant, is not explained.

My life was dispair'd of by Doctor Charleton after he had tried all his skill, and by his own desire Dr Moisey was call'd in when in three days my faintings left me and I got strength. I am now what they call out of Danger: I wish my Dear Friend I could sleep refreshing sleeps, then all would be well again. You shall hear from me again soon. My Dear Good Wife has set up every night ti'l within a few and has given me all the Comfort that was in her power. I shall never be a quarter good enough for her if I mend a hundred degrees.

Rumours got round that he was dead. On 17 October the *Bath Journal* reported that on Friday last 'died Mr Gainsborough, an eminent Painter of this City.' On the 24th it retracted: 'Mr Gainsborough, an eminent Limner of this City, is not dead as mentioned in our last.'[9]

On 30 December he wrote to Unwin that his head was still extremely bad and he had not been able to sit down till now. 'I have so many returns of my Nervous complaint in the back part of my Head, that I almost dispair of getting the better of it. I am really a weather cock; more so now than what you always took me for. All my hopes are built upon what the spring may do in throwing out the humour that yet seems playing about me. My spirits are at times so low, but damn it, I won't entertain you with any more of my misfortunes.' He had taken a house about three-quarters of a mile along the Lansdowne Road, which at that time was out of town. ''Tis sweetly situated and I have every convenience I could wish for; I pay 30 pounds per year, and so let off all my House in the smoake except my Painting Room and

best parlour to show Pictures in. Am I right to ease myself of as much Painting work as my Lodgings will bring in.' By 'in the smoake' he means 'in the town', referring to his previous place of residence, the most part of which he proposes to let. He was riding as much as he could unless there was pouring rain; his aim was to be in his office only from eleven to one o'clock, 'but not a moment longer for the King'.

He feels close to Unwin, who seems the only person to whom he could unburden himself about his behaviour in London. He goes on: 'I long to see you more than all my Relations, for not one of them *knows what you do*. I always thought you extremely clever; but whether I have not made you more knowing than you could have been had I been a close cunning fellow, that I must leave. I always think one cannot be too open to sensible people nor too reserved to fools; nay I believe I should have blush'd to have confess'd that to an Ass, which I did to you, and so much for secrets.' He has a trick of trying to win people over by comments that seem bluffly sincere but are really subtle flattery. Worried about having told Unwin too much, he wants to secure his silence and aid. His wife and dear girls, he adds, 'are thank God charmingly well, and what's more (tho' I say it), good in grain.' In a postscript he returns to the subject of the still unfinished portraits of Mrs Saumarez and Mrs Unwin. 'Oh, my poor head.' And he ends with a comment that helps us to grasp one aspect of the emotional symbolism put into landscapes with banks, slopes, donkeys. 'Don't you think a Jackass three-quarters asleep upon the ridge of a bank undermined and mouldring away is very expressive of the happiness of not seeing danger?' (In his next letter he writes of himself, 'Ah! that a Jackass should be so foolish.')

On 1 March 1764 he again wrote to Unwin, wondering if the latter too was suffering from bad nerves as he had not answered a letter. He goes on cheerfully about his girls. Unwin had made some offer about Molly (Mary); Gainsborough thanks him, but says, 'You must know I'm upon a scheme of learning them both to paint Landscape, and that somewhat above the common Fan mount stile. I think them capable of it, if taken in time, and with proper pains bestow'd. I don't mean to make them only Miss Fords in the Art, to be partly admir'd & partly laugh'd at at every Tea Table; but in case of an Accident that they may do something for Bread.' (His late illness had made him think of his womenfolk having to fend for themselves.) He prefers landscapes to portraits

or miniatures, which are 'apt to lay snares in their way'. Landscapes can be painted by the girls quietly on their own. 'I think (and indeed always did myself) that I had better do this than make fine trumpery of them and let them be led away with Vanity, and ever subject to disappointment in the wild Goose chase.'

Both girls did drawings. Mary told Farington in 1799 that her father had taken pains to send her advice when she was learning to draw and that 'she regretted much having lost many letters which he wrote to her and her Sister while they were at Blacklands School, containing instructions for drawing.' We see that for a time the girls were at a boarding school. A painting of about 1763-4 shows them with their artwork, portfolios and pencil, with a statue before them.

Gainsborough goes on to tell Unwin that the rent he gets from the previous house is useful as he has to buy furniture for the new one. 'You'l see this affair has been only the wag of a Dog's tail out of the strait Road.' He cannot forget his London lapse or his writing to Unwin about it. He has painted 'a whole length, three half-lengths, and seven Heads, exclusive of a full-length of Doctor Charleton, and a half-length of Doctor Moysey's son.' He hopes Unwin will pay a visit. 'You'l find me happy with old Margt I hope.' At the end of a P.S. he pretends to remember suddenly: 'Zouns I forgot Mrs Unwin's & Capt. Saumarez's Picture. I shall work upon them soon depend on't, that's enough.'

An undated letter to Unwin may have been written before the last. He tells of a most terrible attack of Nervous Fever, 'so that for whole nights together I have thought it impossible that I could last 'til the morning.' He is now better, thanks to Dr Charleton's bark and saline draughts, and his sister's prescription of six glasses of good old port. 'The truth is, I have apply'd a little too close for these last five years, that both my Doctors and Friends really think.' He has got a steady horse from Sir William St Quintin, and hopes to get well with exercise and nightly port. He'd like to see Unwin and his wife at Bath. 'But all this time what is to be said about the Picture? I think I'll defer that 'til my next, for my Head throbs a little with writing.'

Yet another undated letter to Unwin seems of 1764. Gainsborough mentions a visit to Wilton. (He probably went there several times, and made a copy of Van Dyck's *Pembroke Family* there: the 1789 catalogue says of it: 'Painted by Memory,

after having seen the original at Wilton.') He had gone partly for amusement, 'partly to make a drawing from a fine horse of Ld Pembroke's, on which I am going to set General Honywood, as large as life... My wife says you goe on briskly. I tell her you were always a brisk little man. Thank God I have got the better of all my Complaints both real & imaginary: I don't remember to have enjoy'd better health & spirits any part of my life than at present.' The general's portrait shows him mounted in scarlet uniform on a bay horse for which he seems too large; he is in woodland with a drawn sword and no scabbard.[10]

Probably this year, 1764, Gainsborough wrote to Lord Hardwicke, who seems to have asked him to do a topographical view of his mansion.

Mr Gainsborough presents his Humble respects to Lord Hardwicke; and shall always think it an honor to be employ'd in anything for his Lordship; but with respect to *real Views* from Nature in this Country he has never seen any Place that affords a subject equal to the poorest imitations of Gaspar or Claude. Paul Sandby is the only Man of Genius, he believes, who has employ'd his Pencil that way – Mr G. hopes Lord Hardwicke will not mistake his meaning, but if his Lordship wishes to have anything tolerable of the name of G. the subject altogether, as well as figures etc. must be of his own Brain otherwise Lord Hardwicke will only pay for Encouraging a Man out of his way and had much better buy a picture of some of the good Old Masters.

He is writing with his tongue in his cheek, with a mock-respect. He dislikes topographical works and he pretends to an admiration of Claude that he did not feel. Jackson tells us: 'Sir Joshua always considered Claude as the Raffaele of landscape painting, but Claude was no favourite of Gainsborough. He thought his pencilling tame and insipid.' Sandby did many pictures of seats; the first show of the Society of Artists had his view of Lord Harcourt's Seat at Newnham.

But despite his rejection of Claude's kind of landscape painting, he was ready to learn from him. We noted a Claudean element in his picture of the returning woodman, though it was fused with Dutch and rococo elements. In *Wooded Landscape with Horseman and Flock of Sheep* (shown at the Society of Artists in 1763, the first landscape he exhibited) the Claudean element persists, but a more important role is given to contrasts of light and shadow, which in part look to Ruisdael. The effect also in part derives from an increasing practice of working by candlelight, while the tones of pink, yellow, red, suggesting

reflected lights, and the loose brushwork, suggest a study of Rubens, whose influence merges with that of Ruisdael. A little later is the drawing *Landscape with Herdsman and Cattle,* where the influence of Claude has been fully absorbed, reinterpreted in terms of a loving study of the country round Bath. Gainsborough has also perhaps been learning lightness of touch from Van Dyck's gouache drawings. The result is something delicate and lyrical that is all his own. Thus in the early 1760s he was taking in strong new influences, using them to reinterpret his store of Suffolk memories, and at the same time learning to extend his vision by studying the scenes around him.[11]

He was still struggling to find ways of integrating his portrait-figures in landscape. General James Johnston stands with legs wide apart against a thick birch tree, holding his hat in front, his right hand tucked in his waistcoat, while light flashes on the horizon. Though the tree carried on the curve of the coatline, the informal effect is ungainly. George and Louisa Byam stroll along arm in arm, with little Sarah; he holds out his right arm, hat in hand, pointing at something; there is dark foliage behind and a somewhat lurid sky in the distance. Here is the most elaborate work Gainsborough had so far done. But there is no real link between the trio and the setting, George's gorgeous waistcoat and the sky. The trio would fit into a garden near a fine mansion; they are aliens in the wild scene. (The motive of a group walking with looks fixed on a point outside the picture was taken up by Reynolds and Raeburn.) Mary, Countess of Howe, like the General, stands by a birch but this one is slender, quite different. The clothes have a subtle richness: something learned from Van Dyck. The woman is one with her silks and satins; and somehow the stormy clouds with light-patches, and the homely sort of setting with its fence, are not discordant. Lady Howe is not merged into the scene as are many later ladies in their portraits, yet she harmoniously dominates it. These three pictures show Gainsborough striving hard to find ways of linking his characters with a natural setting, but not succeeding except with Lady Howe where the rich textures of the dress do harmonize with the movement of light and shade, and the slender birch finds an echo in her slight elegant body. The male members of the gentry defy his efforts to relate them to the world of nature, but with the women he has better luck.[12]

In late October came Hogarth's death in London. Gainsborough must have been moved by the news, though no

doubt he found it hard to assess at all exactly what was his relation to the dead master. How strong was Hogarth's impact on him is brought out by the fact that as late as 1784-5 he used the *Shrimp Girl* as the basis of one of the girls in his *Harvest Waggon*. (To see that picture he must have called in at Hogarth's house either when he was alive or after his death.)

In November he told the Duke of Bedford's agent at Bath that he would soon despatch the portraits of the Duke and his wife. On 4 January 1765 the agent wrote that they had not arrived. 'Her Grace orders me to add that if it is agreeable to you to come to London & will keep to your usual prices she will be answerable for paying the expenses of the journey.' Three days later he had still not finished the pictures. 'Owning to some difficulty of pleasing myself in the two Copies of His Grace,' but he'd send all the works next week to Bedford House. 'Tho' my Ill Health forbids my following Business in London (to which I have frequent invitations), Her Grace may nevertheless command me at any time to paint *any of The Family* there.'

On 21 January 1765 he wrote to Unwin. He has missed two posts, having been 'closely employ'd all this winter', but has hopes of visiting Baddow. All depends on what happens with the Duke. He repeats what he told the agent. Work done for the Duke will be 'productive of future advantages, let the present inconvenience be what it will to me. Am I right?' He adds an amusing dialogue with his wife, trying to cover up his bad conscience for still delaying over Mrs Unwin's portrait.

When read your letter to Old Margaret, there, said she, you find Mr Unwin is so much of a Gentleman now, that he would not mention a word to know if Mrs Unwin's Picture was finished, and you so much of a scrubb that you'l not get it done for him. Says I, My Dear, hem, My Dear, He always was a Gentleman, you know from the first of our acquaintance he was a Gentleman, but, but what you scrubb, said she, have you not been as long about a shaddow as he have been in making three substantial whole length figures. No, my Dear, not three, but two. Yes, Mr Dolittle, I say three. Pray did not Mrs Unwin goe away big from Bath the summer before your Illness, and did not she lay in when we came to live up the Hill about this time, of her first child, and then according to Mr Unwin's Letter again in August, and now three months gone again; I say three you scrubb. Pray is all this true or not, Sir?

He thus links his art-productivity with pregnancies. The girls are at boarding-school. 'Molly and the Capt. are out at School and

have been these 5 months.' He adds, 'I am afraid I was not quite in my senses when I writ my last letter to you.'

On 27 January he informed the Duke's agent that he had packed some pictures to go by Wiltshire's Flying Waggon, which left on Sunday evening to arrive at the White Horse Cellar, Piccadilly, on Wednesday morning. He still hasn't finished the Duke's portrait. 'But if Mrs Fortiscue is in Town, should be obliged if you will acquaint Her that it shall be sent as soon as possible to Bedford House.'

Walter Wiltshire lived at Shockerwick near Bath, where Gainsborough often visited him. He acquired many Gainsborough pictures, including the Quin portrait. He ran a large carrier business between his warehouse in Broad Street, Bath, and the White Swan at Holborn Bridge, and refused to take payment for carrying Gainsborough's pictures. 'No, no, I admire your painting too much to take payment'. To objections he replied, 'When you think that I have carried to the value of a little painting, I beg you will let me have one, sir, and I shall be more than paid.' So he built up his collection. Later he lent Gainsborough a grey horse.

The younger Price often rode round with the artist.

When Gainsborough lived at Bath, I often made excursions with him into the country around. He was a man of eager, irritable mind, though he attached himself warmly to those he liked. Though of a lively and playful imagination yet was he at times severe and sarcastic, but when we have come near to cottages and village scenes with groups of children, and objects of rural life that struck his fancy, I have observed his countenance to take an expression of gentleness and complacency.

The emotional reactions that Price describes come out ever more strongly as Gainsborough's art develops. Ozias Humphry also accompanied him on sketching expeditions. His favourite spot was said to be the woods at Claverton and Warley, where he often passed the day with only a sandwich or some bread and cheese in his pocket.[13]

In January 1765 the King granted a charter of incorporation to the Society of Artists of Great Britain. Lambert was President and Hayman Vice-President, with twenty-four directors.[14] On 11 March Tom attended the general meeting at the Turk's Head Tavern, Soho, London. Signing the obligation, he was admitted as a Fellow. (Previously, like Reynolds, he had sent in works without being formally a member.) A few weeks later the annual

show opened at Spring Gardens. Gainsborough was represented by the portraits of General Honywood and Colonel Nugent. The *Public Advertiser* invited readers to send in criticisms. Only one did so. He noted that the picture of the general was 'much admired', but referred to the lack of scabbard. Walpole in his catalogue noted the work, 'Very good', and the King, says Fulcher, expressed a wish to own it. It was based on Van Dyck's *Charles I* with the scheme of light-and-shade reversed and with a much smaller horse.[15]

On 7 November Gainsborough wrote to Unwin, assuring him that nothing in his letters had upset him. To take anything ill from a person of such good qualities 'would be scorning to look at Vandyke whilst conscious of being yet but a dauber.' His health was better. 'Everything goes to my wishes, except Mrs Unwin's Picture and that stands still in my Painting Room, not-withstanding I have the greatest desire to finish it; I have no oftener promised myself the Pleasure of sitting down to it but some confounded ugly creature or other have pop'd their Heads in my way and hindered me.' He ends, 'We are heartily glad you go on so merrily; you put me in mind of a little Fiddle that Giardini pick'd up here at Bath, which nobody would think well of, because there was nobody who knew how to bring out the tone of, and which (though somewhat undersized) in his Hands produced the finest Music in the World: I believe Mrs Unwin has found out the exact place where to fix your sound-post.' One of his bawdy jests based on music. He adds, 'My dear girls are at Chelsea. I send you two letters of theirs to see how prettily they can write.'

He was painting Garrick, and showed the portrait in his studio in the early spring of 1766. In 1762 Reynolds had depicted the ac- tor between Tragedy and Comedy in an ironic version of the theme of Hercules choosing between Virtue and Pleasure; Gainsborough set his Garrick leaning pensively on a pedestal sur- mounted by Shakespeare's bust, with the Palladian summerhouse and bridge of Wilton at the back. He lacked Reynolds' wit, his capacity to use a classical motif in a modified or modernized way; and in trying to introduce a note of poetic meditation he became banal – though Fulcher says that Mrs Garrick 'declared it was the best portrait ever painted of her Davy.' When it was shown at Spring Gardens in April, the *Public Advertiser* wrote:

This Gentleman it seems is done for Mr Garrick, as he has his arm about a stone bust of Shakespeare; and indeed he seems as fond of it as if some

benevolent God had metamorphosed him into the same substance. Mr Gainsborough should have been particularly careful how he had drawn an original which a Reynolds and a Zoffany hath so admirably portrayed; however he has been more happy in his other whole length of a gentleman and in the others equally miserable. I fancy Mr Gainsborough has been troubled with ague lately, or got the falling sickness.[16]

Thicknesse says that Gainsborough excused himself on the grounds of Garrick's contortions and changing face. The obituarist in the *Morning Chronicle* stated:

He told me that he never found any portrait so difficult to hit as that of the late Mr Garrick, for he was upon sketching the eyebrows and thought he had hit upon the precise situation and then looked a second time at the model he found the eyebrows lifted up to the middle of the forehead; and when he looked a third time they were dropped like a curtain, close over the eye. So flexible and universal was the countenance of the great player that it was as impossible to catch his likeness as it is to catch the form of a passing cloud.

The same story is told of the playwright-mime Foote. But it may be true that mobility of features would particularly disconcert Gainsborough, because of the way he did portraits and his reputation for catching an exact likeness. Ozias Humphry states:

If the canvases were of three-quarters size he did not desire they should be loosened upon the straining frames, but if they were half-lengths or whole-lengths he never failed to paint with the canvas loose, secured by small cords, and brought to the extremity of the frame, and having previously determined and marked with chalk upon what part of the canvas the face was to be painted, it was so placed upon the Easel as to be close to the Subject he was painting, which gave him an Opportunity (as he commonly painted standing) of comparing the Dimensions and Effect of the Copy, with the original both near and at a distance; and by this method (with incessant study and exertion) he acquired the power of giving the masses, and general forms of his models with the utmost exactness. Having thus settled the Ground Work of his Portraits, he let in (of necessity) more light, for the finishing of them; but his correct preparation was of the last importance, and enabled him to secure the proportions of his Features as well as the general Contours of Objects with uncommon truth.

Humphry does not explain very clearly. Gainsborough liked to have the canvas on which he painted a head as close as possible to the original. With small canvases there was no problem. (The three-quarters is head-size.) But with larger canvases he could not normally bring the part on which he painted the head close in this way. So, after chalking in the head roughly, he had the canvas

67

released from the stretcher and pulled over by strings fastened temporarily at the back, until it came to the edge of canvas, right up against the sitter's head.

His rise in reputation is shown by an anonymous poem *A Candid Display* on the show at Spring Gardens; he is linked with Reynolds: 'There Gainsborough shines, much honoured name. There Veteran Reynolds, worthy of his fame.'[17] Richard Graves, author of *The Spiritual Quixote*, who was among Gainsborough's Bath friends, wrote a poem addressed to 'A Limner at Bath: equally excellent in Portraits and Landscapes', in which he rhapsodized on the pastoral or paradisaic element in the latter: 'Crystal founts and amaranthine bowers of Eden.' He compared the lovers in the pictures with Adam and Eve. 'Like that bless'd pair, by G—nsborough's pencil drawn. Here each fond couple treads the flow'ry lawn.' A footnote explains that the artist has painted 'several ladies and gentlemen drawn in that taste'. The poem tells of British nymphs, 'And he who paints them truest, charms the most.' Graves recognizes an important lyrical element in Gainsborough's work, but writes as if it were defined in idealized classical terms. He was rector of Claverton near Bath, friend of the poet Shenstone at Halesowen with his famous landscaped garden. He and Gainsborough may well have met at Prior Park, where Graves, having a long distance to ride, was allowed to dine in boots; absent-minded, he once went off with his napkin on his spurs. Thicknesse remarks that 'Mr Graves by his address & manners seems a clown, but yet he certainly is clever.'

About Christmas Gainsborough moved to the Circus. As at Lansdowne Road he was on high ground, north of the town, not at all near the baths and places of entertainment in the older and lower parts where the visitors, on whom he mainly relied for clients, gathered in the season. Matthew Bramble in Smollett's *Humphry Clinker* describes the approach to The Circus:

The only entrance to it, through Gay street, is so difficult, steep, and slippery, that in wet weather it must be exceedingly dangerous, both for those who ride in carriages and those who walk on foot, and when the street is covered with snow I don't see how any individual can go up or down without the most imminent danger of broken bones.

As the main season was in winter, sitters had to climb or be carried up this unpleasant steep hill. Beattie, the poet, noted a few years later how the chalk was pounded by hooves or heels into a

fine powder that flew about in dry weather. However, some rich and noble people lived in the Circus; the fourth Duke of Bedford had one of the two central mansions in the northern block, and Gainsborough may even have been his next door neighbour. It is not easy to make out which room was used as a studio. The back of the house, facing north-east, was useless; and perhaps Gainsborough used the first-floor front room. It has been suggested that he had a studio nearer the centre of town, but Thicknesse speaks of his inviting Mrs Thicknesse up into his picture-room.[18]

About this time an artist, probably Hoare, painted him. His face has grown heavier and lost its touch of jaunty charm; the heavy brows and large nose are unchanged and there is still a distrustful look about the eyes. One of the jobs he undertook for himself was a copy, unfinished, of Rubens' *Descent from the Cross*. His work, which shows the composition in reverse, was made from Vorsterman's engraving and a modello at Corsham Court. What attracted him was the rich interflow of the figures, which are strongly massed and yet create a clear diagonal. He managed to catch something of Rubens' luminous quality (which he would have known from other works of his).

Among the women he painted were Anne Horton and Lady Eardley. Anne, who perplexed Reynolds and Wright of Derby with her complex wiles – 'coquette beyond measure', wrote Walpole, 'artful as Cleopatra, and completely mistress of all her passions and projects' – was grasped by Gainsborough with complete ease. He defined the demure oval of her large-eyed subtly-challenging face with insight and charm. Lady Eardley, recently married, stands squarely and placidly amid trees, but this time there is a cottage to the rear on the right. The worlds of the grand lady and the peasant are set side by side, but unrelated. The brilliant handling of the satin dress does not solve the relation of human life to the life of nature.[19]

That dress shows how he has been absorbing Van Dyck, and an undated letter to Garrick about this time shows how that artist was on his mind.

Don't think I am in the least angry with any of our friends at the Exhibition I don't look upon it as it is conducted at present to be calculated so much to bring about good painters as bad ones. There is certainly a false taste & an impudent style prevailing which if Vandyke was living would put him out of countenance; and I think even his work

would appear as opposed to such a glare. Nature is modest and the artist should be so in his addresses to Her.

Clearly he thinks of himself as Van Dyck, whose handling of paint he takes as a criterion of true aesthetic feeling; but it is not obvious how he manages both to identify himself with Van Dyck and to see his work as representing truth to nature. The confusion of thought is on the same level as the confusion of method in *Lady Eardley*.

The landscape he showed this year, 1766, *Wooded landscape with Milkmaid and Drover,* brought its elements together with great success. There is a vast mass of varied foliage through which a light-shaft falls on two lovers. The drover has left his cart in the road to go to the girl. In the scene beyond there is no breakthrough, but the light on the lovers and the near tree-trunk starts off a diagonal leading up between the trees into the sky. The dark mass of overwhelming trees shows the influence of Ruisdael; for the first time Gainsborough manages this sort of massing. The path leads up out of the bank, but is merged beyond the horses in the enclosing forest.[20]

At Bath he had grown more and more used to artificial lighting when he worked. Ozias Humphry tells us:

Mr Gainsborough painted during these years several landscapes of extraordinary merit that were mostly executed by candlelight, to which he was much accustomed...

Exact resemblance in his portraits...was Mr Gainsborough's constant aim, to which he invariably adhered. These pictures, as well as his landscapes, were frequently wrought by candlelight, and generally with great force and likeness. But his Painting Room, even by day (a kind of darkened Twilight) had scarcely any Light, and [I] have seen him, whilst his Subjects have been sitting to him, when they or the pictures were scarcely discernible.

In his Fourteenth Discourse Reynolds remarks on Gainsborough's painting by artificial light, a practice 'very advantageous and improving for an artist'. He used candlelight especially in connection with lighting and in order to dramatize his subject. Many of his works come strongly alive when seen by artificial light. Early Bath works showing the use of candlelight are the portraits of Colonel Nugent and Mrs Portman. Linked with the fascination of candlelight was his increasing interest in the play of reflected lights in silks and satins. As a result of these developments he felt it necessary to insist that his works were

hung at the right levels; he refused to modify his style to suit the needs of exhibitions.

Fulcher says that when his sitters went he used to close the shutter, in which was a small circular aperture, the sole access for light, and work on by subdued light, thus getting rid of superfluous detail. Williams says that he loved to subdue his studio light, so much so that at times objects were barely visible. Thus he made a room approximate to a cavern of forest glooms and filtered lights.[21]

In 1766 Humphry Gainsborough won an award for his seed-drill. Jethro Tull had devised the drill, and his book on it had started off much discussion, which died down, then was revived by a book by Du Hamel, *Elements of Agriculture* (translated 1764). The Society of Arts, concerned with farming improvements, took up the matter, and a premium for a new drill was awarded in 1765. Drills were tried out on ground at Brompton on 10 April 1766, when four designs were tested. The premium of £50 was shared by James Willet and Humphry. Gainsborough may well have been in London at the time for the show of the Society of Artists, so he could have gone with Humphry to the testing.[22]

6 Bath (1766-1769)

*A*t Bath Gainsborough was able to hear all the leading musicians and singers, and to make their acquaintance. His love of music was reflected in the fascination that musicians had for him. He had met Giardini again in Bath, and painted him around this time.[1] (Giardini had met young Romney at Whitehaven and excited him so much that he hesitated for some time whether to devote himself to music or to art.) The main local musicians were the Linleys. Thomas Linley was a carpenter's son, who studied under the organist at Bath Abbey, then in Naples. Returning to Bath, he became a music-teacher 'almost unrivalled in England', says Parke. He was mainly responsible for the concerts at the Assembly Rooms, which in the season drew the most famous performers of the day. His house was thronged with them, and Tom lived 'in great intimacy' with the family. Linley's star pupils were his own daughters, Elizabeth and Mary (as well as Maria born in 1765) and his eldest son Tom, a gifted composer and violinist whose accidental death at the age of twenty-two deeply affected him. Linley's first opera was written in 1767, but his main success came in the 1770s. Elizabeth's debut occurred in a masque, *The Fairy Favour*, acted by children for the four-year-old Prince of Wales on his first visit to the theatre; she never appeared again on the stage, as her father feared the moral effect of stage life.[2]

Thicknesse tells how, after returning from a concert about this time 'where we had been charmed by Miss Linley's voice, I went home to supper with my friend, who sent his servant for a bit of clay from the small beer barrel.' Gainsborough then modelled

Elizabeth and coloured her head 'in a quarter of an hour, in such a manner that I protest it appeared to me even superior to his paintings.' Thicknesse adds that next day he 'took a friend or two to his house to see it, but it was not to be seen; the servant had thrown it down from the mantelpiece and broken it.' Fulcher notes that C.R. Leslie had 'an exquisite plaster cast of a head of Miss Linley from a clay model by Gainsborough, which unfortunately met with a similar fate.' He adds, 'Gainsborough would now and then model the faces of friends in miniature, finding the material in the wax candles burning before him; the models were as perfect in their resemblance as his portraits.'

At Bath Gainsborough came to know Carl Friedrich Abel, who seems to have played under J. S. Bach in the Electoral Kapelle at Dresden. He arrived in 1759 in London, where his first patron was the Duke of York; he was soon in demand for concerts. Settling in Soho, he was joined by Johann Christian Bach, eleventh son of J.S. Bach, who had studied in Italy, where he became a Catholic and organist at Milan Cathedral, and also composed operas.

On Bach's going into partnership with him Abel turned from Spring Gardens, where they gave their first concert, to the establishment of the notorious Theresa Cornelys, and in 1764 superimposed a symphonic concert pattern on the indecorous background of balls and masquerades that had hitherto brought notoriety to Carlisle House. Abel and Bach gave concerts there and also in Almack's and in 1775 moved to the newly built Rooms in Hanover Square (which were regularly used from 1775 until 1874). These concerts became famous and fashionable. In addition to the symphonic works of Bach and Abel the best of European music was made available...Bach [wrote Parke] 'seems to have been the first composer who maintained the law of contrast as a principle'. (Young)

Bach and Abel shared a house. Abel was the last of the great *viola da gamba* virtuosi; he became, says Burney, 'the umpire in all musical controversy, and was consulted like an oracle'. He himself said, 'There is one Abel'. No doubt through him Gainsborough came to know Bach. There was also Tenducci, castrato from Siena, who spent most of 1760 in jail for debt. He had a great success in Arne's *Artaxerxes* in 1762 and eloped with an Irish heiress. Gainsborough would have met him while attending Bach-Abel concerts in London during 1765-66. Bach, who had his own money-troubles, did his best to help Tenducci, whom Gainsborough painted in his late Bath period.[3]

Another musician was William Jackson, to whom Gainsborough was introduced by the miniaturist Samuel Collins.

Son of an Exeter grocer (later master of the workhouse), Jackson was trained by the cathedral organist; in 1748 he went to London as pupil of John Travers of the Chapel Royal, and turned to composing church music. In 1775 he had some success with a set of twelve songs. Until 1777 his main work was music-teaching at Exeter, but he attended meetings of musical bodies in London like the Madrigal Society. He tried to paint in 1757 and was hurt that his artist friends, including Tom, gave him little help. Thus he wrote of Collins that he 'possessed a great command of the black lead pencil, and a happy talent for making washed drawings of figures in the humorous style. He saw that I was wrong, and was always saying it, but he never informed me how to be right.' He was friendly with the Linleys, who played some of his works, and he gave Gainsborough lessons in music, receiving in return some instruction in painting and drawing. In his *Four Ages,* 1798, he wrote about the latter in a very superior way, though he did convey his passion for music. Sir George Beaumont commented on the book, 'It is unjust to him as an artist, & seems intended to make him ridiculous as a man.'[4]

Gainsborough loved musical instruments as well as the sounds that came from them; he seems to have played almost every instrument of the period. Thicknesse says he more than once remarked that he'd give a hundred guineas for Mrs Thicknesse's viol, the one hanging behind her in the portrait: made in 1612 'of exquisite workmanship, and mellifluous tone'. He persuaded her to hand it over on condition that he did a full-length of her to hang by the painting of her husband. Jackson jeers at him in a series of tales that describe him as thinking of music as the work of the instrument, not the player. First he wanted Giardini's violin, then Abel's viol, then Fischer's hautboy. (He persuaded Fischer to play to him in private on the violin, 'But this was a profound secret, for Fischer knew that his reputation was in danger if he pretended to excel in two instruments.')[5]

Then he heard a harper and wanted a harp. 'He really stuck to the harp long enough to play several airs with variations.' But a visit from Abel brought him back to the viol, to which he was faithful for some years, though there was occasionally 'a little flirtation with the fiddle'. Then he heard Crosdill on the violoncello. Though he did not try to acquire that instrument, 'All his passion for the bass was vented in descriptions of Crosdill's tone and bowing, which were rapturous and enthusiastic to the last degree.' Next he saw a theorbo in a Van Dyck picture and heard

of a German who played it. Jackson gives a long, ludicrous account of the dialogue as Gainsborough tries to get the man to sell his double-necked lute and teach him how to play it.

In this manner he frittered away his musical talents, and, though possessed of ear, taste, and genius, he never had application enough to learn the notes. He scorned to take the first step, the second was of course out of his reach, and the summit became unattainable. He hated the harpsichord and the pianoforte. He disliked singing, particularly in parts...He had as much pleasure in looking at a violin as in hearing it. I have seen him for many minutes surveying in silence the perfection of an instrument from the just proportions of the model and the beauty of the workmanship.

We saw how he already played the fiddle at Ipswich. His development at Bath was linked with his entry into a wider and fuller musical sphere. Rimbauld, organist of St-Giles-in-the-Fields, a keen collector of Tom's drawings, whose father as a boy had known Gainsborough and listened to him playing, declared that he may have been too capricious to study music scientifically, but 'his ear was so good, and his natural taste so refined, that these important adjuncts led him far beyond the mechanical skill of the mere performer who relies upon technical knowledge'. He 'knew a little of almost every musical instrument such as are used for solo playing, but his chief forte consisted in modulating upon the harpsichord.' Harry Angelo recalled him playing his mother's harpsichord. He says that Tom not only knew the notes, but could accompany a slow movement on that instrument both on the flute and on the fiddle, with taste and feeling. Jackson says he hated the harpsichord, but he later bought one for his daughters, the younger of whom is said to have been an accomplished musician. (Angelo indeed claims that Jackson's whole picture of Gainsborough as a musician is a caricature.)[6]

Certainly Gainsborough loved the instruments for themselves. Thicknesse says:

Having admired Abel's *viol da gamba* for its fine tone, without perhaps considering how much the power of the bow and touch contributed to it, Abel presented it to him. Gainsborough immediately stretched two large canvas frames, and declared he would paint him a couple of his best landscapes, and send them in return completely finished before he touched a brush for the first person of the kingdom, and did so.

Jackson makes out that Gainsborough was obsessed by a sort of instrument-fetichism, and insists that he could never learn the

notes; other writers, describing him as a natural musician, say that he was not at home with scores. But a later writer in the *Monthly Mirror* declared that he had more than once seen him play from notes. He added that, after reading Jackson's account, he

applied to several musicians of eminence who had a personal knowledge of the artist, and they unite in opposing Mr Jackson's statement. One of them assures me that Abel composed a fugue purposely for his friend Gainsborough to practise on the *viol da gamba*. And this could not be done without having his notes.

He thinks Jackson must have forgotten the facts, since he and Gainsborough, 'who had once been convivial associates, were of late years estranged from one another.'

Bate, who knew Gainsborough well later, stressed his musical skill. He touched the viol 'with the most exquisite skill, truth and expression; and in an adagio movement, or largo, his richness of tone, expression and feeling brought him very near indeed to Abel's standard.' He cited the critic Dr Walcot, who heard Gainsborough playing a minuet by Vanhall, and an allegro air, and exclaimed, 'That must be Abel, for by God, no man besides can so touch an instrument!' He adds that Abel gave him a viol,

But this was in return for two valuable landscapes and several beautiful drawings. This instrument was worth little, but at Abel's death the instrument which Mr Gainsborough seriously admired he purchased, and paid forty guineas for; and at the same sale the presents from the genius of the pencil to the musician sold for about £200, though they consisted only of a part of his liberal gifts.

Jackson said that Gainsborough disliked singing, but we know how he admired Elizabeth Linley and Tenducci. He was connected with the Opera House, but this was as a painter. Six years before his death a writer in the *Morning Chronicle* said that all the recent improvements there did not make up for the loss of his fine figure of Comic Dancing, and hinted that the dancers on the stage, French, English, or Italian, suffered from comparison with it. (Gainsborough painted two other figures for the Opera House, one on each side of the stage; they were removed in 1784 and Corinthian pillars substituted.)

The question of Gainsborough and music is not a side-issue, merely raising an amiable aspect of his character. His feeling for music and even his love of its instruments were an integral part of his whole art-impulse. The ways in which he created a pervasive

mood in a landscape or transformed the material of nature with harmonious massings and rhythmical variations were inseparable from his response to music. Something of a fusion of the elements of pictorial or plastic art with music can be traced from Giorgione on, through the baroque world, into Watteau. But with Gainsborough the relation of music and pictorial art is central. His aesthetic cannot be grasped unless we see how it includes his need to live in a musical atmosphere and to master in varying degrees the ways whereby harmony and modulations were created by the various instruments. The growing breadth of his landscape vision, in which we see a response to Rubens, must be connected with his entry into the sphere of symphonic music through Bach and Abel, and with his response to Bach's use of 'the law of contrast as a principle' in large-scale musical constructions.

But if the impact of music drew him away from direct recordings of nature into a sphere of rhythmical transformation, his equally strong need to base himself on a real world made him construct model landscapes. Reynolds remarked, 'From the fields he brought into his painting-room stumps of trees, weeds, and animals of various kinds; and designed them, not from memory, but immediately from the objects. He even framed a model of a landscape on his table; composed of broken stones, dried herbs, and pieces of looking-glass, which he magnified and improved into rocks, trees, and water.' Later a writer, signing himself an Amateur of Painting, in an appeal on behalf of the modeller-in-cork Dubourg, who had grown infirm, referred to the adaptability of cork and the use Gainsborough made of it.

I had the honour to be acquainted with that truly British genius at Bath, and have more than once sat by him of an evening, and seen him make models – or rather thoughts – for landscape scenery on a little old-fashioned folding oak table, which stood under his kitchen dresser, such an one as I have often seen by the fireplace of a little clean, country ale-house. This table, held sacred for the purpose, he would order to be brought to his parlour, and thereon compose his designs. He would place cork or coal for his foregrounds; make middle grounds of sand and clay, bushes of mosses and lichens, and set up distant woods of broccoli.

Jackson adds:

He made little laymen for human figures, he modelled his horses and cows, and knobs of coal sat for rocks – nay he carried this so far, that he never chose to paint anything from invention, when he could have objects themselves. The limbs of trees, which he collected, would have made no

inconsiderable wood-rick, and many an ass has been led into his painting-room.

He was not alone in such devices. Richard Wilson 'consulted the broken surface and rich hues of a large decayed cheese, for ideas of form and colour', when painting his *Meleager and Atalanta* (done before 1771). We may note too how Peter Pindar in his Odes on the R.A. in 1785-6 suggests that landscapists are using odd things as models: a broomstick with a coloured wig for an 'autumnal clump'. In some pictures, 'Green Bays [baize] hath surely sat for a green field; Bolsters for Mountains, Hills and wheaten Mows; Cats for Ram-goats – and Curs, for bulls and Cows.' He bids the artists go instead to Wales, 'where scenes of true magnificence you'll meet'.[7]

Gainsborough felt an equal need to have an object (person or thing) close before him when he was painting, and to transform that object in terms of a rhythmic whole. But he also felt a need to translate the visual effect by means of brushwork which again transformed it. The textures and tonal values of the actual world were both reflected and transported into a new dimension, that of pigment. His plastic transformations are done mainly by means of an intensified richness and fluidity in the brushwork, or by means of impressionistic simplifications of the forms, in which their mass and movement are defined in an extremely compressed and dynamic way.

His methods here were so much in advance of his time that they annoyed or mystified many people. Even a skilled but conventional painter like Reynolds did not know what to make of them.

It is certain that all those odd scratches and marks, which, on a close examination, are so observable in Gainsborough's pictures, and which even to experienced painters appear rather the effect of accident than design: this chaos, this uncouth and shapeless appearance, by a kind of magic, at a certain distance assumes form, and all the parts seem to drop into their proper places.

We saw that he needed a person before him in order to paint a portrait and that he even devised a system by which he could work right up against the head he was depicting – with the result that all his contemporaries agreed on his power to catch remarkable likenesses. (Thicknesse said that it was possible to judge one of his portraits as though it were the actual person.) And yet as he went on he found an increasing need to get away from mere lifelike

reflection and to merge his figures, especially those of women, with the world of nature, using ever more powerfully the means of transformation we have discussed.

The conflict and harmony of his impressionistic, apparently haphazard technique and his close observation of the subject, were brought out in the *Morning Chronicle* obituary:

His portraits are calculated to give effect at a distance, and that effect is produced in so eminent a degree, that the picture may almost be mistaken for the original, but closely inspected, we wonder at the delusion, and find scumbling scratches that have no appearance of eyebrows or nostrils.

All experiments that promised new insights, new comprehensions of his material, excited him greatly. Angelo says that while at work on his moppings he was 'as impatient as a spoiled child waiting for a new toy'. He felt it hard to contain himself as he found himself on the trail of some new pigment, paper, or so on, that seemed likely to provide new means of approach.

In 1767 he sent three full-lengths and a landscape to the London show. The landscape, *The Harvest Waggon*, showed a big change from the landscape of 1766. True, there is again the tree-mass on the left with a light-shaft; but the tones are lightened and warmed. The sky appears between the tree-mass and the single tree curving over from the right, so that there is a slight Claudean balance as well as a road swerving to the church in the distance. But the main new note is found in the concentration on the waggon and its folk; there is a strong pyramidal building-up as well as points of action in the men struggling for the bottle and the excited horse. Gainsborough has used his daughter Mary as the model for the girl reaching up to be helped into the waggon. (Perhaps there is here a touch of intuitive allegory: Mary is outside the group-life and needs help to be drawn in.)[8]

The full-lengths included portraits of the Duke of Argyll and the Countess Grosvenor. That of the Duke shows the influence of Rubens in the light key and the rich handling of clothes and sunset; but the discrepancy between the figure and the setting remains. Gainsborough's sense of the haughty egoism of the noble prevents him from defining a link with nature. The picture of the Countess has been cut down to head-and-shoulders, but the head is warmly alive. The breadth of Rubens is being added to what has been learned from Van Dyck.

The only notice of these works seems to be in the *Universal*

Museum: 'Gainsborough has various merits, but is unequal.' Oddly, Kirby was the talk of the show, as one of his landscapes was said to be really the King's work: an evening view of Kew ferry. (Kirby's house adjoined the ferry-steps.)[9] Gainsborough for once did not go up to see the show, as we learn from *Satiric Poems, Epigrams, Poetic Epistles, & c.* (1768) by a poetaster Underwood, who on leaving Cambridge visited Bath this spring. In the *Epistle* to Gainsborough Underwood 'reminds him of his promise made in April last to present him with a whole-length picture'. The *Epistle* was written in September after Underwood had recovered from a bad illness; he lets Gainsborough know that he'll soon call on him at Bath. The artist denied the promise and Underwood added a sharp footnote to the amiable poem:

The Author takes this opportunity to thank the *Gentleman* for his *strict attention* to his promise, and the very *genteel ingenuous reception* he has since met from him, and at the same time assures him that he is preparing with all convenient dispatch the *public retort* which he has already *privately engaged* to treat him with.

Underwood went on to Wales, seeking subscribers and quarrelling with editors of local papers who did not print his contributions. In a verse letter to a London friend he declared that Gainsborough, 'Apostate-like denies his word', so that the poet will 'blast the petty Gentleman' in Churchillian style and make him a second Hogarth 'maul'd in my corroding stew'. Simon Pine, miniaturist at Bath, tried vainly to reconcile the pair, and Underwood damned him for a meddling fool. He put an advertisement in the *St James's Chronicle* that he would shortly publish another *Epistle* to Gainsborough, but seems to have failed to get into print. Gainsborough, who could be carried away by momentary enthusiasms or likings, must have said something which Underwood misinterpreted. About this time, in a letter to Garrick, he adds without explanation at the end, 'Damn Underwood'.[10]

On 23 August, apparently this year, he wrote to Jackson, who had been discussing History Painting and had suggested the Flight into Egypt as a theme. Tom jestingly asks if he did not mean 'my flight out of Bath'.[11]

Do you consider my dear maggoty Sir, what a deal of work history Pictures require to what little dirty subjects of coal horses & jackasses and such figures as I full up with; no, you don't consider anything about that part of the story, you design faster than any man or any thousand men

could Execute. There is but one *flight* I should like to paint and that's yours *out* of Exeter, for while your numerous & polite acquaintance encourage you to talk so cleverly, we shall have but few Productions, real & substantial Productions – But to be serious (as I know you love to be) do you really think that a regular Composition in the Landskip way should ever be fill'd with History, or any figures but such as fill a place (I won't say stop a Gap) or to create a little business for the Eye to be drawn from the Trees in order to return to them with more glee – I did not know you admired those *tragicomic* Pictures, because some have thought that a regular History Picture may have too much background and the composition hurt by not considering what ought to be the principle [principal]. But I talk now like old square toes there is no rule of that sort say you

But then say I
damme you lie!

He has thought hard on the question of History and has worked out his own position from bedrock. Recalling the troubles Hogarth had brought on himself by setting out his ideas on art, he was not going to be tricked into argument except in the evasive joking way of this letter. He slightly overstates his case when he speaks of figures in his landscapes being only pauses or points of emphasis in the natural scene, since he was clearly very interested in the lovers, drovers, herdsmen, woodmen, milkmaids of his pictures. But he insists that they must not obtrude as the characters of History did, as if the setting were there only to show them off. They were part of nature and nature was part of them; there must be a harmonious interplay as well as a separation of the elements making up the composition. Prince Hoare says that 'he was so disgusted at the blind preference paid to his powers of portraiture, that, for many years of his residence at Bath, he regularly shut off all his landscapes in the back apartments of his house, to which no common visitor was admitted.'[12]

A letter of 2 September 1767 certainly comes soon after the one just cited. The comments on himself, the notes of mischief, sarcasm, mockery, liable to intrude at the heart of his seriousness, enable us to understand how a person like Underwood could gain the wrong impression from his remarks:

Tho' I'm a rogue in talking upon Painting & love to *seem* to take things wrong, I can be both serious and honest upon any subjects thoroughly pleasing to me – and such will ever be those wherein your happiness and our Friendship are concerned – let me then throw aside that damn'd *grinning trick* of mine for a moment and be as serious & stupid as a Horse. Mark then, that ever since I have been quite clear in your being a

real Genius, so long have I been of opinion that you are dayly throwing your gift away upon *Gentlemen* & only studying how you shall become the *Gentleman* too – now damn Gentlemen, there is not such a set of Enemies to a real artist in the world as they are, if not kept at a proper distance. *They* think (and so may you for a while) that they reward our merit by their Company & notice; but I, who blow away all the chaff & by G— in their eyes too if they don't stand clear, know that they have but one part worth looking at, and that is their Purse; their hearts are seldom near enough the right place to get a sight of it – if any gentleman comes to my House, my man asks them if they want me (provided they don't seem satisfied with seeing the Pictures) & then he asks *what* they would please to want with me; if they say a Picture, Sir please to walk this way and my Master will speak with you; but if they only want me to bow and compliment – Sir my master is walk'd out – and so my dear there I nick them.

He goes on about the difference if 'a *Lady* a handsome Lady comes.' Jackson has thrice mutilated the passage, where Gainsborough went on to crack some bawdy jokes.

In these two letters he speaks his mind without any censorship. He seems to have liked the young Jackson, no doubt seeing in him an ambitious provincial lad such as he himself had been. Jackson must have made a conventional protest, for in a reply on 14 September Tom maintains his point by retreating into the mocking ambiguities that were his defence against the world of gentlemen, fools, and upholders of correct established values.

Now you seem to lay too much stress upon me, and show yourself to be a serious fellow. I question if you could splice all my Letters together whether you would find more connection and sense in them than in many Landskips joined where half a Tree was to meet half a Church to make a principal object. I should not think of my pretending to reproach you who are a regular system of Philosophy, a reasonable creature and a *particular Fellow*. If I meant anything (which God knows if I did) it was this, that many a *real Genius* is lost in the fictitious Character of the Gentleman; and that as many of these creatures are continually courting you, possibly you might forget, what I without any merit to myself remember from mere shyness Namely that they make no part of the Artist. Depend upon it Jackson you have more sense in your little finger than I have in my whole Body and Head; I am the most inconsistent, changeable being, so full of fits and starts, that if you mind what I say, it will be shutting your Eyes to some purpose.

In his mocking way he compares his capacity to keep up a changing response to the variety of life with Jackson's 'regular system', the flat dead system of accepted values which he hates

and rejects. At the same time he approves of Jackson as the provincial youth invading the sphere of metropolitan culture, and he wants to encourage him. He goes on in a way that brings the self-identification out into the open. 'I might add perhaps in my red hot way that damme Exeter is no more a place for a Jackson than Sudbury in Suffolk is for a G.' And he ends with a lewd joke. 'I could say a deal more but what can a man say pent up in a corner Thus; if you was a Lady I would say what I have often said in a corner by way of making the most of the last Inch. Yours up to the hilt.'

Soon afterwards Jackson did come to Bath; for one of Underwood's poems is addressed to him 'on hearing the *Lycidas* of Milton performed at Bath under his direction, and the music of his composing, at Gyde's Room, November, 1767.' The performers included Giardini and the Linleys, father, son, and daughter. Tom was certainly there.[13]

The day before his third letter to Jackson he wrote to Richard Stevens, MP for Winscott, Torrington, about the framing of his sister's portrait. He has found it hard to finish the work. 'I suffered some hardships in the first part of my Voyage and fancying now that I see *Land* makes me forget myself.' He tries to pass over his difficulties with diverting jests, jeering at gentlemen as he belittles himself. As for the result, 'I hope it will pass, especially Sir whilst the Eyes of your Friends are employ'd in admiring the Excellence of my Performances. I wish I could make you laugh till you forget how deficient I have been in point of good manners. I hope Sir, the more I have punished you, the less pain you will suffer from the Gout. Methinks I could with pleasure bear a pinch in my Toe for you.' In a postscript he describes recent buildings:

I believe Sir it would astonish you to see how the new Buildings are extending in all points from the old centre of Bath, The Pump Rooms – We almost reach Landsdown & Cleverton – down, north & south, but not quite to Bristol & London for East & West. I think verily the End of some of our *Master* Builders will be to meet some of their Marylebone Friends near a certain Ditch. It does not appear to me that many of the new Houses are occupied by Genteal Families newly residing in Bath, but only that the Lodging-House *Cats* are endeavouring to draw more Talons upon us, by having Houses in all quarters.

Some time soon after this his sister Mary, now Mrs Gibbon, became one of those Bath Cats.

On 2 October he wrote again to Stevens, joking this time to cover up the discomfort he feels at making money demands. The frame-maker wants four guineas. 'For 3 Guineas & ½ I have the Burnish'd Gold sort.' But 'if you, Sir, think it dear too I shall be willing to become a fellow sufferer as My Profits in the Portrait way is a little upon apothecary order.' He adds 'I hope the Gout has left you.' Then, in a postscript, 'Packing Case cost me 7 shillings which my Wife desires me always to remember and I often forget voluntarily because I'm afraid to mention it.'

Farington later said of Tom that he 'maintained an importance with his sitters, such as neither Beechy [*sic*] nor Hoppner can preserve.' We have another tale of his refusing to take orders from the nobility when too crudely given. A duchess sent to learn why her picture was undelivered. 'He gave it a wipe in the face with his background brush, and sent her word that her Grace was too hard for him, and he could not do the work.' Even if such tales were invented in gossip, they show the sort of reputation he had.

How thorough he was in looking round for new materials is shown by two letters written to James Dodsley in November 1767. In Anstey's *New Bath Guide*, which Dodsley had published, he noticed some paper suited 'for making wash'd Drawings upon'. So he wrote off at once for half a dozen quires of it. 'There is so little impression of the Wires, and those so very fine, that the surface is like Vellum.' He had some of Dodsley's fine writing paper, but he liked the book-paper much more, as it had less glaze on it. Dodsley sent him a sample, but in it was the impression of small wires as well as of a large cross wire, which the book-paper had lacked. 'I am at this moment viewing the difference of that what you send & the Bath guide, holding them Edgeways to the light, and could cry my Eyes out to see those furrows; upon my honour I would give a guinea a Quire for a Dozn quire of it.'[14]

About this time he did *Peasants returning from Market through a Wood*. The road winds up and through the trees, with cows drinking from the pool in the lower right corner. We see the growing impact of Rubens in the breadth and rich warm colours; the forms are built up in rapid impressionistic strokes. The work seems to have been commissioned by Lord Shelbourne, for his Wiltshire house, Bowood, who also bought landscapes by Barret and Wilson. The three pictures were 'intended to lay the *foundation of a school of British landscapes*'.[15]

It was probably in this year that Thicknesse passed through

Sudbury and called on Jack. He sat with Jack's wife for an hour and asked if Tom helped them. 'Oh yes, he often sends us five guineas, but the instant my husband gets it he lays it all out in brasswork to discover the longitude.' Jack then came in:

He would not suffer me even to tell him my name, or that I was a friend of his brother, but brought forth his curious brasswork, and after showing me how neatly it was completed, observed that he only wanted two guineas to buy brass to finish it. I could hardly determine whether his deranged imagination, or his wonderful ingenuity, was most to be admired; but I informed him that I had not capacity to conceive the genius of his unfinished work, and therefore wished him to show me such as was completed. He then showed me a cradle which rocked itself, a cuckoo which would sing all the year round, and a wheel that turned in a still bucket of water. He informed me that he had visited Mr Harrison with his timepiece, 'But,' said he, 'Harrison made no account of me in my shabby coat, for he had Lords and Dukes with him. After he had shown the Lords that a great motion of the machine would no ways affect its regularity, I whispered to him to give it a *gentle* motion, Harrison started, and in return whispered me to stay, as he wanted to speak to me after the rest of the company were gone.'

Thicknesse departed without giving him the two guineas. Fulcher says that Jack sent his timepiece to the proper quarters, and 'though the result did not fully answer his expectations, a sum of money was awarded him for his ingenuity.'[16]

On 28 January 1768 Gainsborough wrote again to Stevens about his failure to paint a satisfactory portrait of the latter's sister. 'I believe nobody can always succeed alike at all times. I can only say it was not for want of either pains or Inclination; & as to the Frame it was done after the Drawing you sent, by the best frame-maker at Bristol.' If the picture can be got to Bath, he will make any wanted alterations without charge. He then again refers to Stevens' gout.

A letter to Jackson of 6 February, perhaps of this year, deals with the rumour that Jackson had broken his neck when returning to Exeter. Gainsborough describes the report farcically. Jackson had tied the horse's head so tight it was dragged off going downhill; then he ordered the near-sighted driver to go back for the body. 'The Chaise horses frightened at the sight of the boys riding up on a horse without a head,' and Jackson 'took a flying leap out at the window and pitched head foremost into a hollow tree.' A postscript asks, 'Will you meet me at London anytime and I'll order Business accordingly.'

Soon after he wrote again. 'If your Neck is but safe, damn your Horse's head.' He praises Jackson's use of indigo. 'Your Indigo is cleare like your understanding & pure as your Music, not to say exactly of the same Blue as that Heaven from whence all your ideas are reflected.' (Through the use of indigo instead of ultramarine in some landscapes his skies have faded, for example in *The Harvest Waggon*.) He then describes his idea of unity in a picture.

The lugging in objects whether agreeable to the whole or not is a sign of the least Genius of anything, for a person able to collect in the mind will certainly groupe in the mind also; and if he cannot master a number of Objects so as to introduce them in friendship, let him do but a few – and that you know my Boy makes simplicity. One part of a Picture ought to be like the first part of a Tune; that you can guess what follows, and that makes the second part of the Tune and so I've done.

In this important statement he declares that all the parts of a picture should be organically and rhythmically linked together – not in a formal imposed way, but out of a living relationship, so that one part flows from another and the whole picture has the dynamic unity of a piece of music. We may note how he turns instinctively to music for an explanation of the structural interconnections of a work of art, and how he has instinctively identified musical sound with bodily union or contact. 'The Harp is packed up to come to you and you shall take it out with Miss —— as I'll not *take* anything for it but give it to you to twang upon when you cannot twang upon Mrs Jackson, to whom pray my Compts if there is no impropriety in the Introduction.' Such passages help us to revive the lively looseness of his conversation. His letters to Sam Kilderbee were 'brilliant but eccentric, and too licentious to be published.' The heirs apparently destroyed them.[17]

Jackson was unsure of his musical prospects and hoped to turn to art. Then he tried to get a government post. This spring he went to London to apply for a post of receivership of taxes, and stayed with Arnold in Norfolk Street, Strand, inviting Gainsborough to be his guest for a few days. On 11 May the latter replied that he couldn't get up for the exhibition; he had begun a large picture of Tom Linley and his sister. 'I suppose you know the boy is bound for Italy the first opportunity.' At an earlier date he had been with Jackson in London; for he now asked him to call on a picture-dealer near Hanover Square where they had been. He had been struck by a work there: 'with the leaving and touch of a little

bit of Tree; the whole Picture not above 8 or 10 inches high and about a foot long.' He wants to know the price and asks Jackson to call in on his way home. 'I can always make up one Bed for a *Friend*.' We see how he keeps his eyes open for any artworks from which he can learn.

For the spring show he had two full-lengths. The Society was rent with cabals and the better-known members withdrew from meetings. Were directors to be elected yearly or indefinitely appointed? The revolting majority elected sixteen directors this year. On 25 May Gainsborough wrote to Unwin (who was at Wooton Lodge, near Ashbury, Derbyshire) with apologies for still not having finished his wife's portrait. 'Thank God I shall now shut myself up for the summer and not appear til September comes in.' The summer months meant an escape from portraits. He didn't think he had altered since his days at Hatton Garden, but his wife thought he wasn't so good. 'Well, I'm better settled tho than ever I was in my Life, *more settled* more creditably settled and happier so who knows.' The fine weather too is settled, 'but rather too warm for Riding in the middle of the day especially upon Lansdown where there is no shade.' The thought makes him long for woodland. 'I suppose your Country is very woody – pray have you Rocks and Waterfalls! for I am as fond of Landskip as ever. The Captain [young Margaret] begs her Compts only she is making a damned jangling upon the Harpsichord this moment.' Feeling a bad conscience over unfinished works, he adds, 'God bless that good woman Mrs Somerez.'

Fulcher says that Margaret inherited all her father's fondness for music and played exquisitely on the harpsichord. Later, the Queen 'expressed a wish to hear Miss Gainsborough's performance, but the young lady was out of temper, and refused to gratify royalty.'

On 29 May Gainsborough wrote to the Duke of Bedford recommending Jackson for the post of Receiver of the Land-Tax for Devon. He puns and jokes to cover his embarrassment. 'Your Grace has doubtless heard his Composition but he is no *Fiddler* your Grace may take my word for it.' Well-off friends are ready to be bound over for him in any sum and are applying to the Duke of Grafton; but Gainsborough felt impelled to turn to the Duke of Bedford. 'Your Grace knows that I am an *Original* and therefore I hope will the more ready to pardon this monstrous freedom.' Jackson did not get the post.

Gainsborough wrote at least three letters this year to Garrick. The first deals with further work he is doing on the portrait or with a new version or copy. He has been very ill, 'but having had 12 oz: of Blood taken immediately away am perfectly recovered, strong in the Back and *able* so make your sublime self easy.' He complains of the badness of an old representation of Shakespeare

...so as I said before, damn *that*. I'm going to dinner, and after, I'll try a sketch – I shall leave the *Price* to you – I don't care whether I have a farthing if you will but let me do it – to be sure I should never ask more than my Portrait price (which is 60 guineas), but perhaps ought to ask less, as there is no confinement of Painting from Life but I say I leave it to you, promising to be contented *upon Honor*. I could wish you to call *upon any pretence* any day after next Wednesday at the Duke of Montagu, because you'd see the Duke and Duchess in my *last* manner; but not as if you thought anything of mine worth that trouble, only to see his Grace's Landskip of Rubens (*The Watering Place*), and the 4 Van Dykes whole length in his Grace's dressing-room.

On 2 August he was still at work on the Garrick. There had been continual rain so that he hadn't gone to Stratford. 'My Genius is so dampt by it that I can do nothing to please me.' He had been rubbing in, rubbing out the Shakespeare design; now he thinks he'll let it go. 'I was willing like an Ass as I am, to expose myself a little out of the simple Portrait way, and had a notion of showing where that inimitable Poet has his Ideas from, by an immediate Ray darting down upon his Eye turn'd up for that purpose; but G—damn it I can make nothing of my Ideas there has been such a fall of rain from the same quarter – you shall not see it for I'll cut it out before you come.' Shakespeare's bust 'is a silly smiling thing, and I have not sense enough to make him more sensible in the Picture and so I tell ye you shan't see it. I must make a plain picture of Him standing erect, and give it an old look as if it had been Painted at the time he lived and there we shall fling 'em Damme.' He adds that Mrs Pritchard, actress famous for her Lady Macbeth, has died, and ends with a pun; 'Time puts us all into his Fobb, as I do my Timekeeper, *watch* that my dear.' In a postscript he writes, 'Impudent scoundrel says Mr G. – Blackguard.' In such weays he anticipates an adverse response and ridicules it. Probably round this time he wrote an undated letter in which he says that he is sending a sketch but cannot go next day to bid Garrick goodbye as he has three sitters coming and he has caught a cold in the rain. Garrick must not thank him for the chalk scratch (sketch) except by speaking kindly of him.

Later on he wrote again, still worried about the painting and the payment for it. All he asks is that Garrick will never think himself in his debt. 'I wished many years for the happiness of Mr Garrick's acquaintance, and pray, dear sir, let me now enjoy it quietly.' He then tells the story of the Ipswich singer who could not read at first sight.

Perhaps this year he wrote to Jackson on 2 September after a visit to Exeter. On his way home he met Lord Melbourne, who insisted on his staying with him a while. 'And I don't regret going ('tho I generally do to all Lord's houses as I met wth Mr Dunning there).' John Dunning was the leading lawyer of the day and in 1768 was Solicitor-General in the Duke of Grafton's administration. Gainsborough gives a remarkable description of him:

He seems the only man who talks as Giardini plays, if you know what I mean; he puts no more motion than what goes to the real performance, which constitutes that ease & gentility peculiar to the damn'd Clever Fellows, each in their way. I observe his Forhead juts out, and mine runs back a good deal more than common, which accounts for some differences betwixt our *Parts* – no doubt, with me, but he has an uncommon share of Brains and those disposed so as to overlook all the rest of his *Parts,* let them be ever so powerful. He is an amazing *compact* Man in every respect; and as we get a sight of everything by comparison only think of the difference betwixt Mr Dunning almost motionless, with a Mind brandishing, like Lightening, from corner to corner of the Earth, whilst a long cross made fellow only flings his arms about like thrashing flails without half an Idea of what he would be at – and besides this neatness in outward appearance, his Store-Room seems cleared of all french ornaments and gingerbread work, everything is simplicity and elegance & in its proper place; no disorder or confusion in the *furniture* as if he was going to remove. Sober sense and great acuteness are marked very strong in his Face, but if these were all, I should only admire him as a great Lawyer; but there is a Genius (in our sense of the word) shines in all he says.

He ends, 'Pray make my Compliments to one Lady who is *neat about the Mouth* if you can guess.' He has been flirting in Exeter. His remarks about Dunning sum up his whole response to life and art. His ideal is a compact vital unity in which, without fuss or display, a great energy is felt, pervading the whole and giving a dynamic and significant effect to moments or passages even of quiet and repose: 'a Mind brandishing, like Lightening, from corner to corner of the Earth'. In the repudiation of French ornaments we perhaps hear his new enthusiasm for Rubensesque rhythm and breadth against rococo, though he himself had drawn

from rococo its stronger elements and never been interested in decoration for its own sake.

He is said to have painted in November 1768, in one hour forty minutes, Ignatius Sancho, a black man of letters, who kept a chandler's shop in Westminster. Born on a slaver, Sancho had been taken up by the Duke of Montagu, who made him butler and left him an annuity. This month Kirby became President of the Society of Artists; eight more directors had resigned. Gainsborough was nominated for the new committee, but at the end of the month he received a letter from Reynolds asking him to become one of the thirty-six founding members of the Royal Academy, which was set up by royal instrument on 10 December. On the 5th he wrote to the Society resigning; and when he got his Royal Academy diploma he had it hung, finely framed, behind his studio-door. He must have felt rather bad about letting Kirby down. With the advent of the R.A. Hogarth's plans for a democratic organization of artists were ended.[18]

This year Johann Christian Fischer, oboe-player, came to England, and on 2 June appeared at the Thatched House Assembly Room, St James's Street, when J. C. Bach played the pianoforte as a solo instrument for the first time in public. Fischer became a star performer at Vauxhall Gardens and at the Bach-Abel concerts. He used a more sophisticated form of the oboe than had been previously played. Parke says his playing was 'soft and sweet, his style expressive and his execution at once neat and brilliant'. He also composed much music that was popular; Mozart wrote a set of variations on a minuet of his.

This year also Humphry Gainsborough invented an apparatus for condensing steam in a chamber separate from the cylinder of the new steam-engine.

It was stated by his family and friends, that Watt owed to him one of his great and fundamental improvements, that of condensing the steam in a separate vessel. Certain it is that Mr Gainsborough had constructed the working model of a steam engine, to which his discoveries were applied, and that a stranger, evidently well acquainted with mechanics, and supposed to be connected with Watts as an engineer, was on a visit to Henley and called upon him, to whom he unsuspectingly showed his model and explained its novelties. His relatives have assured the Author that such was the fact, and that the circumstances of having thus lost the credit of his discovery, made a deep and melancholy impression upon his mind. (Fulcher)

Thicknesse, to whom Gainsborough gave the model after

Humphry's death, also tells of 'a cunning, designing artist' who stole the idea. Such stories were liable to spring up round a disappointed inventor, but we may accept the account of Humphry devising a condensing apparatus. When Thicknesse died, the model was lost.

In 1768 Gainsborough painted Viscount Kilmorey, whose heavy frame is wrapt in a big blue cloak and red waistcoat trimmed with zigzag gold (echoed by the gold on the hat under his arm). He stares with a mixture of stolidity and lordly assurance modified by a slight quizzical warmth. A tree trunk swings away to the left and the strong colours are set against silvery greys. There is an effect of massive strength, yet of something ridiculous in the vast gaudy expanse of cloth and flesh under which the legs cannot but look weak props. Round this time Gainsborough also painted the Duchess of Montagu. The strong vertical design suits the haggard face and stiff body of the old woman, but is relieved by the light which curves round from the horizontal arm and leads to the rondure of the cap. This is the work that Gainsborough mentioned to Garrick as in his last (latest) manner; on its wall is a landscape also in his last manner. In his portrait of Viscountess Molyneux, a twenty-year-old bride, he calls up the Van Dyck glamour in textural brilliance and gesture; but the girl with her softly-modelled face remains dull and empty against a rather vague background.[19]

In April 1769 came the first R.A. show, in Pall Mall. Gainsborough had not presented the Academy with a picture on his nomination; but he now sent along a landscape and the portraits of Lady Molyneux and a boy. The *St James's Chronicle* picked out the Lady. Arrangements were being made for a Shakespeare Festival at Stratford upon Avon, where the Town Hall was rebuilt that year. Garrick presented a statue of Shakespeare and the poet's portrait by Benjamin West; the corporation paid Gainsborough £63 for his painting of Garrick and West £74 for its frame.

On 24 May Gainsborough's mother died. She was buried in Sudbury at the Independent Meeting House. Since he gave a receipt to the Earl of Dartmouth on the 25th for £120 for two full-length portraits, it seems unlikely that he attended the funeral.[20]

There are four letters to Jackson with years omitted, which may be dealt with here. Writing on 4 June Gainsborough brings out afresh the link of his musical sense with his landscape painting

and the deep conflict between the life he leads and the life that appeals to him. The thought of music as usual stirs him to lewdery, and we see how bored he is with his home life and its conventional round.

I think I begin to see a little into the nature of Modulation and the introduction of flats and sharps; and when we meet you shall hear me play extempore – My Friend Abel has been to visit me, but he made a short stay, being obliged to go to Paris for a Month or six weeks, after which He has promised to come again. There never was a poor Devil so fond of Harmony, with so little knowledge of it, so that what you have done is pure Charity – I dined with Mr Duntze in expectation (and indeed full assurance) of hearing your scholar Miss Floud play a little, but was the second time *flung*. She had best beware of the third time, lest I *fling* Her, and if I do I'll have a Kiss before she is up again. I'm sick of Portraits and wish very much to take my Viol da Gamba and walk off to some sweet Village where I can paint Landskips and enjoy the fag End of Life in quietness and ease. But these fine Ladies and their Tea drinkings, Dancings, *Husband huntings* and such will fob me out of the last ten years, & I fear miss getting Husbands too – But we can say nothing of these things you know Jackson, we must jogg on and be content with the jingling of the Bells, only damn it I hate a dust, the Kicking up of a dust, and being confined *in Harness* to follow the track, while others ride in the waggon, under cover, stretching their Legs in the straw at Ease, and gazing at Green Trees & Blue skies without half my *Taste,* that's damned hard. My Comfort is, I have 5 Viols da Gamba, 3 Jayes and two Barak Normans.

In the second letter he mentions two full-lengths and a landscape for the Exhibition at the R.A. 'Never was such slight daubs presented to the Eyes of a Million, but I grow dauntless not of Meer stupidity as I grow old, and I believe any one that plods on in any one way, especially if that way will bring him bread & cheese as well as a better, will grow the same.' He makes some lewd remarks, stirred by the thought of music, which Jackson has twice expurgated. 'The Harp is come back and I'm sorry you thought it worth the...pains of returning as the Lady was not...of it – I suppose you had played upon her ti'l you was tired and so could not let her have it – thanks for the Indigo a little of it goes a great way, which is lucky.'

In the third letter he deals with Jackson's ambitions as an artist, gives some advice to him, and says that he is capable of doing drapery and landscape backgrounds. 'Perhaps you don't know that whilst a Face painter is harrassed to death the drapery painter sits and earns 5 or 6 hundred a year, and laughs all the

while... I'm an impertinent Coxcomb – this I know, & will speak out if you kill me for it, you are too modest, too diffident too sensible & too honest ever to push in Music –' Five words are crossed out; again Jackson censors bawdry linked with music. Interestingly Gainsborough shows a clear awareness of his own nonconformity:

I am soon lost if I pretend to reasoning; and you being all regularity and Judgment, I own provoke me the more to break loose; as he who cannot be correct, is apt to divert the Eye with a little freedom of handling but no more of it. I must own your calculations & comparison between our different professions to be just provided you remember that in Mine a Man may do great things and starve in a Garret if he does not conquer his Passions and conform to the *Common Eye* in chusing that branch which *they* will encourage & pay for. Now there cannot be that difference betwixt Music & Painting unless you suppose that the Musician Voluntarily shuns the only profitable branch, and will be a Chamber Counsel when he might appear at the Bar...

Finally there is a note to Jackson who had fallen ill on a visit to Bath. Gainsborough in his haste writes on fine drawing-paper.

I thought you was sick as I had not seen you for some Days, and last night when I went to the Play in hopes of meeting you there, Mr Palmer confirmed my fears; I fully intended putting on my thick shoes this morning, but have been hindered by some *Painter Plagues;* pray send me word whether there is any occasion for Doctor Moysey to come to you, in *Palmer's opinion,* damn your own, for you are much too like me to know how it is with you... I'll be with you soon to feel your pulse myself.[21]

A tale told by Thicknesse may be appropriate here. One night he met Gainsborough on his way to the theatre. He stopped him and told him of a friend who had committed suicide in London, leaving a wife and child almost destitute, and showed the wife's letter. Later that night a note was delivered to his house. 'I could not go to the play till I had relieved my mind by sending you the inclosed bank-note, which I beg you to transmit it to the poor woman by tomorrow's post.' Thicknesse adds, 'His susceptible mind and his benevolent heart led him into such repeated acts of generosity, though at the time I knew he was not rich, and I suppose he did not die with a tenth part of what he might have been possessed of had he been a worldly-minded man.'

In the off-season Gainsborough moved around, visiting mansions and making drawings from nature. He probably more than once visited Barton Grange near Taunton. The owner,

Goodenough Earle, owned many of his drawings. Once Gainsborough painted there a lad who, says Fulcher, used to carry his materials when he went out to sketch. We see the lad (known as the Pitminster Boy) with keen eager face; the strong lighting brings out his lively character as he stares up. A sheet with six vivid drawings of a cat is said to have been given to the hostess of a place where the artist stayed; it is one of the few sheets he carefully signed.

He had been widening the range of his landscapes. In *Peasants returning from Market through a Wood* (done for Lord Shelburne) he used rapid brushstrokes to define both people and trees, drawing on a rich palette of colours from red and orange to blue and violet, with a glistening sky of pink and yellow. In *River Landscape with Figures in a Boat* he thinned out the trees so that he could deal with the broad movement of light through foliage and across water on a wide expanse reaching to a church-tower in the distance. The pen-and-ink sketch, with grey and brown washes, of a boy resting in a cart shows how far he could go in stark simplification of forms, with both treatment and conception looking to Rembrandt.[22]

He was rarely mentioned in Bath papers, but this year a poet in the *Bath Chronicle* paid tribute to his power of getting a likeness: 'The Picture to the Original so like You all Beholders with Amazement strike.' Also this year at Bath William Jones, Fruit Painter, took over the business of Dixon, art-dealer, and claimed to have works by Rubens, Murillo, Holbein, Poussin, though a critic who visited his gallery was disrepectful. Jones in his reply stated that several artists supported the attributions. Gainsborough may have been among them. Perhaps from Jones came some of the supposed Old Masters that Gainsborough's widow later found hard to sell even at the lowest prices.[23]

Thicknesse had inherited through his wife a hill-farm on stony ground at Quoitca in Monmouthshire and Gainsborough may well have gone with him there in the late 1760s or early 1770s. Thicknesse stayed there at least one winter; and in 1768-9 he wrote from there to Wilkes in his London jail, to say that he proposed 'to make a little Stone-henge' in his grounds, which he would inscribe with the names of Liberty and Wilkes. He sold the estate in 1773. Wilkes had become the radical champion of Liberty since his criticism of the King's Speech opening parliament, in the *North Briton* of 23 April 1762, had led to the issue against him of a General Warrant (which named the offence

but not the person to be arrested), his outlawry, exile in France, triumphant return, and continuing sharp conflict with the government. Gainsborough may well have met him through Thicknesse.

7 Bath (1770-1774)

*I*n 1770 Gainsborough sent to the R.A. a Book of Drawings, a portrait of Jackson, and *The Blue Boy*. In a reversion to schemes of the early 1750s Jackson was shown leaning back with his right elbow on an open music book against a grassy mound over which fell a sprig of ivy. The Blue Boy was Jonathan Buttall. A drawing-teacher, Taylor, told J. T. Smith that Gainsborough was 'an odd man at times. I recollect my master Hayman, coming home after he had been at the Exhibition and saying, "What an extraordinary picture Gainsborough has painted of a Blue Boy; it is as fine as Vandyke". Who was the Blue Boy, sir? "Why, he was an ironmonger. He lived at the corner of Greek and King Streets, Soho, an immensely rich man." ' The catalogue merely stated 'Portrait of a Young Gentleman'. Till 1798 portraits, apart from those of the royal family, were given general titles: A Nobleman, A Lady of title, A Gentleman, an Artist. This effort to shield the sitter from publicity was defeated by the newspapers, which printed lists of names with catalogue numbers. As the Buttalls held property in Ipswich, Gainsborough may have known the family some time; he became very friendly with Jonathan, who collected his drawings. When the latter sold up his stock in 1796 it included pictures by Gainsborough and by his nephew, a small select library, musical texts and instruments, and 160 dozen bottles of old red port.

A story was told later of *The Blue Boy*'s originating in an argument between Gainsborough and Reynolds. We may dismiss that, but the work none the less plays an important part in the wordless polemic between the two artists. Gainsborough would

96

have known that Reynolds took the conventional line (later stated in the Discourse of December 1778) in praise of Venetian effects. The masses of light, said Reynolds, should always be of warm mellow colours; greys and greens should be used only to support and set these off. 'Let the light be cold and the surrounding colours warm, as we often see in the Roman and Florentine painters, and it will be out of the power of art, even the hands of Rubens and Titian, to make a picture splendid and harmonious.' Gainsborough always liked to go against dogma, but he was also challenging Reynolds' evocation of Van Dyck in his *Brown Boy* (Thomas Lister, aged twelve) of 1764. He based his Blue Boy on Van Dyck's *George Villiers and his brother Francis*, altering only one hand. He linked his boy with the background by the left arm, a diagonal echoing the rising ground and carried on into the luminous patch of sky. He was reversing the normal system: the sky-blue is drawn down to envelop the boy while brownish greys are transferred to the sky. The painting was not commissioned; Gainsborough did it for his own pleasure. (X-rays have shown under it the beginnings of a picture of an older man.)[1]

Critics have praised the work for its strong feeling of the archetypal model of aristocracy, but in fact Gainsborough is deliberately setting a middle-class lad against the aristocrats of Van Dyck and Rubens, giving him a direct force of character. What fascinated him in Van Dyck was the element leading on to Rubens, the free assured sweep of paint, the delight in fine textures, the integration of colour and form. The use of Van Dyck costumes had long been fashionable. In the 1730s Sarah, Duchess of Marlborough had written to her granddaughter, whose portrait she had commissioned from Isaac Wood, 'Many women are now drawn in the Van Dyck manner.' She suggested as model the portrait of Anne Carr. Diana objected that she'd look old-fashioned beside the recent portrait of her husband, the Duke of Bedford, in his coronation robes. Sarah suggested a compromise: Van Dyck's white satin with sleeves and waist brought more up to date. Horace Walpole wrote in 1741 to Mann: 'I saw at the Duchess of Norfolk's quantities of pretty Van Dycks and all kinds of pictures walked out from their frames'. Reynolds in his Seventh Discourse argued that an artist will not paint a lady 'in the modern dress, the familiarity of which alone is sufficient to destroy all dignity'. So he dresses her up in 'something with the general air of the antique for the sake of dignity and preserves something of the modern for the sake of likeness'. Ozias

Humphry, stressing the surprising resemblance of Gainsborough's portraits and the fact that 'likeness was all he avowed to aim at', adds that 'the satisfaction arising from the resemblance was lessening daily as the fleeting fashions varied'. Gainsborough himself strongly disapproved of fancy-dress in portraits; but he did draw on Van Dyck for poses, for example a male figure with one arm resting on hip, the other hanging loose (Blue Boy); a male with a stronger transfer of weight to one side, so that straight and bent legs are contrasted (Kilmorey); a female standing with one arm hanging down, its hand touching or lifting the dress, and the other arm bent in and held across the body (Lady Sheffield); a female with both arms folded or linked so as to frame the torso (Perdita).[2]

On 9 June he wrote to tell Jackson that his portrait was 'as I expected hung a mile high. I wish you had been a created Lord before my sending the Picture, then that puppy Newton [R.A. secretary] would have taken care you had been in sight.' On account of his painting methods he was always sensitive about the way his works were hung. He hopes to visit Exeter in the autumn, 'to bathe in order to *stand* next winter. My wife seems coming into the scheem.' He cannot resist a touch of bawdry in writing to Jackson. He adds that he has been three months away at the country house of George Pitt, the first Lord Rivers, (whose portrait he had shown in 1769).

He explains this visit in a letter to Unwin on 10 July. He had meant to spend only two or three days, taking leave of Pitt, 'a staunch Friend of mine before his going to Spain, and behold he had got two whole length canvases, and his son and daughter, *Lord & Lady Ligonier*, in readiness to take me prisoner for a month's work.' He says that for five years he hasn't been able to write to Unwin since the latter left Essex, forgetting that he had written at least twice in 1765, and had sent a letter to the Derbyshire address in May 1768. Once more he curses portraits. 'The curs'd Face Business...the nature of face painting is such, that if I were not *already cracked,* the continual hurry of one fool upon the back of another, just when the magot bites, would be enough to drive me crazy.' He suggests that Unwin and his wife come to Bath in the autumn for six weeks 'and make our house your home'. If they do, 'I'll pack up all my Drawing things, and see Derbyshire next summer, if I'm alive.' Finally in anguish he admits that he still hasn't finished Mrs Unwin's picture. 'I wish I were a Razor-grinder – I'll begin a new one of Her and you

together if you'l come. Poor Mrs Saumarez too, O Lord...'

What had happened at Pitt's house? We learn a lot from the two paintings he did there, which are both linked and contrasted. The lord stands with a horse on his right, leaning easily against him; his head and body are parallel with the horse's. (A reviewer was later worried that 'the horse is as good a man as his master.') He is identified with his horse and sums up the character of the complacent noble landlord. The turn of his head makes him glance with possessive confidence at his wife Penelope in the second picture. She stands in much the same pose, yet is at every point contrasted with him. A pedestal with a statuette of a dancing Bacchante takes the horse's place, and her left arm turns up to support lightly her head. She is in-turned, looking down and ignoring her extrovert lord. He stands in the open air; she, holding a paintbrush, is closed in her room of art with its casts and statues, claimed by the Bacchante who swings her arm over towards her. The knots of the scarf round her waist are repeated in the knots of her hair; she is completely involved by a different sort of life from that absorbing her lord. He is part of the surrounding tree-scene; for her the trees beyond the curtain have a wayward luring effect. At the same time both pictures are linked by their colours, red, buff, yellow-gold, greyish white.[3]

In November this year Penelope began her affair with Count Alfieri, and the whole thing came out when her groom, who had preceded Alfieri as her lover, told the story to her husband. Scandalous rumours abounded, with tales of earlier affairs and denials. Gainsborough may well have got wind of her behaviour in the household; but he was quite capable of intuiting her character as he painted her. He has certainly defined the relations of the pair with deep insight.

On 15 November he wrote to Unwin. For delays in replying he blames a lady who has turned up on his wife's invitation, and who now, through the entreaty 'from some part (not the most insignificant of my Family)', proposes to stay for Christmas. If Unwin comes, Gainsborough will take lodgings for him. 'I hope we shall ride often together, and set you up for another seven years.' On the 21st he got the receipt for his portrait of the young Duke of Buccleugh, painted as a gift for the Royal Society of Edinburgh. (The Society declined the work, objecting to the magnificently painted dog which the Duke clasped with locked hands.)[4]

Thicknesse wrote a character of Gainsborough about this time, which begins:

Nature was his master, for he had none other! He caught her ideas with wonderful quickness and executed them with the utmost facility. With a black lead pencil he is equal to any of the greatest Masters of Antiquity; and although Landscape Painting is his natural turn, he has exceeded all the modern Portrait Painters, being the only one who paints the mind (if we may be allowed the expression) equally as strong as the countenance.

He stresses that Gainsborough knows 'how to act, and think, like a gentleman, as he does to contemn and despise those who dare to treat him in any other light.'

Farington says that 'he was irregular in his application, sometimes not working for 3 or 4 weeks altogether, and then for a month wd. apply with great diligence. He often wondered at Sir Joshua Reynolds' equal application.' This was a comment on Gainsborough's later years, but probably applied to all his phases. He preferred to work direct on canvas. When uncertain, in his early years, he made some studies, but later he made a drawing only for a large picture, to get the elements of the composition clear. However, he made many drawings for their own sake, mostly of landscapes, which he did often in the evening as a sort of relaxation, an escape into the sphere he loved. If he used these as basis for a painting, he made small changes. The studies he did make were usually of details, plants, animals, a part of a costume such as a cuff. He made several drawings of ladies' clothes, mostly in the 1760s when he was coming up against the problem of larger portraits; he needed to feel at ease in treating the often complicated details of fashionable clothes. And he made careful preparations for his first equestrian portrait. But in general drawing was for him a form of art to be carried on and enjoyed for its own sake.

His mind kept playing round what he was doing, seeking to find ways of bringing the representation closer to a satisfying unity, an expressive system of rhythmical interrelations. 'Before going to rest he would often go into his painting room and mark with chalk on his pictures such alterations as he proposed to make in them' (Farington). In early years he tended to work piecemeal; but as he matured he learned, in Reynolds' words, to form 'all the parts of the picture together; the whole going on at the same time'. Usually he did the head first. Thicknesse says of his own portrait, 'He soon finished the head, rubbed in the head colouring

of the full-length, painted my Newfoundland dog at my feet.' He mostly used fine-grained brushes for a smooth surface, beginning with a light priming, generally of greyish-yellow or pinkish tint. This gave him a luminous underlay, which at times he let shine through, varying the texture of his paint and helping him to get a unifying brilliancy. First he roughed out his design, at times with mauve outline for portraits and bits of local colour. His paint-structure he built up as an aspect of his drawing and modelling so that in the last resort the character of a person or scene was defined as much in the brushwork as in the colour or drawing. Because he gave such thought to the final result, he took great care over his frames and the way his pictures were hung.

Angelo describes his method of moppings in the late 1760s, which he could not have got away with anywhere except at Bath. 'I saw him at his easel there, dashing out his designs, so long since as 1768.' The method, though difficult, 'seemed to be effected without an effort of art.'

Gainsborough had in his experiments exhausted all the legitimate methods and all the tricks of painting in his oil pictures. He had established a reputation for a style of drawing as desultory in its way, when, not acknowledging bounds to his freaks, instead of using crayons, brushes, or chalks, he adopted for his tools his fingers and bits of sponge. His fingers, however, not proving sufficiently eligible, one evening whilst his family and friends were taking coffee, and his drawing thus proceeding, he seized the sugar tongs, and found them so obviously designed by the genii of art for the express purpose, that sugar tongs at Bath were soon raised two hundred per cent.

He had all the kitchen saucers in requisition; these were filled with warm and cold tints, and, dipping the sponges in these, he mopped away on cartridge paper, thus preparing the masses, or general contours and effects, and, drying them by the fire (for he was as impatient as a spoiled child waiting for a new toy), he touched them into character with black, red, and white chalks.

Some of these moppings and grubbings and hatchings, wherein he took unusual pains, are such emanations of genius and picturesque feeling as no other artist ever conceived, and certainly such as no one has ever surpassed.[5]

On 21 March 1771 Gainsborough wrote to the Hon. Edward Stratford, mentioning the report that the men who had robbed the latter had been caught and 'hang'd out of the way, as they richly deserved.' He is working hard for the R.A., having done two large landscapes and three full-length portraits. He jokingly says that the Hon. Edward, whether or not he has got his money

back, should buy the landscapes, which 'are the best I ever did, and probably will be the last I shall live to do.' (He may make that remark for effect, but with his varying health he clearly did feel at times that he was going to break down.) The portraits of the Hon. Edward and his wife are half-lengths, so cannot be sent to the R. A., where such sizes 'are overlook'd in such a monstrous large room and at a Miles Distance'. He offers to work afresh over chalk drawings made with the portraits as they have been rubbed. He adds slyly that he is ready to do anything else when he comes to town, 'well knowing that if ever I am Knighted or have anything to do at St James's it must be through your interest and singular Friendship for me'.

An earlier card, written while the Stratfords were sitting, asks if they want the dog put in with Mrs Stratford or done separately by Monsieur Dupont. This must mean that already his nephew, son of his sister Sarah, was living in the house and working with him.[6]

In April he wrote three letters to the Earl of Dartmouth, much concerned at the way in which he was being asked to paint his wife. He had painted her in a style far more generalized and idealized than he liked; the costume was of no particular period (as Reynolds advocated) and the landscape a mere backcloth. He seems not to have been allowed to alter it as he would have wished, but he did do a smaller picture of her with a rose in Van Dyck costume, in which her character is better defined. The importance of the commissions, however, lies in the way in which they made him protest and set down his ideas about costume. He says that he will make alterations when the lady comes to Bath, 'as I cannot (without taking away the likeness) touch it unless from the Life.' (We see one reason why he could not bear to finish a work without the sitter available.)

I believe your Lordship will agree with me in this point that next to being able to paint a tolerable Picture, is having judgment enough to see what is the matter with a bad one. I don't know if your Lordship remembers a few *impertinent* remarks of mine upon the ridiculous use of fancied Dress in Portraits about the time that Lord North made us laugh in describing a *Family Piece* his Lordship had seen somewhere, but whether your Lordship's memory will reach this trifling circumstance or not, I will venture to say that had I painted Lady Dartmouth's Picture, dressed as her Ladyship goes, no fault (more than in my Painting in general) would have been found with it. Believe me, My Lord, 'tho I may appear conceited in saying it so confidently.

I never was far from the mark, but I was able before I pull'd the trigger to

see the cause of my missing and nothing is so common with me as to give up my own sight in my Painting room rather than hazard giving offence to my best Customers. You see, my Lord, I can speak plainly when there is no fear of having my bones broke.

His usual style of mixed independence and humorous self-depreciation. On the 18th he wrote yet more plainly.

Here it is then – nothing can be more absurd than the foolish custom of painters dressing people like Scaramouches, and expecting the likeness to appear. Had a picture voice, action, etc. to make itself known as Actors have upon the Stage, no disguise would be sufficient to conceal a person; but only a face confined to one view and not a muscle to move to say, 'Here I am' falls very hard upon the poor Painter who perhaps is not within a mile of the truth in painting the face only. Your Lordship, I'm sure, will be sensible of the effect of the dress thus far, but I defy any but a Painter of some sagacity (and such you see I am, my Lord) to be well aware of the different Effects which one part of a picture has upon another, and how the Eye may be cheated as to the appearance of size, and by an artful management of the accompanyments. A Tune may be so confused by a false Bass – that is if it is ever so plain, simple and full of meaning, it shall become a jumble of nonsense, and just so shall a handsome face be overset by a fictitious bundle of trumpery of the foolish Painter's own inventing. For my part (however your Lordship may suspect my Genius for Lying) I have that regard for truth, that I hold the finest invention as a mere slave in Comparison, and believe I shall remain an ignorant fellow to the end of my days, because I never could have patience to read Poetical impossibilities, the very food of a Painter; especially if he intends to be KNIGHTED in this land of Roast Beef, so well do serious people love froth. But, where am I, my Lord? this my free Opinion in another Line with a witness – forgive me my Lord, I'm but a wild goose at best – all I mean is this, Lady Dartmouth's Picture will look more like and not so large when dressed properly; and if it does not, I'll begin another.[7]

Reynolds had been knighted in 1769 and it seems that Gainsborough keeps asking why he too shouldn't have a handle to his name. We may note too how he always feels driven to musical analogies.

On 4 May he wrote very gratefully to Garrick about the copy of his portrait which had been sent to his house; he stressed the 'honour and esteem' to which the latter was entitled. He had added a frame (price 55s) 'contrary to my wishes and expostulations'. In the R.A. he exhibited portraits of the Ligoniers, Lady Sussex, Mr Nuthall and Captain Wade (master of ceremonies at Bath). A critic said of Lady Ligionier that she,

'who has something of a French look, has a remarkably piercing eye'. The *Wade* had a landscape background which was largely painted out; steps were inserted in its place. A poem explained that Wade had looked ashamed of his trade, 'walking alone in the fields'. A change was needed, but why then 'draw him as if hurrying out of the room Down a steep flight of steps? much like those of his home. Or why must the meadows retain a sly peep?' The picture thus appeared as a sort of parody of Gainsborough's efforts to relate to nature people who obstinately refused any such relation.[8]

This year, 1771, a disaster fell on Gainsborough that shadowed the rest of his life. His daughter Margaret, now nineteen years old, had a serious mental breakdown. The family doctor, Moysey, took a pessimistic view of her condition. A letter from Palmer on a Sunday night in late October to Garrick explained that he had found it hard to deliver a message to Gainsborough, who 'has been so very indifferent from his attention to and confinement with his daughter in her illness'. The girl was now better, but Gainsborough 'complains very much of Moysey's behaviour; who paid no attention to her, declaring that it was a family complaint and he did not suppose she would ever recover her senses again; so that Gainsborough was obliged to call in Schomberg and Charleton, who called it by its right name, a delirious fever, and soon cured her. Gainsborough sent home after this the picture of Moysey and his family, which he had painted gratis for him, and the old doctor paid for the frames.' Palmer then tells how he and Gainsborough were standing in the Assembly Rooms:

...admiring the figures which the ingenious Committee had drawn by Garvey the landscape painter, we narrowly escaped having our crowns cracked by a branch falling out of one of the chandeliers; it was taken little notice of by the company, but the Committee met upon the next morning, and that the public might not be alarmed by it, and to make them easy, put the enclosed publication in the papers: which had so good an effect that the next night they had not two hundred people in the room.

Moysey had been unforgivably blunt, but he had rightly decided that the girl had some inherited taint (presumably syphilitic). Both Thicknesse and Angelo say that Gainsborough himself was not far from the line dividing genius from insanity; but the taint in the girls presumably came from the Beauforts. Gainsborough had suffered badly while Margaret raved; and though he rejected Moysey's diagnosis, he must have continued to be worried.[9]

On 10 December Reynolds gave his Fourth Discourse, and some time after that Prince Hoare sent Gainsborough a copy of the text. Reynolds contrasted the grand style of History with the Ornamental, which he linked with the Venetians. 'Though it be allowed that elaborate harmony and colouring a brilliancy of tints, a soft and gradual transition from one to another present to the eye what an harmonious concert of music does to the ear, it must be remembered that painting is not merely the gratification of sight.' So the Ornamental belongs to 'the humbler walks of the profession', such as portraiture, which finds it 'necessary to its embellishment'. Gainsborough in his reply does not want to argue about what Reynolds says of History; he feels it is enough to insist that there is no call for the style in England. What he defends is the use of texture and colour in portraiture to reveal the individual vitality of each sitter.[10]

The Ornamental style (as he calls it) seems form'd for Portraits. Therefore he had better come *down to Watteau* at once (who was a very fine Painter taking away the french conceit) and let us have a few Tints; or else why does Sir Joshua put tints equal to Painted Glass, only to make the People talk of Colors flying when the great style would do. Every one knows that the grand style must consist in plainness & simplicity, and that silks & satins, Pearls and trifling ornaments would be as hurtfull to simplicity, as flourishes in a Psalm Tune; but Fresco would no more do for Portraits than an Organ would please ladies in the hands of Fischer; there must be variety of lively touches and surprizing Effects to make the Heart dance, or else they had better be in a Church – so in Portrait Painting there must be a Lustre and finishing to bring it up to individual Life.

But, hating the sour critic, he suggests they discuss the matter some evening over a glass. 'There is no other Friendly or sensible way of settling these matters except upon *Canvas.*' The test is practice.

Late in 1771 or early in 1772 he wrote on a Sunday afternoon to Sir W.J. Pulteney, whom he was painting. 'I generally view my Works of a Sunday, tho I never touch.' He feels that the portrait needs 'one more little sitting of about half an hour,' and asks Pulteney to come along the next day or so.

On 2 January 1772 Thicknesse wrote to his friend John Cooke of Gaytre, Monmouthshire, 'I spent three days with Mr Gainsborough at Bath, and *one Evening* with Mr Wilkes there.' Whether Gainsborough met Wilkes we do not know. Wilkes was

engaged in a struggle with the City of London; he had become Sheriff in 1771, and was now trying to become Lord Mayor.

On 12 January an indenture was drawn up, apprenticing Gainsborough Dupont to his uncle. Thicknesse says that Dupont was 'fostered under his uncles's wing from a child'. Bate, who always showed a friendly interest in the youth, says that he was with Gainsborough from his infancy. The seven-year apprenticeship was defined in the usual terms. The lad was to serve faithfully, not haunting taverns, inns, and alehouses, and so on. 'Matrimony he shall not contract' is added in writing to the printed clauses. His mother is to keep him. 'Apparell' is inserted in the list of provisions, Meat, Drink, Washing, etc. Gainsborough is to 'Teach and Instruct, or cause to be Taught and Instructed in the best way and Manner he can' the Art 'or Mystery of a painter.'

On 1 May Gainsborough wrote to Edward Stratford; he still hadn't finished the portraits of him and his wife. 'I was obliged to cobble up something for the Exhibition or else (so far from being knighted) I should have been expel'd the Society.' He calls up his note of mock-humility so that he can get away with saying just what he means. 'I wish you would recollect that Painting and Punctuality mix like Oil and Vinegar, and that Genius & regularity are utter Enemies, and must be to the end of time – I would not insinuate that *I* am a genius any further than as I resemble one in your Opinion, who think I have no such things as punctuality about me.'

In May there was trouble at the R.A. The hanging committee rejected Gainsborough's painting of Lady Waldegrave because of her secret marriage with the Duke of Gloucester, which had much upset the court. (Earlier this year the Royal Marriage Act had been passed, against much opposition, to prevent such unions.) A notice in the *Public Advertiser* seems inspired by Gainsborough. It calls his portrait the best finished picture sent in this year. 'The same artist has been affronted in this manner several times before, from which they may depend upon his implacable resentment.' But he did exhibit four portraits and ten landscapes, two of which were watercolours varnished to look like oils. 'Very great effect,' noted Walpole, 'but neat like needlework.'

The newspaper critics began to attack his colours: 'a wash of purple into every colour', the result of a failure to clean his brush or 'a reflection of the purple colour from his eyes' (*Westminster Magazine*); 'Too glowing. It would be well for him to borrow a

little of the modest colouring of Sir Joshua Reynolds' (*Middlesex Journal*). From now on it became usual for journals to contrast him with Reynolds: which must have increased the competitive animosity between the two men. Cosmetics were often used lavishly at the time; Kitty Fisher is said to have died through the effects of the lead. Bath ladies were at times singled out for their painted faces. The fashion was to have a vivid red mouth, cheeks almost purple on white powder, hair heavily powdered. (We hear in 1765 of trouble in Vauxhall Gardens when a man said, 'Here comes another iron grey', using the cant term for a well-powdered lady.) Gainsborough reflects the mode since he paints women as they are. Reynolds seems to have modified the cosmetics of his ladies; but as his flesh colours have faded to a general sallowness it is hard now to tell.[11]

In 1770-1 Gainsborough had painted Alexander Fordyce. On 10 June 1772, Black Monday, the failure of the financial house of Neal, Jones, Downs and Fordyce brought ruin to thousands of people of means who had invested their property in the firm. In the first panic it was thought that most other private banks would also crash, but the Bank of England stepped in to prop up the shakier ones. Trade for a while was paralysed and public amusements stopped. Many actors had invested savings in the bonds of the bankrupt house and were relieved by benefit performances.

On 22 June Gainsborough wrote to Garrick, apologising for the delay over the copy of the portrait for Mrs Garrick. He says he had wanted a copy for himself, to hang in his own parlour, but he had failed with it. He begs Dear Mrs Garrick to hang her copy in the best light she can find. He guarantees that it will go next Wednesday by Wiltshire's flying waggon.

An undated letter seems to have been written soon after. He clearly has the accusations of overdone colour on his mind. In fact the letter reads like a meditation addressed to himself; as always he turns to music for the satisfying solution.

When the streets are paved with Brilliants, and the Skies made of Rainbows I suppose you'l be contented, and satisfied with Red ,blue & yellow – It appears to me that Fashion, let it consist of false or true taste will have its run, like a runaway Horse; for when Eyes & Ears are thoroughly debauch'd by Glare & Noise, the returning to modest truth will seem very gloomy for a time; and I know you are cursedly puzzled how to make this retreat without putting out your lights, and losing the advantage of all our new discoveries of transparent Painting etc, etc. How

to satisfye your tawdry friends, whilst you steal back into the mild Evening gleam and quiet middle time.

Now I'll tell you my sprightly Genius how this is to be done – maintain all your Light, but spare the poor abused Colors, til the Eye rests and recovers – Keep up your Music by supplying the place of *Noise* by more Sound, more Harmony & more Tune, and split that curs'd Fife & Drum. Whatever so great a Genius as Mr Garrick may say or do to support our false taste, He must feel the truth of what I am now saying, that neither our Plays, Painting or Music are any longer real works of Invention but the abuse of Nature's lights and [what] has already been invented in [former] times.

The excitement with which he writes is brought out by the omission of two words in the last sentence. In a postscript he says that the portrait was meant to hang breast-high and if it is hung higher it will look with 'a hardness of Countenance and the Painting flat'.

He was indeed going through something of a crisis. For example, in the near needlework drawings he found it hard to keep tonal control. He sought both to refine his technique and to expand strongly in composition and colour. From the early 1770s he was loosening his handling of paint as he strove to merge sitter and setting in a more active way. He responded both to Claude and to Rubens. In *Wooded Stream with Pastoral Figures and distant Bridge* the cows and rustic lovers are familiar, but there is a Claudean balance in the composition and the distance is clearly defined. In the drawing *Wooded Landscape with Figure and Ruined Castle* the melancholy mood suggests Richard Wilson. He is using black and white chalk, with stump, to build up strong masses; across the scene is a scatter of lights. The motif of ruins and the figure under them is not characteristic. He is submitting to elements of the period's sensibility that he had previously rejected. Above all he feels the need to link his rococo systems with the broader rhythms of Rubens and to deal boldly with colour without forced effects, 'the abuse of Nature's lights'.

In 1772 he painted Captain Matthew, who was wooing Elizabeth Linley. To escape the Captain she left for France, escorted by R.B. Sheridan (who fought two duels with his rival). Sheridan was still only an actor with little promise. Not long before the elopement Gainsborough showed his picture of the two Linley girls, a contrasted pair. Mary turns with mischievous eyes to the spectator; Elizabeth looks dreamily aside into the distance. A dense mass of foliage encloses them both.[12]

In October a young actor, John Henderson, appeared in *Hamlet* at Bath for Palmer at a guinea a week on a three-year contract. Fulcher says: 'Gainsborough, who was on intimate terms with the proprietor, and had free access to a box on all occasions, a courtesy which he repaid by the presentation of several beautiful pictures, was among the audience. So pleased was he with the abilities the young man displayed that he invited him to his house, painted his portrait, and before the first season was over became the firm friend and patron of John Henderson.' Henderson became known as the Bath Roscius; he also drew, etched, and wrote poems. Later, with Sheridan, he published *The Practical Method of Reading and Writing English Poetry*.[13]

We get a glimpse of Gainsborough at this period in a small lively sketch by Zoffany. The heavy nose and the alert eyes remind us of earlier portraits, but the scrutiny of the world has now become rather agitated. The pose of the head catches him at a moment of sharp response, seeking to find the witticism, the diverting comment, which will overcome his sense of an environing hostility. He is on the edge of growing excited, but at the next moment he may well revert to good humour.

On 29 January 1773 he wrote to Jackson, describing at length the method of his varnished drawings, in which white touches have a dry appearance of chalk rather than looking like oil paint. He tells how this effect is got by the use of Bristol chalk in an ingenious way. 'Swear now never to impart my secret to anyone.' On 14 April (this year or perhaps earlier) Thicknesse wrote to Cooke, 'Miss Tyler is sitting to Gainsbro – and Gainsbro has given me a head of his young Nephew painted I think better than ever Painter painted one before – it is more like the work of God than man, & the face tho very like has a Divine countenance.' Dupont indeed had a fine delicately featured face.

Elizabeth Linley had been singing in oratorios at Drury Lane. Fanny Burney wrote, 'The whole town seems distracted about her. Every other diversion is forsaken; Miss Linley alone engrosses eyes, ears, hearts.' She and Sheridan were married in April. Gainsborough was having his first open break with the R.A. Walpole wrote in his catalogue: 'Gainsborough and Dance, having disagreed with Sir Joshua Reynolds, did not send any pictures to this exhibition.' Gainsborough's boycott went on till 1777. As he took no part whatever in the business of the Academy, the trouble probably went back to the hangings of

1772; Dance had been on the Council that year.[14]

It was probably in 1773 that, on 1 April, Gainsborough wrote to Garrick about Henderson. 'I think he must be your Bastard. He is absolutely a Garrick through a Glass not quite drawn to its focus, a little mist hangs about the outlines, and a little fuzziness in the tone of his voice, otherwise the very ape of all your tricks.' All he needs is to be sharpened into a real Garrick. Gainsborough adds, 'I don't send to the Exhibition this year; they hang my likenesses too high to be seen, and have refused to lower one sail to oblige me.'[15]

We have two of his letters to Henderson this year. On 27 June, when Henderson was in London, he bids him take care in the hot weather, 'and don't run about London streets, fancying you are catching strokes of nature, at the hazard of your constitution. It was my first school, and deeply read in petticoats I am, therefore you may allow me to caution you. Stick to Garrick as close as you can, for your life.' He thinks Garrick will be 'fond of such an *ape*', but adds a warning against overeating. 'You'll get too fat when you rest from playing.' (Thicknesse says that Henderson was a greedy eater with very bad table-manners, and Romney's drawings of him as Falstaff show how fat he grew.) As with Jackson, Gainsborough shows a mixture of paternal solicitude and self-identification in writing to Henderson.

The last thing Garrick wanted was an ape; he was jealous of Henderson. He and Foote, dramatist-manager, heard him; but made no offer. Colman, manager of Covent Garden Theatre, refused to hear him. John Ireland tells of Garrick inviting him to breakfast and asking him to show his mimic powers. Henderson impersonated various actors; but when Garrick asked to see himself, he pleaded that he was beyond imitation. At last, however, he gave in and mimed Garrick. Everyone said the effect was perfect, except Garrick, who remarked, 'Egad!: if *that's* my likeness, *I* have never known it.' Henderson had to stay on at Bath till 1777.

On 18 July Gainsborough wrote again, with the same advice. 'In all but eating, stick to Garrick.' But at the same time he flatters Henderson on the way he swallows with good nature and eats with grateful countenance. Take no notice of fools who talk of copying. 'All is imitation.' The test is practice. 'Why only one Garrick with Garrick's eyes, voice, &c. One Giardini with Giardini's fingers, &c? But one Fischer with Fischer's dexterity, quickness, &c.? Or, more

than one, Abel with Abel's feeling upon the instrument? All the rest of the world are mere *hearers* and *see'rs.*'[16]

In early August he and Thicknesse went on a trip to Shobdon, Lord Bateman's seat, nine miles north of Leominster. Here the big brick mansion in Louis Quatorze style rose on the side of a hill from a balustraded terrace, with a wide view of farmlands and distant hills. In 1756 Lord Bateman had built there a Strawberry Hill Gothic church, and besides the formal gardens there were fine old oaks, cedars, Spanish chestnuts. On the 10th Thicknesse wrote to Cooke to say they'd been there a few days, but would return to Bath. On 6 September he wrote that they'd 'set out in a whisky tomorrow morning for Shobdon.' On the 22nd he sent an account of his misadventures:

I left Ld Bateman in a pet, for using indelicate (to say no worse) arguments to prevent Mr Gainsbro's accompanying me to your house. It seems Ld Bateman met with Mr Cecil, and Mr Cecil is an impertinent fool as well as a Blockhead, & therefore I hope you will show him silent contempt; Ld Bateman according to his annual custom made me very angry.

My scheme was in taking Gainsbro (& no man in England could have taken him but me) to get him to give me a sketch of Ld Bateman & Ld Bateman a sketch of My Lady, then to have taken him to Gaytre & have got one taken of you.

When my first two points were carried Ld Bateman did all he could to send me off by myself – & to prevent Gainsbro's going to your house etc. I therefore set off alone at five o'clock from Shobdon leaving a letter on his Lordship's table to tell him how exceeding ill I took his behaviour – that tho it might be an indifferent thing to him whether I travelled an hundred miles alone, or with a friend I loved, & to see a friend I loved too it was much otherwise with me, & beside he knew I was ill & had eat no meat for two days nor drunk any of his wine & ought not to have been left to travel alone, nor ought he to have urged Gainsbro to stay behind his time as every five days was a loss to him of at least an hundred pounds: & this I told him, & that I had promised Mrs Gainsbro to return him in the time agreed to.

A later letter, of October, added more details. Gainsborough 'drew at Shobdon a sketch of Ld and Lady Bateman, the latter of which I am sure my Ld would have given twenty guineas for had he seen it anywhere to have been sold, yet I complained, he brought the worst port to the Table and did not even open a bottle of Champagne which was upon the Side Board, for a public Day'. Thicknesse clearly felt insulted that he himself had not been better entertained. He stressed that he made it a rule in his own house to

give friends the best he had, whereas the Lord 'regulated his civilities and attentions to the fortunes of his visitors'. In his farewell letter he had explained that Gainsborough 'is, as he might see, a shy bashful man, that he could have opened *him* with a bottle of Champaigne at dinner and another at supper, for he knows he is one of the first geniuses in Europe; and I know he is the most generous man in the world'.

The walk to Leominster was eight miles, and he did it on foot. then, 'just as I got into a shayce to proceed to Monmouthshire, Gainsbro (who must have been upon the watch all night) missed, pursued, and overtook me.' He adds, 'Last night I saw a letter from Ld B. to Gainsbro, in which he says that he loves me, what a pity it is that so agreeable a man who possesses so many good qualities, should not be able to regulate his childish passions – passions which have lost him so many friends, and created him so many enemies, that when he next meets me he shall behave as if nothing has happened, and therefore not answer my letter.' These comments infuriated Thicknesse, who says that he acted not with passion but with silent contempt. 'I think I shall never darken a Lord's doorstep again.'17

Gainsborough himself was liable to steal away from a lord's house. Angelo cites Sir George Beaumont for the story of his visit to the seat of the Earl of Radnor in the West Country, where morning prayers were the custom. 'He was loath to attend for fear of laughing at the chaplain, whose puritanical physiognomy had whimsically wrought upon his imagination.' The Earl hinted that the service was held at nine. Gainsborough felt that he 'could not have attended even if the chapel altar-piece had been painted by Correggio.' A few days later the Earl reminded him, 'Perhaps, Mr Gainsborough, you geniuses having wandering memories, you may have forgotten.' 'No, my Lord,' he replied, 'I have not.' But he still did not attend.

As soon as the Earl and his household had assembled at their devotions, the chapel bell having ceased, Gainsborough rang the bell of the apartment in which he was painting, and desired the servant who attended to inform his Lordship that he was gone to breakfast at Salisbury. A few days afterwards, the eccentric genius sent a letter from Bath to inform his Lordship that he had returned home, adding that he knew he had stayed too long at the noble seat, and, taking his Lordship's second hint to be off, he had accordingly departed.18

We are reminded of the difficulty he often had not to laugh at the

faces of the sitters he studied, and his attempts to cover his feelings up by deprecating remarks.

We have a tale of one of Fischer's visits to Bath. He liked riding, says Fulcher, and kept 'several spirited animals in his stable. One day having an engagement at Salisbury, he mounted a favourite mare, and was riding over the plain when he overtook a heavily-laden waggon.' The mare shied and threw him. Unhurt, he rode on to Salisbury, whence he wrote a jesting letter to Gainsborough on the event. A day or two later he received a sketch of himself flat on the ground, with the quatrain:

> A runaway horse you here may see,
> A warning sent, my friend, to thee:
> Better it is to shun the wheel
> Than ride a blood to look genteel.

Among sitters this year was Dr Dodd, tutor of the fifth Lord Chesterfield, a popular pulpit orator and writer of religious books; for some time he had a chapel at Bath, and with his wife became friendly with the Gainsboroughs. When the portrait was done, Mrs Dodd sent 'an elegant silk dress' from London to Mrs Gainsborough; and on 24 November Gainsborough wrote to say that no one in the family had the elegance for such a dress, though Mrs Dodd's 'seeming to think them so is a compliment equal to the charm of her generous present.' Dodd won't be 'frightened at any flight that may dash upon paper', as he has heard Gainsborough; 'talk wild enough in a warm fit'. The latter would like to add some touches to the picture if he thought he could make it more handsome, 'though the ladies say it is very handsome as it is; for I peep and listen through the keyhole of the door of the painting room on purpose to see how you touch them out of the pulpit as well as in it. Lord! says one, what a lively eye that gentleman has!' He adds:

We are going this evening to the benefit of a certain musical gentleman who talks of talking by notes ere long, & then I suppose some extempore gentleman will preach by notes. We had a stranger that gave us a strange sermon last Sunday at our chapel, by which I fear our good friend is not well at Weston, but I shall take a walk to see him tomorrow. I have not neglected the chapel one day, *since I took a liking to it*, nor don't mean ever to quit it.

Some compliment to Dodd seems to lie behind these remarks; we hear nothing more of Gainsborough as a chapel-goer.

This year a visitor to his studio wrote a poem in the

Gentleman's Magazine. He attacks the connoisseurs and says that what he seeks is 'modern merit'. He describes the magic pieces that he had seen, vivid colours and elegant design, rich strokes of fancy, chaste and flowing line: 'All Nature's beauties in thy tints that glow.' The living landscape on the canvas wears 'New grace, and gay enchantment all appears.' He wants to rove to the Cottage, 'that scene of beauty and domestic love.' He has indeed grasped much of Gainsborough's driving impulses. In the early 1770s the Cottage begins to appear in the drawings as the symbol of a life in harmony with nature, opposed to the urban world of money and falsification; its door leads into another world.

In 1773 Philip de Loutherbourg, scene-master for Garrick at Drury Lane, 'first introduced his newly-invented transparent shades, so much admired afterwards in the popular exhibition called "The Eidophusikon", which by shedding on them a vast body and brilliancy of colour, produced an almost enchanting effect' (W. D. Parke). Gainsborough would have known and enjoyed these experiments from the outset, during his visits to London.[19]

About this time he painted the brewer, Sir Benjamin Truman. The man is bulkily planted in the scene, like Lord Kilmorey, but there is no effort to mitigate the heavily coarse and domineering face, which is both merged and contrasted with the powerful background of trees, wild skies, castle-forms. Men such as this Gainsborough could look fully in the face, whether he liked them or not, and record their crude energy; with many of his noble sitters, especially the men, he sees nothing in the countenances but an egotistical emptiness.

The landscape that stirred the poet with the vision of the Cottage was *The Woodcutter's Return*. The man is worn out by his hard day's work, but he has his cottage to return to. The union of peasant and nature is defined by the double lighting. The rich sunset-glow (painted in strong impasto) is contrasted and merged with the warm inner glow of the cottage. In *Peasants going to Market* there is a fine sweeping effect of dawnlight, and Gainsborough cannot resist giving much charm to his peasants (as, for example, the red-headed girl). But Hazlitt overstated the case when he said later that he adds 'the air of an Adonis to the driver of a hay-cart, and models the features of a milkmaid on the principles of the antique.' His figures are never like those of a *fête galante*, of the upper class masquerading in a pastoral. For the

most part his peasants have an earthy element and do not jar with the scene.[20]

In 1774, on 6 January, his bank account mentions the payment of £52 10s to Fischer. On 14 February he wrote to Giovanni Battista Cipriani, history and decorative painter, who had come to London in 1775 and who lived near Mewes Gate, Hedge Lane, Charing Cross. Gainsborough has been in London and complains that since his return he has done nothing but fiddle, 'so much was I unsettled by the continual run of Pleasure which my Friend Giardini and the rest of you engaged me in, and if it were not for my Family, which one cannot conveniently carry in one's Pocket, I should be often with you, enjoying what I like *up to the Hilt*.' (An earlier letter made clear that the last phrase refers to the penetration of a woman.)

Visits like this must have made him want to move to London from Bath, where it was so much more difficult to hide any backslidings. Also, patronage may have been drying up. Wright of Derby, who moved to Bath when Gainsborough left, in the hope of making money, wrote on 8 February 1775 that he had spent the winter season 'without any advantage'. His only sitter was the Duchess of Cumberland, and she reduced her order of a full-length to one of a mere head. 'The great people are so fantastical and whining they create a world of trouble.' The other artists are jealous. 'I have heard from London – and from several gentlemen here – that the want of business was the reason of Gainsborough's leaving Bath. Would I had known this sooner, for I much repent coming here,'[21] On the other hand Gainsborough had raised his prices substantially in 1770-2, and there are enough portraits of the early 1770s to suggest there was no slackening of orders. Still, he may have detected signs of things drying up. But no doubt his main reason for the move lay in the greater ease with which he could dodge off to enjoy himself in London, and in the feeling that the time had come to confront Reynolds and the others in the metropolis.

The account by Elizabeth Noel on 24 February suggests that many visitors still did not see much difference between him and Hoare:

Papa *wd* walk out this morn: which was very wrong, as *no one* can hardly against the wind. I went out with Br[other] and Bow[water?] to see Hoare's and Gainsbro's Pictures, & I lost my Hat petticoat head breath &

every thing, & do assure you I am still in a tremble from the effects of the wind, wch has blown away all my understanding... I saw nothing very capital at the two Painters, excepting a portrait of the Dss of Kingston in her weeds, looking at a picture of the Duke, her robes carelessly behind her on a Chair, & an Hour glass & Scull on the Table, all her own device – she wd have had some bones at her feet, but Hoare would not comply with *that*.

She had wanted her portrait as a *Vanitas* fancy piece; we see that Gainsborough was not the only artist who had to struggle with his sitters over their notion of an expressive portrait. When on 12 April Elizabeth Orlebar visited the two studios, she greatly preferred Gainsborough's portraits to Hoare's, 'as they are such very good likenesses.'

Gainsborough seems to have found little pleasure at home; Thicknesse says that his wife rarely allowed him to entertain friends there, so that the rigour drove him into irregularities abroad. Thicknesse is biased, but he seems correct enough in this comment. Mrs Gainsborough was clearly in many ways a devoted wife, though Cunningham idealized her when he wrote of 'a remarkably mild and sweet-tempered woman, who gave her husband his own way, and never thought to win him to her way except by gentleness. Indeed he was one of the last who would have brooked controul', being as proud as he was whimsical.

In his letter to Cipriani he shows how he enjoyed the company met in London. 'I beg my best compliments [to] you...and I should heartily rejoyce to see you all at Bath and will do my utmost to make the place agreeable to you.' He also gives a good account of his 'hums', the ways he ragged people: a trick that could at times be very irritating.

I wrote two Letters in the little time I have been at Home to Giardini, and the D——l a word can I draw from him, 'tho in my last I fudged up a pretence of wanting a tune which I left in his parlour that Abel wrote for me, only to extract a word or two against his will. I'm cursedly afraid that I have affronted him with an old trick of mine, commonly called a hum, for you must know I took it into my Head one Day as I was going in his Chariot with him to insinuate (merely to try his temper, and a damned trick it was) that the Picture he has of mine of the Cottage and ragged family was only a *Copy*. I believe you can set him right about that, and he was cunning enough not to seem the least hurt. I repented as I generally do very soon after my folly, and the more so as he has always been the politest creature to me I ever was acquainted with. I wish my Dear Cip you could pump him a little and give me a line. I have a tollerable Picture

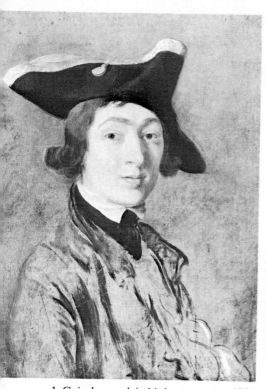

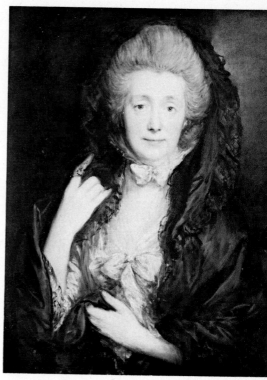

1 Gainsborough in his late twenties, 1754
Marquis of Cholmondeley, Houghton
(Photo: Sydney W. Newbery)

3 Portrait of the Artist's Wife, *c.* 1778
Courtauld Institute Galleries, London

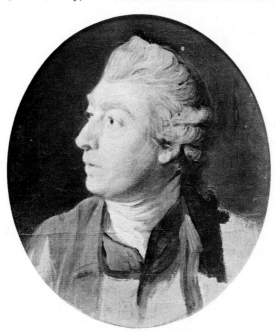

2 Zoffany: Gainsborough, early to mid forties *c.* 1771–2
National Portrait Gallery, London

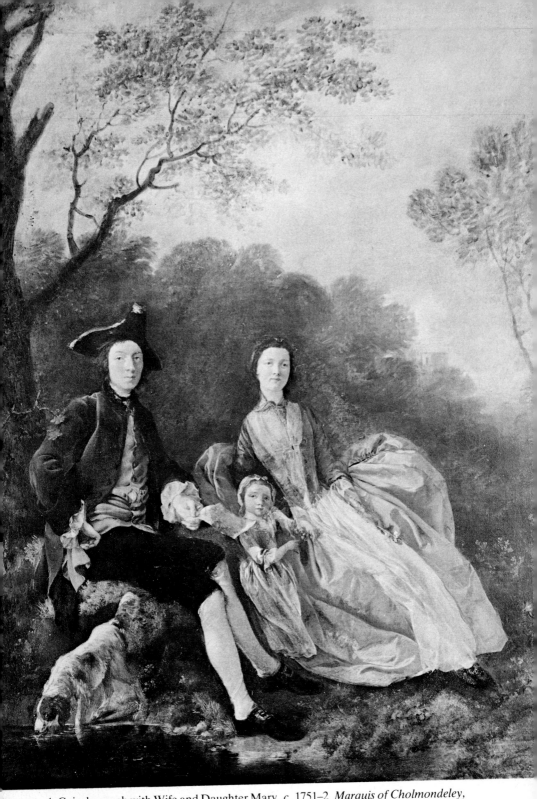

4 Gainsborough with Wife and Daughter Mary, *c.* 1751–2 *Marquis of Cholmondeley, Houghton* (Photo: Sydney W. Newbery)

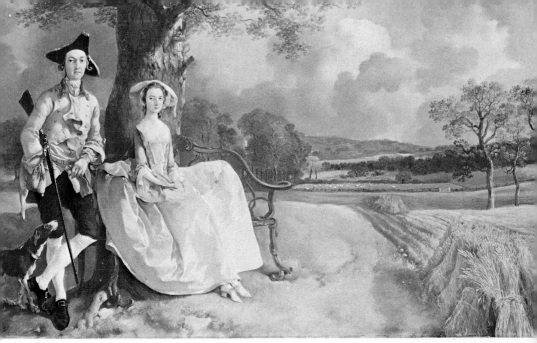

5 Richard Andrews and his wife Frances, *c.* 1748–9 *National Gallery, London*

6 Wooded Landscape, known as Cornard Wood or Gainsborough's Forest, 1748 *National Gallery, London*

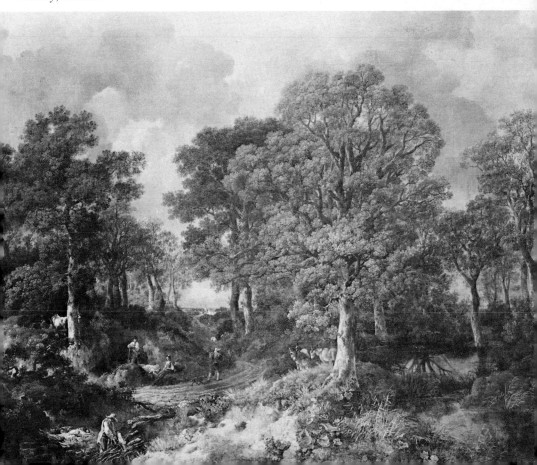

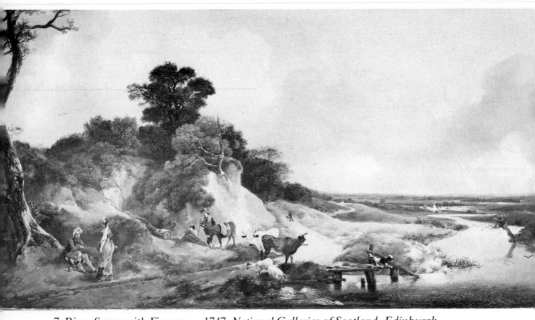

7 River Scene with Figures, *c.* 1747 *National Galleries of Scotland, Edinburgh*

8 The Harvest Waggon, *c.* 1784–5 *Art Gallery of Ontario, Toronto. Gift of Mr and Mrs Frank P. Wood, 1941*

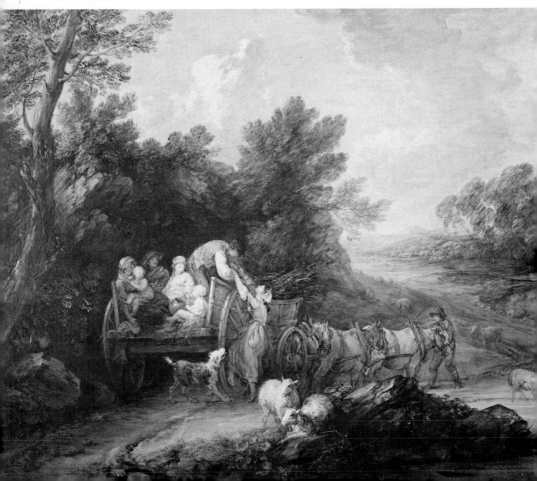

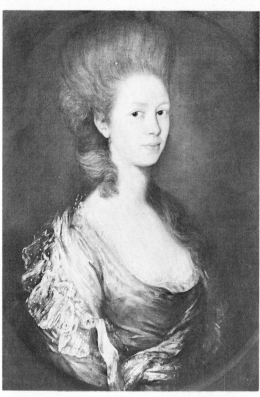

9 Portrait of Mrs Samuel Kilderbee,
c. 1757, altered 1770s *Ipswich,
Christchurch Mansion* Ipswich Borough
Council (Museum) Photo: N. J. & L.
Cotterell

10 BELOW LEFT: Portrait of John Joshua
Kirby mid-1750s *Victoria & Albert
Museum, London*

11 BELOW RIGHT: Portrait of Mrs John
Kirby before 1750 *Fitzwilliam Museum,
Cambridge*

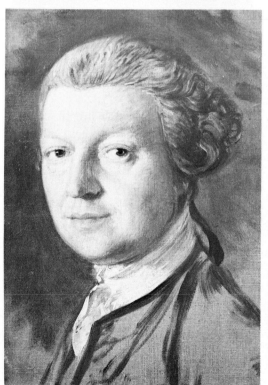

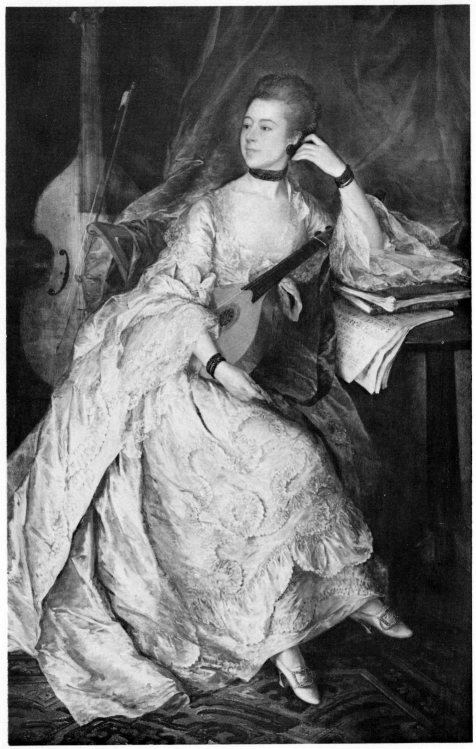

12 Portrait of Ann Ford, Mrs Philip Thicknesse, 1760 *Cincinnati Art Museum, Ohio.*
Bequest of Mary M. Emery

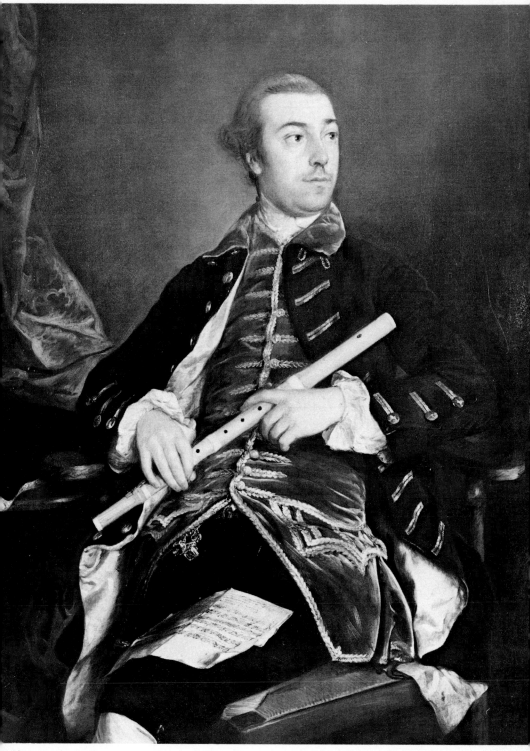

13 Portrait of William Wollaston *c.* 1758–9 *Ipswich, Christchurch Mansion* Ipswich Borough Council (Museum) Photo: N. J. &. L. Cotterell

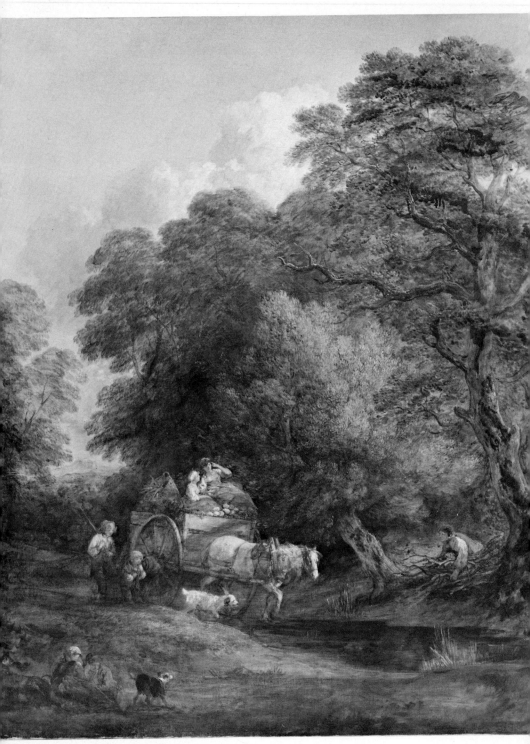

14 The Market Cart, 1786 *The Tate Gallery, London*

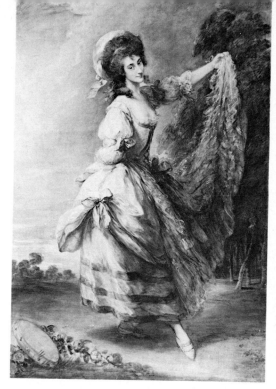

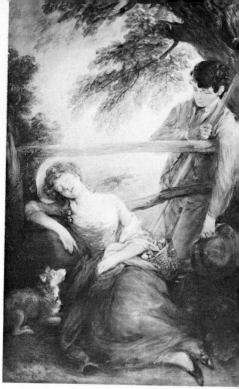

15 ABOVE LEFT: Portrait of Madame Giovanna Baccelli, 1782 *The Tate Gallery, London*
16 ABOVE RIGHT: The Mushroom Girl, 1785 *Courtesy Museum of Fine Arts, Boston, Mass,*
Hopkins and Sweetser Residuary Funds
17 BELOW LEFT: Portrait of Mrs Graham, RA, 1777 *National Gallery of Scotland, Edinburgh*
Photo: Annan
18 BELOW RIGHT: Portrait of Mrs Richard Brinsley Sheridan, RA, 1783 *National Gallery of Art,*
Washington, Andrew Mellon Collection 1937

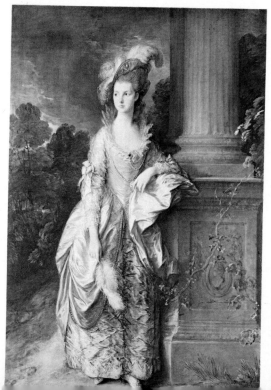

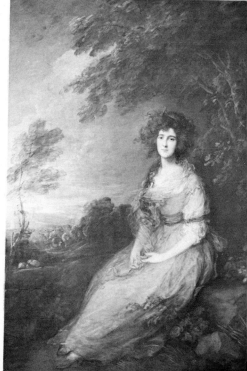

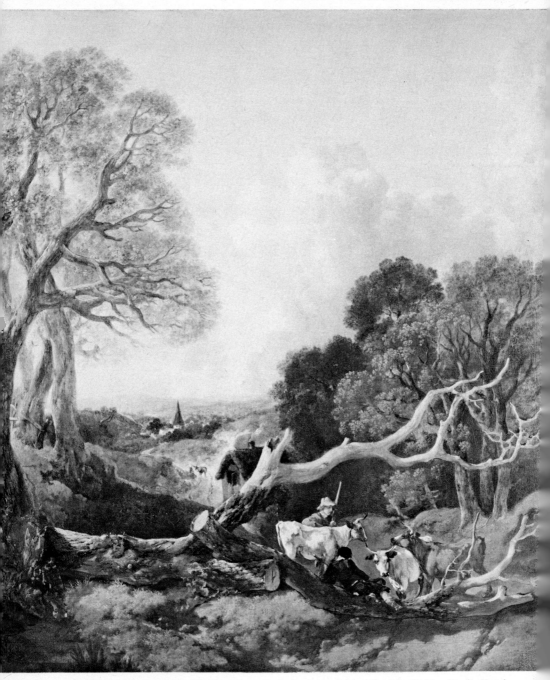

19 The Fallen Tree, c. 1748–50 *The Minneapolis Institute of Arts, The John R. Van Darlip Fund*

20 The Mall in St James's Park, London, 1783 *The Frick Collection, New York*

21 BELOW LEFT: Diana and Actaeon unfinished 1788 *Reproduced by Gracious Permission of Her Majesty The Queen*

22 BELOW RIGHT: Cottage Girl with Dog and Pitcher, 1785 *The Medici Society Ltd, London*

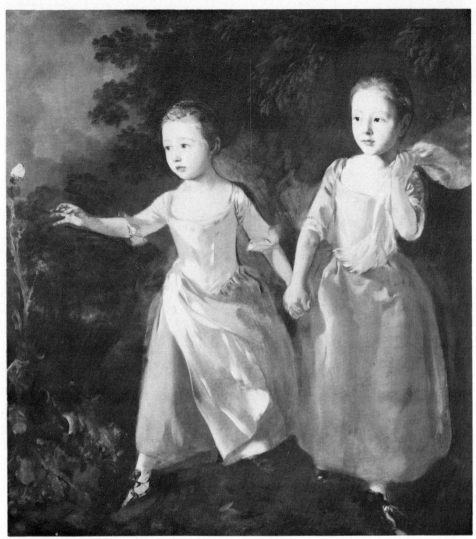

23 Chasing Butterflies late Ipswich period *National Gallery, London*

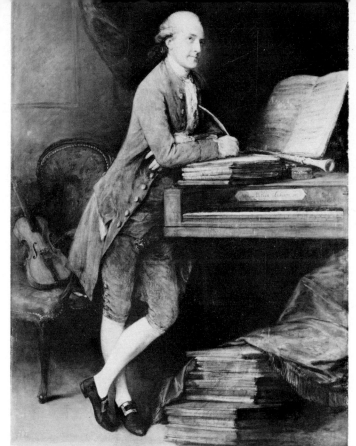

24 Portrait of J. C.
Fischer, RA,
1780 *Reproduced by
Gracious Permission of
Her Majesty The Queen*

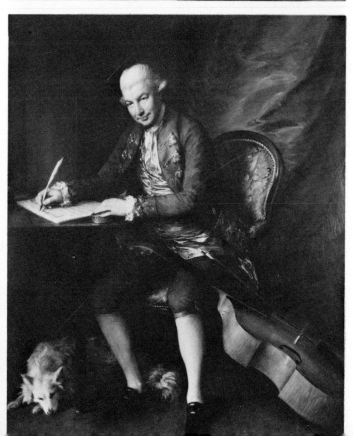

25 Portrait of C. F.
Abel, RA, 1777 *The
Henry E. Huntington
Library and Art Gallery,
San Marino*

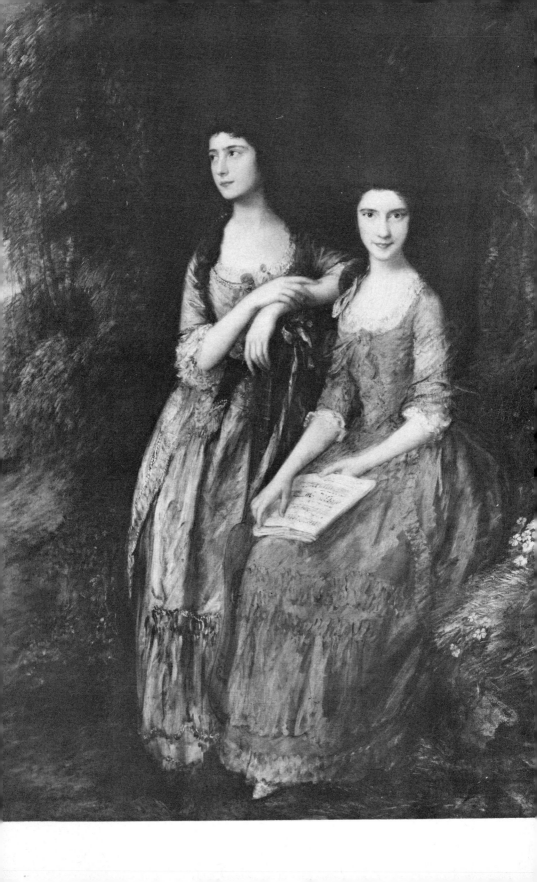

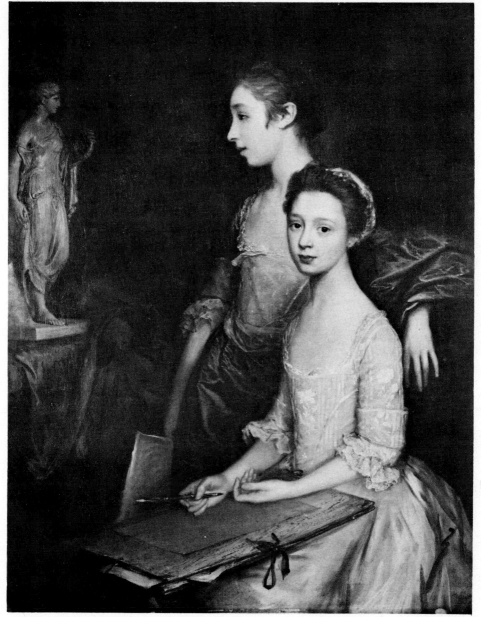

27 The Artist's Daughters, Mary and Margaret *Worcester Art Museum, Worcester, Mass.*

26 OPPOSITE: The Linley Sisters, RA, 1772 *Dulwich College Picture Gallery, London*

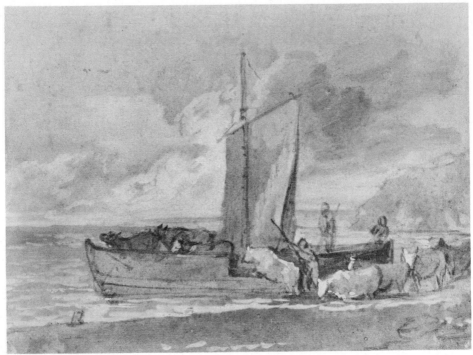

28 The Cattle Ferry, mid to late 1780 *Courtesy City Museums and Art Gallery, Birmingham*

29 Wooded Landscape. Drawing, pen and brown ink with grey and brown washes, later 1760s
Courtesy British Museum, London

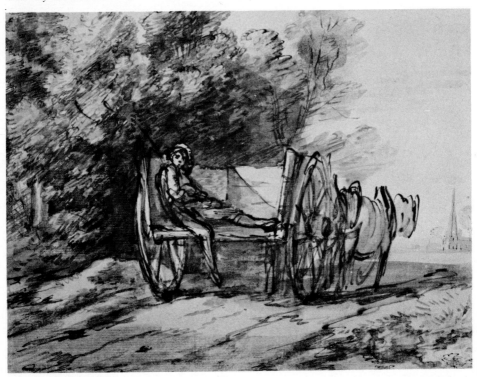

of another rural subject which I entend for him but I would not have him know it.

Jon Bee, in *Slang*, 1823, defines a hum as 'a whispered lie, and he is a *humbug* who has recourse to the meanness.' The reference to the Cottage and ragged family shows how important this theme had become to him. Perhaps he was already using his nephew Dupont to make copies.

In March Giardini chose a Broadwood harpsichord for Gainsborough and arranged despatch to Bath; it went off on the 11th. Clearly he was not yet contemplating a move. On 4 March Thicknesse had written to Cooke, asking him to pay 'that impudent fellow Abgood for a toothpick case Mr Gainsbro bought of him but forgot to pay'. Abgood had written a most insolent letter to Gainsborough 'charging him with a kind of fraud, and put at bottom *Abgood Davies & Co.* I sent W. Davies a copy of the letter and he has made a civil apology to Gainsbro.' It looks as if there had been a visit to Wales.

Garrick had written to Palmer, remarking that Gainsborough hadn't looked him up while in London. Gainsborough wrote to him in the extravagant way he affected when he lacked plausible excuses. 'Had I dreamt that it wd have afforded the least satisfaction to my good Friend that I should have poked my long neck and hatchet Face into his doors, in the common how d'e do way, not all the Giardini's on Earth should have prevented me; but I did not know that a first Man, assured of the affection as well as admiration of all sorts and sizes, expected every common hack to interrupt Him in his precious Moments.'

On 20 June Kirby died and was buried in Kew churchyard. In August Thicknesse at last quarrelled with Gainsborough; the only surprising thing is that their relationship had gone smoothly so long. On 4 August Thicknesse wrote to Cooke that his wife

has quarreled with Gainsborough – this has vexed me, yet I think she had some cause, – he fell in love with her viol de gamba (& it certainly is the finest in the world) – he more than once *said to me* he would give an hundred guineas for it: I persuaded her to give it to him: & she did upon condition he painted my picture at full length. When he had got my face in & my body sketched, with my dog, *Boy*, he, instead of finishing it, set it by, to paint Fischer the Hautboy player, at full length: & painted him in Scarlet, laced, like a Colonel of the Guards: – now Mrs Thicknesse who happened to see Fischer in a *laced coat*, finished (a picture not to be paid for, & mine in plain *ked kigg, it turned her sick*: so without saying

anything to me, she wrote him a saucy [*tear*], & he sent the Viol back. However he and I are as we were, and I have insisted upon it, that he finishes the picture very well, & sends it to Mrs Thicknesse, because I asked him where he could find a woman who had such an instrument to show herself to advantage upon, who would have given it up, for the picture of an old superanuated invalide soldier – & that I should answer the Question – no where but in the Crescent at Bath. He is ashamed, for he shall never have the viol now, & I don't care a farthing about the picture – yet I have been vexed about this business.

On 21 September he sent more news of the dispute:

I wrote a good humoured letter to Gainsbro yesterday & desired him to give me the *Drownded man* unfinished, and just as it was: he was so angry at my repeating Mrs Thicknesse word *Drown'd* that he sent it directly unfinished, & said he loved me & always should, but that Mrs Thicknesse and I had better have let alone some of our Compliments, & desired that no Bath Painter might be employed to finish it as he rather wished the cause of our dispute should not be known. I told him he might rest assured that no Painter in Bath or in Great Britain should ever touch it during my life, & after my death there would be no danger [*tear*] it is too well done to let any men [breathe?] into my nostrils to fetch me to more life. Indeed I should think it better as an easy sketch than if he had finished it. For a compleat whole length picture does nothing – says – *look at me*! now I repeated *Drowned* in order to soften of Mrs Thicknesse in the background of her *note to him*: It was an expression severe enough, had it been said to a daubing painter, but Gainsbro should not have felt it.

In his little book on Gainsborough Thicknesse blows up the dispute and makes it the cause of the artist leaving Bath. But in a letter to Cooke on 23 November he merely says, 'Gainsbro is gone and settled in London', without linking departure and quarrel. In the book he makes the trouble last a long time and adds many details. Gainsborough dropped in at his house and offered a hundred guineas for the viola. The Thicknesses were contemplating a move, so invited the Gainsboroughs to dinner, and after supper Ann asked the artist to play the instrument. 'This I say was *after supper*, for till poor Gainsborough had got a little borrowed courage (such is his natural modesty) he could neither play *nor sing!* He then played, and charmingly too, one of his dear friend Abel's lessons.' Ann said he could keep the viola and should paint her husband when he had leisure. Gainsborough was transported, but said, 'Keep me hungry! keep me hungry! and do not send the instrument till I have finished the picture.' However, Ann sent it next morning. He began the portrait, soon finished

the head, and 'rubbed in the dead colouring of the full length.' Then, a considerable time later, the Thicknesses saw the Fischer portrait, while Thicknesse on the canvas, through lack of light and shade in the drapery, had the look 'of a drowned man ready to burst, or rather of a ragged body which had been blown about upon a gibbet on Hounslow Heath.' Ann burst into tears and wrote to Gainsborough asking him to put the work away in an attic and not leave it by Fischer's portrait. He did so and returned the viola. Next morning at the Assembly Rooms Thicknesse asked him how he could have acted so imprudently. He admitted he was wrong and should never have asked for the viol that Ann had played since childhood. He had long decided to return it with the portrait. Thicknesse goes on: 'In a few days after, we met, and shook hands, and seemed as good friends as ever; but days, weeks and months passed and no picture appearing, either at his house or mine, I began to think it then became my turn to be a little angry too; for I suspected, and I suspected right, that he had determined never to touch it more!' So he wrote in protest. He also heard that a tale, attributed to him, was going the rounds of the coffee-houses: that at Ipswich, in the early days, the Gainsborough children ran about the streets without shoes or stockings. Dr Schomberg had told Gainsborough that Thicknesse started the story off – in the hopes (says Thicknesse) of receiving himself the drawings that usually came his way. However, Gainsborough assured him that he did not believe him capable of so gross a falsehood.[22]

Then, after the unfinished picture arrived, Thicknesse felt upset, sick, every time he went into the room where it was. He asked Ann to return it. She agreed if she were to send Gainsborough a card with it. 'In that card she bid him take his brush, and first rub out the countenance of the truest and warmest friend he ever had, and so done, to blot him for ever from his memory.' Gainsborough, on getting the card, left at once for London, took the house in Pall Mall, and, returning to pack his things, sent a note, 'God bless you and yours, I am going to London.'

Thicknesse has drawn out and dramatized the incident, as usual stressing his own important role in Gainsborough's life. The latter indeed seems to have acted rather quickly; but no doubt, once deciding to go, he wanted to get things over as soon as possible. His haste is suggested by the fact that in 1801 the antiquarian John Britton saw in a house in the Circus more than fifty of his

paintings and sketches.

He took with him Wiltshire's grey horse. As he could not induce Wiltshire to accept fifty guineas, he sent him *The Harvest Waggon*.

8 London (1774-1780)

S chomberg House, where Gainsborough now lived till his death, had been the residence of the Dukes of Schomberg; then it passed through Lord Holdernesse in 1765 to John Astley, painter and fellow-student of Reynolds under Thomas Hudson. Astley, who had married a rich widow, paid £5,000 for the house and spent the same sum in making alterations including an attic storey with a wide view of London. Gainsborough had thus secured a rather grand situation in the very midst of the fashionable world. The house faced north, but no room at the front was suitable for a studio except for small works. Gainsborough's section, the west wing, had a rather short frontage, a third of the space taken up at each storey by a small room projecting over the entrance. With his methods involving the use of a six-foot brush and the bringing in of pigs and donkeys as models, he needed a good-sized room to work in; and he probably had a large one built over the garden. The house's entrance was into a square hall with a long narrow room on one side looking out on Pall Mall. The hall led into a larger one from which a circular staircase rose to the upper storeys. This inner hall had almost the width of the house and was lighted by a glass roof; a good place for showing pictures. From it a long passage led to the room over the garden. (William Beechey mentions the passage as hung with unsold landscapes.) The room was some 35 feet by 25, with windows looking south, though perhaps at this time there was also a window facing north or east. There was a similar room above; and in one of these two rooms he must have showed his work when in 1784 he quarrelled with the R.A. Only a few yards

away were Christie's salerooms, where he spent many hours of relaxation. The tenancy was dated from Midsummer 1774. The Westminster rate-books show the rent as £150 yearly till 1783; then it was £112.

Thicknesse claims to have started Gainsborough off in London by urging Lord Bateman 'to give him countenance and make him known'. In 1773 we saw him cursing this Lord, to whom in any event Gainsborough was well known. His works shown at the Society of Artists and the R.A. had made his name familiar to all persons interested in art. Thicknesse adds: 'Nor did he *background-brush* my countenance, as Mrs Thicknesse had desired, for some years afterwards I asked him whether he had so done. "No, no," said he, *colouring*, for he was a good colourist, "one day or other, some of your family or friends will be glad to it." But I now suspect it has had the brush or the scissors, a fate many of his portraits have met in the course of forty years. Jealousy or hatred has occassioned many such murderous deeds.' He is getting in a cut at Mrs Gainsborough. On 10 December Gainsborough was appointed to the Council of the R.A. With him were elected Dance, Cosway, and the miniaturist, J. Meyer.

London was a very different place than it had been in the 1740s. Gainsborough had kept in touch with it fairly steadily since he left in on return to Sudbury, but now he was back in the midst of it and must have felt a different relationship to the city than when he was a casual visitor. Not only was it much larger and more complex; the art-world had quite changed since the days of the St Martin's Lane Academy. Hudson was alive, but near his end; his work and the Kneller tradition no longer set the standard. Hogarth, Ramsay, Hayman, Arthur Devis and many others had widened the scope of art; and Reynolds and Romney, while adapting portraiture to the needs of the new middle class, at the same time preserved as much of the aristocratic tradition as they could on the new level. Reynolds was jealous and somewhat afraid of Gainsborough as an odd element hard to categorize. But he was too intelligent not to see that his rival had great powers even if he could not quite approve of them. He once remarked to Sir George Beaumont as he went round one of the exhibitions, 'I cannot. imagine how he manages to produce his effects.' Gainsborough's comment on Reynolds was, 'Damn the fellow, how various he is.' They represented opposed trends. Reynolds wanted to save as much of the grand manner as he could success-fully adapt in terms of portraiture; Gainsborough wanted to trust

to his sense of brushwork, of the lustre of individuality.

The moment was not a good one in the London art world. Sir William Chambers had written on 29 April 1774: 'We are over-stocked with Artists of all Sorts.' Bate later admitted that the earlier period at Pall Mall was spent 'not very profitably'. Thicknesse said with some truth, 'He possessed least of that worldly knowledge, to enable him to make his way into the notice of the GREAT WORLD.' But he had a guileless system of his own, combining boldness and humility, irony and forthrightness, on the lines we have seen in his letters.

Meanwhile his musical friends got him a job that was likely to have him talked about. On 3 February 1775 Mrs Harris wrote to her son in Berlin:

Your father and Gertrude attended Bach's concert Wednesday; it was the opening of his new room, which by all accounts is the most elegant room in town; it is larger than Almack's. The statue of Apollo is placed just behind the orchestra, but it is thought too large and clumsy. There are ten other figures or pictures bigger than life. They are painted by some of our most eminent artists; such as West, Gainsbro', Cipriani, &c. These pictures are all transparent and are lighted from behind; and that light is sufficient to illuminate the room without lustres or any candles appearing. The ceiling is domed and beautifully painted, with alto-relievos in all the piers. The pictures are chiefly fanciful. A Comic Muse by Gainsborough is most spoken of.

He would have been excited by the use of transparencies. Jackson tells us of one of his devices: 'Gainsborough once dealt in red shadows and as he was very fond of referring everything to nature, or, where nature was not to be had, to something substituted for it, he contrived a lamp with slides painted with vermilion, which illuminated the shadows of his figures, and made them look like the splendid impositions of Rubens.'

He had nothing in the R.A., where Reynolds exhibited his *Mrs Sheridan as St Cecilia*; newspapers regretted his absence and that of Dance and Cipriani. The Linleys were in London. Tom Linley had written effective music for Sheridan's *Duenna*; but it was the big success of *The Rivals* this year that reconciled old Linley to Sheridan. In April Gainsborough was helped in his new start by some royal patronage. The *Morning Chronicle* noted: 'The Duke and Duchess of Gloucester are often going to a famous painter's in Pall Mall; 'tis reported that he is now doing both their pictures, which are intended to be presented to a great Lady.' We can be sure that Kirby had talked enthusiastically of

Gainsborough to the royal family; and the hope of getting the benefit of such recommendations may have been at least one of the motives drawing him to London. [1]

About this time he painted the recently-married Mrs Lowndes-Stone. Here we see a decisive advance. He is using still all the charms of Van Dyck, but he has at last managed to place the figure securely in the landscape. The brushwork unifies the textures of skin and clothes with those of foliage and sky. In particular the curls and curves of hair are linked with those of leaves. The weight of the body is set firmly on the earth in which the trees are growing. The young woman has the half smiling uncertain look of so many of Gainsborough's women, and the dog stepping at her side has something of a parodying echo of her movements. Later in 1775 George Selwyn took his (supposed) daughter to sit. 'I have been with Mie Mie to Gainsborough, to finish her picture.'

On 7 June, Gainsborough had a brush with highwaymen. Late in the evening he was homing in a chaise when he was stopped on the main western road, just before Hammersmith, by two horsemen who took his watch and two guineas. J. C. Bach in a carriage just ahead was robbed by the same men. Abel was there too but does not seem to have been robbed. A day or two afterwards the thieves were caught with some of the stolen goods on them. They – Henry McAllister and Archibald Birdwood – were traced through the hostler of the Star Tavern, Blackman Street, Borough, from whom their horses were hired. They were lodging nearby, in a surgeon's house, in Kent Street. In their rooms Bond, the magistrate's clerk, found Bach's watch, chain, and seals. Gainsborough's watch was in Birdwood's pocket. Both men were committed by Fielding and twice tried at the Old Bailey, before Baron Hotham for robbing Gainsborough and before the Recorder for robbing Bach. In evidence Bach told how he and his friends were coming to town when they were attacked by a highwayman half a mile from Hammersmith. 'He cried, "Stop, your money or your watch!" That waked me, for I was asleep in my carriage. He took my watch and a guinea; the business was very soon over. I should not know the person who robbed me. It was almost half-past nine or ten o'clock.' Before the Baron they were charged: 'that they in the King's highway in and upon Thomas Gainsborough did make an assault, putting him in corporeal fear and danger of his life, and taking from his person a watch with the inside case made of metal and the outside case

covered with shagreen, and two guineas in money.'

But though the watch, which in fact belonged to Gainsborough Dupont, was found in Birdwood's pocket, both men were acquitted, and Birdwood alone was found guilty of robbing Bach. However, there were other charges and at the end of the session both men were sentenced to death; but there is record only of McAllister being hanged at Tyburn on 16 August.[2]

At some time in Gainsborough's Bath period his sister Mary had come to Bath, where she married a dissenting minister, Gibbon, and let apartments. Now he wrote to her. Despite her strong religious convictions he was able to open his heart very frankly to her in the discussion of family troubles. On 13 November 1776 he thanked her for a gift of fish, which Humphry, visiting London, had also partaken of. 'He went home to Henley to-day, having been with us ten days, which was as long as he could well be absent from his business of collecting the tolls upon the river.' Humphry's wife had recently died. 'We did all we could to comfort him, and wish him every possible happiness, as he is a good creature.' Mrs Gainsborough had been ill with a disease prevalent in London: 'a sort of cold, attended with a bad cough, and it has gone through our family, servants and all; but, thank God, we are upon the mending hand.' He mocks gently at Mary's religious feelings:

I am glad to hear that business in the lodging-house way goes on so well. I know you would willingly keep the cart upon the wheels, till you go to heaven, though you deserve to ride there in something better. I told Humphry you were a rank Methodist, who says you had better be a Presbyterian, but I say Church of England. It does not signify what, if you are but free from hypocrisy, and don't set your heart upon worldly honors and wealth.

An undated letter to Mary can best be considered here. He writes frankly about his wife, falling into touches of a pietist idiom as he seeks to explain himself. Humphry had been with them, 'as happy as could be expected'. He himself feels that he has done his utmost:

against all rebuffs and discouragements possible from Ignorance and evil spirits, and at the last hazard and tryal of my own Constitution, with this reward, that *I stand now just where I did*; whereas if I had had my own way (with all my mighty Vices) I should have wasted many thousands – My present situation is that of being as much encouraged as the World can bestow, with every success in my business, but in the other scale,

counteracted with disobedience pride and insolence, and eternal obraidings & reflections – I was induced to try how far Jealousy might be cured by giving into her Hands every Farthing of the Money as I earned it, but very soon found that (as a punishment for so unmanly a condescention) instead of convincing, it was a further incouragement to Govern me, and invert the order of nature in making the Head the foot and the foot the Head; so that now I have taken the staff into my own hands again, and purpose (God willing) to try my own Virtue and strength to walk straight and do the best for my Children let them follow the Vanity of the Age, or weakness of their leader as they will – I am at an Age now to see right from wrong; and have a pretty good knowledge of Mankind – and I trust if I do my best, all will be well through the merits of Him who hath promised to make good our failings if we trust sincerely.

It is clear that he is not only in conflict with his wife over money and his ways of wasting it, but also with her and the two girls over their social life, their desire to follow the Vanity of the Age.

On 6 December the Royal Society of Arts resolved to approach him to carry out a commission given two years back to Dance: a posthumous full-length portrait of Lord Folkestone in his coronation robes (to be based on a 1749 three-quarters length by Hudson). Dance had pleaded illness and pressure of work, and gave up the commission. Gainsborough agreed to take over and complete the picture by the start of next October. On 4 December the R.A. Council decided that Gainsborough, having declined any office and never attending any meetings, was not eligible for the next year. On the 11th the General Assembly overrode the decision; but he never served and his name was not again put on the list, as the laws of the Academy laid down. (Not till 1800 was the original plan of succession by rotation properly observed.)[3]

On 26 December he wrote to Mary again. 'What will become of me time must show.' Things were going satisfactorily, but 'I have built upon sandy foundations all my life long.' He was spending a full thousand pounds a year. 'Had I been blessed with your penetration and blind eye towards fool's pleasures, I had steered my course better, but we are born with different Passions and gifts.' Then he sends bad news which he asks her to keep to herself.

If I tell you my wife is weak but good, and never much formed to humour my Happiness, what can you do to alter her? If I complain that Peggy is a sensible good girl, but Insolent and proud in her behaviour to me at times, can you make an arm long enough to box her ears for me while you live at Bath? And (what has hurt me most of late) were I to unfold a secret and

tell you that I have detected a sly trick in Molly by a sight I got one of her Letters, forsooth, to Mr Fischer, what could all your cleverness do for me there? and yet I wish for your Head-piece to catch a little more of the secret, for I don't choose to be flung under the pretence of Friendship. I have never suffered that worthy Gentleman ever to be in their Company since I came to London; and behold while I had my eye upon Peggy, the other Slyboots, I suppose, has all along been the Object. Oh, d——n him, he must take care how he trips me off the foot of all happiness.

He adds, 'She does not suspect I saw the letter.' Mary was now in her twenty-third year. Clearly Gainsborough had been carefully guarding the girls. We have his early remarks on the dangers that would hem them in if they painted portraits or the like. His fears may well have been accentuated by Margaret's breakdown. There is practically no reference to the girls in the correspondence of his friends or the many memoirs of the period. Yet both girls were comely and accomplished, and as his daughters they must have been the object of a certain amount of interest. Fulcher gives an account of Mrs Gainsborough that seems based on family traditions:

Soon angry, he [Gainsborough] was soon appeased, and if he was the first to offend, he was the first to atone. Whenever he spoke crossly to his wife, a remarkably sweet-tempered woman, he would write a note of repentance, sign it with the name of his favourite dog, 'Fox', and address it to Margaret's pet spaniel, 'Tristram'. Fox would take the note in his mouth and duly deliver it to Tristram. Margaret would then answer – 'My own dear Fox, you are always loving and good, and I am a naughty little female ever to worry you as I too often do, so we will kiss and say no more about it; your own affectionate, Tris.'

This year Dupont, now a lad of seventeen, was admitted as student at the R.A., on the same day as John Hoppner.

James Christie had soon become a good friend of Gainsborough. Bred to the navy, he had resigned his commission to take up auctions. Friend of Garrick and Reynolds, he became a good judge of painting and used to consult leading artists about pictures consigned from abroad. Many years later a writer in the *Library of the Fine Arts* recounted of Gainsborough: 'Whenever he appeared, either at a morning lounge, at Christie's amidst the enlightened and polite, or at My Lady's midnight rout surrounded by bowing beaux and curtsying belles, his gaiety enlivened every group. He knew everybody and everybody knew him; he was, however, most at home with the worthies of the auction room.' For some years he and Garrick were often

together there, and the amusement they caused gave zest to the proceedings. Christie remarked that the presence of the choice pair added 15 per cent to his commissions on a sale.[4]

More than ever Gainsborough threw himself into the musical world. J. T. Smith tells how he was taken to Pall Mall by the sculptor Nollekens.

The artist was listening to a violin, and held up his finger to Mr Nollekens as a request for silence. Colonel Hamilton was playing to him in so exquisite a style that Gainsborough exclaimed, 'Now, my dear Colonel, if you will but go on I will give you that picture of the ''Boy at the Stile'', which you have so often wished to purchase of me.' Mr Gainsborough, not knowing how long Nollekens would hold his tongue, gave him a book of drawings to choose two from, which he had promised him. As Gainsborough's versatile fancy was at this period devoted to music, his attention was so riveted to the tones of the violin that for nearly half an hour he was motionless, after which the Colonel requested that a hackney coach might be sent for, wherein he carried off the picture. It has been engraved by Stow, a pupil of Woollett. Mr Gainsborough, after he had given Mr Nollekens the two drawings he had selected, requested him to look at the model of an ass's head, which he had just made.
Nollekens; 'You should model more with your thumbs; thumb it about till you get it into shape.'
Gainsborough: 'What! – in this manner?' having taken up a bit of clay, and, looking at a picture of Abel's Pomeranian dog which hung over the chimney. 'This way?'
'Yes,' said Nollekens; 'you'll do a great deal more with your thumbs.'
Mr Gainsborough, by whom I was standing, observed to me, 'You enjoyed the music, and I'm sure you'll long for this model; there, I will give it to you'; and I am delighted with it still. I have never had it baked, fearing it might fly in the kiln, as the artist had not kneaded the clay well before he commenced working it, and I conclude that the model must still contain a quantity of fixed air.
Colonel Hamilton above mentioned was not only looked upon as one of the first amateur violin players, but also one of the first gentlemen pugilists. I was afterwards noticed by him as an etcher of landscapes, and have frequently seen him spar with the famous Mendoza in his drawing-room in Leicester Street, Leicester Square.

Angelo's father used to lend his country-house to Bach and Abel, and Gainsborough often joined them there. Angelo, discussing the common belief that not one musician in twenty cared a straw for pictures, describes the relations of the three men.

Bach and Abel, who were as intimate, as inseparable indeed, as Cipriani

and Bartolozzi, were the only exception to this remark. These two distinguished musicians were connoisseurs of pictures and prints and in my younger days I remember the many happy hours, for many a winter season, that these four worthies passed under my father's roof in Carlisle Street.

Gainsborough, as is sufficiently known, was an enthusiastic admirer of music, and, though, certainly no musician, yet his love of sweet sounds was such, that he had tried his native skill upon almost every instrument. He was too capricious to sit and study any one methodically, though, having a nice ear, he could perform an air on the fiddle, the guitar, the harpsichord, or the flute. Under Fischer, his son-in-law, he did take a few lessons upon the hautboy or clarionet, I forget which, but made nothing of it. He, however, could modulate to a certain degree on a keyed instrument and used frequently to chaunt any rhodomontade that was uppermost, accompanying himself with the chords on my mother's pianoforte.

Bach, who had a true German share of dry humour, used to sit and endure his miserable attempts, and, laughing in his sleeve, exclaim, 'Bravo!' while Gainsborough, not at all abashed at his irony, would proceed, labouring hard at any particular key, be it major or be it minor, and drolly exclaim, 'Now for Purcell's chaunt; now a specimen of old Bird.'

'Dat is debelish fine,' cried Bach.

'Now for a touch of Kent and old Henry Lawes,' added Gainsborough, when Bach, his patience worn out, would cry:

'Now, dat is too pad; dere is no law, by Goles, why the gombany is to listen to our murder of all these ancient gombosers,' when, getting up from his seat, he would run his finger rattling along the keys, and, pushing the painter from his seat, would sit himself in his place, and flourish voluntaries as though he was inspired.

Once Bach called upon him in Pall Mall, and, going straight to his painting-room, he found him fagging hard at the bassoon, an instrument that requires the wind of a forge bellows to fill. Gainsborough's cheeks were puffed, and his face was round and red as the harvest moon. Bach stood astounded.

'Pote it away, man, pote it away; do you want to burst yourself, like the frog in the fable? De debil, it is only fit for the lungs of a country blackschmidt.'

'Nay now,' exclaimed Gainsborough, 'it is the richest base in the world. Now do listen again.'

'Listen!' added Bach; 'mine friend, I did listen at your door in the passage, and, py all the powers above, as I hobe to be saved, it is just for all the world as the veritable praying of a jackass.'

'Damn it!' exclaimed Gainsborough; 'why, you have no ear, man – no more than an adder. Come then' (taking the clarionet).

'Baw, baw,' exclaimed the musician, 'vorse and vorse – no more of your canarding; 'tis a duck, by Gar, 'tis vorse as a goose.'

Another friend linked with the musical world was John Joseph Merlin, who, born in Liège, had come to England in 1760, where he worked as the main mechanic at Coxe's Museum of mechanical curiosities. In 1773 he set up his own museum in Princes Street, Hanover Square. His many inventions were both serious and light-hearted. In 1774 he took out a patent for a Compound Harpsichord which combined a single manual harpsichord and a pianoforte with down-string action. In the Fischer portrait the instrument is inscribed as by Merlin, but not enough of it is visible to make clear if it is a Compound Harpsichord.[5]

Then there was Willoughby Bertie, fourth Earl of Abingdon, now in his thirties. Gainsborough painted him about this time, but did not finish the work, which is of interest in showing the way he now tackled a portrait, forming all the parts of the picture together, as Reynolds said. He blocked out the whole composition and only then seriously started on the head. Why the work was left unfinished is not clear; later the Earl was glad to buy it. No doubt something interrupted the painting and Gainsborough had his usual difficulty in getting back to it. Bertie was strongly radical, a friend of Wilkes, who supported the American revolt and the French Revolution. 'A singular young man,' said Walpole, 'not quite devoid of parts, but rough and wrong-headed, extremely underbred but warmly honest.' He was a talented flautist and later did some composing; he was closely associated with Abel and his sister married an Italian dancer and impresario, Giovanni Gallini, a papal knight who liked to be called Sir John. Gallini became half-owner of the Hanover Square Concert Rooms in 1774, with Bach and Abel jointly owning the other half. Gallini organized balls, masquerades, suppers, while Bach and Abel looked after the concerts.

However the concerts did badly and by November 1776 the partnership was dissolved. Gallini, however, kept Bach and Abel on a fee basis to give concerts, and Bertie is said to have supported the musicians to the extent of £1,600, till Bach's death. Bach dedicated several compositions to him; and when invited to send a portrait for a gallery of famous musicians being formed at Bologna, he asked Gainsborough to paint him. He wrote to Bologna, 'The portrait is already finished, and only awaits an opportunity to come to you.' But it took years to be despatched.[6]

The Linleys were doing well. At this time Linley, Sheridan and Dr Ford were joint patentees of Drury Lane, with Linley in charge of the music and writing much of it himself. He still kept his

daughters off the stage, limiting them to genteel concerts and oratorios. Elizabeth sang at subscription concerts in her own house, to which came, says Fanny Burney, the highest circles of society, drawn by 'the talents, beauty and fashion.' Gainsborough would have been at many of them.[7]

In August 1776 Humphry died at Henley in an apoplectic fit. He was going to dine with some friends who lived not far from his house, but did not arrive. Search was made and he was found lying dead by the roadside. The same month Gainsborough made payments to a drapery-painter, Peter Toms. He must have been pressed for time, as it was rare for him to use any helper apart from his nephew. All parts of a picture excited him, as Thicknesse said.

On 5 November he wrote to Mary Gibbon. He had been meaning to notify her what had been done towards settling Humphry's affairs, but had waited till his stock was sold. 'Mr Cooper advised me to keep on the home till we can make the most of the steam-engine, (as the work, if taken to pieces, perhaps may never be put together again,) and also the maid in the house, lest any discovery should be made of it. The goods are sold, but none of the books.'

Thicknesse was not doing well. In April 1775 he could not find a buyer for his Bath house and next month petitioned the King for aid on the grounds of long service in various climates. Though backed by two or three nobles, he failed and in June went with his family to the Continent, where he hoped to live more cheaply. He was abroad some years, contributing to *St James Chronicle* descriptive articles signed 'A Traveller'. He was also probably the author of letters on Humphry to the *Gentleman's Magazine*.

On 25 January 1777 Gainsborough wrote to Jackson with apologies. He had been four times after Bach on some errand for Jackson, and had failed to find him. He had made a parcel of two drawings and a box of pencils, as Jackson asked, but it hadn't been taken to the Exeter coach. He blamed 'two blockheads one my Nephew, who is too proud to carry a bundle *under his arm*, though his betters the Journeymen Taylors always carry their foul shirts so; and my d..mnd cowardly footman who forsooth is afraid to peep into the streets for fear of being press'd for sea service, the only service God Almighty made him for.' This year Jackson was appointed at Michaelmas sub-chanter, organist and choir-master of Exeter cathedral.

131

Gainsborough must have felt that his absence from the R.A. exhibitions was harming him; he began negotiations with the Council. Minutes of March and April show him asking for some privileges before sending pictures, for example, on 25 March: 'Resolved that Mr Dance be desired to wait on Mr Gainsborough and explain to him the reason why his request cannot be complied with.' Dance was chosen as an artist sympathetic to him, who might be listened to. Six days later he wrote to the Council. The entry on 13 April ran: 'Read Mr Gainsborough's request. Resolved that he be left to the [Hanging] Committee to do as they think proper.' Some sort of agreement was reached.

So he sent along full-lengths of the Duke and Duchess of Cumberland, Abel, Lord Gage, A Lady, Group of Two Gentlemen and a landscape. His works were ignored by the *Gazeteer*, but more influential journals like the *Public Advertiser* welcomed his return. The *Morning Chronicle* admitted that as landscape painter he was one of the first living; as a portraitist 'a formidable competitor with the ablest', but revived the complaint of purple fleshtints and found his *Duke* inferior to Reynolds' version of the same sitter in 1773. The *Morning Post*, with Bate as editor, ignored Reynolds and found *Abel* the finest modern portrait the author could recall, the landscape a masterpiece, 'but viewed to every possible disadvantage'. Bate was taking up Gainsborough's complaints about bad hanging; his comment suggests that the latter had not had things all his own way in the argument with the Council. Indeed, in almost all the notices he was to write of Tom he kept up the charge of bad hanging. In *Abel* the sitter leans forward but is balanced by the lines of the arms and the flowered waistcoat; there are strong diagonals of curtain and viola da gamba, with a column to stabilize things. Here is a rich version of Italian baroque, as the portrait of Ann Ford was in many ways the culmination of Tom's complex development of rococo. The *Lady* was Mrs Graham. She had been married, in December 1774, aged seventeen. 'Portrait of a lady, rather of a divinity', cried the *Morning Chronicle*. Here Gainsborough brought to a climax his Van Dyck elements, with magnificent impasto and passages of impressionistic brushwork, a broken pattern of crimsons, lakes, pinks, that merge at the right distance into powerful forms. The young woman has a majesty that can stand up against heavy plinth and columns, yet is at the same time lost and pathetic. Just as the vine wreathes the pillar, she is drawn into nature, her hat-plumage into foliage. She is both

there in her clothes and somewhere else in the tree-world, with the pillar in the last resort asserting a line of demarcation: an effect learned from Watteau.

The landscape was *The Watering Place*, which was recognized by Walpole as 'in the Style of Rubens, and by far the finest Landscape ever painted in England, and equal to the great Masters'. In fact there is a union of Rubens and Claude, which produces a new concentration, an enclosing simplicity in pattern and lighting.[8]

This year, 1777, Astley vacated the central part of Schomberg House, disposing of his collection of Italian, French and Flemish artworks. Dr Dodd was convicted of forging Lord Chesterfield's signature: which provoked much argument in Gainsborough's circle. Bach wanted Dodd hanged; Abel wanted him reprieved. Bate and Sheridan's father went round Soho with ink-bottles in their buttonholes and with a long roll of parchment for signatures in a petition for reprieve. Dodd was hanged. Colman took over the Haymarket from Foote and at last gave Henderson his London chance. In June he played Shylock with much success, and from now until his death in 1785 he kept his place on the stage. Gainsborough must have been delighted.[9]

Also in 1777 Gainsborough painted his daughter Mary in what looks like her best dress, with her hat on, as if she were on her way out for a visit. She has a strong determined face, with an unhappy note: as we feel if we compare her with Lady Margaret Fordyce in a rather similar portrait done about a year before. The latter, much less handsome, smiles with assurance. A portrait of the younger girl Margaret seems to have been painted about the same time as that of Mary. Here we see a face of anguished breakdown, with the eyes turned distractedly up. It is remarkable that Gainsborough had the courage to paint his daughter in such a lost state. After looking at it, we canot doubt that his later years were filled with disquiet over the girls and that his art embodied a struggle to overcome the deep anxiety that haunted him. His impulse to turn from the world around him and to find a refuge in his woodland images must have been intensified. The entry into a new world through the cottage-door acquired an ever fuller significance.

Bertie published his pamphlet on the American revolt. Gainsborough no doubt read it, or at least heard it discussed; but neither now nor at any other time do we detect the least flicker of interest in the political situation. Yet during the whole period of

his maturity there were continual wars, not only in Europe, but in North America and the Caribbean, in India and elsewhere, in which Britain was deeply implicated. A decisive mercantile and colonial expansion was going on all the while. The Seven Years War had broken out in 1756 and, especially after 1760, when Gainsborough moved to Bath and George III came to the throne, the imperial development increased in pace and violence. Then in 1773-4 had come the crisis in relation to the American colonies, followed by open warfare. Many of his friends were of strong Whiggish views, highly critical of what was happening. The trend of events may have helped to make him feel yet more out of tune with the world around him, but it bred no direct response. Extremely independent in outlook and critical of his society, he saw things wholly from a personal point of view. He felt less sympathy than ever with the class who commissioned portraits from him; he felt an ever stronger impulse of sympathy for the hard-working peasant, who gained nothing from the hurlyburly of greed, violence, oppression. But he did not translate these emotions into any conscious political position.

On 18 August Thicknesse told Cooke an anecdote that must refer to the Bath period. 'When I detected Gainsborough of spoiling a Lady's picture on purpose to have a chatt while she sat for another to be better done, the Lady popped out at me, that she was to sit again – yes said I with a wink I know you are – she indignantly replied, "I'll never sit." '

The kind of man he was shows up clearly in story after story, and his letters beyond doubt give us the style and intonation of his talking. Fulcher writes of his modest deportment and 'the elegance of his person'. He was tall and fair and well-proportioned. But this account, set down nearly seventy years after his death, seems based on the recollections of an old lady of Sudbury who as a young girl had seen him on a visit to the town in 1784 in 'a rich suit of drab, with laced ruffles and a cocked hat'. He was 'gay, very gay, and good-looking'. We know from Thicknesse that he was shy and given to blushing. But that was only one side of his personality. He had his outbursts of anger and contempt; Jackson says that his conversation was sprightly but licentious and that he hated the common topics 'or any of a superior cast', which he always interrupted 'by some stroke of wit or humour'. He had no time for conventional small-talk and at once reacted sharply against any pretences of superior intellect.

In the letters we hear a living voice. Clearly he wrote as he

spoke, and spoke as he thought, with rambling but witty comments, often going to the heart of a matter, then sheering off into hums and mocks at himself and his interlocutor. We have Jackson's word for the similarity of the written and spoken word. 'So far from writing [he] scarcely ever read a book – but, for a letter to an intimate friend, he had few equals, and no superior. It was like his conversation, gay, lively – fluttering round subjects which he just touched, and away to another.' We see a veering inconsequentiality that is close to Sterne's style; but we can be sure he was not copying that author. In both cases the apparently meandering style, with its jumps and diversions, had behind it a logic vitally its own, which was both jeering at the accepted systems of rationality – what he calls 'a regular system of Philosophy' in mocking at Jackson – and suggesting a different kind of interrelations in the life-process. Jackson shrewdly saw the link with Sterne. The styles of the two men were so alike that 'if it were not for an originality that could be copied from no one, it might be supposed that he had formed his style upon a close imitation of that author'. W. H. Pyne commented that 'He had, and used, a nomenclature purely his own, for everybody and everything.'

Bate tells us that 'in conversation his ideas and expression discovered a man full of rich fancies and elegant truths – it is not an exaggeration to say that two of the first writers of the age, Mr Sheridan and Mr Tickell, have frequently been witnesses of the most astounding bursts of genius from him at these moments, and never fail to bear testimony to his pregnant imagination.' Garrick is said to have commented that 'his cranium is so crammed with genius of every kind that it is in danger of bursting upon you, like a steam-engine overcharged.'

Once, dining with Garrick, he met Dr Johnson. Through watching him closely, he took over his habits of involuntary twitching and gesticulation. For a month or two, awake or asleep, he couldn't keep still. 'In fact, I became as full of megrims as the old literary leviathan himself, and fancied that I was changed into a Chinese automaton, and condemned incessantly to shake my head'. He made a sketch of the Doctor's brown wig seen above a book of old English plays in which he had short-sightedly buried his head while reading in an armchair at Garrick's. (Dr Johnson is said to have spoken respectfully of him to Garrick as 'the ingenious Mr Gainsborough' or 'your sprightly friend'.)

He was certainly given to drinking. A writer in the *Monthly*

Mirror tells a tale which he claims to have heard Gainsborough himself relate soon after the event. He had been with Abel and, though drunk, insisted on going home alone. The night was late and dark. He fell on the pavement, couldn't get up, and went to sleep. A woman of the town, seeing him, put him in a coach, took him to her lodgings, and put him to bed. He awoke in the morning, surprised at the strange room, got out of bed, examined his pockets, and found his gold watch and pocketbook gone. Alarmed, he went back to bed. Soon the woman appeared, saw him restless and uneasy, and asked the cause. He told her of his loss, saying that bills of £430, received the day before, were in the pocketbook. She reassured him. She had taken the watch and book, afraid that a young man 'of bad habits and disposition', with whom she was connected, would turn up and rob him. So he 'gave her the odd £30, and having thanked her, departed. He continued a friend to her till his death.'

His daughter Margaret told Farington in 1799 that her father 'often exceeded the bounds of temperance and his Health suffered from it, being occasionally unable to work for a week afterwards.' She said that he had his two faces, 'his studious & Domestic' and 'his Convivial one'. He himself, we saw, admitted to Sam Kilderbee his dissolute life. We can understand then that his wife with her frugal and careful ways did her best to control him; the result must have been an uneasy tension in the house, intensified by Gainsborough's own fears of himself and of what was going to happen to his girls. Thicknesse's account seems then generally correct, even if it shows no sympathy for the wife's delemma:

But those who best loved Mr Gainsborough and whom he most loved were unfortunately least welcome to his house, his table, and the goodwill of some part of his family, for he seldom had his own way but when he was roused to exert a painful authority for it, and then he flew into irregularities and sometimes into excess; for, when he was once heated, either by passion or wine, he continued unable and unwilling also to do business at home, and at those times squandered away, fifty times over, the money which an extra joint of meat or a few bottles of port would have cost to have entertained his friends at home. I mention this, because, had it not been for such pitiful doings, he would still have been in all human probability, the delight of his friends, and the admiration of the world for years to come. He had so utter a disregard to money, that somebody smuggled up in a few years at Bath five hundred pounds.
Those who have sat to Mr Gainsborough know that he stood, not sat, at his palate, and consequently, of late years at least, five or six hours' work

every morning tired him exceedingly, and then, when he went into the Park, for a little fresh air or up in the city upon business, if he took a hackney coach to ease his tired limbs back again, he was obliged to be set down in St James's Square, or out of sight of his own windows, for fear of another set down not so convenient either to his head or his heels as riding out twelve pennorth of coach hire, after having earned fifty guineas previously thereto.

I have more than once been set down by him in that manner, even when I was going to dine with him, and have more than once been told *by him why we were so set down*. If, therefore, I have told this tale so severely, let it be remembered I have lost a friend whom I sincerely loved, and . . . 'Let the stricken deer go weep.' [10]

On 12 September 1777 he wrote to Mary Gibbon to thank her for some cheeses. He hadn't been able to send her you know what (money), because he had been 'disappointed of receiving any thing *privately*' – that is, unknown to his wife. He was on his own.

My Family had a great desire to make a Journey to Ipswich to Mr and Mrs Kilderbee's for a fortnight, and last Sunday morning I pack'd them off in their own Coach, with David on horse back; and Molly wrote to me to let me know that they arrived very safe; but some how or other they seem desirous of returning rather sooner than the propos'd time, as they desire me to go for them next Tuesday, the bargain was that I should fetch them home. I don't know what's the matter, either people don't pay them honour enough for Ladies that *keep a Coach,* or else Madam is afraid to trust me alone at home in this great Town.

He is in good health, working on a lady's face in a full-length. He is glad that his niece Sal has got over her sore throat.

That he had been borrowing money from Mary appears to be likely by a letter that followed the other on the 22nd. The family was still at Ipswich; he had not fetched them home as Miss Read, grand-daughter of Truman, had come from Wiltshire to be painted. They were to leave on the 27th, next Saturday, and would arrive Sunday evening. Then, after an anxious preamble, he comes to the point. He needs money. He has fifty guineas in his pocket, sent by Truman as half the fee for Miss Read's portrait, 'but you know it would be certain death to make use of a farthing of it for private as I am under everlasting engagements to deliver up to my Wife, all but Landskip deductions where she cannot come at the knowledge of my Price.' The Duke of Dorset would soon be buying two landscapes, 'and there I cribb a few guineas in spite of the D——l.' So he begs Mary to lend him

twenty pounds for a deed of 'Charity and humane feeling.'

A poor wench whom I used to speak to in Bath, came to London with some worthless ungrateful Villain, and who left her to go abroad, in a poor state indeed, and it is a person of that merit that if her heart was bad enough, would have no occasion for my help. But mind my Dear Sister the misfortunes of this poor Creature, whether by fretting or what, I know not, she went into a bad state of Health and a sore broke out in her leg, which now is as wide round as the top of a Tea Cup, and down to the bone; in the greatest agony this poor Creature lay lamenting her situation without a friend. Do you think that I am proof against such a sight, and would let her perish and be lost for want of assistance; no let me have what faults I may, that shall never lay on my conscience. The Creature would have died rather than hazard my domestic happiness by making any request to my House, and it was by chance that I went to afford timely relief.

The story rings true; but Gainsborough does not explain how he knew that this girl, whom he dared not mention to his wife, had come to London and where she was lodging. (Thicknesse, claiming that he owed his health to taking doses of laudanum and inhaling the breath of young girls, says that such girls were especially available in Bath.)

The Rev. Henry Bate (later Sir Henry Bate Dudley) was now a close friend of Gainsborough. Though ordained, he was early connected with newspapers. At twenty-seven he helped to found the *Morning Post*, of which he was editor, except for a short interval, till he left it to found the *Morning Herald*. He was a vigorous character, the Fighting Parson or pugilist, friend of the Prince of Wales, dramatist, magistrate, Canon of Ely, duellist, agriculturist, musician (playing the violoncello and writing the libretto for William Shield's *Flitch of Bacon*). His paragraphs, often coarse in humour, show him a man after Gainsborough's own heart. John Taylor described his style as of a 'sportive severity', and said that he gave a new character to the public press which had been mostly dull, heavy, insipid. 'It may be said that he was too personal in his strictures in general, and in his allusions to many characters of his time.' As a result he had to fight his duels. In 1777 he was firmly in charge of the *Post* after fierce quarrels among the proprietors which he and his adherents won. His publicity methods are illustrated by the account Walpole gives of some thirty or forty men in bright uniforms distributing handbills in Piccadilly.[11]

We hear little of Gainsborough in 1778 apart from his

contributions to the R.A., which included portraits of Christie and Lord Chesterfield. The main interest was aroused by his pictures of women, especially that of Mrs Elliott, a demi-mondaine referred to by the journals as Dolly the Tall. Bate stated of his works shown this year that they 'consist chiefly of *filles de joie*,. and are all admirable likenesses, no. 114 particularly, being that of the beautiful Mrs E.' The *Chronicle* remarked that such women were fit subjects for him: 'since he is rather apt to put that sort of complexion upon the countenance of his female portraits which is laughingly described in the *School for Scandal* as "coming in the morning and going away at night," than to blend what is, properly speaking, Nature's own red and white.' Dolly the Tall is depicted with a certain pathos as she advances on high heels across the canvas in a Van Dyck pose with its dignity turned into something light-hearted, warmly casual. On the other hand the Hon. Frances Duncombe carries on the full Van Dyck glamour from Mrs Graham, but moves from the slanting tree and vertical monument on the left, across a lurid unreal landscape of which she is an unconscious part. With her slightly pert face, her effect of awakening charm as well as of loss, uncertainty, she is a girl in an unrealized world of strange possibilities, somehow outside it all. (This year she brought a fortune in marriage to her husband John Bowater.)[12]

Lord Chesterfield was depicted with all the dislike that Gainsborough often conveyed in his portraits of nobles; the *Chronicle* seized the chance of suggesting he had shown the Lord in all the insensibility and lack of meaning for which he was remarkable. The same critic complained that in most of the works only the heads were finished. Two days later Bate retorted in the *Post:* 'If his pieces be view'd at a proper distance, which as it is manifestly his design is the only just way of estimating their merit, this imputation will appear totally without foundation.' He claimed that Gainsborough's portraits were not excelled even by Reynolds while he is 'the competitor of Rubens in his landscapes'. One of the latter on show was inspired by lines from William Shenstone's *Schoolmistress* about the release of the children on the green, 'with boisterous revel, rout and wild uproar'.

About this time Gainsborough painted his wife in a black mantle, which, with the fine placing of the hands, gives an effect of a circling movement, from which emerges her face, afraid, trusting, appealing. We feel the close relationship between the two of them, the element of deep dependence he felt, as well as

the need to resist, to draw away.

In February 1779 Garrick died and was buried in Westminster Abbey. In May Bach organized a benefit concert for Tenducci (returned from Paris), in which Abel, Fischer, Giardini, and Crosdill the cellist all performed, and a new quartet by Bach was given. At the R.A. Gainsborough showed several portraits: the Duchesses of Gloucester and of Cumberland, the Duke of Argyll, Baron Perryn. Bate, whose position on the *Post* had weakened, did not give any eulogies; in any event public interest was absorbed by the court-martial of Admiral Palliser. Critics were mostly favourable but the complaint of artificial colouring came up again.[13]

Sometime in his London years Gainsborough seems to have given lessons to Charlotte, daughter of the physician Richard Warren. Thicknesse also says that his daughter Anna 'now and then obtained a hint of importance' from him and 'prevailed upon him to give her a little feint tinted drawing of his to copy'. She made her copy and one night after supper at her house she laid it before him, 'Said nothing, but waited to hear what he would say. Gainsborough instead [of] saying anything, took it up and instantly tore it through the middle! The truth was, inattention, good spirits, and a glass or two of wine, had so cheered him, that he thought it was his own, yet at the same time perceiving that it was not quite so perfect as a work of his own ought to be, he demolished it.'

On 24 June he wrote to Dr Charleton at Woodhouse near Bristol, blaming 'some plaguesome sitters' for delay in answering a letter. Also there had been a sick House, 'but thank God all is right again. Molly had a smart fever at the time I received your letter, but my next door neighbour Doctor Heberden sent Her to Chiswick for Air, and now she is *purely* as my Friend Bob said of the old woman.' He had forgotten the doctor had 'a copy of the little dutch spire of my Hand'. Charleton may keep it. 'I'd give it to Mother Gibbon but she delights not in worldly Prospects; I have a d-mned plague with her when she comes to Town, to find out new Methodist Chapels enough for Her, for she Prays double sides, and cares not a farthing for what Bishops can say.' His comment here on Mary is very different in tone from the letters that he wrote to her.

On 8 July he was back in Bath on a visit and wrote to Jackson, in-

troducing Edmund Garvey, 'an excellent Landskip Painter and particular Friend of mine, who lives in Bath.' He asked Jackson to show Garvey round Exeter. 'I hope to see you in about a fortnight, as I purpose spending a month or six weeks at Teignmouth or other places round Exeter – get your Chalks ready, for we must draw together.' We see that he still visited the West Country and drew from nature there. On the 31st he was still in Bath, writing to Mrs Ditcher of Lansdowne Road about his portrait of her husband, a Bath surgeon, which he had begun before he left for London. He apologizes for not having paid for the picture's carriage in his hurry, and wants nothing for picture and frame, 'overpaid abundantly by my friend's attention to my family while we lived at Bath'. Mrs Ditcher, a daughter of Samuel Richardson, was friendly with the Sheridans, who called a daughter after her.

The year 1780 was marked by an event that much upset Gainsborough and led to worse anxieties. His daughter Mary, despite all his surveillance, was wooed and won by Fischer. On 23 February he wrote to Mary Gibbon:

I imagine you are by this time no stranger to the alteration which has taken place in my family. The notice I had of it was very sudden, as I had not the least suspicion of the attachment being so long and deeply settled; and so it was too late for me to alter anything, without being the cause of total unhappiness on both sides, my *consent*, which was a mere compliment to affect to ask, I needs must give, whether such a match was agreeable to me or not. I would have had the cause of unhappiness lay upon my conscience; and accordingly they were married last Monday and are settled for the present in a ready furnished little house in Curzon Street, Mayfair. I won't say I have any reason to doubt the man's honesty or goodness of heart, as I never heard anyone speak anything amiss of him; and as to his oddities and temper, she must learn to like as she likes his person, for nothing can be altered now. I pray God she may be happy with him and have her health. Peggy has been very unhappy about it, but I endeavour to comfort her, in hope that she will have more pride and goodness than to do anything without first asking my advice and approbation. We shall see how they go on.

He seems to have forgotten the intercepted love-letter he wrote about some four years earlier. The marriage took place on 21 February at St Anne's Church, Soho. Fischer had lived at 23 Frith Street, so Soho was his parish. The ceremony was performed, under licence from the Archbishop of Canterbury, by the Rev. William Hivens, described in the register as minister; the witnesses were Gainsborough, his wife and his nephew.

Fischer was shy, eccentric, proud. W. T. Parke, also an oboe-player, says that he was so devoted to his musical studies that he had very little intercourse with society, forgetting his own language without acquiring another. He adds that Gainsborough, talking of Fischer's oddities, described a walk with him one frosty day in Pall Mall. A gentleman ahead slipped and fell. Fischer, startled, spluttered out, 'I never did that – I never in my life made a slip.' 'And in a fortnight,' concluded Gainsborough ruefully, 'he married my daughter.' Over the last few years both the Gainsborough girls had fallen in love with him; but in their restricted way of life they probably had few chances of getting to know any men apart from their father's companions. A writer at the time of Mary's death deplored that Gainsborough had let her marry a man 'devoid of prudence, and with no more intelligence than his hautboy'. W. H. Pyne tells us:

The two enthusiasts [Gainsborough and Fischer] sometimes left their spouses, mamma and daughter, each to sleep away more than half the night alone. For one would get at his flageolet, which he played delightfully, and the other at his viol-di-gamba, and have such an inveterate set-to, that, as Mrs Gainsborough said, a gang of robbers might have stripped the house, and set it on fire to boot, and the gentlemen been never the wiser. 'In truth,' said Caleb Whiteford, 'I never met with fellows that, like them, lost all reckoning of time, when timing it to their *cat-gut* and *tootle-too*.'

If indeed these musical bouts were dated to the period after the marriage Gainsborough must have been making an effort to keep close contact with the new addition to the family and thus to ensure that he and his wife maintained something of a watch over Mary. In 1781 Fischer was appointed to the Queen's Band with a fee of £200 a year. That year, as he played at a court concert, young Prince Adolphus, hiding under his desk, snatched his oboe away. Fischer looked so ludicrous, says Bate, that the whole company, including the King and Queen, burst into loud laughter. 'Poor Fischer was so much disconcerted that after recovering his hautboy he retreated with great precipitation.'[14]

In the R.A. of 1780 Tom had six landscapes and ten portraits: of Fischer, General Cosway, the Rev. W. Stevens, Crosdill, Mme le Brun (the singer Francesca Danzi), Henderson, George Coyte, Mrs Beaufoy, Bate, Isaac Gossett. Gossett had invented a composition of wax in which he modelled portraits, gaining even royal patronage; he modelled Gainsborough, who

seems to have known him well. (He was in the list of mourners at the latter's funeral.) Fischer in his portrait stands pen in hand leaning negligently on a Merlin pianoforte, on which lie a two-key oboe and some manuscripts. 'So like, so handsome,' wrote Susan Burney to her sister Fanny. (Cleaning in 1968-9 showed many alterations as if the composition caused much trouble or the canvas had been earlier used for a different scene.) Bate is shown in a confident challenging pose. About this time Gainsborough also painted Mark Beaufoy, Quaker and vinegar-distiller, in the relaxed pose of a tough businessman who keeps on his hat and has one hand gloved. (The studio-chair used here appears also in the Abel portrait.)[15]

The Academy had now moved to Somerset House, Strand, from the old rooms in Pall Mall not far from Tom's house. Galleries had been designed at the new location; there were also apartments for the keepers and for the schools. Bate remarked that the concourse at the opening of the exhibition was incredible. 'The carriages filled the whole wide space from the New Church to Exeter Change.' The doorkeepers were said to have taken in some £500. Certainly receipts for the season more than doubled those of the best years in Pall Mall. Some 20,000 catalogues were said to have been sold. The system of listing changed. Previously all the works by a man were grouped under his name and numbered consecutively; now, following a proposal made in the *Public Advertiser* in 1775, they were given in the order of each room. (In 1783 an alphabetical list of artists with the numbers of their works was added at the end.)

Bate again complained about the bad hanging of Gainsborough's works, this time pointing to the landscapes. These had attracted much attention. In *The Cottage Door* a critic recognized the pervasive lament of idyllic escape: 'This beautiful scene where serenity and pleasure dwell in every spot, and the lovely figures composed in the finest rural style, their situation worthy of them, forms a scene of happiness that may truly be called Adam's paradise.' The mother with babe in arms stands near the open door of the nestling cottage, with half-ragged children playing merrily before her. The group forms a pyramid moving up into the cottage and balanced by two leaning trees (one a tall dead trunk). Gainsborough manages to give the careless hair of the woman the look of a fashionable coiffure.

He also showed a landscape of a *Country Churchyard*, which is now lost. We know its composition, however, from the aquatint

143

by Maria Prestal, 1790. The church is in ruins, and a young peasant and his girl kneel to read the inscription on a tombstone. The aquatint has sixteen lines from Gray's *Elegy*. About the same time Gainsborough made a soft-ground etching with many of the same ingredients in a much rougher form. An old peasant leans on a staff reading a tombstone; there is a donkey, and the lovers sit on the edge of the slope with their backs to the ruin. Far back, in the late 1750s, he had made a drawing of a ruined church with two donkeys in the churchyard. In the painting there is an elegiac mood not present in drawing or etching, and there is something of a movement to History, with the suggestion of *Et in Arcadia Ego*. The work is thus one of the many that show Gainsborough seeking to widen his scope in the 1780s, to take in elements from History Painting while preserving his own vision.[16]

This year Bate quarrelled with his co-proprietors on the *Post* over a libel of the Duke of Richmond. After a court-action he was sentenced to twelve months' imprisonment and served part of it, then was unconditionally freed after refusing to make any terms with an intermediary of the Duke. Not long afterwards the new *Post* editor was indicted for a libel on Bate and sentenced to three months and a fine of £100. Jackson had his first opera, *The Lord of the Manor,* performed at Drury Lane with much success. His music was melodious and lyrical, and he wrote the whole score: which was unusual for a musical show of this kind. Astley rented the central part of his house to Dr Graham, who gave demonstrations of 'the secret of perpetual youth and beauty', using mudbaths and the Celestial Bed (to help couples who wanted children). He was aided by a lovely woman: for half a crown you saw her in a mudbath up to her neck, her hair decorated with powder flowers and ropes of pearls. Graham's wig was a marvel of the *perruquier's* skill. He lectured with his assistant as the Goddess of Health. Gainsborough must have been intrigued by these nearby events. Also in 1780 his brother Jack and his cousin Samuel were commissioners under the Stour Navigation Act; so too was Golding Constable, father of the painter. The commissioners met once a year at the Queen's Head Inn, Nayland.[17]

9 London (1781-1786)

*F*or 1781 we know little of Gainsborough apart from his R. A. pictures and his reaction to de Loutherbourg's Eidophusikon. He exhibited full-lengths of the King and the Queen, Bishop Hurd (done for the Queen), three landscapes, and *A Shepherd*, the first of his rustic figures to attract attention. Bate, now with a free hand again in the *Herald,* brought up the old complaint of unfair hangng. The *Shepherd* 'in a tempestuous scene is evidently the chef d'oeuvre of this great artist, a composition in which the numberless beauties of design, drawing, and colouring are so admirably blended as to excite the admiration of every beholder'. Two seascapes 'show the universality of his genius'. One of these depicted the sea calm, the other a storm. The storm-picture has great power in its effect of a rising gale, which is expressed in its rhythms, its low tonality with sweeping movement of light and shade, its strong brushwork. Walpole said the work was 'so fine and natural that one steps back for fear of being splashed'. No other work of the century comes so near the dynamic unity of a Turner.[1]

Reynolds also made a special effort this year. 'Ensis' in the *London Courant* took up Bate's challenge, attacking the *Herald*'s 'impertinent and ignorant rapture in a place that exhibits sixteen pieces by Reynolds, the least of which exceeds the power of Gainsborough as far as Johnson's that of Bate.' But the same issue included a comment on the unfair hanging of Gainsborough's work. The pictures of the royal couple were generally seen as good likenesses. Somehow Gainsborough had made the Queen charming, although in Ramsay's portrait she is rather repulsive. A

writer commented, 'I do believe that Opie would have made a calf's head look sensible, as Gainsborough made our old Queen Charlotte look picturesque.' Here Gainsborough seems to have done his best to flatter, but he gained his effect through the sheer vitality of the painting. James Northcote, who had been a pupil of Reynolds, cried, ''Tis actual motion, and done with such a light, airy facility. It delighted me when I saw it. The drapery was done in one night by Gainsborough and his nephew; they sat up all night, and painted it by candle-light. This, in my opinion, constitutes the essence of genius, the making beautiful things from unlikely subjects.' Certainly the comment on motion goes to the heart of Gainsborough's achievement as an artist.

Soon after the R.A. closed he received another royal commission: to paint Prince William Henry, who sat twice. By mid-July he was in effect the court painter, although without any actual appointment. There were envious tales of backstairs influence, but it seems that the only friends at court he ever had were first Kirby, then Fischer. In August and October the young Prince of Wales sat several times for him. Gainsborough was clearly much pleased at his success and made the most of his chances. His particular kind of good humour, of boldness and self-deprecation, probably suited the King. Here his behaviour indeed ran counter to his declared antagonism to the gentry; but his general principles were always liable to be modified by personal likes and dislikes. Besides, in these years he was all out to beat Reynolds, who had the disadvantage in the court's eyes of being closely linked with several Whig politicians. In October came the first mention of his portrait of Perdita Robinson, which he finished by the end of the month; there were rumours it was to go to France.

Bach was in poor health, with money-troubles. But about this time Angelo made a jaunt with Gainsborough, Bach and Abel to Windsor, where they passed an afternoon and evening at the Swan near Eton Bridge. They met 'that eccentric and inscrutable humourist Fischer there'. Angelo says that Fischer, though sparing of speech, yet in the few things he did say 'was so original and so entirely to his Majesty's taste, that he [the King] usually reported the good sayings of Fischer to the Queen and Princesses, which was sure to excite their risibility.' Angelo continues:

Gainsborough, afraid of his wife, and consequently ill at ease at home, was not entirely comfortable abroad, lest his Xantippe should discover

what he expended on his rambles. It is true that he was no economist of his cash, but the parsimony of his lady was beyond the endurance of any man possessing the least spirit of liberality, and Gainsborough was liberal to excess.

Fischer, who, on the contrary, was anything rather than an uxurious spouse, used to banter his father-in-law on his submission; particularly as Gainsborough's income was large, and he was known to be so eminently bounteous to his wife; for, excepting the ready cash which he kept in his purse, she was, as Fischer said, 'receiver general, paymaster general, and auditor or her own accompts'.

Angelo adds a tale of the Queen asking Fischer if Gainsborough was a very liberal man. Fischer replied that he was.

'Which is not entirely agreeable to his lady?'

'Nod at all so, nod at all, may it please you. Mine moder-in-law is twin sister of the old lady in Threadneedle Street.'

The Queen smiled and he went on, 'She shall not be gontent, not if mine fader-in-law pour into her lap the amoundt of the national debt.'

On the trip with Abel and Bach Gainsborough was

as usual in tiptop spirits. Everything which presented itself on the road from our passing the gate at Hyde Park Corner, all the way right and left to Windsor, begat an anecdote, a pithy remark, or some humorous observation. We agreed to club expenses, and travelled in a glass coach, for which he had, however, unknown to us, previously paid, observing, when we remonstrated, 'Nay, it is but fair; we were to have posted it, but Abel (who was very corpulent) would have taken more than his share of the chaise; the coach, mark you, is mine own affair.' On this delightful journey I enjoyed his company three entire days.

It forms not the least part of the pleasure, in looking back to this trip, to remember walking with this original genius through the State apartments of the Castle. I shall never forget the rapture he appeared to feel on gazing out of the window of Queen Anne's china closet upon the magnificent prospect which suddenly burst upon his sight. 'Claude,' said he, 'could find no study in Italy comparable with this. Look, Abel, what say you to this? Mine ancient shepherd, the cattle grazing down there in the home park appear so many gems pinned on a cushion of green velvet; it is verily part of Dame Nature's old-fashioned toilet.'

Angelo has much to say of Gainsborough's experiences at court. He remarks that he did not seem to think highly of the works in the royal collection, though delighted with Van Dyck's portrait of Queen Henrietta in white satin. 'Why do not the French women dress with that elegant simplicity now?' French taste had degenerated.

'Yes,' said Abel, who was a man of observation, 'but, howsomdever dat may be, vot a strange degeneracy of your countryvomans for to imitate all the drumperry fashions from France.'

'True,' replied Gainsborough.'I once, in conversing with His Majesty upon the subject of modern fashions, took the liberty to say, "Your painters should be employed to design the costumes."...The King said, "You are right, Mr Gainsborough; I am entirely of your opinion. Why do not you and Sir Joshua set about it?" adding, "but they are bewitching enough as it is – hey, Gainsborough, hey!" '

'And what did you rebly to dat?'

'Why, like the saucy dog as I am, what our gracious King listened to, and only answered with a smile. I said (faith, I am ashamed to repeat it), "Yes, please your Majesty, it were as well to leave the dowdy angels alone." '

Gainsborough considered that the King had good taste in art – 'much more so, indeed, than many of his courtiers, who held their heads high upon the advantage of foreign travel; lordlings who, for all their pratings about carnations, contour, and gusto, prefer a racer to Raffaele, and a stud to the studio of Michael Angelo himself.'

In such accounts Angelo no doubt preserves the general tenor of Gainsborough's remarks, though not the exact terms. The latter did not care for Raphael or Michelangelo. However, since they were accepted as the supreme masters, he may have used their names to bring out the insincerity of the aristocratic cult for them. Also, the homely downright element in George III may well have appealed to him, and the two men seem to have got on well together.

I remember Gainsborough relating to Sir George Beaumont, that one morning, whilst waiting upon the Queen at Buckingham House, His Majesty entered the apartment, and, whilst looking at one of the heads which Gainsborough had just completed, he turned suddenly and observed, 'I hope you have not entirely relinquished the study of landscape, Mr Gainsborough?'

'No, sire,' replied Gainsborough; 'I have been honoured with commissions to paint several compositions of late, but my portraits must be completed, for I have received from my sitters sums in advance.'

'Ay, ay, a good custom that – first set on foot by Sir Joshua, hey. An excellent custom. Yes, I respect your integrity; I am sorry to say, however, that there are some members of your profession who are not very conscientious upon that point. Yes, you are right; professional men cannot be too punctilious on these matters.'

'Not, your Majesty, but what I prefer landscape painting.'

'Doubtless,' replied the King, 'portraiture is a tantalizing art – no pleasing your sitters, hey. All wanting to be Venuses and Adonises, hey. Well, Mr Gainsborough, since you have taken to portraiture, every one wants your landscapes; is it not so?'

'Entirely so, your Majesty.'

'Ay, ay, that is the way of the world; I knew it would be so.'[2]

De Loutherbourg had now devised his Eidophusikon or Representation of Nature. It consisted of a small stage (some eight feet wide, six feet high), on which moving scenes made up of painted flaps and transparencies were shown to audiences of up to 130 at a time; the whole thing was mechanically moved and accompanied by music. The shows went on for the next few years. Gainsborough, and also Reynolds, much admired the contrivance. Fulcher says that Gainsborough's sympathies were so completely enlisted that for a time he could talk of nothing else and passed his evenings watching the displays. Once, as the machine was projecting a seastorm off the coast of Naples, a thunderstorm broke out over London. The superstitious members of the audience ran into the lobby to protest against the presumptuous artist who dared to imitate the mysteries of nature; but he with two or three friends, who included Gainsborough, went up to the theatre's roof to watch the storm and to compare it with the stage-representation visible below. Tom after a while turned excitedly, 'De Loutherbourg, our thunder is the best!' Fulcher adds:

He was, indeed, an enthusiastic encourager of every scheme for the improvement of his art, and himself loved to experimentalize. When a Mr Jarvis made an exhibition of some stained glass, Gainsborough was so impressed with its beauty that he immediately began to construct an apparatus that should diffuse a similar splendour on the productions of his pencil. This ingenious piece of mechanism is described as consisting 'of a number of glass plates, which were moveable, and were painted by himself, representing various subjects, chiefly landscapes. They were lighted by candles at the back, and viewed through a magnifying lens, by which means the effect produced was truly captivating; the moonlight pieces, especially, exhibiting the most perfect resemblance to nature.'

This Show-Box was a wooden construction fitted with a moveable lens to show painted transparencies. The light came from three candles in containers behind the transparencies, and was diffused by a silk screen set between light and glass, producing flickering light-effects. As there was only one lens, only one person could look at a time. Whatever the position of the lens, the 'angular'

size of the transparencies was not affected, but an effect of distancing could be got. With the lens in its closed position and the lens-holder pushed firmly in, the image appeared magnified two and a half times, but to be two and a half times (62 inches) farther off. With the lens pulled fully out, the image was magnified five times, but seemed five times farther off (172 inches). Using a system of cords and pulleys, combined with a moveable carriage for the slides, the viewer did not need to take his eye away as he ran through the whole set.

The Box was designed to take twelve slides. Twelve survive, though two may be by some artist of the Norwich school, added later to fill the loss of two original ones. *The Cottage Door* in particular shows how Tom used the potentialities of the method and was in return stimulated. Its effect was carried over into the painting, *The Woodcutter's Return* of 1782, where the sunset afterglow is offset by the fire blazing in the cottage. In the transparencies this kind of contrast between two light-sources is intensified by the artificial illumination from behind and the distancing lens. We are told that Gainsborough showed the slides to friends who called in of an evening while they 'sat and sipped their tea'. But they were devised to help him in his exploration of light and colour.[3]

Thomas Jarvis as well as de Loutherbourg had influenced him. Jarvis executed windows for both Reynolds (New College, Oxford) and Benjamin West (Windsor Castle); he held several shows of stained glass, not at all only church-work. One show (undated, but apparently of the early 1780s) consisted of eighteen small works, mostly of candlelight and moonlight effects. Angelo also tells how his father at the the Carnival in Venice 'saw that pleasing little pictorial drama, entitled *Le Tableau mouvant*. He was so delighted with its effect, the scenes painted as transparencies, and the figures being all black profile, that he constructed a stage on the same plan, and it was greatly admired by Gainsborough, Wilson, and other English landscape painters.' This system was also called *Les Ombres Chinoises* and was used in public shows in Panton Street, Haymarket, not far from where Angelo had given his demonstrations to friends. (The date of Angelo's stage is not clear, but it seems earlier than de Loutherbourg's Eidophusikon.)[4]

On the first day of 1782 Bach died, with debts of £4,000. A gift from the Queen to his widow enabled her to return to Italy. His death was not much noticed, but on 10 April Mozart wrote from

Vienna: 'No doubt you know that the English Bach is dead. A sad day for the world of music.' In January Gainsborough worked at a companion piece to the *Shepherd*: a peasant girl gathering sticks in a wood. The *Shepherd* had been 50 by 40 inches; the new picture was 67 by 49. At last Gainsborough had the confidence to enlarge the figures of his landscapes: which meant that he was setting his version of what was called a Fancy-Picture on the same scale as his portraits, and was achieving his own kind of Modern History, the rustic counterpart of Hogarth's urban depictions. He meant to send the *Peasant Girl* to the R.A., but changed his mind; perhaps he was still a little afraid of making his challenge to the accepted genres.

In March he announced that he had for the R.A. his full-lengths of the Prince of Wales, the Prince's friend Colonel St Leger, Colonel Tarleton (a cavalry officer whose exploits in the American War were still fresh in mind), Mrs Robinson, Mme Baccelli; and a kitcat (short portrait) of the Duke of Dorset. Only four of these works were in fact shown. The Duke objected to appearing with the Italian dancer (Mme Baccelli) whom he had installed as mistress at Knole. Gainsborough himself no doubt withdrew Mrs Robinson after the revelation in the *Public Advertiser*, a fortnight before the show opened, that she had got £10,000 from the Prince as hush-money after threatening to publish his letters. She was now having an affair with Tarleton. Gainsborough's rivalry with Reynolds was at its height. The latter had sent in his own portrait of Tarleton. Gainsborough, who had painted him with his horse, had no doubt invited him to sit; Tarleton would hardly have commissioned two portraits in the same year. Both artists had also painted Mrs Robinson and Mme Baccelli.

The works of this year show Gainsborough's matured style and method. The head of Dolly the Tall is built up with quick touches that model the features and at the same time achieve a mobility of light, tone, texture, colour. The result is the desired definition of character: sensuous charm, an inner uncertainty, a subtle appeal for acceptance. But the elements are much more complex in the picture of the dancer. The dance-effect is gained by a set of balances and unbalances. Mme Baccelli leans back as she moves lightly forward; against her line of body, almost a diagonal from the lower right-hand corner, there is the mass of the uplifted dress and the trees behind it. But there is a downward movement in the texture of the lifted dress as well, with a sort of circular effect as

151

the dainty cataract of material links on with the rest of the dress and the underskirt, and joins the swirl of forms up to the tilted face, which is both stressed in its position and pulled backward by the rounded hat. The dance-effect is again reflected in the movement of the light rich colour and transparent shadows.[5]

The same maturity appears in the landscapes. *Pool in the Woods with Cottage, Figures and Cattle* has the nestling cottage more towards the centre, and the mother and babe are nearer the foreground at one end of the pool. There is a Rubensesque breadth, with mother, cow, cottage linked by the movement of sunset-light in a triangular relation that expands to take in the whole scene. We see the influence of the Show-Box transparencies. In *The Girl with Pigs* (49½ by 58½ inches) the peasant-forms grow in size in what we have called a Fancy-Picture version of Modern History. The small peasant-girl, the peasant mother with babe, the woodcutter are the three main figures in this development. The mother is linked with the open cottage-door, the entry into a new world, a new life. She becomes the symbol of rebirth in a corrupted world. (In a painting of the summer of 1786 the pig-girl is herself set at the cottage door in a rustic landscape of more sweeping breadth and deeper recession than that of 1782.) The woodcutter stands for the reality of harsh toil in the countryside. The wistfully dreaming young girl represents a semi-awakening to that reality, the hope of something different (which will not be a surrender to the corrupted world). She has a deep meaning for Gainsborough because in these peasant pictures he is returning to the world of his own childhood, when he was as yet unaware of the choices that awaited him. At the same time he is remembering his own two girls and their early years when they seemed secure from the world that has darkly engulfed them. What is the way out? That is a question which he cannot answer. He feels the pull of the open cottage-door and yet broods over the toil and the constricted existence to which it leads. The sadly meditating girl of the 1782 painting is linked by the trees on a mound in an arc with the further pig, and then the curving line along the pig-backs returns to her, running into the lines of her arms which frame her torso and support her head. She is indissolubly tied up with the pigs and their needs, the basin from which they eat.

Reynolds sent to buy the *Girl with Pigs*. Bate says that on learning the price he sent 'a hundred guineas with half as many elegant compliments'. Gainsborough replied, 'I think myself

highly honour'd and much obliged to you for this singular mark of your favour: I may truly say I have brought my Piggs to a fine market.' He uses the jest to cover up the embarrassment he does not quite know how to overcome. Reynolds with his dignity and good sense had perhaps decided to make a gesture which would break through the antagonism built up between them, which was threatening to become a common journalistic theme. By buying Gainsborough's work, which he seems genuinely to have admired, he assumed the benevolent role of the peace-maker, asserting his moral superiority and placing his rival as a painter of humble folk. On 20 April he was given the receipt for his payment. The *Girl* was the most popular picture of the year and had been painted in the Pall Mall studio. Parke tells us:

Being acquainted with Gainsborough at the period when this work was in progress I have seen at his house in Pall Mall the three little pigs (who did not in the common phrase sit for their likenesses) gambolling about the painting room, whilst he at his easel was catching an attitude or a leer from them.

His colour was still discussed; but a critic remarked that if it was strong in the Baccelli, to produce a likeness, he had had 'to lay on his colouring thickly'. Dolly, however, was abused. The *Public Advertiser* thought her eyes far too characteristic of her vocation; the *London Courant* exclaimed, 'A wanton countenance, and such hair, good God!' In fact, as we noted, he painted her with a tender insight, and the hair was done with a fine sense of texture and waving movement which he used to link it with foliage. He seems to have kept a wide connection among the demi-mondaines, who also employed Reynolds and other leading painters. Journals often took a reproving tone at their portraits on the R.A. walls and said that French visitors were shocked at the indelicacy of such women's faces being set by those of women of rank and virtue.

Bate says the Prince paid 500 guineas each for his own portrait and that of St Leger. The galloping horse of Tarleton was much discussed, and it was generally felt that Tarleton had insisted on the scheme. The *St James's Chronicle* thought that Gainsborough's residence in London had given his work 'a classic elegance that was the only circumstance wanting to class him with the most eminent painters this country has ever produced'. John Walcot of Devon, who had preached in Jamaica and practised medicine in Cornwall, where he claimed to have found John Opie

drawing on the banks of a claypit, began this year issuing his Lyric Odes on the R.A. by Peter Pindar. In Ode IV 'the Lyric Bard commendeth Mr Gainsborough's Pig – recommendeth Landscape to the Artist'. The Pig was a well-painted Sow: 'I wish to say the same thing of the Maid'. At times the artist despised Nature's tints; he should attend more to them, 'Instead of Trumpery that usurps their place'.

Joseph Merlin probably pressed Gainsborough to show his portrait this year. In January 1781 he had gone to the Thrales in Streatham to tune the piano, and went back in June. Fanny Burney writes:

During dessert mention was made of my father's picture, when the ridiculous creature exclaimed, 'Oh! for that picture of Dr Burney, Sir Joshua Reynolds has not taken pains, *that is* to please me – I do not like it. Mr Gainsborough has done one much more better of me, which is very agreeable indeed. I wish it had been at the Exhibition, for it would have done him a great deal of credit indeed.

Richard Cosway, miniaturist, showed a portrait of the Duchess of Devonshire. Bate published a poem addressed to Gainsborough by a poet who wanted him to turn to Devon and paint the Duchess. 'Amidst thy fairest scenes, thy brightest dyes, Like young Aurora let the Beauty rise.' The poet sees the artist's genius soaring 'Bold as an eagle in an unknown sky'.

It was this summer, it seems, Gainsborough made the tour in the West Country that Bate later described:

to observe the diversity of landscape, the various combinations of objects, and the tinges of hue in a country so rich and romantic. On one of his extraordinary excursions Lulworth Castle caught his eye. The rich effect of the building, the trees and other scenery, so enchanted this enthusiast of the palette, this poet in colour, that he alighted from his horse and desired his nephew and fellow-traveller, Mr Gainsborough Dupont, to do the same.
Their saddle-bags generally contained their fare, and they took their repast under some ancient trees, contemplating the distant beauties which every vista opened to the eye. Here they were accosted by a venerable looking personage, who prevailed upon them to repair to the Castle. They complied, and he led them to the battlements, where the enraptured eye of Gainsborough feasted on a rich expanse of prospect, everywhere embellished with the rich tintings of the retiring sun. His mind in this luxuriant gratification became stored with some of those beautiful ideas which he afterwards diffused through the fine landscape in Sir Peter Burrell's possession – and the still more enchanting landscape in Mrs

Gainsborough's rooms (the companion of Sir Peter's picture) also retains a fervour from this visit. [6]

The old man was the steward of Wild, the owner of Lulworth; Gainsborough often spoke with pleasure of his kindness. On this trip the travellers may have got as far as Lynmouth, on the edge of Exmoor – or Gainsborough may have made the visit earlier from Bath. Possibly he and Dupont also went now to see Glastonbury and Tintern Abbey, of which he made sketches. At some time he worked in Wales, for a landscape at the sale after his death was noted as done after his return from a tour there.

Among his London friends at this time were Henderson, John Beard, Paul Whitehead; and we catch a glimpse of him at tavern or coffee-house with the playwright Arthur Murphy. A boon-companion was John Bannister, who began as an artist, much talked-of at the R.A. for his practical jokes, then turned to the stage. He studied under de Loutherbourg, so that besides acting he advised on stage-settings, scenery, costumes. With his restless gaiety he spent much of his leisure time in Gainsborough's studio. 'Jack,' said the latter, 'if I die first you shall certainly have a legacy, my cap and bells, for yours will ere long be clean worn out. That nature intended us both for monkeys is certain; but pray, who taught you to play the fool as well; was it your old crony, Davy Garrick?' 'No,' replied Bannister, 'it was my old Mother Nature, she who put the pencil into your hand and made you a painter.'[7]

In September Gainsborough was again at Windsor, painting the royal family at the Queen's command. Late in the month many of the fifteen portraits were done, and soon afterwards the *Herald* stated that the series was completed. The canvases are dated September 1782 on their backs. Angelo says that Gainsborough was enthusiastic about the charms of the young princes and princesses. 'Talk of the Greeks, the pale-faced, long-nosed unmeaning-visaged creatures. Look at the living, delectable carnations of the Royal progeny.' The elder Angelo jokingly warned him that such excited talk would get them sent to St Luke's (lunatic asylum). He replied, 'Know ye not that I am a painter – ergo a son of St Luke! – ha, ha!'[8]

In the later autumn among his sitters were the Duchess of Rutland, Lady Priscilla Burrell (whose husband was to be a generous friend and patron), and Lady Stormon, younger sister of Mrs Graham. In November he started a portrait (lost) of

Reynolds, who sat for him on Sunday, 3 November, and was to return the next Sunday, but fell ill. There was no resumption of sittings. Northcote says:

Sir Joshua had a high opinion of Gainsborough, and very justly; but Gainsborough and he could not stable their horses together, for there was jealousy between them. Gainsborough, I remember, solicited Sir Joshua to sit to him for his portrait, and he no doubt expected to be requested to sit to Sir Joshua in return. But I heard Sir Joshua say, 'I suppose he expects me to ask him to sit to me; I shall do no such thing.' Sir Joshua had a paralytic stroke, which interrupted the painting of his portrait; when he recovered he sent word to Gainsborough that he was ready to resume his sittings, but the latter declined to take him up again, having found out, I suppose, that his contrivance did not take.

Gainsborough may have wanted to improve his relations with Reynolds after the buying of the *Girl with Pigs;* he may have thought his capacity to gain a likeness would have won more applause than Reynolds' version of him. Certainly the two portraits, if done and exhibited together, would have stirred a great deal of discussion comparing at length the methods of the two portraitists.

What had happened to Mary and Fischer? The marriage did not last long, but we do not know the date and details of its breakdown. An undated letter from Gainsborough to Mary Gibbon, which his wife did not know about, provides the only information as to what happened while Mary and Fischer were together. 'Fischer has deceived me in his Circumstances,' writes Gainsborough, 'and his Wife has been playing the devil to raise Money.' She had gone to a mercer in Bond Street, where she 'bespoke 60 yards of White Sattin for a Bed, and at another Shop white sarsanet to line it to the amount of 10 pounds more.' She then wrote to George Coyte, asking him to sell the materials and send the money on to her. (The Fischers have left London, presumably to go to Bath, where Mary Gibbon could get in touch with them.) What Gainsborough wants to know is whether Fischer is directly involved in his wife's actions. He has put a stop to the scheme; presumably Coyte had got in touch with him. So he asks his sister to speak with Fischer, not with Mary. A recent law, he says, makes a person liable to transportation for taking up goods at one shop and selling them at another. If Fischer denies any knowledge of the transactions, 'send for her and give her such a Lecture as may save her from destruction – do it in the most solemn Manner, for I am alarm'd at this appearance of

dishonesty and quite unhappy – my Wife would smother it, but I like truth and daylight.'

There was a family tradition, mentioned by Armstrong, that the first intimation of Mary's distracted condition came when she went to West End shops and ordered silk, satin, linen by the hundred yards. It seems sure then that Gainsborough has here misinterpreted things. Mary was not acting in any planned way to help a hard-up husband; she had surrendered to an uncontrollable impulse based on the delusions of grandeur which we know overcame her. So Gainsborough's letter marks the first definite stage of the breakdown that wrecked her marriage. He seems to have no suspicion of a mental collapse on her part; what he reveals is a strong antagonism to Fischer. He declares, 'She has convinced me that she would go to the Gallows to serve this man.' Yet he would hardly make so strong statement solely as the result of what Coyte has told him. (Fischer lived on some twenty years, then had a stroke at a royal concert, falling onto the double-bass beside him; he died soon after being taken home, asking for his music manuscripts to be presented to the King.)

Early in 1783 Gainsborough painted two soldiers, Lord Rawdon and Lord Cornwallis; each man wanted to give his portrait to the other. In February he attended the R.A. Council to vote for the admission of his friend Garvey. Northcote commented, when asked how Gainsborough acted with regard to the R.A., 'He never came near it, he was too proud and satirical; he was not a person to be managed by such a set. I believe that the only time he attended was to try to get Garvey admitted – an unworthy errand, certainly.' In fact he did vote at eight or nine elections in person or by proxy, two of his votes being given after the break that was to come in 1784. In March Lord Sandwich, first Lord of the Admiralty and Jemmy Twitcher of satirical prints, sat for him; the portrait was commissioned for presentation to Greenwich Hospital, of which the Lord was a patron.

In April came the R.A. show, and Gainsborough sent in his most varied set of pictures so far: Lord Sandwich, Lord Cornwallis, the Duchess of Devonshire, the Duke of Northumberland, Sir Charles Gould (lawyer), Sir Harbord Harbord, Mrs Sheridan, Mr Ramus (half-length), a landscape, a seapiece, fifteen portraits of the royal family (heads and busts, all identical in size and shape), and *Two Shepherd Boys with Dogs fighting*. He also sent a politely sharp letter to say that if the royal

group 'are hung above the line along with full-lengths, he never more, while he breathes, will send another picture to the Exhibition. This he swears by God. Saturday Morn.' He also wrote to the secretary, Newton, asking for the royal group to be hung with frames touching one another. 'God bless you hang my Dogs and my Landskip in the great Room. The seapiece you may fill the small Room with.' He added a sketch to show how the royal heads should go in three rows. No doubt with so many portraits of the royal family, he felt in a strong position. [9]

The crowds were 'prodigiously great'. Among the first-comers was the Duchess of Devonshire, recovered from an illness, who 'looked and moved as sprightly as ever'. The royal group, hung opposite the entrance to the gallery, aroused much interest. Some critics thought he had shown its members in a way meant to please his royal patrons. Peter Pindar saw him mounted on his painting throne and looking down contemptuously on other brushmen, 'Like our great Admirals on a gang of swabbers'. He mentioned 'A frame full of heads, in most humble imitation of the Royal Family', and suggested a title, Golgotha, the place of Sculls. His verses implied that the heads were too poor to be Gainsborough's work, and correctly declared of the *Two Shepherd Boys with Dogs fighting,* 'Thou foully stol'st the Curs from Snyders'. Walcot, who admired Wilson's outlook, made Nature maintain that she had been kicked out of doors by Gainsborough – she,

> Who, in her bounteous gifts, hath been so free
> To cull such genius of thee –
> Lo! all thy efforts without her are vain!
> Go find her, kiss her, and be friends again.

He ended his Ode with praise of John Opie's portrait of Jackson, aware of Gainsborough's friendship for the latter, and followed with three quatrains to Jackson, praising his music, 'Enchanting harmonist'.

The Duchess of Devonshire seemed to Walpole 'too greenish'. Indeed in the background green tones are infused even into the architectural details. Gown, face, and clouds are richly merged by the use of paint, and the effect of the diagonals, with the balancing curtains and woodland on either side, is to merge the forms further with nature, with the delimiting column used to prevent too complete an entanglement. The Duchess sat three times; a sketch of her was owned by Woolner, who was much affected by it; Bate remarked that he has 'derived from this

picture much real benefit, by studying the freedom of the handling and the clearness of the colouring.' The landscape, hung too low, was admired, though the seascape got little attention, while the *Two Shepherd Boys* was thought by many the best work of the year.

Gainsborough also showed a picture of Lady Horatia Waldegrave (not catalogued). Bate protested at its being set against the chimney-board of the fireplace: that is, under the miniatures which usually had a crowd pressing on for a close view. Gainsborough's chagrin would have been increased by his recalling the great success of Reynolds' picture of Horatia and her sisters in 1781. He seems to have come close to a break with the R.A. A note in the *Artists' Repository* two years later declares that he threatened to leave. 'He endeavoured to go in 1783, but was over-persuaded and left the Council in great wrath.' Probably with the royal portraits on the wall he didn't like to walk out.

On 27 April he wrote to Sir William Chambers, architect and author of two influential treatises, one on Civil Architecture and one on Designs of Chinese Buildings (based on what he had seen in China). Chambers was also the first treasurer of the R.A. Gainsborough asks him to find a job for a poor relation of his wife from Scotland; 'a Joiner, who for want of work in his own country has been obliged to leave a handsome wife and children behind him... He is a good workman about thirty years of age, an honest, sober, hardworking creature.' He then inquires as to Newton's health. 'The world cannot supply his loss should he drop.' (We recall that in June 1770 he had written to Jackson of 'that puppy Newton', obsequious to lords.) He himself had sent in his *Two Shepherd Boys with Dogs fighting* to divert Chambers.

I believe next exhibition I shall make the boys fighting & the dogs looking on – you know my cunning way of avoiding great subjects in painting & of concealing my ignorance by a flash in the pan. If I can do this while I pick pockets in the portrait way two or three years longer I intend to turn into a cot & turn a serious fellow; but for the present I must affect a little madness. I know you think me right as a whole, & can look down upon Cock Sparrows as a great man ought to do, with compassion.

As usual, when he feels himself growing too serious, he calls up a mock-humility, a mock-humour. Note his wish 'to turn into a cot' – to go through the cottage-door into a different sort of world where he can be truly himself.

This year the Free Society of Artists held its last show, in a room in the Haymarket. Gainsborough was in it with two landscapes as well as de Loutherbourg, Bartolozzi, Angelica Kauffmann. Jackson's second opera, *The Metamorphosis,* with lyrics by R. Tickell, was a failure, and he gave up the stage, turning to critical writings on diverse themes.

Early in the summer Gainsborough wrote from his sister's house on Kew Green, one Sunday morning, Church Time, to William Pearce. Pearce, who for a time was Chief Clerk at the Admiralty, wrote librettos for comic operas at Covent Garden and was friendly with Bate. Gainsborough mentions sending Pearce some Perry out of Worcestershire. Now he is on the point of a trip with Sam Kilderbee to the Lake District. 'And purpose when I come back to show you that your Grays and Dr Brownes were tawdry fan-Painters. I purpose to mount all the Lakes at the next Exhibition, in the great stile; and you know if the People don't like them, 'tis only jumping into one of the deepest of them from off a wooded Island, and my reputation will be fixd for ever'. Browne had published in 1775 a long letter praising the picturesque charms of Derwentwater. De Loutherbourg, we may note, had attacked the idea that artists needed to go abroad for the picturesque, and had praised the Lake Country and North Wales.[10]

Gainsborough went to the Lakes and was back by late September. Since the early 1770s he had often used hills or mountains in the far background, but now he put a new stress on them in an attempt to grapple to some extent with the new creed of the Sublime. But that creed was so out of key with his sensibility that he could not master it, did not want to take it into his system. Soon after his return he painted *Upland Valley*. The impact of the Lake Country appears in the greyish tones that evoke a misty atmosphere, but he cannot help making the mountains a part of the general rhythmic construction and discarding any effort to create an effect of rugged grandeur. Similarly in the wash-drawing of Langdale Pikes, drawn direct on the spot, it was the damp blurring atmosphere that interested him.

He had been drawn into the realm of the Picturesque, which he himself, without any theoretical intent, had helped to stimulate. The term had arisen to define those elements in an actual scene which were considered suitable for direct transference into an artwork. In 1768 William Gilpin had defined it as 'expressive of that peculiar kind of beauty, which is agreeable in a picture'. But

in its working-out it came to refer to elements of roughness and irregularity in nature which provoked an aesthetic response. It thus took in the elements which refused to be encompassed in a regular classical system, elements of Variety and Intricacy (exalted in fact in the Hogarthian aesthetic of the *Analysis of Beauty*) which were opposed to the Beautiful and the Sublime of the conventional systems. There was thus a link with many aspects of the Dutch tradition of landscape. Gainsborough with his love of winding roads and sandy banks, pollarded trees and dead or near-dead trunks, donkeys, broken-down rustic buildings ranging from mills to cots, had instinctively moved into the world of the picturesque before the doctrine was articulate. His picturesque sense indeed underlay his use of odd objects such as bits of stone or coal as the materials of the model landscapes from which he painted; for in these he was able to enjoy broken, rough, variegated surfaces, which he sought to define in terms of paint, such an attitude affected his brushwork and drove him more and more towards what we may call a textural use of paint. Further, the lines of development in his art were linked with changes going on in landscape-gardening, in the revolt against the more regular systems of men like Capability Brown.[11]

On 29 September he wrote to his sister Mrs Dupont in Sudbury. 'I promised John, when he did me the honour of a visit in Town, to allow him half a crown a week, which with what his good cousin Gainsboro' allows him, and sister Gibbon, I hope will (if applied properly *to his own use*) render the remainder of his old age tolerably comfortable, for villainously old he is indeed grown.' He sends three guineas as a half-year allowance. The sum seems extremely mean, but he may well be writing the letter under his wife's eye. No doubt the family told one another that John would only waste any extra money on brass or the like. Gainsborough asks Sarah to pay Jack 'what day of the week you judge most good. I should think not on the same days that either sister Gibbon's two shillings is paid, not on those days which his cousin do for him. And that he may not know but what you advance the money out of your own pocket, I have enclosed a letter that you may show him, which may give you a better power to manage him if troublesome to you.' He gives only *6d* a week more than Mary Gibbon.

In early October he was painting the Duchess of Cumberland, a haughty capricious person, who had given Wright his one commission in his first Bath season and nearly driven him frantic.

Gainsborough finished her portrait in November, then had her husband as sitter. Her portrait was to be a gift to the Prince of Wales, who himself sat again this autumn. Gainsborough was now painting *The Mall*. Bate stated in the *Herald* that he was working on 'a magnificent picture in a style new to his hand; a park with a number of figures walking in it. To a connoisseur the most compendious information is to say that it comes nearest to the manner of Watteau, but to say no more it is Watteau outdone.' This account by the artist's close friend proves that he was setting himself up against Watteau, but not as an imitator. As Northcote commented, 'You would suppose it would be stiff and formal with the straight rows of trees and people sitting in benches – it is all in motion and in a flutter like a lady's fan. Watteau is not half so airy.'

The Mall had long been the place for displaying fashions. Twice a day modish London took a turn under the trees in good weather; it was a scene of repartees, appointments, gossip. The promenaders ate fruit or bought flowers from Betty's girl out of St James's Street or drank syllabubs of the red cow's milk. A foreigner recorded with rapture in a poem how next morning the ground glittered with dropped pins. (About 1795 fashion moved north to the walk in the Green Park at the back of Arlington Street, then later to Hyde Park and Kensington Park.) The painting has a central group of four ladies with a man advancing towards the spectator; there is a pair on the left, four pairs on the right passing one another, and four ladies seated over to the left. Jackson says that all the women were drawn from 'a doll of his own creation'. Wilkie Collins, R.A., who once owned Gainsborough's painting table, had a small model of a woman dressed by him, which may have been this doll. Gainsborough cannot resist a rustic touch by bringing cows close to the seated ladies. The composition is a subtler version of the interweaving circular movements and balances which we noted in Hayman's Vauxhall Gardens paintings. The dresses are white, green, neutral earth-colours, but the man is red, the one spot of strong colour defying the pull into nature-union, into the opening depths of soft feathery greenery. For once Gainsborough has a complex of lines and colours drawing the forms into a central vortex, which anticipates Turner.

As 1784 opened, all seemed set for a success at the R.A. Admiral Rodney had sat for Gainsborough just before Christmas. The

King was to sit for another portrait. The group of the three princesses, full-length, was done and was to go to the exhibition with seventeen other canvases. On a sheet of paper he roughed out eight of them and noted that their Majesties were to have a private view of the picture of the princesses 'at Buckingham House before it is sent to the Royal Academy'. On 10 April he wrote to the Hanging Committee that he had painted the princesses 'in so tender a light, that notwithstanding he approves very much of the established Line for strong Effects, he cannot possibly consent to have it placed higher than five feet and a half.' (The established line was that full-lengths should be hung above the level of the doorways, so that the base of the frame was eight to nine feet above the floor.) Otherwise, 'he will not trouble the Gentlemen against their Inclination, but will beg the rest of his Pictures back again.' The Committee (A. Carlini, J. Richards, F.M. Newton, Rev. M.W. Peters, George Dance, architect) at once ordered his pictures to be taken down. They had no doubt had enough of his ultimatums. What he wanted was excellent for his own works, but he seems to have had no thought for the works of other artists. No doubt he was now dumbfounded, considering his strong position with the picture of the princesses, that he was taken at his word and in effect excluded from the exhibition.[12]

The *Post* mentioned the rumour that he and others meant to set up a rival show. A letter in the *St James's Chronicle,* supporting him, was probably written by Thicknesse. Then came an article arguing that there was a political basis for the trouble. Gainsborough had for some time enjoyed the favour of the Prince of Wales and 'in the contest for Westminster he was early in his vote for Mr Fox'. (There had been a long-drawn and hard-fought election in which Fox was finally returned.) Further, Gainsborough may well have known of a trick played on Reynolds, 'the success of which will never be forgiven'. A lord had called on Reynolds to say that 'a certain young man' (the Prince of Wales) wanted to show his sense of the painter's merit. Reynolds asked the lord to use his influence to get the Prince to attend the dinner preceding the R.A. show, and was told that if he voted for Fox there was strong hope of the Prince promising to attend. So Reynolds and five of his friends voted for Fox, only to be told that the Prince might be engaged on the night of the dinner. Mrs Thrale mentions that in fact after the company had waited an hour and a half, he 'sent us word he could not come'. This episode occurred at the time of the hanging of the pictures,

and the news that Reynolds had been fooled got around, says the writer in the *Chronicle,* leading to 'private ebullitions of sarcasm, ill-humour, and rancour which occasioned a secession that no doubt will be beneficial to the arts'. As a result, the writer hints, Gainsborough was refused 'an indulgence in placing some important pictures which has generally been allowed, especially to eminent artists'.

The same article states that Downman, a rising portraitist, had had his works insolently returned for 'requesting that some curious drawings might not be placed in the dark room on the ground floor'. It adds:

We are happy to learn that many of the principal artists intend to form a future exhibition in a room sufficiently large and commodious... The names of Gainsborough, Romney, Wright, Sandby, Nathaniel Dance, Downman, Gardner the portrait-painter, Cipriani, Stuart and Marlow are already mentioned. And it is not to be doubted that most, if not all the Academicians, will join them, for the sake of properly exhibiting the effects of their genius, and of saving the company the fatigue of climbing to the very top of an ill-contrived and miserable building.

Nothing came of all this, and it is hard to put any credence in the story of Fox and the elections, though we may accept the statement that Gainsborough had voted for Fox.

The R.A. Exhibition, opening on 26 April, was mostly dealt with favourably by critics. Reynolds sent in nineteen items, including *Mrs Siddons as the Tragic Muse;* gossip said that he wanted to fill the spaces left by Gainsborough. The picture of the three princesses stayed at Somerset House till 4 May, when it went back to Gainsborough's studio, staying there for two years or more. In early May, Bate, announcing a coming show of his pictures, named Reynolds and Chambers as having protested 'in the handsomest manner' against the action taken with regard to his work. Gainsborough did not open his own show for nearly three months, but Bate kept on bringing his name before the public. In a poem he says that just as the royal presence makes a Court, so Gainsborough's charming works make the Exhibition. Then he printed a longer poem on the picture of the three princesses. In June he said that Gainsborough had another commission from the Prince of Wales, for a full-length portrait in hussar uniform. Gainsborough began a full-length of Captain Berkeley and completed one of Lord Hood for Ironmongers' Hall.[13]

That he had not lessened his contempt for the gentry is shown by Angelo's account of his relations with James Barry, a passionate opponent of the art-establishment, who was later much admired by William Blake.

Barry and Gainsborough were at one time intimate friends. They used to compare notes and laugh at the whimsicalities and affectations of the higher orders. Gainsborough observed a lively book might be written on the Caprices of the Great. 'Upon my conscience, and a moral one too,' said the Professor Barry, 'and I would lend you a willing hand to such a performance. What think you of it, Wilson?'
'Why,' replied the cynic, 'would not a work entitled "Whims of Painters" do just as well?'
'Indubitably,' answered Barry, who was no less candid than blunt. 'I thank ye for that, Dick Wilson; it would make a better book. In the one you would have a history of tomfoolery polished into artificial refinement; in the other the raw material – independence worked in with a sprinkling of wit.'
Much has already been said of Gainsborough, and more might still be said; for the circumstances of his life were as various as the style, manner, and practice of his art. Some of his humours, however, were as nearly allied to tomfoolery as those of his superiors in rank who were the subject of his sarcastic remarks.

Here, in his friendship with Barry, we see his one connection with the world of Blake; and also how close his positions were to those of radical revolt – yet at the same time how distant, with his intensely personal refraction of all social issues. Fulcher gives us one more tale of his bitter resentment at lordly insolence:

One gentleman lost his temper, and inquired of the porter in a voice loud enough to be overheard: 'Has that fellow Gainsborough finished my portrait?' Ushered into the painting-room, he beheld his picture fresh from the pencil, and complete to the gold buckles. After expressing his approbation, he requested it might be sent home at once, adding, 'I may as well give you a cheque for the other fifty guineas.'
'Stay a minute,' said Gainsborough; 'it just wants the finishing stroke;' and snatching up a back-ground brush he dashed it across the smiling features, indignantly exclaiming, 'Sir, where is my fellow now?'

On 5 May Thicknesse wrote to Cooke, 'I have peeped into the Society of Arts room, but all the best artists except that mean fellow Sir Joshua Reynolds have withheld their performances. See the *St James Chrle*, for Gainsbro's part. I have eat with him.' The account in the *Chronicle* was doubtless written by Thicknesse himself.

Though Gainsborough had been preparing since May, not till late July did he open his own show in Schomberg House. At such a date all fashionable folk had left London, and he did not do well. Now until his death he carried on with his own private gallery, noticed now and then by the journals. Bate seems to have been the only leading critic invited to the first show. His long account, no doubt using information provided by Gainsborough himself, later appeared in the *Herald*. Among the works exhibited was an unfinished half-length of Lord Cathcart, brother of Mrs Graham. *Mountain landscape with Peasants crossing a Bridge* shows his reaction to the Lake Country in its open spaciousness, and there is a touch of ruggedness in the steep heights on the right; but the main effect he seeks is still that of a rhythmic flow, and under the height nestles his cottage in its trees. Light streaks across the track of the peasants in a slight undulation, and the forms are defined effectively with squiggles of paint more uncompromising than ever. In *Peasant Family receiving Charity* he came his closest to the anecdotal genre-picture: the servant-girl of a country-house gives food to a needy peasant family. The strong verticals are mainly relieved by the movement of light, which gathers the figures together and makes the pan of charity the central point of interest. However, we have only to compare the work with the sort of thing, similar in theme, that Francis Wheatley was soon turning out, to realize its lack of sentimentality.[14]

In August Allan Ramsay died, and the post of principal Portrait Painter to the King fell vacant. Bate urged that Gainsborough should be chosen, but Reynolds was appointed. His position as President of the R.A. was too strong, and indeed to have appointed Gainsborough in his state of secession would have been something of an insult to the King's own Academy. But beyond doubt Gainsborough had felt sure that he would step into Ramsay's shoes. He had had such a strong claim as the painter of the royal family in recent years, while Reynolds was not liked at court. In a letter to the Earl of Sandwich he couldn't hold back his chagrin. The Earl had wanted a copy of the portrait of the Queen for the Corporation of Huntingdon. A copy by Dupont, says Gainsborough, has been put on the waggon. If his Lordship doesn't like it, let his cookmaid hang it up in the kitchen as her own portrait, 'and get some sign-post gentleman to rub out the crown and sceptre and put her on a blue apron, and say it was painted by G———who was very near to being King's Painter only Reynold's Friends stood in the way.'

Fulcher says that to divert himself from the lack of interest in his show, he visited Sudbury; no doubt it was rather to escape from the disappointment he felt over losing the court appointment. 'From the personal recollections of a lady until recently living in Sudbury, we learn that he was a guest at her father's house, and that he taught his hospitable host the seductive lesson which Hamlet promised to teach Horatio during his visit to Elsinore.' This was the time he wore a rich suit of drab and was gay, very gay. Fulcher adds: 'The remembrance of his arrival in Sudbury to exercise his elective franchise as a free burgess of the borough is still preserved: from his recorded votes – and we may assume that these at least were free from undue influence – he appears to have been a Tory of the old school.' Fulcher must be merely guessing in defining him as such a Tory. We have seen that he seems certainly to have voted for the radical Whig Fox, and he was friendly with similar politicians such as Sheridan and Burke. But certainly he would have insisted that he had no interest in political strife and that he judged politicians, like everyone else, on their own merits. At the same time, as the friend of James Barry, he had all the seeds of a strong radical independence in his character and in his views. However, to preserve his creative driving-force he needed to translate his emotions of revolt into imagery of reunion with nature, imagery that exalted the peasant and yet could see no fate for him but lonely toil relieved by the family-bond.

The turn to nature was for him a return to childhood. In *The Girl with Pigs* he had achieved his image of the peasant-girl; he needed also the image of the peasant-boy. He had already done his Shepherd, and as far as back as the late 1760s had depicted the eager Pitminster Boy. Now more than ever he kept his eye open for children who would serve as models, when he walked in the streets or fields. Late in 1784 near his house he was accosted by a beggar woman with a handsome little boy. He gave her some money and asked her to call next day with her son. She came. He had the boy washed and dressed, and offered to take complete charge of him. The woman asked for a few days to consider, then said that she couldn't part with the boy, as during the last year he had gained seven shillings a day by begging.

Angelo tells us that Abel managed to amass a large number of Gainsborough's drawings, which he pinned to the walls of his apartment on the paper-hangings, but that he later gave most of them to his mistress Signora Grassi, for whom he took a house in

Frith Street. She framed them and hung them in her drawing-room.

The woman, though no beauty, was a wit, and called the apartment her Painted Paradise. Fischer, Gainsborough's son-in-law, though a man of few words, in making a visit there with his friend Abel, objected to this designation by exclaiming: 'Abel, you are a fool, and mine fader Gainsborough is a blockhead; for the only painted thing is mine lady's cat face.' The lady was not present, but for her and himself, Abel made no other return to Fischer for his German politeness than a most grave and profound bow.

No doubt some basis lies behind this story, but Cecilia Grassi had been Bach's wife and certainly was never Abel's mistress. Angelo may have got the name of Abel's mistress wrong and confused her with Cecilia. Abel in later years was a hopeless drunkard; we hear of the curtain at a concert having to be lowered as he could not stand to acknowledge the applause.

This year, 1784, Fischer played in the Handel Commemoration in Westminster Abbey; Charles Burney wrote how alone with his sweet and graceful tone he 'filled the stupendous building.' About this time Giardini, challenged by younger musicians and suffering from dropsy, went back to Italy. (Returning to England in 1789 he did badly and went off to Russia where he died in Moscow in poverty.)

Gainsborough did not lack commissions. In January 1785 Henry Beaufoy sat for a portrait to pair off with that of his wife done five years before; and progress was being made with the full-length of Lord Rodney with a bantam-cock. (A cock crowed all through the action of 12 April 1782 when he took five French ships-of-the-line.) In the winter of 1784-5 *The Harvest Waggon* was painted. In composition it was close to the picture of the same name completed nearly twenty years earlier, but the eye was drawn first by the lighting to the people of the waggon, then down via the arms where the girl is being helped up, to the horses and the turning track, and round to the tree-masses and the clouds rearing above them: the tree on the left linking earth and sky and returning the movement from the clouds to the people. Gainsborough's capacity to unite diverse styles is shown by the Rubensesque breadth and concentration together with a figure (the child at the back of the waggon) that suggests Rembrandt, and another based on Hogarth's *Shrimp Girl* (the shadowed girl).

Thomas Coke, agriculturist of Norfolk, commissioned an

equestrian portrait of his friend the Prince of Wales, which was to go with Van Dyck's *Duc d'Arenburg* at Holkham. Gainsborough was painting Mrs Siddons, not on commission but at his own request. Clearly he wanted to challenge Reynolds' picture of her as the Tragic Muse. She was sitting to him in March, and the work seems to have been completed by month-end. No buyer could easily be found. Later the artist Scott, who also painted her, remarked that he found her nose hard to draw; and she answered, 'Ah! Gainsborough was a good deal troubled in the same way. He altered and varied the shape a long while, and at last threw down the pencil, saying, "Damn the nose – there's no end to it." ' To compare the portraits of Gainsborough and Reynolds is instructive. Reynolds starts with a set idea: 'Ascend your undisputed throne, and graciously bestow upon us some good idea of the Tragic Muse.' In those terms he welcomed her and strove all along to define her. Gainsborough sat her in a chair, moved her about, studied her face. Profile or full face would not do. Her nose could only be tackled from a three-quarters view. That point settled, the way her body disposed itself followed as a matter of course, and in turn the construction of the picture. All the main systems there had to be linked with the nose and express it in some way or another. The picture was built out of 'a series of long slightly tilting ovals that parallel the shape of the famous nose' (Paulson). So the picture is one of her nose and its continual reflections or reproductions in space, in the body and dress of the sitter. Not that what evolves is a merely formal matter. The nose brings the actress's sharp intelligent face to its point of fullest awareness. In constructing the picture out of it Gainsborough makes her whole form and its ambience, its tensions with surrounding space, express in varying ways that shaping intelligence. [15]

To 1784-5 we may date *Greyhounds Coursing a Fox,* where the whole organization derives from the long curving lines of the backs of the greyhounds in their lithe leaping movement. The trees are drawn over, but space is re-stabilized by the trees on the left in the open space. About 1785 was painted *Haymaker and Sleeping Girl,* the culmination of Gainsborough's rustic lovers. Here the boy and girl are separated by the bars of the fence, yet linked by criss-crossing diagonals inside the burst of light which gives a rounding effect, holding apart his intent head and her head that lolls back, and yet enclosing them in a private luminous space. The portrait of the Duke and Duchess of Cumberland may

be dated 1783-5; we have two drawings for it. It begins as a conversation-piece, feels compelled to unify the pair and penetrate them with light, then to enclose them in a rich oval tree-scene where nature takes over and threatens to absorb them.

In April Gainsborough was painting The Rt. Hon. C.W. Cornewall, Speaker of the House of Commons, the young Lord Darnley, and Lady Sheffield. The Lady had recently been married and her dreaminess is expressed by the way she is drawn into the landscape by the evenly sufused light. In the spring he worked on Mrs Sheridan and *Beggar Boys*. Thirteen years before he had painted Elizabeth Linley with her sister; now she is lost in a saddened meditation which is one aspect of her absorption into nature. There is an interwoven movement of wind-loosened hair, gauzy scarf and dress, foliage and cloud. Bate says that the lambs were added later to give 'an air more pastoral'. The beggar boys were based on the street-urchin he had used for the Shepherd of 1781. The picture shows a strong influence of Murillo, but what is added is an emotional intensity, a sense of loss and homelessness. There is no saint or madonna for these boys to look up to appealingly, but they still look.[16]

There was much interest, as the R.A. show neared, as to whether Gainsborough would exhibit. Rumours went round that he had been reconciled, for example in the *Public Advertiser*. He sent nothing in. The *Morning Post* said that his absence and that of Romney were less important than that of Wright. The *General Advertiser* saw a 'melancholy appearance of decline' despite Reynolds' cramming-in of sixteen works; unless the absentees were brought back, in a few years the R.A. would be deserted by all men of merit. The *Advertiser,* however, was sarcastic about Gainsborough. Reynolds was criticized for hanging his picture of the notorious Mrs Smith close to a religious work by West. Peter Pindar in his First Ode is advised by Satire to abuse Gainsborough and fall foul of Mrs Cosway's *Samson.*

> Deal Gainsborough a lash, for pride so stiff,
> Who robs us of such pleasure for a miff;
> Whose pencil, when he chuses, can be chaste,
> Give Nature's form, and please the eye of Taste.

In the last days of May he finished *Cottage Girl with Dog and Pitcher,* and almost at once sold it to Sir Francis Basset for 200 guineas. Bate says the girl was a young peasant met near Richmond Hill carrying a puppy under her arm. Hazlitt, who saw

only the weak side of such a picture, said in 1814, 'There is a regular insipidity, a systematic vacancy, a round, unvaried smoothness to which real nature is a stranger, and which is only an idea existing in the painter's mind', though he found the girl's attitude easy and natural. There is, however, in such a work by Gainsborough a genuine pathos and insight into poor folk, with an element added from his own deep regrets and sense of loss. Of the Fancy-Pictures Hazlitt preferred *Cottage Children,* now called *Wood-Gatherers* (1787).[17]

From early days, as we have seen, he used landscapes to express a way of life that he could whole-heartedly approve, a way of life opposed to that of the upper-class sitters whom he had to paint – opposed indeed to the life that he himself lived as the creature in many ways of the gentry he despised. In drinking and wenching he also found something of an escape from the conventional life into which he could not happily fit – though here he was taking the conventional way out and binding himself yet closer to the system he despised. He could not resist the lures, which in many ways were both expressed and denied by the music he loved. But the satisfactions he received returned him in the end with increased anxiety to the thing he wanted to escape. He needed the dream of a return to nature, to the peasantry, if he were to keep his spirit alive. The cottage, which had at first been merely one of the properties of the rustic world, became more and more the supreme emblem of that world. Its open door became the passage leading to rebirth, to the reunion of body and spirit in the family-bond, the embrace of lovers, the daily toil of the drover, ploughman, woodman. Although all these elements are present from the outset, they steadily grow in a coherent significance, especially from the early 1770s. As London closed finally in on Gainsborough, he felt ever more the need to define the woodland with its door of escape and renewal. The rhythmic swing of the path or road, which ran up into his trees and beyond, expressed the movement he wanted to surrender himself to – a movement which he more and more identified with the free flow of melody and rhythm in music.

The Suffolk pattern grew ever more dominant, the pattern which I have suggested he first absorbed in the Croft or common land at the back of his house leading down past St Gregory's Church to the river with its thickets and bushes. The scheme is that of a gently swelling slope, which lifts into woodland and descends into water. He found an endless satisfaction in the

imagery here, which he repeated with ceaseless variants, stressing both the movement up and the movement down, but always concerned with the movement deeper into nature. Work is not ignored. The movement of carts, horses, donkeys, cattle and sheep, with the accompanying peasants, up and down the slope, along the curves and turns, is necessary for the full meaning. We see the bent and obsession of his mind in the hundreds of drawings; for these he did for himself. Apart from the handful which he made as preparations for paintings, or (in earlier days) to familiarize himself with some of the niceties of costume, these are almost wholly devoted to the themes outlined above.

A large number of points, aesthetic and emotional, follow from what I have called the Suffolk pattern. First, we may say that it led him to reject the topographical outlook. Where he depicts buildings, they play their part in a rhythmical structure and cannot be separated out, and converted into their plan. He is concerned with certain essences of the natural scene, not with describing a particular place. The weakness in this approach is that the forms can become overgeneralized; its strength is that he never succumbs to making a mere reflection of what is before him, but is always concerned with rhythms of growth, of man in relation to nature. Hence, besides a number of basic natural forms, from hill-slope to leaf, as part of his grammar of expression, he also has a series of forms or objects, drovers, woodmen, children, flocks, cottages, that embody the human side of his vision. He continues to draw and study from nature.

He thus defines various moods, especially the calm and serene merging of man and nature. These depend, not on some vague evocations or diffuse emotion and generalizing of forms, but on a deeply-felt sense of union between man and nature that finds its expression through precise rhythms and structures.

Sloping ground becomes an essential part of his vision of nature, and in many ways it is the embosoming effect of nature that moves him rather than breadth of vista, though the open or opening scene has its own importance which we shall discuss after considering his obsession with enclosing structures. In the slope he can make full use of the effects of rising and falling, meandering and undulating paths, which represent man's movement into nature and into himself: his active relation to the scene and the connection of work with the natural forms. The artist is thus able to define the active passage into nature and the environing pressures and interacting patterns with endless variety.

So his characteristic glance is up into a rising series of curves and planes. But though the movement of definition is from the hidden base upward, there is also the returning movement to the base from which the structure has emerged and on which it rests. Often at the base there is water. The typical movement is that of cattle or horses (ridden or drawing carts) down to the water, which they are to ford or drink from. At times they stand in the water, which is a sort of primordial element out of which the earth rises. Or they rest on the slope, as do the human figures. These come right down only when riding a horse that drinks or seated in a cart rumbling across a bridge. Occasionally they are in a boat. At times the herd crosses a bridge, or, where the slope is less steep, they may turn to pond or stream.

The light-effects are linked with this system. Light bears down, falls over to one side in the arriving dark, with the sky above still holding a clear glow. There is no darkness proper, only the oppositions of masses of varying depths of green to the intrusive sunlight. At times we see a clearing amid thick woodland that threatens to take over; men and animals may be coming down into it. The main image or structure counteracting the downward pull is the cottage, usually set among trees that seek to close it in and reclaim the ground. The human figures are generally linked with the cottage and make diverse patterns that in the last resort also help to hold up the downward movement.

We thus get something of a coherent world-picture. At the lowest level is the water-depth (at times water in movement), with perhaps herdsmen coming down or woodmen at work in the forest-edge. The movement up along the turning track brings us to the cottage and peasant family. Then we may come to peasants seated on steps or along a path that descends from a villa or village above, as if with a great effort men have broken out of the encircling woodland and reached a relatively cleared space nearer the sky. One landscape shows the church-tower, then cottages, then peasants, then a path down to water. Men and nature are entwined in the rhythms of growth, merged by the intermingling colours and textures. The forms are thus in the end drawn together as variants of a single system or process.

One is tempted to say that here we meet the symbolic imagery of a primitive creation-myth: the earth-mountain rising up out of the primeval waters. When one recalls that each ancient Egyptian temple was seen as the earth-mountain thus emerging, Gainsborough's image of the earth sloping up out of water to the

village-church becomes strangely suggestive. Pyramid and ziggurat were also earth-mountains founded on the abyss; and the ziggurat with its winding ascent again suggests the artist's world-image.

Not that he had anything so grandiloquent even remotely in mind. He was simply seeking to clarify the elements of landscape which most strongly appealed to him: which most subtly stirred his emotions and became intellectually significant. But by steadily seeking to get down to the essentials of the image of a slope of trees rising up out of water and revealing men and women at work or in their family relationships along the winding path that penetrated into its recesses, he achieved a symbolic system that went deep into human experience.[18]

These comments will perhaps seem not too far-fetched or grandiloquent if we glance at Coleridge. He wrote:

I bent down to pick something from the ground...as I bent there came a distant vivid spectrum upon my eyes; it was one little picture – a rock with birches and ferns on it, a cottage backed by it, and a small stream. Were I a painter, I would give outward existence to this, but it will always live in my memory.

Here, we see, is a fundamental romantic system. It appears in more extended and dynamic form in *Kubla Khan,* where it is water (not the trackway as in Gainsborough) that meanders with a mazy motion. Consider these comments on the poem:

An implication of cycles of creative energy, swelling and subsiding ...both circuits of the river conclude with a descent... It is appropriate that the fountain and the river should be associated with the process of reconciliation and mediation in stanza two. The fountain rises in the chasm, which since it 'slants' downward from the upper world to the lower, in effect mediates between them – a midway region of dynamic creativity that shades off in another direction towards a static extreme. (Chayes)

I should prefer to speak of dynamic balances with momentary resolutions of unstable states; but we can see how the dream-imagery of the poem, its landscape with descending levels and interconnections, has a strong similarity to Gainsborough's symbolic language, which finds its simple equivalence in the reverie-image of the poet in the first passage.

A selective element was part of the theory of the Picturesque. Gilpin and Price (accepting ideas set out in Reynolds' *Discourses*) held that what mattered in a landscape was the composition, not

the fidelity to fact, 'arrangement not observation'. Gilpin declared, 'Nature gives us the material of landscape; woods, rivers, lakes, trees, ground, and mountains: but leaves us to work them up into pictures as our fancy leads.' That did not mean we could intrude quite new features, such as a castle, a big impending rock, a river; it meant only that we could give more grace or character to an ill-formed hillock. The artist 'may shovel the earth about him, as he pleases, without offence. He may pull up a piece of awkward paling – he may throw down a cottage – he may even turn the course of a road, or a river, a few yards to this side, or that'. These ideas of procedure have a certain affinity with the way that Gainsborough shapes his landscapes; but in the last resort the criteria are different. The picturesque artist is fiddling about with details to secure what he thinks a more effective composition; Gilpin thought the framework of design should be firmly based in Claude. Gainsborough was transforming the scene or the material he had gathered in terms of the rhythmic image we have discussed. Not that he was uniformly successful. At times his simplifications have their links with the picturesque beautifications; he over-generalizes and repeats himself. But, taken as a whole, his work shows the struggle of transformation on the lines set out. To give him courage and a sense of direction two factors were necessary: music and the rococo aesthetic (both in its more conventional aspects and in the more vigorous and deep-going interpretations of Hogarth's *Analysis of Beauty*.)[19]

In music he felt the liberated forces of art carrying the elements of experience to a new level of concentration, cohesion, transformation. We have noted again and again how he turns to music for the terms in which to explain his ideas about pictorial art. Music above all nerved him to attempt more and more in his art a unity of theme, brushwork, texture, form and colour in dynamic interrelation.

The rococo aesthetic provided him again with the conviction that he need not inertly accept the forms and constructions in a scene before him, however much they fascinated him. Music and rococo curves gave him a sense of entering into the principles of growth expressed in the forms of nature. So he could validly use them to reorder, redefine the observed scene, in terms of a more significant and evocative unity.

Already in his teens in London he began the struggle to bring together his direct observations of Suffolk nature and the rococo of the pattern-books, of Hogarth and Hayman, of Watteau and

other French artists. The *rocaille* (rockwork or grotto-work), which was the basic element in the origins of rococo found its key-image in the conch shell (lying on its side) where there was a curving and coiling movement inwards. Here we have the direct link with the grotto, which for the century's gardener represented the point of movement into the recesses of nature. (In Thicknesse's Landguard cottage the garden has a recess about twelve feet deep, ornamented with shell-work; there was also a small archway leading to a tunnel lined, top and sides, with shells, that opened into a room 'entirely covered with shingles, shells, talc, small pieces of looking-glass, and spar, besides a great number of small copper coins dug out of the ruins of the castle.') Hogarth with his concern for the serpentine line of beauty set the shell upright, making it a mixture of labyrinth and pyramid. Gainsborough responded to such concepts and developed them in his own way, though he was unaware of the wider intellectual and cultural implications.[20]

It is however important to understand something of those implications, which he in part absorbed from the general cultural trends of the day without realizing it. Thus Antoine Parent, who in France anticipated some of the Hogarthian ideas about curves, developed the theory of the working of water-wheels. The artist Giles Hussey argued that every face was in harmony with itself and that the drawing of the human form should be corrected by the musical scale. Above all there were the mathematical theories developed by men like Jacob Bernoulli or Colin Maclaurin. Maclaurin worked out his theorem of the equilibrium of elliptical spheroids and discussed the flux and reflux of the sea; he was concerned with the organic description of plane curves. Bernoulli built up the mathematics of the spiral:

It is a curve to be found in the tracery of the spider's web, in the shells upon the shore, and in the convolutions of the far-away nebulae. Mathematically it is related in geometry to the circle and in analysis to the logarithm. A circle threads its way over the radii by crossing them always at right angles; this spiral also crosses its radii at a constant angle – but the angle is not a right-angle. Wonderful are the phoenix-like properties of the curve: let all the mathematical equivalents of burning it and tearing it to pieces be performed – it will reappear unscathed! (Turnbull)

So Bernoulli asked for the spiral to be engraved on his tombstone with the motto: *Eadem mutata resurgo* (The same, changed, I rise again). We see that rococo had deep roots in the scientific efforts of the time to understand nature, and the practical efforts being

made to control and transform it. As rococo ideas were formalized, the vital link with such efforts tended to be minimized. But in the ceaseless creative struggles of artists like Hogarth and Gainsborough we see an intuitive attempt to grasp and revive the vital content of the style.

In so far as there is stress on downward movement in Gainsborough's slopes, we can relate his work (as Paulson does) to certain trends on the Continent, for example, Meisonnier's working-out of the grotesque element in rococo forms, or the way in which Filippo Juvara (in his *Prospettiva Ideale,* 1732) produces rococo forms that twist into stairways leading down off the page, partially closed by arches. We can further compare the structures of Piranesi. By the 1750s the Designs of J.E. Nilson turn the *rocaille* into torn treetrunks on hill-slopes, into monstrous rock-shapes that come close to vortical constructions. In such developments we see a more violent and tormented version of one aspect of Gainsborough's methods of organizing his world-image, his slope of nature. Some touches of these attitudes perhaps appear in his predilection for dead or near-dead trees, which often play an important part in the compositional structure, especially as diagonals. But they are used always in contrast with thriving tree-masses. The Continental artists seem to express some bafflement and despair, in societies facing what seem insoluble conflicts. For Gainsborough the world, however full of oppressions and injustices, presents a creative tension of opposites, of upward and downward, in which hope can assert itself.

Vortex indeed seems too strong and violent a word to apply to his system; but if we can speak of a gentle vortex we come close to the way in which his rhythmic forces operate. He is reacting, as we saw, against the geometries of closed perspective-space, which he knew all about through his friend Kirby. The closed space had been finding its expression since the Renaissance in urban buildings and lay-out. So he totally excludes urban life and structures from his vision. (The nearest he came to defining a space where the buildings in their hard lines dominate people was in his *Peasant Family receiving Charity,* but even that was only a farmhouse.) He hates all classical architectural forms, with their intellectual apparatus of fixed systems and perspectives; for him the town is a set of mathematically formulated boxes in which men are jailed. He wants at all costs to break out, into the free rhythms of natural process, into a space where what matters is the

relation of man or animal to earth-mass and tree-mass: with man's constructive powers expressed in the roadway, the bridge, the cart, the boat, and in a few cases the plough. That is, with objects which are directly linked with the natural scene and with man's movement into and through it: movements determined in turn by the lay of the ground, the winds, the currents of water. In earlier works the church-tower in the distance was often the focal point; later the cottage merging with the greenery represents the home of the people who live in harmony with nature while grappling with her in work.

In developing his system Gainsborough had to absorb and transform the work of many landscapists: the Dutch, Watteau, Claude, Rubens. But he never halted at imitation of them. He took in what suited him and steadily adapted it to his own needs. One aspect, as we noted, of his attempt to transform the given scene by stressing rococo curves as aspects of the formative processes of nature was to create a sort of gentle vortex, drawing the spectator into the curving-and-coiling shell-movement. Here was the effect which Turner was to develop with much greater power and complexity. Trimmer tells us how he showed Turner the eight early landscapes which Kirby, his grandfather, had owned. Turner examined them 'so carefully one evening, that next morning he said he had hurt his eyes'.

In the vortical aspects we see again the effort to realize in a single image the union of opposites: of movement both inwards and outwards, as in his slope-pictures he realizes the union of movement up and down. Already in his early *Cornard Wood* we find banks falling down to water in the foreground, but with an opening vista through the enclosing trees. Throughout his life, despite the great significance to him of the slope, he is also concerned with the breaking-open of the enclosed space, and here he uses elements from many schools of art to gain his effects: at times developing the Claudean aspects so that the movement inwards is balanced by forms on either side, at times relying on broad Rubensesque swings of rhythm to define the involved movement inwards and outwards. Roads and the people on them, the carts, horses, donkeys, which are aspects of the world of work operating inside nature, play a key-part in revealing all that the complex movements signify: movements in and out, up and down. What is defined is not a static system of balances but a tension continually reasserting itself and continually resolved.

Gainsborough, we have noted, was not a man of ideas in any

ordinary sense of the term, although he thought hard and clearly in his own way. It is possible, however, that he knew something of Rousseau; for Thicknesse in his *Valetudinarian's Bath Guide* of 1780 has a passage on that thinker whom he praises as 'the most remarkable man that ever appeared in the world', outstanding for his originality and independence of spirit. So he may well have expatiated on Rousseau and Nature to Gainsborough. We saw how Thicknesse had his Cottage near Felixstowe. When in 1774 he moved from the Circus, he took a cottage which he called St Catherine's Hermitage at Bathampton, a mile or so from Bath. He used this 'hermit's hut, built on the side of the dingle', in summer. He had told Lord Thurlow that if he had any talent 'it was the earliest and humblest of all; that of *cottage making*'. At his Hermitage, he said, 'My eyes are as often turned upwards as downwards', and he had water at the bottom; from his study window he looked down on the Avon. He called the place '*my paradisiacal* abode'. It is possible then that his cult of the cottage and his exaltation of Rousseau may have helped Gainsborough in the confirmation of his attitudes, which however in their essence sprang from deep within his own spirit.

In June 1785 Gainsborough painted Lord Maldon, rake and journalist, who had been, said gossip, the intermediary between the Prince and Perdita. 'When the Ladies of Cypria next lose their favourite they may console themselves with his picture.' He also painted a lady who is called 'a successful cruiser on the Cyprian coast'. In summer two portraits of his were hung in public buildings in the City: the Duke of Northumberland in Hicks' Hall (the Sessions House of the County of Middlesex) and Lord Hood in Ironmongers' Hall. In August came the completion of pictures of two seamen, Admiral Graves and Lord Mulgrave.

He had no lack of work, and he worked hard, but he was tiring and seems troubled by anxieties. His daughter told Farington:

Her Father always dined at 3 o'clock, began to paint abt. eleven o'clock and was generally exhausted by dinner time.
Her Father had drawn much by Candle Light towards the latter part of his life when He thought he did not sleep so well after having applied himself to drawing in the evening not being able to divest himself of the ideas which occupied his mind, so therefore amused himself with Music.

What had been a vital stimulus was in part becoming a drug, Thicknesse stresses that his way of always standing as he painted,

which of late involved five or six hours work on his feet in the morning, 'tired him exceedingly.'

About this time the *Herald* promised to publish 'The stanzas on the Palette belonging to the celebrated Mr Gainsborough,' but the poem did not appear. What we know of the palette is set out in the recollections of the Rev. Trimmer. He knew Briggs, the near neighbour of Margaret Gainsborough in her last years, and says of the palette:

This I had from Mr Briggs, but have lost it; still, as I have copied several Gainsboroughs, I think I can furnish you with it. Yellows: yellow-ochre, Naples yellow, yellow lake, and for his highlights (but very seldom) some brighter yellow, probably a preparation of orpiment, raw sienna; Red: vermilion, light red, venetial, and the lakes; Browns: burnt sienna, cologne earth (this he used very freely, and brown pink the same). He used a great deal of terre verte, which he mixed with his blues, generally with ultramarine. Latterly he used Cremona white; this he purchased of Scott in the Strand, who on retiring from business gave me what remained. It was the purest white I ever used, and accounts for the purity of Gainsborough's carnations.[21]

But this can hardly be a complete account. We know that he used indigo at Bath, perhaps experimentally. Indeed all serious artists of the time were in many ways experimentalists with pigments and materials. Field in his *Chromatography* speaks of Gainsborough at one time painting flesh with red and green alone, but cites no authority. Asphaltum seems one of his favourite pigments; he is said to have boasted that with its help he could paint a pit 'as deep as the infernal regions'. And in a list of artists' colours soon after his death we meet Gainsborough's Essence of Asphaltum cited after Van Dyck's Brown.

Trimmer says that Margaret used to sit in her father's painting-room. 'She said his colours were very liquid, and if he did not hold his palette right would run over.' We know he liked long brushes. A writer in the *Morning Chronicle* excused what was considered his lack of finish by saying that he worked with a very long and broad brush. To use such a brush for lengthy periods must have been very tiring. J.T. Smith tells us that Gainsborough

frequently allowed me to stand behind him to see him paint, even when he had sitters before him. I was much surprised to see him paint portraits with pencils on sticks a full six feet in length, and his method of using them was this: he placed himself and his canvas at a right angle with the sitter, so that he stood still, and touched the features of his picture exactly at the same distance at which he viewed his sitter.

Not that all his work could have been done with broad brushes of hog-hair. Dupont, who inherited his implements and colours, left, as well as many hog-tools, twelve bundles of camel's-hair brushes.[22]

In the autumn of 1785 Gainsborough copied with much sympathetic understanding a Velasquez then called *The Competitors*. (Reynolds once said that he had to examine a copy of Van Dyck by Gainsborough a long time before deciding if it was a copy or the original.) According to Northcote, Gainsborough would have liked to buy Velasquez' portrait of Don Balthazar on horseback but could not afford the price. He was now offered a commission for three portraits of a judge, Baron Skinner, which he started in October; two were done by 1786. A royal commission came in for a companion to *The Mall*; all its figures were to be portraits (no doubt of the royal family) and the landscape the 'Richmond water-walk, or Windsor'. This would have been a highly important work if he had done it; what survive are some fine figure-drawings. William Pearce writes of one of them:

While sketching in the Park for this picture, he was much struck with what he called 'the fascinating leer' of the Lady who is the subject of the drawings. He never knew her name, but she was that evening in company with Lady N... field, & observing that he was sketching she walked to & fro two or three times, evidently to allow him to make a likeness.

It seems clear that a rich and flowing relation of figures and trees would have dominated in the picture.

In the autumn he painted *The Morning Walk* in which young Mr and Mrs Hallett, married in July, have been taken as depicted on their first walk after the wedding night. Here is a strong development of what has been called the mood-portrait (as for example in Lady Sheffield); and the work has been called a romance of young love. But in fact the newly-wed couple could hardly be less sensuously and spiritually together. Their faces are hard, closed, egoist. (Hallett was well-known on the turf.) What gives the romantic effect is the splendid unity of colour and design, which makes the couple a vital part of the scene.

The smooth darkness of the squire's jacket and trouser-leg are repeated in the deep shadows of the foliage and tree trunk. Mrs Hallet's hair, the fluffy mass of foliage of the single tree silhouetted against the clouds, and the dog's curled plume of a tail are echoes of one another in texture and in shape. The agitated ruffles and highlighted roundness of the lady's breast

and the flowing puff of clouds; the plumes of her hat and the downward plumes of the foliage directly behind her; these and several other details masterfully tie together the landscape...
The technique of painting the Hallets and their dogs, as areas of varying texture, admirably unites them with the landscape. (Buchwald)

Gautier understandably said that on seeing the work he felt 'a strange retrospective sensation, so intense is the illusion it produces of the spirit of the eighteenth century. We really fancy we see the young couple walking arm in arm, along a garden avenue.'[23]

Fulcher says that at Richmond Gainsborough spent 'mornings and evenings in sketching its picturesque scenery. When on his walks he saw any peasant children that struck his fancy, he would send them to his painting-room, leaving with their parents very substantial proofs of his liberality'. Thus he met Jack Hill, an intelligent boy of about ten years and offered to provide for him. The parents agreed and the boy was taken into the household. Mrs Gainsborough liked him and Mary was so carried away that she wanted the boy all her own. After two or three pictures the boy pined, then ran away. Brought back and kindly treated, he seems never to have felt at home. Mrs Gainsborough finally got him entry into the Blue-Coat School.

In November Gainsborough painted *Cottage Children with Ass,* using as model the girl he had painted with dog and pitcher. Before Christmas he finished the work, which is now lost, though an engraving was made of it. Bate says that the little boy and girl lived in a cottage near Richmond, 'where Mr Gainsborough has a house'. This house, near that of Reynolds, was held for some years, though we do not know when it was first taken. In his will Gainsborough left its contents to his wife. The King, who often resided at Kew, used to call at the house, where he admired a picture by Vandervelde. (Some surprise was expressed that it was not bought for the royal collection when offered for sale after Gainsborough's death.) Angelo says that the Queen took lessons from him, 'during the then fashionable rage for that artist's eccentric style, denominated Gainsborough's moppings.' Pyne also mentions her as his pupil, and the princesses probably also took lessons, although no sign of his style appears in the surviving portfolios of their work.

This year, 1785, Henderson, thrice painted by Gainsborough, died of a fever. There was a story that he was poisoned by his wife in error. Jack Gainsborough also died. Our last glimpse of his is

as an old man standing by the hour drawing diagrams in the sand on his floor. Fulcher says he decided to go to the Indies in order to prove the efficiency of his invention for determining longitude. He reached London and died there, leaving his Sudbury house filled with brass and tin models of every size and form, mostly unfinished. Tenducci's opera, *The Campaign, or Love in the East Indies,* at Covent Garden, seems to have been a failure. Perdita was in a bad way. The Sheriff of Middlesex seized the things in her house in Berkeley Square; among articles sold at auction was Gainsborough's portrait of her, knocked down at 32 guineas to an unnamed person (doubtless an agent of the Prince of Wales).

In January 1786 Gainsborough visited Bath. We hear of Mrs Heathcote, who in an epidemic had lost four or five children and who begged him to paint the surviving son. 'I am here for a rest and cannot do it,' he told her. She went off, but returned with the boy. As she had hoped, Gainsborough was touched. 'If you had paraded him in fancy costume, I would not have painted him; now I will gladly comply with your request.'

In February he was finishing his second full-length of Lord Mulgrave. Rumours went round that he was to paint the Prince of Wales in the costume of Edward III's time for the new gallery of the Duke of Orleans in the Palais Royal, but nothing came of it. Nor of a momentary impulse to paint the wreck of the *Halewell,* a great East Indiaman, lost on 6 January off the Dorset coast with heavy loss of life. (The captain and his two daughters were drowned; he had been interested in art and taken Zoffany to India. The cargo included much art-materials.) Opie also thought of painting the wreck, but it was Northcote who did it. The idea shocked Bate and certainly would not have suited Gainsborough.[24]

Instead he worked on landscapes and by the end of March had done seven, all small. Four indeed were very small, finished with extreme neatness. A week or two later these 'seven imaginary views' were in his newly arranged show at Schomberg House, where, says Bate, they were much discussed. There were also two unfinished portraits of the Prince of Wales, full-lengths of Lady Sheffield (started 1785) and of Mrs Sheridan (now completed with some background alterations, for example, the lambs). Mrs Watson was depicted in the costume of Rubens' wife; and the portrait of Mrs Siddons was now shown. There were six male full-lengths: W. Cornewall, Lord Frederick Campbell, Lord Rodney, Admiral Graves, Beaufoy, G. C. Berkeley (shown in 1784 also),

and two half-lengths of Baron Skinner. The portrait of the three princesses was still at Schomberg House. (Bate wrote that it would stay till the completion of the Saloon at Carlton House, where the Prince meant to hang the many pictures of his brothers and sisters. A few days later he added that the King had given the Prince many fine works including the most recent royal portraits by Gainsborough.) The *Morning Walk* was not in the show.

In April he still had in hand the portrait of Lord Surrey begun two years before; and he was painting Lady Impey. With the R. A. show the papers printed much discussion about the quarrels among the artists. The *Public Advertiser* remarked, 'Gainsborough's Ass is an Ass indeed if it stays out of the Exhibition. It would be loaded with popularity.' The *Morning Chronicle* saw as a desertion of duty 'the perverse sequestration of Gainsborough, of Wright of Derby, of Meyer, of Dance, and perhaps some others.' Bate replied that Gainsborough still felt the affront to his Three Princesses; he also attacked Reynolds:

Why does Sir Joshua hang Mr Gainsborough's little picture of the pigs in his cabinet collection of all the great masters of past times? Does Sir Joshua really intend this as a compliment to his contemporary, or is it to afford room for invidious comparison? Let Sir Joshua mean as he will, the merits of the painting cannot be destroyed.

As Bate was unlikely to write such a passage without talking it over with Gainsborough, we may assume that the latter approved of it. In fact Reynolds, writing to Lord Ossory about a work he owned, thought to be a Titian, said in his postscript, 'I am thinking what picture to offer you in exchange. What if I gave Gainsborough's *Pigs* for it? It is by far the best picture he ever painted, or perhaps ever will.' Perhaps he wanted to depreciate his rival as a portraitist. Northcote says that at the Artists' Club he spoke of him as the first landscape painter in Europe, and Richard Wilson, annoyed, put in, 'Well, Sir Joshua, it is my opinion that he is also the greatest portrait painter in Europe.' Reynolds had sent in thirteen pieces to the R. A.

In May Gainsborough was again painting pigs, perhaps using studies made earlier when he had pigs in the studio. *The Cottage Door with Girl and Pigs* was soon bought by Wilbraham Tollemache, who already owned *Two Shepherd Boys with Dogs fighting.* The cottage here was set in a more open view than usual, with something of a Claudean balance but with a softening curve running across. Here the elements of the Fancy-Pictures are reduced to fit into what is predominantly a landscape. Through

the summer he was busy at work. The *Herald* cited some lines by Hayley on his two very different pencils. He can command 'the perfect semblance of the human frame' and 'the wild beauties of the mimic scene'.

He now showed *The Market Cart* (soon bought by Sir Peter Burrell for 350 guineas). Here there was a massive concentration of trees with light breaking in through them sideways on the homing family. He subtly differentiated the tree-mass with all the various hues, tints, tones, of early autumn; and next year added a red-coated lad gathering sticks, feeling on consideration that this bright rich note was needed to bring out the other more closely related hues.

The nobility of the trees, the bright clouds above, the easy naturalism of the scene, and such motifs as the boy in the red jacket, remind us of Constable; and it is only the conventional blue hill and generalized distance, still influenced by Claude, that persuade us we are looking at a picture of the 1780s rather than a Constable of forty years later. The monumental design contrasts sharply with the flowing, Rubensian compositions of a few years before. (Hayes)

He also showed the Duke of Norfolk in Van Dyck costume. Probably a comment of his lay behind a journalist's statement: 'He has chosen to be painted in the Vandyke dress, and so, though the picture is very like, it is not perceived to be so.' There were also two boys, sons of Lord Archibald Hamilton, in Van Dyck costumes.

This autumn the portrait of Thomas Coke in sporting clothes, with spaniels, was finished. Gainsborough once stayed at Holkham and is said to have painted there the self-portrait that hung in the hall. Tenducci, in one of his last activities in England, commemorated Bach at a Hanover Square concert, mainly using Bach's own music. Fischer failed to get the mastership of the King's Band, which fell vacant. Dr Graham moved out of Schomberg House, and the centre section was taken by Richard Cosway, miniaturist, who, with his charming wife, held fashionable assemblies and musical evenings there. A private doorway led to the Prince's Gardens at Carlton House.[25]

About this time Gainsborough painted the red-haired Duchess of Richmond, another of his works in which a richly dressed lady is set against woodland, but seems to have no place there, even to wonder what it's all about. (As in several late works, the right arm is long and thin, suggesting that it is painted from a lay figure rather than from life.) He also made his most impressive effort to

move outside his previous limits into the area of History without discarding in any way his aesthetic principles. This was in his *Diana and Actaeon,* which is a woodland scene with some naked girls in it, who are rhythmically related to the natural forms around them. The fact that he felt himself venturing into new ground is shown by his making three preliminary sketches, in each of which he changes his approach. In the first he tried to define rather dramatically the effect of Actaeon's appearance on the nymphs. In the next two he lessened the drama and increased the rhythmical relations of girls to the trees and the water in which they bathe. It would be going too far to say that the pictures symbolize the fate of the mortal who comes right down into the primal water and is turned into an animal – whereas the safe-homecoming is that of the woodcutter who goes up at sunset to the cottage where the fostering mother receives him. His mind was far from any mythological concepts, which he identified with the false culture he rejected. And yet here in this one work, near the end of his life, he does make a serious effort to enter the field of such concepts and make them his own. (It is an odd chance that just about this time, in the *Lounger* of 13 September 1785, Mackenzie describes a Fancy-Portrait in which a lady is Diana, her women friends are nymphs, and her cuckolded husband is the horned Actaeon; but such jokes are quite out of key with Gainsborough's pictures.) Gainsborough 'looks back to Poussin, and forward to those dazzling Cézannes, in which, through his painterly forms, he articulated a new vision of man in nature' (P. Fuller).

His essential protest against History Painting as the one important genre lay in his Fancy-Pictures, in which he enlarged the figures of his landscapes so that they could more and more assert their human significance and dignity. This development of his art was accepted because, on its weaker side, it could be linked with the growing cult of Sensibility and Sentiment. The *Herald* could thus speak of 'those little simple subjects' which 'awakened in the heart the most pathetic sensations.' But what distinguished these works from those of Jean Baptiste Greuze in France or Morland in England was that he really knew the peasant life he depicted, and that a deep part of him passionately wanted to break away and enter that life. To make that break was impossible and he knew it; but that knowledge at moments merely intensified the emotion he felt.

About this time he painted an oddly Hogarthian work, *The*

Housemaid, which sets out to depict a figure of common life on an heroic scale. The canvas is 92½ by 58½ inches. The painting is unfinished. The girl is sweeping out a doorway, and her untidy hair and its mobcap are defined with quick assured brushstrokes. He must have done the work for himself alone, and it brings out strongly how in his last years he wanted to enlarge the whole field and significance of his art.[26] It has been called *Mrs Graham as Housemaid,* but that title merely expresses the inability to classify such a picture. Gainsborough's transformation of History is aptly illustrated by *The Harvest Waggon* of 1767, where the composition of peasants struggling over drink is based on that of Rubens' *Descent from the Cross.*

10 London (1786-1788)

*J*ohn Boydell was building up in Pall Mall his Shakespeare Gallery with paintings to be engraved. Bate says that Gainsborough asked £1,000 for a scene and so was not called upon. The *World* suggested that he would have done well with Launce and his Dog, but says that his proposal was to paint three works for 3,000 guineas, 'and not till the expiration of three years'. Bate replied angrily next day to the suggestion that his place 'may easily be supplied'; and we learn from him that the themes Gainsborough wanted to tackle were Hamlet in the gravediggers' scene and Timon in his solitude.

He was working on portraits of Lady Clive and Lady Hopetoun; and Pitt came to his studio to sit for a portrait meant for Mr Grenville. Also he was painting the Marquis of Lansdowne (previously Lord Shelburne), of whom Walpole said: 'his falsehood was so constant and notorious that it was rather his profession than his instrument'. Mrs Piozzi wrote:

Gainsborough drew Lord Shelburne's portrait; my Lord complained it was not like. The painter said *he* did not approve it, and begged to try again. Failing this time, however, he flung away his pencil, saying 'Damn it, I never could see through varnish, and there's an end!'

This story may be the sort of thing invented to express his known character; for the portrait was not left unfinished. We have an undated letter that he wrote to the Marquis. He says that he has a copy of Bartolozzi's stipple-engraving of the picture (now its only record), and apologizes that the engraver has failed to get

188

your Lordship's cheerful countenance – It wants (in my humble opinion, *a full Bottle of Champagne* to give even the Vigour that is in the picture, and *that* falls as short as dead small Beer of the original – I beg pardon my Lord, but I'm in a damn'd passion about it, because I have ever been so partial to Bartolozzi's work – He has mounted your Lordship's figure up to about Lord Stormont's height, and sloped the shoulders like *my layman* stuff'd with straw; which he need not have done in order to bring into that size oval, as he might have taken the Head larger: but what hurts me most is that the Head is long instead of round – why will Bartolozzi, my Lord, spend his last precious moments in f——g a young Woman, instead of out doing all the world with a Graver; when perhaps all the world can outdo Him at the former work! Pray my Lord apply these private hints as from your own eyes, lest I should have my throat cut for my honesty. [1]

In the first week of May the portraits of Lord Lansdowne and his son, with other works, were shown at Schomberg House. *Cottage Children with an Ass* was there, but soon sent off to Exton, seat of the Earl of Gainsborough, who bought it for 300 guineas. *The Market Cart* was soon to go to Sir Peter Burrell, whose portrait was also shown. Bate criticized the lack of kneeband in the latter; Gainsborough had no doubt complained to him that Burrell insisted on having things that way.

Gainsborough was now at the height of his prosperity, selling landscapes and Fancy-Pictures for good prices, and much in demand for portraits. He had raised prices, charging 40 guineas for a head, 80 for a half-length, 160 for a full-length. (Reynolds' prices, however, were still higher.) Bate lamented that the demand for portraits would probably stop him from replacing works like *The Market Cart* or *Children with an Ass* for an indefinite period. Gainsborough himself often bought pictures, but had not much luck or perspicacity as a collector. Some of the works he thought to be by famous artists later proved unsaleable. This spring he bought Murillo's *St John in the Wilderness* for 500 guineas from the dealer Noel Desenfans; later his widow sold it for about two-thirds of that sum.

Cunningham has a story of early 1787. Although he cannot always be trusted, in this case he seems to have got the details from Sir George Beaumont, who knew Gainsborough fairly well at this time. Gainsborough was dining at Beaumont's London house. Sheridan, also a guest, was in more than usually high spirits. He and Gainsborough enjoyed each other's company so much that they arranged to dine together soon. They met,

but a cloud had descended upon the spirit of Gainsborough, and he sat silent with a look of fixed melancholy which no wit could dissipate. At length he took Sheridan by the hand, led him out of the room, and said, 'Now, don't laugh, but listen. I shall die soon, I know it – I feel it. I have less time to live than my looks infer, but for this I care not. What oppresses my mind is this: I have many acquaintances, but few friends; and as I wish to have one worthy man to accompany me to the grave, I am desirous of bespeaking you. Will you come? Ay, or no?'

Sheridan could hardly repress a smile as he made the required promise. The looks of Gainsborough cleared up like the sunshine of one of his own landscapes; throughout the rest of the evening his wit flowed and his humour ran over, and the minutes, like those of the poet, winged their way with pleasure.

Sheridan at the time was a leader of the Whigs attacking Warren Hastings, whom the King protected.

In the summer came a case between the dealers Desenfans and Benjamin Vandergucht over the authenticity of a picture that the latter had sold as a Poussin to the former for £700. Both men were well known to Reynolds and Gainsborough; and there were rumours that the rival artists would give evidence on opposing sides. Gainsborough did appear, but not Reynolds. The jury found in favour of Desenfans. We have the report of Gainsborough's evidence:[2]

Mr Gainsborough declared that, having had no opportunity for the study, he was no judge of the hands of the masters. He said however that he had seen and studied most of the celebrated works of Poussin, and that he had always been charmed with the sweet simplicity of the effect and the elegance of the drawing, but that when he saw the present picture it produced no emotion. On a closer inspection he found it to be so deficient in harmony, taste, ease, and elegance, that if he had seen it in a broker's shop and could have bought it for five shillings, he should not have done so. On being questioned whether something more than bare inspection by the eye was necessary for a judge of pictures, Mr Gainsborough said he conceived the eye of a painter to be equal to the tongue of a lawyer.

Perhaps he had seen many of the Poussins in England; the text as given suggests that he had travelled. And ten years after his death a note in the *Whitehall Evening Review* states that he used to say, comically,

of the florid Gothic architecture that it was like a cake all plums. The enthusiasm that he felt in the churches when he went to Flanders he compared nearly to insanity – 'the union,' added he, 'of fine paintings, fine music, and the awful and imposing solemnities of religion.'

But we cannot trust the account; he never went abroad.

On 20 June he wrote to Bate:

Poor Abel died about one o'clock today, without pain, after three days sleep. Your regret, I am sure, will follow this loss. We love a genius for what he leaves and we mourn him for what he takes away. If Abel was not so great a man as Handel it was because caprice had ruined music before he ever took up the pen. For my part, I shall never cease looking up to heaven – the little while I have to stay behind – in hopes of getting one glance of the man I loved from the moment I heard him touch the string. Poor Abel! – 'tis not a week since we were gay together, and that he wrote the sweetest air I have in my collection of his happiest thoughts. My heart is too full to say more.

The next day Bate published a brief article on Abel's death, citing some of Gainsborough's words. Abel's attachment to him, he said, was unexampled. One of his gifts to Abel, the picture of fighting dogs, was now acquired by Crosdill. Later a critic who knew him said that Gainsborough had given the picture in return for lessons on the viol. The dogs depicted in the painting belonged to Abel; and when they saw the work, 'the elder subject, irritated at the presence of a supposed rival, flew at her own resemblance with such fury that it was found necessary to place the picture in a situation where it was free from her jealous anger'.

Gainsborough painted a self-portrait for Abel, which may well be the extant one showing him in his old age. In it 'the head is very thinly painted, and the blues of the coat and greys of the background are loosely brushed in over the brown priming; touches of blue, yellow, brown and orange enliven the modelling of the cravat. The portrait is almost certainly unfinished' (Hayes). It may have been in this state in June 1787, and then left as it was.

The Prince of Wales now promised afresh to sit for two portraits; both works were unfinished when Gainsborough died. In the summer he was painting Sir Francis Sykes, retired Indian governor, and Knapp, Clerk to the Haberdashers Hall. John Smith, Clerk to the Drapers Company, was also done this year.[3] In June he painted *The Woodman,* which he thought his best work. The last touches were given in July. Bate says the original was 'a poor smith worn out by labour, and now a pensioner upon accidental charity. Mr Gainsborough was struck by his careworn aspect and took him home; he enabled the needy wanderer by his generosity to live – and made him immortal by his art!' The man is shown with his dog sheltering under trees in a storm. He is given something of the intensity of a St John in the Wilderness.

Gainsborough made a small bust of the smith, which is said to have 'exhibited all the vigour of Vandyke'.

Bate's continual eulogies could not but irritate other newspapers. Gainsborough was now on bad terms with de Loutherbourg; perhaps he had been annoyed when the latter was on the R. A. Council in 1784. The *Herald* had spoken unfavourably in its notice of the R. A. of de Loutherbourg's *View of Snowden from Llanberis Lane,* adding that Gainsborough's studies of the Lakes would never be surpassed. In July it stated, 'Mr Loutherbourg has quitted the country, and has left numbers to criticize the effects of his distances who have hitherto been pleased with his foreground.' The *World* in an article signed Tycho attacked the *Herald* for hinting that de Loutherbourg had left 'in an underhand manner and meant not to return'. The facts were that he had gone to paint the Lake of Geneva for the engraver Muchel of Basle. Tycho blamed Gainsborough for the imputations cast on de Loutherbourg, calling him the artist who 'is always puffed in the same page as Mr de Loutherbourg is abused in'. The pugnacious Bate sent to the *World's* offices and had an apology printed, which declared the Tycho essay a paid-for advertisement and that the reverend gentleman, hinted-at as the author of the de Loutherbourg paragraph, admired that artist and had not been taking an active part in the *Herald*.

Indeed Bate, now wealthy, used a deputy as much as possible for his journalistic work. Inheriting a fortune, he was the *Herald's* sole proprietor and enjoyed the life of a country-squire on the Blackwater estuary, at Bradwell. Some time back he had bought the next presentation of the rich living there, bringing on himself much trouble and litigation. He had built a fine house and was busy recovering land from the sea, for which the Society of Arts gave him a gold medal, and improving local roads. He was also indulging in coursing-meetings, yacht-races, and 'florists' feasts', at which he offered prizes in competitions. He had a great decoy at Bradwell and in one season claimed to have caught 10,000 wild ducks. During the summer he entertained many visitors, among whom certainly was Gainsborough. Indeed the latter may have had a country house nearby. Probably he painted Mrs Bate at Bradwell this summer. The portrait, with head in profile, uses strong light and high bright colours, matching her red hair and gauzy dress with the feathery foliage. Bate, finding it hard to run the *Herald* from Bradwell, had to resume his work in the offices at Catherine Street, never forgetting to slip in praises

of Gainsborough whenever possible.

The assurance with which he now tackled landscape appears in works like *Wooded Landscape with Cow standing beside a Pool,* done with chalks and washes heightened with white. Here we see his mastery of the basic tonal structure and the varied planes unified by the light-burst on water. In *Wooded Landscape with Ruined Castle* (chalks and stump) there is recession defined by swinging rhythms. In *Cattle Ferry* (oil sketch on prepared brown paper) there is extreme simplicity of forms and strong patches of white paint where light strikes the cows and the waves.[4]

In July he painted the Marsham children gathering cherries. The boy on the right is unsteady, so that a strong movement is given to his outstretched arm, leading on to the girl with hat. The swing is caught and carried on in the swirl of the girl's clothes, then given a fresh movement and stabilization by the diagonals. The painting is a fusion of the Fancy-Picture and the portrait, and shows how Gainsborough was working towards the former from all possible angles.

On 31 July he wrote to Mary Gibbon, who seems to have been offended by one of his jokes:

I hope My dear we have more affection for each other, if not more sense, than to suffer what may be said in Joke to make any material difference in our good wishes towards each other; I assure you what I said was without the least intention of offending, I only meant *in my own manner* to urge all parties to claim their Right; and to set all Joking aside, I do think that Poor Betsy should be allowed something beside her share in other respects to reward her giving up what she might so reasonably expect to recover by Law.

Betsy was his youngest sister, Mrs Bird. It seems that some family-property or inheritance was being shared out.

July saw two commissions. The Duke of Montagu wanted a full-length (based on his half-length of 1768). This job was probably never done. General Sloper wanted 'an interview between the late amiable Mrs Sloper, who is to be *spiritualized* in the representation, and her two surviving daughters.' (This was cut up soon after 1920.) In the summer Gainsborough painted John Langston, the Marquis of Buckingham in his Garter-robes, and Pitt. In October the Duke of York, only member of the royal family not yet painted, arranged to give sittings; in late November it was announced there would be two pictures of him, but we know nothing more of the matter. Bate wrote, after visiting the studio, of *Cottage Children* (*Wood Gatherers,* bought

by Lord Porchester, whom the King complimented on his taste). Hazlitt found in it 'greater truth, variety, force, and character' than in any of the similar groups. The boy in the foreground seems to be Jack Hill. Gainsborough started two more works with Jack in them: *A Boy at a Cottage Fire* and *A Girl eating Milk, and A Boy with a Cat – Morning.*[5]

There were signs of his moving towards reconciliation with the R.A. In September he offered, through Garvey, 'to paint a picture for the chimney in the Council Room, in place of that formerly proposed to be painted by Mr Cipriani'. In the autumn the Liverpool Society for promoting the Arts of Painting and Design held a show, to which he sent *Village Girl with Milk* and *Cottage Children* (apparently the small preliminary study). Also, he accepted a commission from Thomas Macklin to contribute to an exhibition of pictures illustrating British Poets, and was busy on a landscape with peasants, dog and donkey laden with firewood. Bate thought the donkey showed too much 'adherence to nature', with more than the share of misery common to donkeys. In December Gainsborough took part in an academic election, a further sign of moving towards the R. A. In his studio were portraits of Lady Mendip and Mrs Puget of Dublin.

In January 1788 Abel's portrait was sold for only nine guineas. Probably it was the work set a few weeks later above the orchestra in the Concert Room at Hanover Square in place of a bad painting of Apollo. Gainsborough was summoned to Buckingham House. The King wanted to see *The Woodman* and is said to have wanted to buy it. However, he did not, and Gainsborough refused an offer from Desenfans of 400 guineas. On 8 March Greenwood, an American artist turned auctioneer, sold *Cornard Wood* at his room in Leicester Square. Then it was that Gainsborough wrote his letter to Bate about the painting which was cited earlier (p. 25).[6] Boydell bought it and it was reproduced in aquatint by Mary Catherine Prestal in 1790. In April Macklin opened his gallery with nineteen works on the walls. Two were by Gainsborough: *Young Hobbinol and Gandaretta* illustrating a poem by William Somerville in which the couple are cousins growing up together 'to mutual fondness', and *Lavinia* (the lovely orphan in Thomson's *Seasons*), which was in fact the painting of a girl with a pan of milk done in 1786.

In the spring Gainsborough painted his *Peasant smoking at Cottage Door,* the most fully realized of his pastoral scenes,

which remained unsold at the price of 500 guineas, though Bate got it after his death. A rich sunset-glow bursts through sturdy trees on to the cottage and the family; a near-dead tree swings over from the right (looking back to the *Cottage Door* of 1780). A study shows that at first the main figure was to be a woodman with a burden of faggots; but instead of showing the man at his toil Gainsborough decided on the moment of happy relaxation.

Two portraits show how far he had now gone in merging his sitters with the natural world. Lady Petre was painted soon after her return from her honeymoon and was done within a month. The picture carries farther than any other by Gainsborough a romantic dramatizing effect:

The brilliance of the background, with its stormy clouds and patches of fitful light, mysterious shadows and windswept trees, is matched by the force of Gainsborough's extraordinary treatment of the costume, deeply sculptural and highlit by a welter of rapidly applied brushstrokes which would not discredit an abstract expressionist. This roughness of handling extends to the modelling of the head (Hayes).

The portrait of the Duke of Norfolk was the last canvas on which Gainsborough worked. The Duke is whelmed in the wild darkening scene, with the link between his blown hair and the foliage especially stressed.

Lady Petre had been done by 19 April. Not long afterwards Gainsborough was taken ill. He caught a chill in Westminster Hall while listening to the speeches at the trial of Warren Hastings. It was not easy to get in; fifty guineas was offered for a good seat when Sheridan was speaking. Gainsborough was enjoying the rhetoric of that friend and of Burke when he grew aware of a cold spot at the back of his neck. According to Cunningham (with Mrs Lane as informant) he fell ill at once on returning home. The date was probably late in April. A note to the miniaturist Robert Bowyer on 1 May stated: 'I have reason and every assurance from Dr Heberden (who has known many swellings dispersed like mine and no mischief come) I shall not on any account interfere in what Mr Hunter is about.' John Hunter, surgeon and author of a Treatise on the Blood, had scientific and art collections.[7]

Even so, Gainsborough made his will at once, signing on 5 May. Five days later his illness was publicly announced. The glands of his neck had been inflamed by a violent chill and there was hope of a speedy recovery. A few days later he was indisposed but able to paint a small landscape. On 24 May he wrote to Thomas Harvey of Catton near Norwich, a master weaver with a

fine art-collection, which included Gainsborough's *Cottage Door* and works by Cuyp, Hobbema, Poussin, Tintoretto, Wilson. He thanked him for a bank bill of £73 for *Landscape with Cows*, advising him to use only nut oil if he has to deal with 'anything of a Chill come upon the Varnish.' His thoughts are back in his early days.

My swelled Neck is got very painful indeed, but I hope is the [?] near coming to a Cure – How happy should I be to set out for Yarmouth and after recruiting my poor Crazy Frame, enjoy the coasting along til I reach'd Norwich and give you a call – God only knows what is for me, but hope is the Pallat Colors we all paint with in sickness – 'tis odd how all the Childish passions hang about me in sickness, I feel such fondness for my first imitations of little Dutch Landskips that I can't keep from working an hour or two of a Day, though with a great mixture of bodily Pain – I am so childish that I could make a Kite, catch Gold Finches, or build little Ships –

At the end of May he was well enough to be moved to Richmond, where at first the air helped him. About this time he wrote to William Pearce, 'I hope I am now getting better, as the swelling is considerably increased and more painful.' He asked Pearce to accept some of the cheese come from Bath, no doubt a gift of Mary Gibbon. On 15 June he gave instructions that after his death no plaster cast, model, or likeness was to be taken. But 'if Mr Sharp, who engraved Mr Hunter's print, should chose (*sic*) to make a print from the ¾ sketch, which I intended for Mr Abel, painted by myself, I give free consent'. Sharp had engraved Reynolds' portrait of Hunter; but it was Bartolozzi who in fact later engraved Gainsborough's self-portrait.

By mid-June it was realized that he suffered from cancer. Bate says he was not told the facts; but Thicknesse says he only pretended to be ignorant for the sake of the family. He wrote to Sherwin, engraver, to praise his renderings of the portraits of Lord Buckingham and Lord Sandwich. Sam Kilderbee visited him and heard him express regret for his dissolute life. Jackson says that he lamented his life was ending just as he was beginning to do something. His thoughts turned to his rival Reynolds and he wanted to leave the scene with no enmities behind him. He wrote:

Dear Sir Joshua
I am just to write what I fear you will not read after lying in a dying state for 6 months. The extreme affection which I am informed of by a Friend which Sir Joshua has expresd induces me to beg a last favor, which is to come once under my Roof and look at my things, my woodman you never saw, if what I ask [now?] is not disagreable to youd feeling that I may

have the honor to speak to you. I can from a sincere Heart say that I always admired and sincerely loved Sir Joshua Reynolds.

Reynolds must have gone at once, though he was not at the deathbed as Cunningham said. Gainsborough had many unfinished canvases brought in to show Reynolds, and flattered himself that he might live to finish them. Reynolds stated later:

Without entering into a detail of what passed at this last interview, the impression of it upon my mind was, that his regret at losing life, was principally the regret of leaving his art; and more especially as he now began, he said, to see what his deficiencies were; which, he said, he flattered himself in his last works were in some measure supplied.

He died, says Bate, at 2 a.m. on Sunday, 3 August. Jackson says that his last words were: 'We are all going to heaven, and Vandyke is of the party.'[8]

The simplicity of his obsequies was much commented on; he had given his instructions in a document drawn up a few weeks before. He wanted to trouble his family as little as possible: with a private burial in New Churchyard, Kew, near to Kirby's grave, a stone with his bare name, no arms or ornament, and a place left for any of the family who wished to be buried with him. The funeral was to be attended only by a few friends. So, on the following Saturday, he was removed to Kew. Six artists were pall-bearers: Chambers, Reynolds, Bartolozzi, Paul Sandby, Cotes, and West. His nephew was the chief mourner, supported by Sheridan, Linley, John Hunter, Jonathan Buttall, Gossett, Trimmer, and Jeremiah Meyer. The last-named, a miniaturist, lived in Kew and himself died a few months later, buried in a grave adjoining Gainsborough's. Chambers and West had come up from the country to attend; Burke, who was to have been a mourner, was too far off.

The will was proved on 23 August. 'I earnestly request my old friend and acquaintance, Mr Samuel Kilderbee of Ipswich, to act as overseer thereof, and to advise and assist my said wife and daughter Margaret in the execution thereof, which request I trust he will comply with out of our long and uninterrupted friendship which has subsisted between us.' He left £500 to his wife, also 'all arrears of any annuity or annuities'; £100 to Dupont.

If he makes any claim on estate or effects in respect of work done by him or any other account, the legacy is revoked, and Mrs Gainsborough is directed to charge him for board, washing, lodging, and then only the balance of the £100 is to be paid him.

The contents of the houses in Pall Mall and Richmond go to his wife, who is to give Dupont 'such of my models, oils, colours, varnishes, and such like things as she may think useful to him', and to provide him and his two daughters with proper money. Half his moneys and stock in public funds he leaves to Margaret; the other half to her and his wife jointly. Dividends of the trust-fund are to be applied at their discretion to maintain Mary Fischer, and in no case is Fischer to be allowed to interfere with her money, which 'shall not be subject to the debts, power, control, or intermeddling of her present or any future husband.' The minor role played by Mary in the will is certainly due in part to a determination to stop Fischer from getting anything through her, but also no doubt in part to the condition into which she seems now to have fallen. We see that after the breakdown of her marriage Gainsborough was left with a fierce antagonism to Fischer.

A writer in the *Art Union*, citing an old friend of Gainsborough, later stated that on his deathbed Gainsborough was haunted by the fear that his improvident life would leave his daughters unprovided for; but his wife assured him that, 'as he always threw his money about, leaving it to the mercy of everyone', she had managed in twenty or thirty years to save several thousand pounds; and that sum, with the money to come from *The Woodman* and other pictures, would doubtless keep the girls in comfort. 'He thanked and blessed her, saying that he had indeed at times thought he had more bills than he found, and had been puzzled about it.' This story seems merely one of the many told about his wife's thrift. No doubt she did put much money aside, but his investments would have amounted to more than £8,000. Mary's portion, held in trust, was £4,150 invested in 3 per cent Consolidated Bank Annuities.

The poets of 1788, as in the Elegy in the *World*, saw Gainsborough as the painter of Nature, almost ignoring his portraits; at the end of his life he gained the reputation which he had wanted at the outset and throughout his career. Mrs Gainsborough, advised by West and Reynolds, decided to sell none of his pictures till next spring. Bate on her authority wrote about forgers of Gainsborough drawings; as the artist had never sold any drawings, no authentic ones could be in the hands of dealers; the large number he had left were in his widow's hands and would be for sale with his other works. Such a statement was hardly adequate. Gainsborough gave many drawings away, recklessly (says Jackson), to persons often ignorant of their value;

and some would have been sold. Bate seems to be replying on the widow's behalf to a statement in the *Morning Post* that the drawings were being much sought and that the collector Wigstead had much increased the number he held. The *Post* also mentioned that the actor Burton, who painted landscape, specializing in moonlight effects, was busy making copies of the drawings. (Gainsborough had disliked copies of his work, since 'it affected the sale of new pictures,' as he told Ozias Humphry, who had asked leave to copy some of his paintings. He added that he had often refused such applications from friends.) [9]

In the early spring of 1789 it was announced that preparations were being made to sell all his remaining pictures, including *The Woodman, Peasant Smoking,* and many drawings. They would be shown in the room 'where his animated pencil gave them creation'. The King or the Prince might choose a work or two; otherwise nothing would be sold before the opening. All the Old Masters that Gainsborough had collected would be sold. On 24 March Mrs Gainsborough stated that the show would open at Schomberg House on the 30th and would stay open daily, except on Sundays, till further notice, from ten a.m. to six p.m. Admission was half a crown, with Gainsborough Dupont in attendance to deal with sales. [10]

The prices paid for the Old Masters do not suggest authenticity. Only the Murillo (£300) fetched more than £100; Gainsborough's own copies of Old Masters did better. Forty landscapes (two not for sale) were set out, at prices from ten to five hundred guineas. The 148 drawings were priced from two to ten guineas each. The portrait of the Duke and Duchess of Cumberland was bought for 100 guineas by the Queen. *The Woodman* aroused most interest, and the comments show Gainsborough was at long last seen as a painter of pastoral and landscape themes, who did portraits for his livelihood. The Queen and princesses looked in during April, and the Queen bought some drawings. At the end of this month the entry-charge was reduced to a shilling. There was a new influx of visitors and more pictures were sold than in the first stage of the show. The closure came at the end of May, some seven hundred visitors coming on the last day. But the larger portion of the works, old and new, were unsold; not more than a quarter of the drawings had gone. Most of the unsold works were offered again at a sale held by Christie three years later.

Early on the Prince of Wales had tried to help, paying a visit of condolence to the widow and buying two landscapes for 2,000

guineas; he gave the paintings to Mrs Fitzherbert.

To mark further interest in and respect for the memory of Gainsborough, the Prince asked Mrs Gainsborough to call on him at Carlton House, but, unfortunately, Mrs Gainsborough took this invitation as a compliment for herself; and if we give due consideration to the graciousness of the Prince working on her idea that she was a Prince's daughter, and if not then beautiful she had been so, we can excuse the widow's misconduct in spending about £1000 in dress and jewellery wherein to appear at Carlton House. Upon her name being announced there, the Prince came to receive her with every respect, but observing that, instead of calling in becoming widow's attire, Mrs Gainsborough was extravagantly dressed, he wheeled round without a word, to her great mortification, as she afterwards told the anecdote to Mr Pearce who mentioned it to our informant.[11]

There was thus a strong link between Mrs Gainsborough's daydreams, her hints of being a Stuart prince's daughter, and the delusions of grandeur that came to afflict her girls. Mary's mad behaviour seems to have grown worse after her father's death. Fulcher mentions that she believed the Prince of Wales to be desperately in love with her.

The widow stayed on in Pall Mall for three years after the 1789 sale, and Dupont stayed with her, hoping to take his uncle's place. He had a retiring disposition, and, though talented, lacked confidence and originality. Bate and Thicknesse both encouraged him, and Bate in the *Herald* tried to build him up as his uncle's successor. Thicknesse, in the book on Gainsborough he published in 1788, praised Dupont as 'a man of exquisite genius', but seems to have torn the tribute out of many copies of the book after a quarrel with him. Thicknesse had written letters to Mrs Gainsborough in which he threatened to attack her reputation and Gainsborough's, letters 'couched in such execrable terms as would be deemed unpardonable from a drayman, to the most abandoned of women'. Dupont warned him that he, Dupont, was now his aunt's champion. Thicknesse had indeed fallen low. In *Memoirs and Anecdotes* he admitted: 'My friends eat my bread, drink my port, and help to spend that which my enemies supply me with... I can at any time muster ten or a dozen knaves or fools that will put a hundred pounds or two into my pocket merely for holding them up to public scorn.' A reviewer hinted that he got hush-money in the way of some editors who were said to make attacks and then suppress them. Bate, in his blunt way, wrote a denunciation of social pests:

Wherever they go, they announce their power of doing mischief, and lay under contribution female timidity and vicious cowardice. A hoary offender of this description has long escaped the cudgel of resentment and the sword of exasperated rage. He has menaced public men into liberal contributions, and has held numerous families in apprehension and terror. It will not be necessary to put P.T. under this infamous but faithful picture.

Thicknesse wrote a malicious letter to Mrs Gibbon, complaining keenly of Dupont's behaviour.

Mrs Gainsborough always told me that Dupont was a drunken, worthless fellow, and that I did not know him... I have indeed learnt since I came to town of a very mean, shabby trick which Mr Gainsborough himself did by me; but his genius and good qualities overlook that. Dupont's ingratitude and Mrs Gainsborough's meanness I shall not overlook.

However he soon went abroad and died in 1792 while travelling in France.[12]

Dupont gained many commissions and was persuaded to exhibit at the R. A. in 1790. In 1792 he again exhibited, showing the last of the pictures he painted at Schomberg House, where Mrs Gainsborough's tenancy was ending. Before going she tried to dispose of the unsold landscapes she had. Christie announced a sale at Schomberg House in June. Bate tried to puff it and said that he'd print the names of buyers. There must have been few of the latter, for he gave no names and merely noted the sale of *Peasant Smoking* for 380 guineas, without mentioning that he himself had bought it. According to Fulcher *The Mall* was sold for £115 10s. (It had been vainly offered for 200 guineas in 1789.)

Soon after the sale Mrs Gainsborough and the girls left for Sloane Street; Dupont set up at 17 Grafton Street, Fitzroy Square, where he stayed for the rest of his life. His work quite lacked organic flow; his figures were stiffly drawn-out; he failed to catch the expressive quality of his uncle's bold brushwork. Robert Bowyer took over the Gainsborough section of Schomberg House, called it the Historic Gallery. Dupont failed in 1793 to become an associate of the R. A., but he painted actors and actresses for Harris, manager at Covent Garden, and sent one of these works to the R. A. with a full-length of the King, from whom he seems to have had several commissions; he also gained Pitt as patron. Then, after an illness of eight days, he died on 20 January 1797, aged forty-two. His furniture and pictures were sold by his brother Richard in April. Included were fancy-pieces

and unfinished portraits by Gainsborough (his widow's property), which did badly. Only one or two landscapes were sold. *A Nymph at her Bath* (apparently *Musidora*) fetched five guineas; the unfinished *Housemaid,* four and a half. The *Haymaker and Sleeping Girl* was unsold. (One day Dupont had pleased his uncle so much that he was told to take any picture in his studio; he ignored *The Woodman* and took *The Haymaker* to Gainsborough's surprised disappointment. So runs the story, but it is hard to see why the choice of so lyrically charming a work should have upset Gainsborough.)[13]

Mrs Gainsborough kept her husband's sketchbooks and collection of engravings, also his small library and some items of personal interest. She died in Sloane Street in December 1798, leaving property valued at under £10,000, and was buried at Kew. Her will ordered the sale of her remaining pictures and the investment of the proceeds. Her daughter Margaret had the things sold at Christie's, adding the musical instruments, a blunderbuss, and 'a curious box to serve as a portfolio for drawings'. Hoppner bought the lute. Mrs Gainsborough had not given Dupont the two lay figures, and the better one, 'most ingeniously constructed with brass-work joints' brought in £5. There was a book of 54 drawings by Vandervelde of shipping in Indian ink; and the library included Kirby's book on Perspective, Campbell's *Vitruvius,* two volumes of Walpole's *Anecdotes of Painting in England,* Gibbs' *Architecture,* Wood's *Ruins of Baalbec,* Spence's *Polymetis,* and Birch's *Lives of Illustrious Persons.*

The daughters lived to a good age. Little record of them has come down. One of them, probably Margaret, did some painting, as landscapes by Miss Gainsborough appear in early catalogues of sales. In 1803 the two women lived at Brook Green, Hammersmith. Later they moved a couple of miles out, to Acton, then a remote village. An Ipswich friend met them there in 1818, when Margaret was described as odd in behaviour and Mary as quite deranged. They lived in a detached house on a hill. Margaret became friendly with a young artist Briggs who lived nearby, and some of her father's works passed into his hands. The pair of lonely women seem to have grown steadily worse. Mary announced that she would receive no untitled visitors; anyone wanting to see her had to pretend to be noble. Till the end she insisted that the Prince of Wales loved her, and before her death she asked leave to present George IV with Fischer's portrait. In 1824 she was described as having lost all her mental faculties and

apparently doomed 'to waste the remainder of her life in the vain pomp and self-complacency of fancied royalty'. Margaret's will made only one bequest, to a servant; the bulk of her property, valued at £8,000, she left to three female cousins. She died on 18 December 1820; Mary survived till July 1826. Neither woman was buried at Acton. Possibly they were put in the family grave at Kew without any recording inscription.

We can best end by considering certain important points about Gainsborough's work and bringing together various aspects of his development which have come up from time to time; we may thus hope to get to grips with the creative impulse that drove him on and to realize something of the unity underlying his varied forms of expression. He was passionately devoted to landscape, but forced by circumstances to spend much of his time painting portraits. He must have enjoyed certain aspects of his portrait-work, the ways in which he achieved a mastery of the medium and the methods he developed to ensure both a striking likeness and an ever enriched control of textures. But at the heart of it all there was a revulsion, which he continually set out in his letters and which appeared in the difficulty he found in returning to a portrait once the interest aroused by the initial attack had weakened.

His dislike of the portrait as an art form was inseparable from his dislike of the gentry and nobles who were his main customers. (Clearly in dealing with an attractive woman he was best able to forget this class element.) His dislike of the portrait as a form in which the gentry realized their sense of status was in turn inseparable from his rejection of the ruling concepts of what constituted excellence in art, and, yet more deeply, his rejection of the culture of the ruling classes, of what was considered to constitute rationality and the settled order of the universe. His position is well set out in the letter to Jackson where he mocks him for being 'a regular system of Philosophy, a reasonable creature'. He did not arrive at his own positions by any 'regular system', any thought-out rejection of the symmetrical Newtonian universe and the workings of Locke's system of associations, with a benevolent deity presiding over the best of all possible worlds. He arrived at his views intuitively, by his emotional rejection of the ideas that he heard discussed and accepted as the only correct ones for an intelligent and rightly constituted person. Such ideas irritated him so much that he did his best in conversation to

silence them by bad jokes and irrelevancies. But, as with Sterne, his foolery was the expression of a belief that the ideas were hopelessly inadequate in the face of the real complexity of life and of natural processes.

We have noted ways in which his intellectual and emotional dissidence expressed itself in his art: in his rejection of the idea of space as a box of linear perspective, mathematically co-ordinated, and in his search for other forms of organization. He took over the rococo curve, not merely as a decorative element, but as the basis on which to grasp the deep rhythms of growth and movement, finally as a dynamic formative element expressive of the earth itself, of the forces holding it together and breaking it up, reforming it and producing ever new combinations and unities. In the working-out of this vision of nature and its energies he drew on many art forms and varying lines of approach: Dutch naturalism, French rococo (including Watteau), the Pastellists, Claude, Poussin, finally Rubens (with whom he felt the most affinity). But he was never an imitator of any of the artists or schools that attracted him and provided some of the clues he needed for a full grasp of natural objects and processes. Right from the start there is an element in his work which seeks to lay hold of nature in order to transform it.

In his restless need to find a new basis for his art we see him clearly as a man of the Hogarthian world, of the St Martin's Lane Academy and of the decorations for the Vauxhall Gardens. He rejects the bases of organization of the Renaissance and the Baroque worlds; he feels deep inside that he belongs to a quite different world, and that whatever meaningful dialogue he can hold is with people who have turned in new directions. Like Hogarth he belongs to the new middle-class world, but has his own kind of dissidence there. In Hogarth there is a strong plebeian element that prevents him from accepting the middle-classes on their own terms; in Gainsborough there is a strong peasant element. So, while he and Hogarth both belong to the same world, socially and aesthetically, they face in opposite directions. Hogarth looks into the packed urban scene, with hardly a glimpse of the world of nature outside it; Gainsborough resolutely turns his back on the town and everything that is connected with it. At times he gives us glimpses of villages and farms, and his earlier roads wind to the church or congregation in the distance. But essentially the image that dominates him is that of a woodland slope with its curving track. Here lovers meet and

peasants carry on with their work, mainly droving, herding, carting, woodcutting. Ploughing appears in some earlier works, but drops out as unsuitable for the slope-image. The woodland cottage becomes the symbol of country-life as opposed to the city-houses.

Thus Gainsborough is close to Hogarth in his anti-aristocratic approach although he looks in a different direction. He is concerned with the common man as peasant. At first the figures are small, dominated by the natural features of the landscape; but they grow in importance and finally in size. Here he manages to do something that Hogarth failed to do. Both artists are challenging the accepted canon of History as the supreme genre of art, in which the significance of life is expressed. Hogarth achieved his Modern History, but only with small figures which, translated into engravings, could reach and create a new audience for art. Gainsborough, by taking up and developing the Fancy-Picture in his own way, is able to outflank the enemy connoisseurs, the conventional defenders of the art-tradition, and to move towards treating the common man, the peasant, as a fully serious art-subject. To the extent that his Fancy-Picture thus moves into the sphere of History, it is declaring that the really important characters are not kings, heroes, gods, but working peasants. In them resides the real significance of life. His *Woodcutters* represent the first stage of democratic protest and affirmation that is to reach its full explosive expression in Courbet's *Stone-Breakers*. But before that final stage, which created the concept of Realism, could be attained, considerable developments had to occur: the French Revolution with David and his school, Géricault, and so on.

All that was far indeed from Gainsborough's mind. He thinks as a lonely poet, taking in all the romantic ideas from Thomson onwards, discovering them in his innermost self as if they were born solely out of his own sensibility. A deep opposition is felt between Nature and Society. The new social developments, with all their contradictions, are in fact stirring the new consciousness of issues, but they seem to be moving in an altogether dehumanizing direction. The consciousness of alienation is in dire struggle with the alienated consciousness; and the simplest way of formulating what is happening seems to lie in stressing ever more the opposition of Nature and Society – Nature being in part identified with the earlier phases of society in which there were simpler communal forms and men could see more plainly just

what part their labour played in the whole economy. So Gainsborough cleaves with all his might to the vision of an earth in harmony with the men working upon it, and emotionally he sets this vision against the urban world in which he lives, discontented but unable to escape, finding satisfaction only in the fellowship of drink and music, and in the brief rapturous release of women's embraces. Drink and copulation, together with music, are opposed to the urban world of crushing toil, alienation of man from man, and distinctions of status. Music above all becomes for Gainsborough the liberation of the sensuous essences of enjoyment, which in art he defines in terms of an earth of harmonious curves and directly implicated man.

We thus see in Gainsborough fused elements of Realism and Romanticism. Realism must not be confused with Naturalism, which is to be found in many of the Dutch artists who interested Gainsborough. Realism arrives when there is a powerful unifying concept which gives a pervasive significance to the material. That is why it took all the complex social and artistic struggle of the period between Hogarth and Courbet for the idea of Realism to be formulated. Gainsborough has his place in this struggle. In his work the elements of Romanticism are not intrusive; they are integral aspects of the effort to transform Naturalism and infuse the given elements of a scene with rich human and aesthetic elements that deepen, unify and intensify the total significance.

So in Gainsborough there is not a simple line of development. The need to return to the given elements, the actual forms, textures, interrelations in nature, is linked with a need to learn from previous art and to develop his own ways of transforming those elements. Even in the portraits which he disliked he made many advances, which in turn he could apply in different ways in his other art genres. He carried on certain aspects of Hogarth's solid realism in portraiture, for example in *Captain Coram*. Those aspects reappear in works like the portraits of Truman, Lord Kilmorey and many others. At the same time, linked with his musical responses, there is the effort to use rococo rhythms to define a new kind of responsive humanity, as in Wollaston, Ann Ford, the Linley sisters, Willoughby Bertie, and Abel. And, especially throughout his sensuous response to his women sitters, he is moved more and more to use the rich clothes, not as symbols of status, but as expressions of the dynamic human relation to nature. By the bold texture of his brushwork and the lyrical luxuriance of his colour, he brings the people into close contact

with the nature around them. Man and nature penetrate one other, fuse with one another, are akin even when there is conflict defined by stormy and lurid skies, by unstable structures. Thus, at the very heart of the genre that he felt was opposed to his landscapes, he introduces powerful elements born from the latter. In these developments there are elements of acceptance of the people he paints, elements of repudiation and contempt. Willy-nilly, the people are part of nature; he sinks them into it as a sort of revenge; but the revenge in turn becomes a proclamation of human potentiality. The division between nature and man breaks down with endless possibilities of destruction and regeneration.

One aspect of Gainsborough's need to find ways of trans-forming the given scene along the lines described above, was his ceaseless interest in moments of time, or tricks of lighting, that gave a particularly unified effect. Hence his use of candlelight, subdued lighting, transparencies; his interest in moonlight and sunset-glow. From Thomson onwards the poets were much obsessed with sunset, evening, twilight as what Ann Radcliffe called the Hour of Transformation. Shaftesbury had already set out the philosophic case for this obsession. Evening was a moment of total change, the whole face of nature was changed (not one aspect alone), the day of work ended, the moment of family reunion appeared, man was thrown back deeply into himself, yet also was able to realize his social essence, unclouded by the distracting conflict and superficial illusions of the day and its activities, its concern with the cash-nexus. About mid-century important statements of these attitudes appeared in Gray's *Elegy* and Collins' *Ode to Evening*. Constable in his tribute to Gainsborough stressed his feeling for the moments of complete change, the pivotal moments. 'The landscape of Gainsborough is soothing, tender, and affecting. The stillness of noon, the depths of twilight, and the dews and pearls of the morning, are all to be found on the canvases of this most benevolent and kind-hearted man.'

Along the lines indicated above Gainsborough powerfully carried on the revolt begun by Hogarth. We can trace elements of his influence on many artists, especially on Constable. But to limit our analysis of his impact on the development of art to such points is to misinterpret the nature of his work. The essential thing was his general liberating effect, the way in which, despite his use of the Dutch, of Watteau, of Claude or Rubens, he operated by moving away from the accepted stereotypes. He did

not consciously seek to express a precise moment of time as Constable did, or to analyse light in an impressionist manner; and yet in a vital way he was as much precursor of the Impressionists as of Constable, just as he foreshadowed in his gentler way the Turnerian construction of nature in terms of vortices. Why he held so many elements of the future in solution in his work lay in the last resort in the high degree of lyrical intensity with which his pictures are infused and which operates as a transformative factor breaking down old systems and preconceptions.

Appendix: Philip Thicknesse and his Ideas

G ainsborough was a man who very much needed companion-ship when not at the easel. He had his boon-companions like Quin or Bannister, his many musical friends with whom he rapturously mixed music and wine, his younger friends such as Jackson and Henderson in whom he saw something of his own early self, and one older man, Kirby, whom he much respected. But the one person who kept on close terms with him for much of his life – from about 1753 to his last years – was Thick-nesse. True, the latter was a restless man, who kept moving about, but for much of the time he was on familiar terms with Gainsborough. Despite his extreme touchiness and readiness to erupt in violent feuds, he never quarrelled badly with Gainsborough; the conflict over his portrait in 1773 did not end the relationship of the two men, though they could hardly have seen so much of each other in London as in Bath.

On account then of the long connection, it is of interest to know something of Thicknesse's ideas and character. We noted that he was a keen Wilkite radical, who deeply admired Rousseau. Gainsborough was the sort of person who picked up most of his ideas about contemporary culture from listening to the talk of other men; and though he resolutely refused to construct any system out of prevailing conceptions of life and art, he drew on aspects that stimulated him and accorded with his own system of responses. With his tolerant, compassionate and easy-going nature he must have been repelled by many of Thicknesse's attitudes, yet something in him liked the devil-may-care adventurous ways in which the latter tackled his world and made

its more respectable members provide for his livelihood.

For a while Thicknesse was friendly with the playwright, Samuel Foote. Then Foote wrote *A Trip to Calais* (1775) in which Lady Kitty Crocodile was based on the Duchess of Kingston. The Duchess did all she could to stop the play being staged and carried on an acrimonious correspondence with Foote, which was mostly written, it was said, by Thicknesse. At last Foote, for a consideration, rewrote his play as *The Capuchin,* satirizing Thicknesse as Dr Viper. He once described Thicknesse as having 'the stupidity of an owl, the vulgarity of a blackguard, the obdurate heart of an assassin and the cowardice of a dunghill cock'.

Thicknesse held decided views about his world, which must have often amused Gainsborough without gaining his assent. He writes in the most highly moral terms in his *Thoughts on the Times,* 1779, where he is wholly concerned with the question of keeping women chaste and enclosed in the family. He considers boarding schools for girls to be demoralizing; and we see how it was that he managed to put a stop to his wife Ann's professional career where her father failed. 'When married, women either leave music off entirely – or make it a Business – I never knew a Medium. If they leave it off – of what Use has been their Excellence? – If they make it a Business, they commence mere Musicians.' Then their behaviour is not 'compatible with domestic Happiness.' A woman's 'greatest pleasure should consist in rendering herself agreeable to her Husband – in making his Home, more entertaining and pleasing to him.' Absorbed in 'the Scenes of Dissipation, where nothing is heard but Nonsense, and unmeaning Compliment', she becomes

indifferent whether he approves, or censures – is pleased, or discontented – and leaving him to entertain himelf in the best Manner he can, flies abroad to be approved – by a *Crowd*! – I cannot bear to see a Woman of Fashion sit down to a Harpsichord at a public Concert – and hear her clapped by strangers on finishing her Tune – as if she were a common Musician. To say no worse, it throws her off that Level, on which it is her Duty to move. And after all – for what Excellence has she been applauded? She has been clapped, and extolled, because – *she happens to have the Use of her Fingers,* and *a good Ear!* – In the excellence *on which* she so much values herself – and *for which* she has made such a sacrifice of Time, and mental Qualities – she is at least *equalled,* if not surpassed, in every Theatre in London!!! – In the midst of her applauses, I cannot help feeling a secret Regret that she ever learned a Note! – If to sing – to

play the Harpsichord finely – to Dance, and speak Italian – is to be highly accomplished – it follows that, the public Singer – and female Teacher of Music – are – what? – *the most accomplished Women in England*!!!

(Lord Chesterfield tells us that Ann Ford was celebrated for her dancing as well as her music.)

From page 78 to the end, at page 200, however, the book is taken up with an attack on male midwives, with many quotations from Dr Smellie's treatise of Man Midwifery (which elsewhere Thicknesse declared was written by Smollett, whom he disliked). Throughout, Thicknesse lingers with endless detail over the way in which the man-midwife handles the woman's genitals and inserts his finger in vagina and rectum. He ends by suggesting that he excites the woman by tickling her clitoris. (For the meaning of this term he refers the reader to Chambers' Dictionary. 'It is a *Master-Key*.') He insists that 'Infamous, as the Adultress is, her Crime admits of Extenuation, and she seems pure, when balanced *against the Pretender to Modesty, who sends for her Doctor, to be digitated.* Shame on so abandoned a Practice!' The theme was dear to him. He had already treated it in *Man Midwifery analysed,* 1765, where he guaranteed not to 'indulge the fancy in impure thoughts or expressions' – a guarantee hardly carried out.

But he had another side, which helps to explain why Gainsborough accepted his friendship. This side comes out in a publication of 1769, *An Account of the Four Persons found Starved to Death, at Datchworth in Hertfordshire. By one of the Jurymen on the Inquisition taken on their Bodies.* Here he tells how, 'On the 23rd January, 1769, a day-labourer, who lately lived in a poor-house belonging to the parish, told me, that four or five persons were found dead in a poor-house on the green, and that they perish'd for want of food, rayment, attendance, and a habitable dwelling.' Thicknesse went to the place indicated, a small hut, 14 by 12 feet, with parts of the roof unthatched, a windowframe with no glass, and opposite it a large hole in the plaster wall. Here James Eaves, his wife and three children, had been left by the overseers to die. After eleven days' neglect they were found by a shepherd's boy. One child, a boy of eleven, survived in an emaciated state.

Thicknesse at once wrote to two brothers, one a churchwarden, the other the overseer of the parish poor, demanding that the bodies should not be buried till an inquest had been held. On a second visit he intercepted the constable and another man taking the bodies off hastily in a cart to bury them. He then wrote to the

rector, insisting on an inquiry, and went to Hatfield to persuade a Mr Searanche there to take the matter up. After some trouble he managed to get a jury summoned, with himself as foreman. Mr Frost, a surgeon of Hatfield, testified that 'he never saw more bodies more emaciated, and that certainly there had been great neglect *somewhere*.' A neighbour testified that the mother had crawled out some ten days before, to fetch water in a kettle from a pond, but fell down, left the kettle, and crawled back to the hut. People were afraid to go near as the family were said to have caught gaol-fever from a man who had died in the hut 'not long since'.

An elder son, out at service, had visited the family some time before Christmas, and had found them ill, in a starving, helpless condition. 'They directed him to go to the overseer's house, and ask for relief.' But the man was not at home and 'a *woman* there exclaimed, "Send them relief! send them a halter? – let them die and be d——d!"' 'When the lad returned to tell his parents what had happened, 'he met *the man*, who refused to give them any assistance; he accordingly inform'd his parents therewith, who replied, "Then we must perish."' ' He had wanted to visit them again 'a few days afterwards, but living at some distance, his *dame* would not give him leave, and he saw them no more.'

Thicknesse adds, 'Nine women and children are now in a hut within an hundred yards of that in which the family perish'd; which hut is open in many places on the top, the sides, and the end, so that they cannot escape the violence of the frost, the wind, nor the rain; and they assure me, the late snow came upon them night and day in great quantity.' Also a poor widow, Susanna Stratton, has 'made oath before Mr Searanche this day, that her late husband did perish, and was starved to death for want of necessities, in the same house, about the year, 1763.'

Thicknesse, we see, had many sides to his character, good and bad, and we begin to understand why Gainsborough could have carried on so long a connection with him.

Notes

Abbreviations used: B. for Boulton; F. for Fulcher; G. for Gainsborough; H. for John Hayes; P. for Paulson; T. G. for Thomas Gainsborough; W. for Waterhouse; WW. for Whitley. H. pl. refers to the plate and relevant Note in Hayes (13); W. with number to the reference number in Waterhouse (1).

1 Childhood (1727-1740)

1. Cf, Constable, 'I had often thought of pictures of them before I had ever touched a pencil,' on scenes of boyhood: G. Reynolds, (2) 9.

2. Mill: Pyne, who in youth knew him: WW 2. Entry in Town Book, 2 Sept. 1723. Frontage widened 2 feet 2 inches, so 3d a year added to rates.

3. Robert Gainsborow lived at Lavenham 1838. Robert's will mentions brothers and sisters. Thomas G., freeman of Sudbury in 1703 list (where also is another Robert G.), buried All Saints where he had a family altar-tomb in the yard Chapel: deed for appointment of trustees for building new Meeting House, 1709; House opened, 1710. Thomas a trustee and major subscriber for building and repairs. House demolished 1822; Chapel there till 1965. When it was closed, several G. coffins were taken to borough cemetery. Thomas seems cousin of the painter; left sums for support of school and minister, etc. Note also the will of a rich cousin of the painter, Thomas G., London merchant, dying at 29 in 1738. Last member of G. family in Sudbury was Emily G., great-granddaughter of painter's uncle Thomas, dying 1852, aged 66. The name Burroughs is also spelt Burrough.

4. Stour: Worman 14. House-projections so many that 1825 local act for town improvement laid down all houses 'should be made to rise perpendicular from the foundations thereof.' Peel, in the debate on

Sudbury's defranchisement as borough, remarked on 'a most extraordinary piece of legislation to compel people to build their houses upright.' Theatre: Grimwood, ch, xiv.

5. G.'s uncle's wife was daughter of the famed headmaster Dr Busby.

2 London (1740-1748)

1. F. (1) 23, 27; *Gent. Mag.* Aug. 1788; *Morning Herald,* 4 Aug. 1788; *Chronicle,* 8 Aug.; WW 6. Gravelot: H. (10) i 55, and (11). Woodall (4) 13f. Menpes 26, 36 suggests Tom was with William Horrobine and wife Susannah (née G.) and thinks they appear in two early drawings signed 1743-4, carefully drawn but with good character: H. (10) nos. 1-2.

2. Dutch: H. (3) 186-90 and (5). Similar trends in France. Note Nicholas Tull, d. 1762, who imitated Dutch; some of his works were engraved in 1760s. R.W. Harcourt iii 241. Jackson 179 and Letter 49. De Piles on landscape in *The Principles of Beauty* saw Titian and Carrache (Annibale Carraci and Domenichino) as models; later Reynolds used Titian for portrait backgrounds. Hayes (3).

3. Gowing, also Coke; J.L. (1). Mixture of rococo and Dutch elements was not uncommon in the engraving milieu. A note in E. Edwards says G. was put 'under the tuition of Mr Hayman' for a short while; Farington, 6 Jan. 1808. Hayman: see index Angelo (2) and (4).

4. Repairs: Oldfield sale 7-8 Feb. 1786. Influences: H. (10) 41,54-6 Dolls: H. (13) 50.

5. Menpes (1) 13.

6. Margaret: she had relations in London and Scotland, 1794: WW 9, and A. Fraser in *The Portfolio,* cited.

7. H. (10) i 110; W. pl. 17.

3 Sudbury Again (1748-1752)

1. WW. 8f.

2. H. pl. 15; pls. 1,4,5. The title *Cornard Wood* has no early authority. Note drawing after Ruisdael, 1747.

3. Kirby married Sarah Bull of Framlingham, d. 1775. In 1745 he offered in Ipswich for sale 'A Curious Print of Mr Garrick' (Painter, Pond); soon after he tried to dispose of 'A Genteel Chariot'. His Perspective book was very successful, reprinted 1755, 1765, 1768 with additions.

4. For Tom Peartree, 5097 Cocker Bk, Bury St Edmunds Record Office, Fulcher seems to follow Cunningham. Another version sets the orchard in grounds of Rev Coyte, father of one of G.'s boyhood friends. But a Dr Coyte had a botanical garden in Ipswich near to Craighton's garden: WW. 12f. Coyte: W. no. 169 and letter on Mary Fischer; also n. 4 ch. 8 here.

5. Greig and Menpes 12 for son of Jack G., 1752.

4 Ipswich (1752-1759)

1. WW. 23-5. Thomas Wrasse, grocer, advertised the house in 1752; in 1760, Mrs Wrasse. Fulcher says G. lived in Brook Street; now 21 Lower Brooke Street is shown as his place, without any authority.

2. He did a few unimportant topographical views, e.g. Wolverstone, engraved 1788; Elmsett Church, prob. 1750-5. W. 884, 852.

3. Plampin: P. (2) 216f; H. pl 55.

4. Trimmer says this was first-rate, 'I merely mention this, because he has been taken to have failed in his etchings.'

5. Contrast with detailed groundplan of George Lambert's works. For one of the horses G. used an oil-sketch from life.

6. H. pls. 29-31. H. pl. 30 given to G. Earle of Barton Grange. There were several Baldreys among painters and engravers in the eastern counties, later 18th century. Joshua Kirby B., who showed some pictures in R. A., was son of our Baldrey.

7. Barry's portrait came into Sam Kilderbee's possession; G. did another a few years later of Barry with wig and hand thrust in coat. Letter to Harris: Suffolk Record Office, HD 486/1.

8. F. 56f. Giardini: Burney iv ch. 6; Avison 119f.

9. La Tour was much regarded in England, by Hogarth among others: WW. (3) i 30f.

10. Portrait of Clubb not known. Probably John Clubb who wrote a tract, 1758, satirizing conjectural etymologists.

11. Also Unwin, W. 687; Sir R. Lloyd, W. 453; Garnett, W. 302.

12. Daughters: Edwards 143; Woodall (4) 40. Note also picture of daughter gleaning, with delicate tones of yellow, violet, grey. 'The little portrait has much in common with the Fancy Pictures of peasant children' doen later: Woodall.

13. H. pls. 18, 59, 47.

14. WW. 28f; Hayes (8); Harcourt Papers iii 243; WW. 339f. We cannot take seriously an account in the *Town and Country Magazine,* Sept. 1772, about someone calling in at Ipswich, Nov. 1758, and finding G. gone to Bath. After some trouble the narrator locates G.'s studio there and is told he did landscapes only till he went to Bath.

15. 19 April 1759: receipt for portrait of W. Lee; G. also did his wife. Trimmer sees far more variety in trees of Suffolk period than later. H. (8) 69.

5 Bath (1760-1766)

2. Houses: WW. 31-6.

2. Hoare, later R. A.; F. 61.

3. Mrs Delaney iii 605; Kenwood no. 16.

4. Ann Ford: P. (2) 206. Among 1760 works was portrait of Robert Craggs (later Earl Nugent), frankly corrupt, with knack of marrying rich moribund ladies.

5. Incorporated Soc. of Artists, 1761 show at Spring Gardens. Discontented artists still sent works to the Great Room of the Soc. of Arts in Strand till 1764, when it took name of Free Soc. of Artists and held shows at various rooms till 1775. See J. L. (1) and P. (1). G. sent Lord Nugent 1761; Poyntz 1762; Quin, Medlycott (relative of Miss Edgeworth) 1763. He exhibited again in 1765 and on till 1772.

6. H. (4) 450; H. pls. 47, 50, cf. 47. Drawings not necessarily kept in portfolios.

7. Quin: After Dublin at Drury Lane and Covent Garden, where, 1746-7, he was the rival of Garrick. Smollett used him directly in *Humphry Clinker*. Quin was a republican: see his encounter with Warburton at Prior Park. B. 138-42. His jests: Gosse 165-7; Angelo (2), see Index for Quin.

8. Fragmentary letter, 28 July 1763, on sending two bottles of varnish of his own make. In 1763 Kirby's drawing of Kew Palace was engraved by Wollett. Angelo (2) for G. i 141-9, 164, 168-73, 201, 271-6, 351,391-3, ii 315. G. sent Anne's portrait to Thicknesse in London, wrapped in a landscape.

9. Mrs Saumarez: *Conn.* Jan. 1922 5ff. Dr Charleton's portrait in S.A. 1766; he stands with stick under arm amid trees of which he does not form a part. Thicknesse in *Sketches,* on those 'who have made a mean and contemptible figure in some action' cites Dr C-rl-on, 'When he employed Mr Gainsborough to enable him to exhibit his full-length Portrait, in the exhibition room at Spring Gardens.'

10. Gilly Williams, 1764, on Sir Onesiphorus Paul. 'His dress and manner are beyond my painting; however, he may come within Mr Gainsborough's: that's the painter by whom, if you remember, we once saw the caricature of old Winchelsea', WW. 43.

11. Esp. H. pl. 69, n.54.

12. H. pls. 60, 62, 61 with notes.

13. Price (1) ii 368. Humphry: Letter 47. n.d., refusing to allow copies.

14. Arms of the Society: B. 159.

15. Gen. Honywood, suggested by Reynolds' Lord Ligonier, 1761?

16. Lines on the Garrick attributed to Derrick, Master of Ceremonies, WW. 44. G. did six portraits of Garrick; apparently remodelled the Shakespeare one for Stratford, 1769.

17. Poem: Reynolds was only 43 years old. W. Peters, who later took orders and was chaplain to the R.A., got twenty lines for his 'immoral' paintings: WW. 46.

18. Smollett lodged in Gay St., winter of 1766. Quin died 1766.

19. H. pls. 8, 62, 55. WW. 390f.

20. H.pl. 71. Bought for 40 gns by Sir W. St Quintin. For portraits of him and family: W. nos. 595-7a.

21. Earlier artists: Samuel Cooper and candlelight, see Evelyn, *Diary,* 10. Jan. 1662; Piper 117: 'for the better finding out the shadows'. Williams, after quarrel with Bate, left the *Herald*. Here he goes on to depreciate G. and sees his ladies 'over-vermilioned on the cheeks, so as to

look like varnished puppets'. WW. 248.

22. Seed-drill: Fussell; D. Hudson (2). Humphry kept his eye on the latest technological needs and devices.

6 Bath (1766-1769)

1. W. no. 961, *Woodcutter's Return* was owned by Giardini: WW. 361.

2. Parke, i 203; B. 147.

3. Account of Tenducci in *Humphry Clinker,* 1771, given by Lydia Melford. In the 1760s G. seems to have painted the blind musician John Stanley. See Kenwood for music in general. H. (10) 122 and Kenwood for the study of a musical party, only a few strokes to define posture, weight, expression: perhaps the Linleys with Giardini.

4. Jackson gave G. one of his paintings; was pleased when, at the posthumous sale, 'it occasioned many guesses as to the painter'. He was himself painted by G., Keenan, Ozias H., Morland, Opie. There were three editions of his Letters in his lifetime; in his *Four Ages* he wrote on Riches, Quarles' *Emblems,* Cards and Duelling, Bad Associations, Homer's Scale of Heroes, etc. (Sir G. Beaumont had a low opinion of J.'s paintings.)

5. Farington Diary, 6 Jan. 1799, 'passionately fond of music'. *Monthly Mirror,* WW. 360f.

6. Rimbaud: *Notes and Queries* 13 Jan. 1871. He says he often heard his father speak of G.'s playing on the harpsichord 'in terms of great praise.' Bate, *Herald* 11 Aug. 1788, 'His performance on the Viol da Gamba was, in some movements, equal to the touch of Abel. He always played to the feelings.' Jackson as artist: Beaumont in Letters 107-8.; H. (15) and (10) 68.

7. Clark (1) 26: Cennini, last spokesman of medieval tradition of painting, for use of stones as models for mountains: 'should be rough, and not cleaned; and portray them from nature, applying the lights and darks according as reason permits you'. Poussin; Degas on use of crumpled handkerchief held to the light, as model for cloud. Wilson: 'consulted the broken surface and rich hues of a large decayed cheese, for ideas of form and colour,' for his *Meleager and Atalanta* (done before 1771): W.P. Carey, *Letter to I...A...* (Manchester, 1809).

8. H. pls. 77, 80, n. 61.

9. Kirby in 1767 published another book on Perspective; 26 March, F.R.S.; 4 June, F.S.A. Underwood's subscribers included Garrick, Colman, Derrick, Dr Schomberg.

10. He says he'll give a copy of Garrick's portrait to James Clutterbuck, his business-adviser, 'that he may one day tell me what to do with my Money, the only thing he understands except jeering of folks'. The original was meant for Mrs Garrick.

11. We may assume that Tom kept an interest in what was going on in Sudbury. In 1761 bribery in the parliamentary elections led to trouble in

the Friars Street Meeting house, with a split in the congregation, 1765. In 1771 the oligarchy of aldermen and burgesses faced a crisis through refusal to admit certain men as freemen; they were kept in the Moothall by a yelling crowd from just before noon till after 9 p.m. They promised then to submit, but rioting went on, and next month a troop of dragoons was called in. Early 1772 the mayor and friends took back their promise as made under threats.

12. Prince Hoare, 76f.

13. *Lycidas* performed at Covent Garden on death of Duke of York. Jackson later told Samuel Rogers that his teaching took him 'chiefly among the young and often the beautiful of the other sex'.

14. H. (10); 21, refs. Henderson made etchings for Fournier's *Theory of Perspective* (he had studied under him) and in 1767 got premium from Soc. for Encouragement of Arts and Sciences.

15. H. pls. 72-3.

16. Expanding trade, etc. made the question of finding longitude of ship at sea ever more important. Harrison won a government premium of £2,000 for his chronometer, which enabled longitude to be found within certain stated limits of accuracy.

17. WW. 58. On 28 April G. got £21 for three-quarters of Duke of Bedford 'sent to Miss Fortescue in Dublin'. Letters p. 36.

18. On 15 Nov. 1768 receipt for 60 gns from Duke of Bedford for a full-length. Same month Samuel Dixon announced opening of picture-room at the Cross, Bath, where he would show several Old Masters not shown before; he died two months later and the pictures were offered for sale, with lowest acceptable prices marked. Autumn: London show in honour of visiting King of Denmark; G. sent a portrait. Kirby exhibited with Society of Artists, 1765-70, views of Richmond Park, Kew, and neighbourhood. He tried to persuade Reynolds not to join the new R. A. When West's *Regulus* was brought to the King, Kirby asked that it should be publicly shown. Certainly, said the King. At the Incorporated Society of Artists, added Kirby. 'No, no, no, the exhibition of my own Academy.' Kirby is said never to have recovered from the mortification: B. 164.

19. H. pls. 92, 65.

20. W. no. 304; WW. 68f.

21. G. depended on Palmer to get letters to Exeter: Letter 57.

22. H. pls. 73, 74, 81.

23. Verses in *Chronicle* lament death of 'the late ingenious Mr Robins, landscape painter of Bath': 'Where now, O nature, is thy favourite child?' Advertisement shows son carrying on his business and humbly appealing to the Nobility and Gentry. H. (1) for more about Barton Grange. For G. at Shockerwick: Woodall (2) 59f. (Finden).

7 Bath (1770-1774)

1. Story of conflict with Reynolds started by John Young, engraver, in

1821. WW. ch. xx; Burke (1) 214; J. B. Muswick; H. (13); J. L. Nevinson; Woodall (4) 22-4; P.(2) 216. G. left 19 copies, 7 of them after Van Dyck. Bate says in lifetime he could not be got to sell any drawings. W. Doughty, young painter of York, painted self, c. 1780, in Van Dyck costume; later worked under Reynolds: Ingamells. Hudson used Van Dyck in *Unidentified Lady in Pink* (Bristol City Art Gallery).

2. G. S. Thomson, *Letters of a Grandmother,* 1943, 121. Van Dyck imitations by G. were Duke of Norfolk, 1780; Gen. Honywood; Lady Dartmouth, 1771.

3. P. (2) 212-14.

4. Duke of B. engraved by J. Dixon, 1771. Sheridan in 1770, who had been pupil of older Angelo, went to Bath. Dealer Jones still advertising Old Masters (Rembrandt, Claude, Van Dyck). Christie also at times advertised in Bath papers.

5. H. (13) 17, 24-6; landscape basis, H. (10) i 110. Where his paintings have suffered, it is mainly through restorers cleaning off scumbles, glazes, and his easily soluble varnish. For Moppings, cf. (and contrast) Cozens' Blots: J. Lindsay (2) 83.

6. Picture of Stratford (probably 1769-70) engraved with Peer's robes added by S. Einslie.

7. H. pls. 89-90. Receipt to Earl of Dartmouth, Letter no. 15. Crayon drawing: see W. No. 185.

8. Poem by R. Cumberland: F. 88. In 1771 Elizabeth Linley sang with her sister in the Three Choirs Festival; as leading soprano could get £100 a festival. Pictures: WW. 76f. B. 166.

9. *Bath Chronicle,* 23 Oct. Thicknesse and Dodd: Gosse 119. Dr Schomberg wanted to shine as playwright, but his friend Garrick turned his attempts down; he had a small afterpiece at Haymarket, c. 1781. Dr Charleton was wealthy, with seat in Gloucestershire and house in Alfred Buildings, Bath; had large collection of pictures. Sudbury: Grimwood 14.

10. Prince Hoare, son of portraitist, was hon. Foreign Sec. of R. A. in 1799; he wrote *Academic Correspondence,* 1805, *Academic Annals of Painting,* but was best known for his plays.

11. More about Lady Waldegrave: WW. 96. Cosmetics: Piper 190; WW. 89f; Coke.

12. H. pl. 102. Angelo calls her Dally the Tall (not to be confused with Dolly the Tall, Mrs Elliott).

13. At first Henderson called himself Courtney; gave his own name in prologue written by John Taylor, successful as landscapist, who lived in the Circus.

14. Jackson seems somewhat in love with Elizabeth. 'Her genius and sense gave a consequence to her performance which no fool with the voice of an angel could ever attain; and to these qualifications was added the most beautiful person, expressive of the soul within.' WW. 201

15. Cumberland pressed H.'s claims on Garrick, in vain.

16. Gosse 163f. Thicknesse, 'As we were on our way up the Oxford Road, it occurred to me that Lady Bateman would be more disgusted with

Henderson's usual table deportments, than my Lord had been.'

17. G. also painted Miss Tyler of Shobdon, aunt of Robert Southey, beautiful but violent-tempered, B. 180. Lord Bateman: W. 48. W. 912 was traditionally done for the Lord.

18. B. 286

19. Parke, i 2f; W. (1) 45 n.14.

20. H. pls. 115, 114.

21. Wright: Bemrose 45, H. (10) 6. M. Elwin, *The Noels and the Milbankes,* 1967, 37f.; 'she heard Mr Linley, young Thomas and Mary L. in Handel's *Acis and Galatea.* Mary was fine, 'tho' not equal to her Sister, nor does she shine so much in the pathetic.'

Giardini was now composing a lot; played at the Pantheon concerts 1774-80; led the Three Choirs Festival 1770-6; conducted at the King's Theatre. Probably through him G. was commissioned to paint Music and Dancing on side wings of stage.

22. WW. 107; Cunningham cites a lady, who heard the story from Mrs G., that G. paid Mrs Thicknesse privately a hundred guineas for her viol. Thicknesse did not know and renewed his request for his portrait, which G. sent back, 'resenting some injurious expressions' from him. The Fischer shown at R.A. in 1780 seems certainly this earlier portrait. Thicknesse described Dr Schomberg as detected 'last Sunday in stealing the money out of his own plate at the church door, and it now appears the rascal is an old hand at it.'

8 London (1774-1780)

1. Errors about royal patronage in Cunningham and Fulcher: WW. 115f. Chambers: BM Addl. Mss 41, 135; H. (10) 6. Jackson, *Four Ages,* 167.

2. Mrs William Lowndes-Stone: H. pls. 103-4. G. Dupont was held up in a chaise, Oct. 1788, but one of the thieves returned, apologized, said only distress had driven him to crime. Christie, Rowlandson, Burke were also held up by the highwaymen.

3. G. added to Hudson a pair of legs and fine sky with St Paul's in distance. Lord Radmore suggested him.

4. Christie's first sale was in Dalton's Rooms, Pall Mall, where first show of Incorp. Soc. of Artists was held. Coyte of Ipswich, who bought *Landscape with Cattle,* died 1775.

5. Merlin also invented a carriage: Kenwood 44.

6. Letter 60 on franking letters. Bertie was friendly with Haydn and in 1795 composed a pianoforte accompaniment to Earl's *Twelve Sentimental Catches and Glees.*

7. Mary Linley took Elizabeth's place in public concerts, oratorios, till in 1780 she married R. Tickell who worked with Tom L. and Sheridan in plays and librettos for Drury Lane. On 30 Oct. 1776 Secretary of Soc. of Arts reported G.'s painting of Lord Folkestone delivered; order made 6

Nov. to pay him 100 gns, 'the price he usually charges for a whole-length picture' (twice what Dance would have got). Letters, p. 132.

8. Jackson later formed literary society in Exeter where each member read an original work at Glove Inn, Fore St, and he was accepted as one of the minor literary figures of the day. Friendly with Walcot and Samuel Rogers, his executor. The Duke, dull and stupid, had intrigue with Lady Grosvenor; as result he paid £10,000 damages to her husband. No doubt he amused G. (When he was painted by Reynolds, he stumbled about the room till his wife whispered, 'Say something.' He looked at the canvas, stammered, 'What, eh? so you always begin with the head, do you.' WW. 144) In *Morning Post* 'A Dilletante' on the landscape 1777, complains so large a work ought not to have been placed on the line at all; all the good positions were monopolized by Reynolds, G., West, and one or two others. For Mrs Graham and the fate of the picture: B. 220-3, WW. 147.

9. Dodd: Thicknesse has story of wax model by Mrs Phoebe Wright that he was to put in his bed, so that he could escape. WW. 98. Style, character: H. (13) 15f.; *Four Ages* 160 and 183; Pyne (2) 551 and (1) ii 215; P. (2); WW. 367f., 371; Green, 12 May 1809.

10. Hackney, see B. 235 for attempt to put it down to his pride.

11. Bate: WW. ch. vii.

12. *Cristie* praised for its likeness. Dolly was Grace Dalrymple, married physician later known as Sir John Elliott. *General Evening Post* finds 'inexpressible delicacy, united with utmost force and truth... The blue tint, however, is too predominant in the hair, but we surely ought to forgive this seeming imperfection from the inexpressible sensibility which animates the whole figure.' She later wrote a Journal of her life during the French Revolution. Portrait: Burke 216. 1778, Bach's portrait at last to Italy; G. held it up by wanting to paint a replica. His work conveys Bach's cordial confident character.

13. Crosdill, leading native cellist of the time, popular with public and at court; appointed Chamber Musician to the Queen, 1783. G. was 'rapturous and enthusiastic' about his playing: Jackson. H. (10) 70.

14. Fanny Burney, 1785, 'Imagine what a charm to my ears ensued on the opening of the evening concert, when the sweet-flowing, melting, celestial notes of Fischer's hautboy reached them!'

15. B. 250, 253. H. pls. 58, 127, 87. Mrs Beaufoy: closer to Reynolds than Van Dyck, 'yet the contrasts are even greater. In Reynolds' *Lady Bamfylde* (pl. 88) the head is far more abstracted, the costume and background more generalized, and the lighting broader: studio-controlled rather than naturalistic or even dramatic. The Reynolds retains overtones of the antique where the G. could never be mistaken for anyone but a fashionable, though perhaps rather vapid, lady of the late eighteenth century'. (Hayes.)

16. *The Cottage Door*: WW. 168-70; H. pl. 116 and H. (19) for *Country Churchyard*. In the etching the peasant leant on stick may echo figure in Bentley's illustration to the *Elegy*, etched by Grignion. The lovers in contrast represent the lived moment: H. (19) 117, 119. In early to

mid-1770s G. was fascinated by possibilities of aquatint, then of soft ground etching, for reproductions of his drawings. The themes he chose are significant. Thicknesse: 'Read Gray's pathetic elegy': Gosse 319. See Hagstrum 295-301, 279;

17. 1780, Jackson's first opera a big success: libretto by Gen. Burgoyne (commander of defeated British at Saratoga, 1775), based on Marmontel: at Drury Lane (under T. Linley and Sheridan). Stour: Worman 14.

9 London (1781-1786)

1. WW. 175 on pamphlet *Earwig*.

2. Hazlitt to Northcote: 'G. did not make himself agreeable at Buckingham House', B. 120. Angelo says that G. said 'the King uttered more original *petits jeux de mots,* and in a playful style purely his own, than any person of rank he had ever known; but, as they were usually applied to the localities of the moment, they lost half their *naiveté* by every attempt at repetition.' Note drawing *A River Scene* (Windsor) inscribed Sept. 17 1782 (Woodall (2) 79).

3. Mayne; F. 121-4, B. 217; W. p.33; WW. (5) 113 suggests G. got idea of Box from amateur landscapist John Taylor, who in 1760s showed Thomas Sandby an invention of the kind as a thing then new in England. (But WW. gives no source.) Angelo (2) i 8; A. Dobson 93-109. *Les Ombres Chinoises* were given at the Théâtre Séraphin, Palais Royal, Paris.

4. Farington saw the Box; sometime after it was acquired by Dr T. Monro who in 1824 lent three slides to a show of drawings at Cook's, Soho Square. Jarvis: J. A. Knowles 45.

5. Perdita (Mary Robinson) was prospering; she commissioned two portraits from Romney, one each from G. and Reynolds. Reports stated she liked best that by Reynolds (in which she was shown as Rubens' first wife), least that by G. as unlike her. Going ill-clad after Tarleton to port where he was to embark, she was almost frozen and left crippled, aged 24. WW. 181. *Woodcutter:* W. nos. 960-1. Baccelli had danced at King's Theatre since 1774, must have known Giardini well, and so also G. New opera at the Theatre, 1776, by Rauzzini was dedicated to the Duke of Dorset, done under Giardini. In Paris with ribbon of the Garter, WW. 180. *Baccelli* painted at Knole: Woodall (2) 80. For pictures H. pls. 149, 128, 131, 122, 146. Dolly (probably 1782), W. pl. 211.

6. Tour: WW. 355; H. (12) 26; *Herald,* 19 Sept 1790; H. (10) i 29. *Life of Bannister* by Adolphus: B. 288f, and Angelo (2) see index.

7. H. (10) 69; Pyne (2) 552, WW. 250-2, B. 209.

8. Duke of York missing; he was travelling abroad, B. 213f.

9. Pearce wrote libretto for comic operas at Covent Garden, later years of the century, wrote poem on Bate's Bradwell hospitality, no doubt he and G. at times shared it; died 1842. Letter he sent to George IV dealing with 'a transaction with his Majesty when Prince of Wales': WW. 393. H. (10) i 29.

10. Payne Knight included Hobbema, Ruisdael, Ostade, Waterloo (as well as Claude and Rosa) among models for landscape gardeners. Hipple, ch. 18; H. (4) 450. Gilpin on working up nature for a picture: *Three Essays,* 2nd ed. 1794. John Hassaell in *Tour of the Isle of Wight,* 1790, for linking English painting and picturesque, e.g. 'Many old stumps of trees lay scattered near the road, that, with a team of horses, formed a fine group.' Adds, 'A well-known favourite subject of the late Mr Gainsborough,' ii 40. Again, 'At the entrance of Newtown we met with one of those subjects so often touched by the pencil of Mr Gainsborough: a cottage overshadowed with trees; while a glimmering light, just breaking through the branches, caught one corner of the stone and flint fabric, and forcibly expressed the conception of that great master,' i 137; Morland, ii 633, 212. Gardening: Buchwald links G.'s stages with the movement from the *ferme ornée* to Brown's open landscape and then to picturesque. There are indeed connections but she much overstresses them. Morland: Woodall (2) 110.

In 1789 Thicknesse made his last attempt at cottage-making in the fishing village of Sandgate near Hythe, taking over a deserted barn, 'determined to try the efforts of his creative genius on it': Gosse 308f.

11. *Morning Post*: he asks for the princesses to hang not higher than five and half feet; reply that no exceptions can be made; then letter, 10 April. *Mall:* P. (2), H. pl. 148. Rowlandson's *Vauxhall Gardens* was done 1784. At the Dupont sale, 1797, it was said that the figures were 'probably known Portraits of the time'. It was supposed to be done for the King, though perhaps its not being a View prevented him buying it. G. worked on it straight after the Lakes. (Sir Martin Archer Shee later said that G. often forced the light and shade of pictures he sent in, and toned them down when they came back to his studio.)

12. Debts stopped the Prince from carrying out his project of a portrait gallery at Carlton House, with pictures of his family and close friends.

13. Late this year the Prince sat several times for a portrait in Hussar uniform, which was in advanced stage early December. Perhaps Hoppner wrote the passage in the *M. Post* on the reality of G.'s country-pictures: WW. 257. Dealing with the problem of painting the Duchess of Devonshire, the critic says, 'I am tempted to think that Gainsborough sees with more truth than any of his contemporaries,' WW. 232f. Years later Hoppner in the *Quarterly Review* said of G. and Reynolds: 'While the first was content to express the body, it was the ambition of the latter to express the mind.' H. pls. 134, 141, 143.

14. P (2) 210f. He notes that some art-treatises measured the body in terms of Noses. WW. 370, 235f.

15. H. pls. 155, 78, 129, 156, 159, 144, 153, and P (2) 218.

16. Hazlitt preferred of the Fancy Pictures *Cottage Children* (now called *Wood Gatherers*). The girl with pitcher is the same girl as the one with pigs.

17. See in general Paulson's essay, which is full of striking insights. (I myself arrived at the idea of the slope-image as central through what I

have here set out about the slope below the Stour Croft and G.'s childhood.) Paulson tends to see the whole stress as on the downward movement to water; I consider there is an equal, or even stronger, pull up to the light and the cottage (or church). G.'s image is thus dialectical, uniting the movement up through work to the family (society, union of producers) with the pull down to origins, to the waters of birth or renewal (refreshment etc.). For the Cottage, see Drawings nos. 144-6, 221, 217, also 163, 178, later 340-2, 351, 474, 535; door, 380, 447, 451, 478-9, 552, 798. In paintings, esp. the landscape sent in 1780-1, H. (7) 21.

18. See C.P. Barbier, C. Hussey, J.H. Hagstrum, E.W. Mainwaring, Gage on Turner.

19. P. (2); J.L. (1) 175f, etc. Turnbull, 107f.

20. Scott seems John Scott: in 1797 water-colour preparer, 417 Strand. There were also Newman's (Gerard St., later Soho Sq.) where Richard Wilson bought paints; Middleton of St Martin's Lane, who supplied many artists, later Turner and Raeburn. WW. 246f.

21. John Williams (Pasquin) said G. prided himself on using longer and broader tools than others, and on standing further from canvas.

22. H. pl. 157.

23. P. (2) 215; Buchwald, 374–5. Note the landscape has a church.

24. Spring: Prince now bought a second landscape, though both stayed with G. till his death: WW. 259.

25. The story that he stayed at Holkham to instruct Coke's daughters cannot be true; Jane was ten in 1788. No clear evidence about the self-portrait. H. pls. 145 and 162. See Gatt for claim that G. was faithful to seasonal effects.

26. Influences: Murillo, Adriaen de Vries, etc. A wooded landscape, probably of Bath period, was called *Hagar and Ishmael* by 1792, but is not History in any clear sense. For Mercier as predecessor, see R. Raines: use of children or young girl, of candlelight. Also Wright, not only in his works dealing with scientific experiments, but also in *Young Woman Reading over a Lettter by Candlelight:* see *B.M.* xcvi March 1954, fig. 8. G.s picture of his daughters chasing butterflies has affinities with Mercier's bubble-theme, etc. Fuller, *New Soc.,* 18 Oct. 1980.

10 London (1786-1788)

1. It was thought to be meant as a gift to the King of France, and highly praised. Bate, praising the work, added four quatrains satirizing the Marquis, 'Himself a dealer deep in oil and varnish'. WW. 272.

2. E. Edwards says Reynolds thought the work genuine, but was not called through a misunderstanding between him and Vandergucht (? over the Earl of Upper Ossory's Titian): WW. 280.

3. The Haberdashers decided to spend not more than 100 gns, apart from a Carlo Muratti frame; but G. accepted the commission for 120 gns in February 1787 (just before he raised full-length prices to 160). The

work was done early June. Payment, 5 Sept. On 19 Sept order made for Knapp to apply to G. for erasing name of Joseph Malpas from the paper Knapp held in the picture. Malpas had somehow got G. to insert his name.

4. H. pls. 171, 152, 120, 130 (Mrs Bate).

5. Jack Hill: WW. 292f., F. 134f, W. nos. 808-9. 1787 Mary Tickell died, to sorrow of sister Elizabeth.

6. Woodall (1) letter 5. Name of Cornard Wood given in 1875; WW. 300 on criticism in *Gazeteer* 1790. 'The picture is placed too near the eye.' It was owned by Constable's uncle: WW. 301. H. pls. 164, 52, 168, 163.

7. Also portrait of Lady Petre's brother, Mr Howard, WW. 303.

8. Last landscape sold by Mrs G. to Tyrwhitt, WW. 314. *European Magazine* stated the trouble was a large wen which internally obstructed the passage: WW. 309. *General Evening Post* said the same, adding that the two self-portraits in the gallery 'with a modesty peculiar to the painter, had their faces turned to the wainscot'. Obituaries in *Herald, Morning Chronicle, Gentleman's Magazine,* and *European Magazine.* Ipswich and Bath papers added nothing new.

9. In Nov. 1788 Bate took advantage of alleged irregularities over Fuseli's election as Associate R.A. to raise sharply again the matter of the Three Princesses. Linley this year had his last opera on the stage; he suffered from depression, Maria, Mary and Tom were dead, Elizabeth soon to die. Soon after G.'s death there were announcements of a volume of anecdotes about him (in which praise would be given to Lord Gainsborough, Lord Porchester, Sir F. Basset, Sir P, Burrell, Tollemache, 'for that spirit and taste by which his admirable pictures of rustic history were encouraged'). Bate wrote of the book, but it never appeared: WW. 354. Note the phrase 'rustic history'.

10. Newspapers make clear that Mrs G.'s aim in showing pictures in rooms where they had been produced, and in refusing to sell any till the show opened, was to checkmate forgers now busy. Bate notes 'an execrable imposter of the brush who resides at Bath' and had been active in forgeries for months.

11. Mrs G. and the Prince: Pearce cited in *Notes & Queries,* B. 244.

12. Thicknesse had no visible means of support most of these years apart from a little journalism. We know of one of his tricks. He printed some letters of Lady Mary Wortley Montagu on a private press, then sold the letters to Lord Bute with a promise not to publish them.

13. Dupont's art: H (15) and (10) 64-7.

Bibliography

The following abbreviations are used: *G.* = *Gainsborough*;
T.G. = *Thomas Gainsborough*; *B.M.* = *Burlington Magazine*;
Conn. = *Conoisseur*. Place of publication is London unless otherwise
stated.

Abrams, M.H., *The Mirror and the Lamp* (N.Y.), 1953.
Angelo, H., (1) *Reminiscences*, 1828. (2) Reprint of previous title, 1904.
 (3) *Angelo's Pic Nic*, 1834. (4) Reprint of previous title, 1904.
Anon, (1) *Somerset House Gazette,* 1824 ii 8. (2) *Gentleman's Magazine*,
 n.s. xxxiv 219 (Kirby).
Antal, F., (1) *Hogarth and his Place in European Art*, 1962. (2) *B.M.*, xci
 1949 (Highmore).
Armstrong, W., (1) *G.*, 1894. (2) *G. and his Place in English Art*, 1898.
Armytage, G.J., *Register of Baptisms and Marriages at St George's
 Chapel, May Fair* (Harleian Society), 1889.
Avison, C., *An Essay on Musical Expression*, 1753.

Baker, C.H. Collins, (1) with M.R. James, *British Painting*, 1933. (2)
 *Catalogue of the Paintings in the Henry E. Huntington Library and Art
 Gallery* (San Marino, Calif.), 1931. (3) *Conn.*, Oct. 1954.
Barbier, C.P., *William Gilpin* (Oxford), 1963.
Barrell, J., (1) *Listener,* 12 May 1977. (2) *The Dark Side of the Landscape*
 (Cambridge), 1980.
Barrington, D., *Archaeologia*, vii 1785 (read 13 June 1782) on Progress of
 Gardening.
Bemrose, W., *Life and Works of J. Wright*, 1885.
Borenius, T., *B.M.,* May 1944 106-10 (G'.s Collection of Pictures).
Boulton, W.B., *T.G.*, 1905.
Brookner, A., *Greuze*, 1972.
Bruand, Y., *Gazette des Beaux Arts,* Jan. 1960 (Gravelot).

Buchwald, E., *Studies in Criticism and Aesthetics 1600-1800*, 1955.

Burke, J., (1) *English Art 1714-1800* (Oxford), 1976. (2) *England and the Mediterranean Tradition*, 1945. (3) *Eighteenth-Century Studies*, Winter 1969 (Hogarth, Handel, Roubiliac).

Burney, C.L., *General History of Music*, 1789 iv.

Busby, T., *Concert Rooms and Orchestra Anecdotes* (3 vols), 1845.

Butler, P., *Paintings in Ipswich,* 1973.

Catalogue of the Pictures of the late Mr Gainsborough. . . . 1789 (MS at G. House).

Chamberlain, A.B., *Life of T.G.*

Chayes, I.H., *Studies in Romanticism*, vi 1-21.

Clark, K., (1) *Landscape into Art* (Pelican), 1956. (2) *Memoirs and Proceedings of Manchester Philosophical Society*, lxxxv (Romantic poets and landscape painters).

Coke, David, *The Muses' Bower, Vauxhall Gardens* (G. House), 1978.

Colburn, H. and R. Bentley, *The Private Correspondence of David Garrick*, 1831.

Collins, N.W., *Memoirs of the Life of William Collins*, 1848.

Conran, G.L., *Paintings, Drawings and Prints by F. Hayman* (Kenwood), 1960.

Constable, J., *Correspondence,* ed. R.B. Beckett, 1964 ii.

Constable, W.G., *Richard Wilson*, 1953.

Cook, C., *The Life and Work of R. Hancock*, 1938.

Cunningham, A., (1) *The Lives of the most eminent British Painters*, etc, 1829. (2) op. cit., ed. Mrs C. Heaton (3 vols), 1879.

Davies, M., *National Gallery Catalogues: The British School*, 1946.

Dayes, F., *Notes on Contemporary Artists*, 1805.

Delany, Mrs, *The Autobiography and Correspondence of Mary Granville*, ed. Lady Llanover, 1861.

Dilke, Lady, *French Engravers and Draughtsmen of the 18th Century*, 1902.

Dobson, A., *Side Walk Studies*, 1902.

Dodsley, R. and J., *London and its Environs Described*, 1761.

Dulap Singh, P.F., *Portraits in Norfolk Houses* (Norwich, n.d. = 1928).

Du Piles, R., *The Principles of Painting*, 1743.

Edwards, E., *Anecdotes of Painters who have resided or been born in England*, 1808.

Farrer, E., *Portraits in Suffolk Houses* (West), 1908. (2) *Portraits in Suffolk Houses* (East) MSS in National Portrait Gallery.

Fell, G., *Conn.*, xcviii 1936 210.

Fiske, R., *English Theatre Music in the 18th Century*, 1973.

Fletcher, E., ed., *Conversations of James Northcote R.A. with James Ward on Art and Artists*, 1901.

Fry, Roger, *Reflections on British Painting*, 1934.

Fulcher, G.W., (1) *Life of T.G.*, 1856. (2) 2nd ed. (dated 1856). (3) *Fulcher's Almanack*, 1847.

Fussell, G.E., *Jethro Tull* (Reading), 1973.

Gage, H., *B.M.*, Jan.–Feb. 1965 (Turner and Patronage).

Gainsborough House, (1) *G.'s House, Sudbury*, n.d. (2) *The Painter's Eye,* June 1977.

Gatt, G., *G.*, 1968.

Gilpin, W., (1) Anon: *An Essay upon Painting*, 2nd ed. 1768. (2) *Observations on the Western Parts of England,* 1798. (3) *Three Essays,* 1792, 1794, 1808. (4) *Observations on the River Wye*, 1782. (5) *Observations... The Mountains and Lakes of Cumberland and Westmoreland*, 1786. (6) *Observations on the Western Parts of England,* ed. S. Lyall (Richmond), 1973. (7) *Observations on Coasts of Hampshire, Sussex and Kent,* 1804.

Girouard, M., *Country Life*, 13 Jan., 27 Jan., 3 Feb. 1966 (Rococo).

Goodison, J.W., *B.M.*, Sept. 1938 (Highmore).

Gosse, P., *Dr Viper*, 1952.

Gower, R.S., *T.G.*, 1903.

Gowing, L., *B.M.*, xcv Jan. 1953.

Graves, A., (1) *The Royal Academy of Arts: a complete dictionary of contributors* 1905-6. (2) *Art Sales* (3 vols), 1918-21. (3) *The Society of Artists of Great Britain: The Free Society of Artists*, 1907.

Green, T., *Diary of a Lover of Literature* (*Gentleman's Magazine*, Feb. 1835).

Greig, J., with M. Menpes, (1) *T.G.*, 1909. (2) *Morning Post*, 11 Oct. 1921 (G.'s marriage).

Grimwood C.G., with S.A. Kay, *History of Sudbury*, 1952.

Hagstrum, J.H., *The Sister Arts*, 1958.

Hammelmann, H.A., (1) *Country Life*, 3 Dec. 1959. (2) ibid., 14 Oct. 1954. (3) ibid., 14 Sept. 1967 (Book Illustrators of 18th Century). (4) *Book Collector*, 1952-3.

Harcourt, R.W., ed., *Harcourt Papers* (Oxford), n.d.

Harrison, S.E., *Conn.*, lxii Jan. 1922 5ff. (Unwin Correspondence).

Hawcroft, F., *Conn.*, 1959 232-7 (Crome and patron T. Harvey of Catton).

Hayes, J., (1) *Conn.* Feb. 1966 86–93 (Barton Grange). (2) *Apollo*, July 1965 (patrons of landscape) 38-45. (3) ibid., March 1966 188-97. (4) ibid., June 1966 444-51. (5) ibid., Nov. 1962 667-72 (later landscapes). (6) ibid., Aug. 1963. (7) ibid., July 1764 20-6. (8) *B.M.*, Feb. 1965 62-74 (early portraits). (9) *B.M.*, April 1964 190. (10) *The Drawings of T.G.*, 1970. (11) *Apollo*, Jan. 1962 2 (Howbraken). (12) *Journal of R. Soc. for Encouragement of Arts*, etc., April 1965 (no. 5105, vol. cxiii) 310-33. (13) *T.G.*, 1975. (14) *Conn.*, April 1968 219-23. (15) *Master*

Drawings, iii (3) 1968, drawings. (16) *Conn.*, Jan. 1970 17-24 (Jackson). (17) *B.M.*, Jan. 1968 28-31. (18) *B.M.*, Aug. 1963. (19) *G. as Printmaker,* 1971. (20) *T.G.* (Tate Gallery), 1980.

Hazlitt, W., *Criticisms on Art*, 1843.

Heil, W., (1) *Art in America*, xxi March 1933. (2) *Pacific Art Review*, Summer 1941.

Henry, S.A., *B. M.*, Dec. 1958.

Highmore, J., (1) *Gentleman's Magazine*, 1766 533ff. (2) ibid., 1778 526ff.

Hilles, F.W., (1) *Portraits of Sir Joshua Reynolds*, 1952 ed. (2) *The Literary Career of Sir Joshua Reynolds*, 1936.

Hipple, W.J., *The Beautiful, the Sublime, and the Picturesque in 18th-Century British Aesthetic Theory*, (Carbondale) 1957.

Hoare, Prince, *Epochs of the Arts*, 1813.

Hoff, U., *Catalogue of European Painting before 1800* (National Gallery, Melbourne, Victoria 1961.)

Horne, H.P., *An illustrated catalogue of engraved portraits and fancy subjects painted by T.G. (and G. Romney).*

Hudson, Derek, (1) *Sir Joshua Reynolds: A Personal Study*, 1958. (2) with K.W. Luckhurst, *The Royal Society of Arts*, 1954.

Humphry, Ozias, *Biographical Memoir*, MSS c. 1802 (original correspondence of O.H. in R.A. Library).

Hussey, C., *The Picturesque*, 1927.

Ingamells, J., *B.M.*, July 1964.

Jackson, W., (1) *The Four Ages, together with Essays on Various Subjects* 1798 (on G. 147-61, 229). (2) *The Leisure Hour*, May-Sept. 1882 (autobiography).

Kenwood, *G. and his Musical Friends*, 1977.

Knight, R.P., *The Landscape*, 1794.

Knowles, J. A., *Journal of the British Society of Master Glass-Painters*, x (1) 1951.

Lane, R., *Studies and Figures selected from the Sketch Books of the late T.G.*,1825.

Lane, Sophie, MS Notes in Copy of Cunningham 1829, in Victoria and Albert Museum Library, London,

Latham, J., *Antique Dealer and Collector's Guide*, May 1968 (Wax Portraits).

Leonard,J. N., *The World of G. and Others*, 1970 (Time-Life Library of Art).

Lindsay, J., (1) *Hogarth*, 1977. (2) *J.M.W. Turner*, 1966. (3) *Courbet*, 1973.

Lockman, J., *A Letter to a noble Lord*, 1751 (Vauxhall Gardens).

Malmesbury, Earl of, *A Series of Letters of the 1st Earl of M., his family and friends*, 1870.

Manwaring, E.W., *Italian Landscape in 18th-Century England*, 1925.

Mayne, J., (1) *T. G.'s Exhibition Box*, 1971. (2) *T. Girtin* (Leigh-on-Sea), 1949.

Menpes, see J. Greig.

Merchant, W.M., *Shakespeare Quarterly*, ix Sept. 1958 (Hayman).

Millar, O., *T.G.*, 1949.

Muswick, J.B., *St Louis Museum Bulletin*, 1947 7-10 (G. and Van Dyck).

Nevinson, J.L., *Country Life Annual*, 1959 25 (Van Dyck dress).

Nichols, J., *Hogarth*, no. 8 (Mrs Trimmer on G. and Kirby).

Nichols, R.A. with F.A. Wray, *The History of the Foundling Hospital*, 1935.

Nicholson, B., (1) *J. Wright of Derby* (2 vols), 1968 (P. Mellon Foundation). (2) Introduction to Wright Exhibition Arts Council, 1958. (3) *B.M.*, Feb. 1965 58-62.

Parke, W.T., *Musical Memories*, 1830.

Parris, L., *Catalogue of the Tate Exhibition, Landscape in Britain c. 1750-1850*, 1973.

Partridge, C., *The East Anglian Times*, Jan.-Feb. 1929 (bound in volume form in the Victoria and Albert Museum, London).

Paulson, R., (1) *Hogarth* (Yale) (2 vols), 1971. (2) *Emblem and Expression*, 1975. (3) *Eighteenth-Century Studies*, vi 1972 106-17. (4) *Studies in Burke and his Times*, 1968 1080-2.

Pilkington, M., *A Gentleman's and Connoisseur's Dictionary of Painters*, 1770.

Piper, D., *The Human Face*, 1957.

Price, Uvedale, (1) *An Essay on the Picturesque, as compared with the Sublime and the Beautiful*, 1794. (2) expanded as *Essay* 1810.

Proctor, I., *Masters of British Painting*, 1955.

Pyne, W.H., (Ephraim Hardcastle), (1) *Wine and Walnuts*, 1824. (2) *Fraser's Magazine*, Nov. 1840.

Raines, R., *Apollo*, July 1964 27-32 (Mercier).

Reveley, H., *Notices Illustrative of the Drawings and Sketches of some of the most Distinguished Masters*, 1820 (8th ed. revised by T. Green).

Reynolds, G., (1) *New English Review*, Oct. 1948. (2) *Constable the Natural Painter*, 1965.

Reynolds, Sir Joshua, *Discourses,* ed. R. Wark. (San Marino, Calif.), 1959.

Roberts, W., *F. Wheatley, R.A.*, 1910.

Ruch, J.E., *B.M.*, Aug. 1970 (Hayman and Tyers).

Salomons, V., *Greuze*, 1911.

Saxl, F., with R. Wittkower, *British Art and the Mediterranean*, 1948.

Shipp, H., *The English Masters*, 1955.

Shock of Recognition (Arts Council 1973): The Landscape of English Romanticism and Dutch 17th-Century School.

Sitwell, Edith, *English Eccentrics*, 1933.

Smith, J.T., (1) *A Book for a Rainy Day*, 1828. (2) *Nollekens and his Times*, 1828. (3) Revised edition of previous title, ed. G. W. Stonier, 1949.

Southworth, J.G., *Vauxhall Gardens* (Columbia University Press), 1941.

Sperling, F.C.D., *History of Sudbury from Hodson's Notes*, 1896.

Spielmann, M.H., *Walpole Society*, v 1915-17 91ff.

Steegman, J.E.H., (1) *B.M.*, April 1942 98f. (2) *The Artist and the Country House*, 1949.

Terry, C.S., *J.C. Bach*, 1925.

Thicknesse, Anne, *Letter from Miss F—d*, 1761.

Thicknesse, P., (1) *A Sketch of the Life and Paintings of T.G. Esq.*, 1788. (2) *Sketches and Characters of the most Eminent and most Singular Persons now Living*, 1770. (3) *Memoirs and Anecdotes*, 1768. (4) *Thoughts on the Times*, 1779. (5) *The Valetudinarian's Bath Guide*, 2nd ed. 1780. (6) *Man-Midwifery Analysed*, 1765 and 1790.

Thomson, G.S., *B.M.*, July 1950 201f.

Thornbury, W., *Life of J.M.W. Turner*, 1862 ii 59ff.

Tinker, C.B., *Painter and Poet* (Cambridge, Mass.), 1938.

Turnbull, H.W., *The Great Mathematicians*, 1952.

Turner, James, *The Dolphin's Skin*, 1956 (Jack G., 109-40).

Waller, A.J.R., *The Suffolk Stour* (Ipswich), 1957.

Walpole, Horace, (1) *Anecdotes of Painting in England*, ed. F.W. Holles and P.B. Daghlian (Yale) v 1937. (2) op. cit., ed. Dalloway and Wornum 1849. (3) *Letters*, ed. P. Toynbee, 1903-4.

Ward-Jackson, P., (1) *English Furniture Designs of the 18th Century*, 1958. (2) *Victoria and Albert Museum Bulletin,* Reprints iii 1969.

Wark, R. (1) *Art Bulletin,* Dec. 1958 (Thicknesse and Cooke) (2) *See* Sir Joshua Reynolds.

Waterhouse, E.K., (1) *G.* 1958. (2) *Painting in Britain 1530 to 1790*, 1953. (3) *B.M.*, June 1946 (Fancy-Pictures). (4) *Conn.*, March 1936 123ff. (5) *Walpole Society*, xxxiii. (6) *Reynolds*, 1941. (7) *Journal of Warburg and Courtauld Institutes,* xv 1952 (Gravelot). (8) *B.M.*, March 1945 (Sale at Schomberg House).

Whitley, W.T., (1) *T.G.*, 1915. (2) *Walpole Society*, xii 1925 44f. (Bate). (3) *Artists and their Friends in England 1700-1799*, 1928. (4) *Studio*, lxxxvi Aug. 1923 63ff. (G. Family Portraits). (5) *Art in England, 1800-20* (Cambridge), 1928.

Wittkower, P., *Journal of Warburg and Courtauld Institutes*, 1945 100-3.

Woodall, Mary, (1) *The Letters of T.G.*, 1963. (2) *T.G.*, 1949.

(3) *Antiques* (N.Y.), Oct. 1956 (models). (4) *G.'s Landscape Drawings,* 1939.

Worman, Isabelle, *T.G.* (Lavenham, Suffolk), 1976.

Young, P. M., *The Concert Tradition*, 1965.

Index

Index

(3) PORTRAITS

Index

(4) PAINTINGS OTHER THAN PORTRAITS

Index

244